Singing for our lives

Stories from the Street Choirs

Campaign Choirs Writing Collective

"Choirs can be an incredible force for telling the stories of our times, the stories of the world around us. This book rightly champions those choirs who take their singing out of those warm rehearsal rooms and onto the streets." Boff Whalley, Chumbawamba and founder of the Commoners Choir.

"This is a gem of a book. If you're not actually listening to – or singing with – the harmonious voices of these rebels, singing truth to power, then reading their testimonies of the highs, lows and disc(h)ordant moments of the street choir is surely the next best thing." David Harvie, University of Leicester, Sฺng Meanwood and Commoners Choir.

"This book gives a unique opportunity to read about the growth of political choirs from as far back as the early 40s to their being a widespread phenomenon today." Frankie Armstrong, founder of the Natural Voice Network.

SINGING FOR OUR LIVES: STORIES FROM THE STREET CHOIRS
© Campaign Choirs Writing Collective 2018

The right of Campaign Choirs Writing Collective to be identified as authors of this work has been asserted in accordance with the Copyright, Designs and Patent Act 1988

British Library Cataloguing in Publication Data
A catalogue record for this book is available from the British Library

ISBN-13: 978-1-910849-10-1
ISBN-10: 1910849101

Singing for Our Lives: Stories from the Street Choirs/ Campaign Choirs Writing Collective
1. Music 2. Social Movements 3. Community Heritage 4. Social History
5. Politics 6. Cultural Studies

First published in 2018 by HammerOn Press
Bristol, England
https://www.hammeronpress.net

Cover design and typeset by Eva Megias
http://evamegias.com

ACKNOWLEDGEMENTS

We, the Campaign Choirs Writing Collective, have been lucky enough –
and, frankly, have worked more than hard enough! - to obtain funding
from the Barry Amiel and Norman Melburn Trust and the Sharing
Heritage programme of the Heritage Lottery Fund. Both partners have
understood the reach of our oral history project, which extends beyond
the more usual boundaries of the local or regional to covering three
nations and even casting its eye internationally to trace musical, political
and communal connections. Apart from our funders, we have also been
fortunate in getting sustained academic support from Gavin Brown at the
University of Leicester. Gavin was able to extend his support to doing – we
hope you'll agree – a great job in editing this volume. Pete North at the
University of Liverpool also supported the project, particularly through
some daunting early days. Resisting the temptation to 'go off on one'
about the neoliberalisation of the university, suffice to say here that there
is not much in this project – certainly no cash and probably no kudos
from 'management' – that benefits our academic supporters. What there
is, we sincerely hope, are the satisfactions of working in solidarity with
grassroots activists in a vibrant social movement. Our supporters have
helped us to offer knowledges that might otherwise have been lost to an
audience that includes activists and academics as well as a wider public.
Next, thanks to our supportive publisher, HammerOn, especially to D-M
and cover artist Eva Megias. We also thank Holly Near for generously
letting us borrow her song title 'Singing for Our Lives'. Not to duck a
cliché, *last but not least*, we are delighted to acknowledge the support we
have had from the Campaign Choirs Network, particularly those choirs

who participated directly in the research, made us so welcome, let us join in their singing, and shared their stories. These choirs put themselves out to accommodate our necessarily intense interview schedules, confined as we were by costs. We are sorry not to have been able to speak with all the choirs in our Network, but we do still want to work with you to get more of your stories heard. Meanwhile, thanks again to all funders, supporters, participants, friends and comrades. And thank *you* for reading.

INTRODUCTION

'INSPIRED BY LIFE AND LOVE'

I think music goes straight to the soul, and it makes your body literally move, that's changed – you get goose-bumps, you feel you want to dance, you want to scream: like, music does change people in a very literal way. It makes sense that it can move people to create other kinds of movements.[1]

If you can't necessarily judge this book by its (we think) terrific cover, at least we're confident that it will live up to its sub-title and so bring you 'stories from the street choirs'. The stories we present are gleaned from oral history interviews with forty-two members of eleven contemporary street choirs from towns and cities across Wales, Scotland and England, namely Aberystwyth, Birmingham, Cardiff, Edinburgh, Leicester, Liverpool, London and Sheffield. We 'sampled' these street choirs from a much greater number that we know about. The Campaign Choirs Network, for instance, has 43 street choirs signed up and active, while the annual Street Choirs Festival has attracted more than 100 different choirs over the last ten years. In Chapter 1 we'll describe the Campaign Choirs Network and the Street Choirs Festival in some detail. Later, we'll draw on our research to explain more fully how their members define a 'street choir' for themselves. For the moment, let's say that a street choir is a group of people singing together in a public space, the street. But these are also campaigning choirs: they have something to say, sentiments to share through song. The stories of members of these choirs relate to why and how they have brought music and politics together in their lives.

1

From there, we are especially interested in what they are singing for: the sort of world they want to see, both in their individual heres and nows and in the near and far-flung futures of others.

Exploring their role in political culture, this book, Singing For Our Lives (S4OL), aims to introduce the neglected world of street choirs to a wider public. At the time of writing, if you Googled[2] 'street choirs definition', nothing about the grassroots movement that we are talking about comes up except – low down the listing – an article we wrote ourselves for the political magazine Red Pepper.[3] We hope to inspire the reader to engage with this neglected world: to find out more about street choirs, to join a choir in their community, to enlist their local street choir to support campaigns for social change and, more generally, to mobilise artistic creativity in progressive social movements. We ask, who are the people who assemble together in street choirs? What are their common and uncommon musical and political backgrounds? Why do they choose singing as a means of political expression? What songs are street choirs singing? Who wrote them? And who's writing new ones?

We don't claim that the people we interview from a particular choir represent the views of that choir. And we certainly don't argue that, taken together, our interviewees represent the Campaign Choirs Network or the wider constituency of street choirs in the UK. Those disclaimers made, we do believe that the interviews provide us with a platform from which to make some useful, if always tentative, observations. So, after we have thoroughly immersed ourselves in people's stories, we will dare to surface and suggest how street choirs might develop their individual and collective potentials in ways that take into account the everyday realities, hopes and dreams of their members. Holding a mirror to those suggestions, we'll consider why new people would want to join a street choir, especially people who think they can't sing, as well as those alienated from, despairing of, or apathetic about politics. Ultimately, S4OL will seek to understand something about how making political music together can contribute to non-violent, just and sustainable social transitions.

By the way, the sub-title of this section, 'inspired by life and love', is a

line from Billy Bragg's version of 'The Internationale', which is the adopted anthem of the annual Street Choirs Festival in Britain. Eugène Pottier, a former member of the Paris Commune, the radical government of France for a few near legendary months in 1871, wrote the original French words of 'The Internationale' in that year. His lyrics were set to music in 1888 by Pierre Chrétien De Geyter, a Belgian socialist, and the song has been a standard of socialist movements across the world ever since. One of the choirs that we interviewed, Côr Cochion Caerdydd, Cardiff Reds Choir, pride themselves in members singing the Internationale in up to five different languages simultaneously! Billy Bragg released his version of the song on an eponymous album in 1990. We think his verse two, in particular, speaks to and says something about the street choirs movement in today's Britain:

> Let no one build walls to divide us
> Walls of hatred nor walls of stone
> Come greet the dawn and stand beside us
> We'll live together or we'll die alone
> In our world poisoned by exploitation
> Those who have taken now they must give
> And end the vanity of nations
> We've but one earth on which to live[4]

Of course, given their diverse political characters, we would also expect street choirs to contest and debate these lyrics: what, for instance, would 'ending the vanity of nations' mean? Throughout the book we'll weave in some song titles and lyrics that can contribute to the overarching street choirs story. We are especially interested in those songs written by members of street choirs. We also focus on the spaces where songs are rehearsed and performed.[5] Above all, however, this is the story of the people who are singing the songs.

We chose 'Singing for Our Lives' as the title of our project and this book because we feel it resonates with a collective ethos of the street choirs that we engage with. 'Singing for our lives'[6] is a song by Holly Near,

an American singer-songwriter, feminist and anti-war activist. Penny Stone, one of the Musical Directors of Edinburgh street choir Protest in Harmony, reminds us that the song 'began life as a cry for and from members of the global LGBT community in response to the killing of councillor Harvey Milk and mayor George Moscone in San Francisco in 1978.'[7] The story of that assassination is the subject of several books, including Randy Shilts' acclaimed biography of Milk,[8] and at least one excellent film, *The Times of Harvey Milk*, which won the Academy Award for best documentary in 1984.[9] Since Holly Near released the song on the album *Lifeline*, also in 1984, street choirs and others have sung 'Singing for Our Lives' in many, many contexts. In Penny's case, for instance, she reports having sung it when protesting against the Trident nuclear weapons system at Faslane in Scotland, on the frontline with non-violent activists in Palestine and – in something of a tragic full-circle for the song – on the street in Edinburgh when forty-nine people were killed by a hate-fuelled terrorist gunman who targeted a gay nightclub, Pulse, in Orlando in June 2016.[10]

The research project which led to us gathering stories from the street choirs had its origin in an Economic and Social Research Council seminar series, 'Sustainability Transitions.'[11] Considering 'processes of social change to sustainable patterns of production and consumption', the series consisted of four seminars staged at the Universities of Liverpool, Leicester, Manchester and Nottingham Trent, culminating at the Centre for Alternative Technology in Wales in September 2012. It gave rise to a group of academics and activists together conceiving a multi-stranded research project around the theme of 'care for the future'. Although the wider research project foundered on the rocks of limited capacities and a dearth of funding possibilities, one activist strand, this one, persisted and eventually flourished.

As a research project, S4OL was conceived because the Campaign Choirs Network were, and indeed remain, interested in how street choirs could appeal to more people, to sustain, grow and diversify the movement. On their various websites some of the Campaign Choirs we engaged with in this research express their 'care for the future' in different

terms, singing 'songs of worldwide celebration, struggle and change', 'for peace and socialism', 'for freedom, justice and peace around the world', 'for peace, justice and the environment, against militarism, capitalism, racism and sexism', and so on. Setting out their various oppositions to oppression, exploitation and fascism, street choirs typically express their solidarity with others in their struggles, both those close to home and also far away geographically and historically. Later, we'll touch upon how choirs might express something akin to solidarity beyond the human realm, for instance for other species, landscapes and the environment.

THE ETHICS OF CARE

As we've begun to see, street choirs set out their political values in the here and now, and so begin to illuminate their visions of social change towards a better future, in terms such as justice, freedom, diversity, equality, peace and environmental sustainability. In conceiving this research project, we considered these expressions along with our own experience of singing with and working within street choirs. The 'analytical framework' that we decided could best encompass Campaign Choirs' values and practices, and best suit the Network's desire to learn more about themselves, and so diversify and grow, is drawn from the feminist theory of 'the ethics of care.' Very briefly, the ethics of care focuses on relationships between people rather than on individual virtue or self-interest. It encompasses sets of both values and, most insistently, practices. No abstraction, then, the ethics of care is thoroughly grounded in everyday, material reality and it involves *work*. We've already presented some of the values that street choirs hold and, clearly, choirs are relational in at least the immediate sense. And, joyful as choral singing is, it is also hard work for most of us, from composers and arrangers, through conductors or Musical Directors, to the singers: the sopranos, altos, tenors and basses who learn the words and melodies to finally render all that work in songs that aspire to sound effortless. Handily for us, the ethics of care provides a standard against which to evaluate contemporary practices

and so suggest beneficial changes and alternatives. Moreover, we hope that this research project can contribute in some small measure to the development of the ethics of care as a moral theory that rejects and counteracts violence and domination.

The defining features of an ethics of care that make it such a good fit with our research within and for the Campaign Choirs Network begin with its central focus on 'meeting the needs of particular others for whom we take responsibility'.[12] Street choirs across Britain – and doubtless beyond – do nothing if not strive to address the needs of particular others. In practice, taking such responsibility may manifest in a variety of forms, for instance taking direct action to close a Job Centre and so shame the brutal bureaucracy of austerity in the UK, busking to raise money for a hard-pressed refugee camp in France, or street singing to raise awareness of the plight of Palestinians and so garnering political support for their cause.[13] There are other, more emotional, community needs to be met too, for example vigils for victims of domestic violence, war, terrorist attacks and hate crimes. The ethics of care values emotions such as sympathy, empathy and responsiveness alongside reason, especially in politics at all scales from the household to the global. Abstraction is not regarded as a virtue, and the ethics of care respects the claims of the various particular others with whom we relate. In other words, the expression 'justice is blind', wherein impartiality and objectivity are viewed as paramount, is anathema to the ethics of care, which recognises the realities of interdependence, valuing as it does friendship and loyalty.

A fourth defining feature of an ethics of care is that is adheres to the feminist maxim that the personal is political and vice versa. No moral distinction is made between the values and practices in play in private or public life. So, oppression and violence in the home is considered on a par with similar practices in, say, the conduct of government. The ethics of care addresses moral issues arising in unequal and dependent social relations, noting too that these social relations are often involuntary for at least some of the parties, parent-child relationships being a prime example. Pertinently for our research, this understanding extends to a wider society and to involuntary relations like gender, race and

class. Within the framework of an ethics of care, people are viewed as relational and not as predominantly independent nor self-sufficient: taking independent action actually depends on the existence of a network of social relations. Virginia Held writes that: 'The ethics of care must concern itself with justice (or lack of it)'. Whilst there can be care without justice, there can be no justice without care, which may thus be considered as the more fundamental value. Moreover, care allows for the development of a more capacious moral theory. That is, it judges no-one, and arguably no thing, to be beyond its reach. As Held states: *'The social changes a focus on care would require would be as profound as can be imagined'.*[14] The ethics of care thus provides us with a radical analytical framework for our research with street choirs.

PARTICIPATORY ACTION RESEARCH

Without splitting too many fine theoretical hairs, we understand our project as being participatory action research (PAR). PAR is an approach oriented towards actively challenging oppression in pursuit of social justice[15]. In supporting street choirs in such an aim, we believe that PAR can reveal power relations differently and so suggest new ways that political struggles might be constructed. As a research method, it can be distinguished by being a collaboration between researchers and researched on the diagnosis of a problem. The collaboration then continues into the development of a 'solution'. PAR encompasses a commitment to democratic knowledge-making and an affirmation of human agency. It respects the capacity of people to act to solve their own problems and support others whom they care about.

Process, considered as a collaborative relationship, is one of PAR's main aims rather than a means to an end. Moreover, transparency and accountability are core values, trumping quantification or reproducibility. In the first instance, at least, the approach seeks to increase local and particular knowledges. That said, we believe that PAR 'might jump scales and/or travel across space to contribute to other knowledges.'[16]

For instance, lessons from one local struggle may well be relevant to a national struggle and/or to a local struggle in another land. So, we researchers did indeed collaborate with others in the Campaign Choirs Network, both via formal discussion in meetings and through informal conversations, to identify the 'problem', i.e. how to know, grow and diversify the membership and better pursue network aims. Ultimately, this book can be read as our proposal for continuing that collaboration to develop a solution. We trust that it can also be read as an entertaining and informative slice of social movement history that dares to imagine social change. We note here that we researchers and writers who comprise the Campaign Choirs Writing Collective are all committed, long-term and enthusiastic members of street choirs. Unlike some 'engaged' or 'embedded' researchers, we have no 'exit strategy'! We consider ourselves what Gavin Brown dubs 'observant participators'[17] rather than the 'participant observers' typically explicated in social science texts on research methods. So, we are intent on our activist engagement and what we can give rather than any academic detachment and what we might extract from collaborative research.

Very much in harmony with PAR, we view process as an aim of our research. Hence we developed research methods with participating choirs that were, we believe, both mutually informative and enriching of social relations between researchers and researched. Our usual practice became to visit choirs in their home towns or cities. There we would rehearse with them and/or join them in taking action, for instance busking or singing on the street in support of a campaign. If possible, we would attend a choir meeting and exchange information about our projects, which we presented as one strand of a wider collective project, namely the Campaign Choirs Network initiative. In many instances, some members of the choir would accommodate us overnight. Though this practice was initiated in the first instance because of our our very limited funds, it was also our methodological preference as, again, it developed collaborative social relations. If choir members socialised after their practices, we also endured the hardship of joining them in some fine hostelries across Britain, all in the name of research excellence, of course. Our interviews

were conducted with a number of members of each street choir, typically four, preferably using the quieter space of someone's home but quite often making the best of a range of public spaces such as cafés and libraries. Interviews were designed to take forty-five minutes and overran more frequently than not. Always, we left space for interviewees to ask us questions and to contribute on any topic that they felt we had omitted.

We transcribed the interviews ourselves, again because of a lack of funds in the first instance but latterly because we came to consider listening again and transcribing as intrinsic to the research. We both transcribed interviews that we had conducted personally and transcribed each other's in a number of instances as a way of increasing our collective understanding. We did not transcribe everything verbatim but we did try to note something about shifts of 'mood' during an interview and all the direct quotes are verbatim. Finally, we shared both audio interview files and transcriptions with interviewees so that they could comment on them. Only in very few cases did interviewees decide to self-censor a remark. Except for one case, where an identity is professionally sensitive, interviewees consented to us using their full names.

WHY, HOW, WHAT ORAL HISTORY?

We chose oral history interviews as a research method primarily because we had decided early on in in the process that it was people's stories that we were interested in, not to say fascinated by. The stories of street choir members, old, new and diverse, past as well as present, would, we felt, yield the best indication of why people chose this form of cultural activism. Thence it could reveal how street choirs could attract and interact with more people. Oral history, as it says on the tin, is predominantly a historical research method used to reconstruct the events of the past: 'The most distinctive contribution of oral history has been to include within the historical record the experiences and perspectives of people who might otherwise have been "hidden from history."'[18] Those thus 'revealed' by oral history include working class

men and women, oppressed peoples and minorities. We realised that we perhaps didn't always recognise oral history as a label when delighting in reading the work of its greatest exponents, writers like Alex Haley, Studs Terkel, and Sherna Berger Gluck (who pioneered women's oral history). We also realised that we were using oral history in a novel way. Ultimately, we were seeking more to imagine future society than reconstruct events of the past. We'll consider this anomaly when we come to assess our research methods, considering too some of the 'travails' of feminist researchers employing oral history as a method.[19]

With some experience of interviewing, but certainly not as historians, we were fortunate enough to be able to attend a one-day training course offered by the East Midlands Oral History Archive in the University of Leicester. We were fortunate too that one of our academic research partners, Pete North from the University of Liverpool, managed to scare up sufficient funding for four street choir members to attend. Reflecting on that training, although it set us up to become quite technically competent interviewers (we trust!), one day was certainly not sufficient to imbue in us the ethos of the oral history research community. Nor was it long enough to familiarise ourselves with the multiple potentialities of the method. Lyn Abrams reminds us of the entwined practice and analysis involved in oral history research.[20] While an oral history interview gleans stories of the past from the interviewee's memory, it is also 'a communicative event': the interviewer must try to understand not only *what* is being said but also *how* and *why* it is being said. Moreover, what is said is largely dictated by the questions that the interviewer chooses to ask. And, like it or not, the interviewer retains control of the material throughout the research process. We note that its academic exponents identify a number of elements of oral history that delineate it from other historical sources, namely orality, narrative, subjectivity, credibility, performativity, mutability and collaboration.

In terms we could readily understand and relate to, Alessandro Portelli explains the significance of some of these elements that are key to our research. Oral histories are oral sources, but herein we can present only the transcripts. Writing just before the burgeoning of the digital age,

Portelli notes that: 'Expecting the transcripts to replace *the tape* for scientific purposes is equivalent to doing art criticism on reproductions or literary criticism on translations'. The tone, volume and rhythm of speech carry meanings that are not reproducible in even the most attentive transcription; emotion is too easily lost or poorly represented in footnotes and the like. Punctuation is in the gift of the transcriber, and that can also change how a story is communicated. Additionally, transcription makes accent invisible, while dialect is hard to capture without falling into the trap of parody. Portelli contends that oral history 'tells us less about *events* than about their *meaning*...memory is not a passive repository of facts, but an active process of creation of meaning'. The most revealing information may be in what interviewees hide and in why they hide it. Portelli concludes that in oral history, 'the impartiality traditionally claimed by historians is replaced by the partiality of the narrator. 'Partiality' here stands both for 'unfinishedness' and for 'taking sides': oral history can never be told without taking sides since the 'sides' exist inside the telling'. [21]

Luckily, even as we boldly engaged with our oral history interviews, we didn't know how little we knew! That said, we believe that our engagement with scholars such as Abrams and Portelli demands that we reveal our significant partialities. Dubbing ourselves the Campaign Choirs Writing Collective does not mean we the authors can disappear behind the stories that we gathered from the street choirs. As we have already 'confessed', as well as being active in the Campaign Choirs Network and so playing our parts in conceiving this project, we are all members of our own street choirs. Moreover, we share some strands of professional and activist history, and we should 'declare our interests'. We three have a background of working on green issues. A chartered structural engineer, Lotte Reimer has, from 2000 onwards, worked in the field of environmental management, training companies around the world in resource efficiency. Previously an appropriate technologist, since 2009 Kelvin Mason has researched 'green citizenship' and activism, climate change and justice, and laboured academically both within and beyond universities. Both Lotte and Kelvin have lectured on the Centre

for Alternative Technology's MSc course on 'Architecture: Advanced Environmental and Energy Studies'. During this research project, Jenny Patient, a former IT manager and educator, worked with Sheffield Climate Alliance of local organisations and individuals, pressing for action to tackle climate change. In late 2017 she began research on the responses of UK trade unions to climate change, undertaking a PhD at the University of Sheffield. The three of us also share an activist background, having 'served in' the Clandestine Insurgent Rebel Clown Army (CIRCA), an affinity group in the global justice movement.[22] There are resonances between our performances as Rebel Clowns and as street choir members, not least in terms of emotional or 'sensuous' solidarities, political performances and/or ethical spectacles.[23] As Rebel Clowns, we've taken action together from Faslane in Scotland, protesting against nuclear weapons,[24] through Copenhagen at COP 15 in 2009, pressing for 'system change not climate change',[25] to Merthyr Tydfil in Wales where we opposed open-cast coal mining.[26] When, therefore, we unavoidably bring our partialities to S4OL, at least you've been partially warned: these clowns aren't fooling!

RAPID AND SEISMIC POLITICAL SHIFTS

In the Spring of 2014, when we first turned our ideas for S4OL into a modest funding proposal, the UK was firmly in the grip of David Cameron's 'age of austerity', initiated by the Conservative and Liberal Democrat coalition government in 2010. Back then, singing against low pay, the housing shortage and, especially, public spending cuts dominated the activist practice of many of the street choirs that we were in touch with, mainly through the annual Street Choirs Festival. Launched in 2010, the civil society network UK Uncut sought to highlight alternatives to austerity; in 2013 the People's Assembly Against Austerity was initiated and, in 2018, continues as a vanguard movement, advocating political alternatives.

Other issues that were occupying street choirs included: the outbreak

of civil war in Syria in 2011; the launch of Operation Pillar of Cloud by the Israeli Defence Force in November 2012, whereby 158 Palestinians were killed; and the UK government's Bowland Shale Gas Study of 2013, which brought fracking - and opposition to it - to the centre of the political stage across Britain.[27] The crisis of privatisation and under-funding in the NHS, which continued to escalate in 2017, was signalled by a Jarrow March-inspired protest in London in September 2014.[28] To lift the gloom a little, 2014 also saw legislation passed in Wales, England and Scotland to allow same-sex marriage. The referendum on Scottish independence vitalised grassroots politics north of the border and resulted in a very high voter turnout, 84.6%, with the 'No' side winning by 55.3% to 44.7%. Across Europe the refugee crisis, which dates back to at least the late 1990s, reached a peak during 2015, according to the European Commission.

Although in 2017 none of these issues had disappeared and they were still very much the concern of street choirs, there had also been rapid and seismic political shifts to respond to. In 2016, the political shit hit the proverbial fan even more randomly than usual, it seemed, at least from a UK perspective. On Thursday 23 June 2016, the UK voted to leave the European Union and initiated a seemingly interminable period of bitter and enervating Brexit politics. Labour MP Jo Cox was murdered by a far-right extremist in June 2016 in the lead up to the Brexit referendum. The vote triggered a wave of hate crimes against perceived immigrants to the UK, countered by public demonstrations and civil society responses such as Hope Not Hate. In July the House of Commons voted to replace Britain's Trident nuclear weapons system. Almost inevitably, an already rolling programme of protests at places like Faslane naval base in Scotland and the Atomic Weapons Establishment at Burghfield will escalate and entreat the support of street choirs in the years to come.

Beyond the UK, right-wing populist Donald Trump won the US presidential election in November 2016. This sparked protests in many places around the world, including in Britain, not least because of Trump's perceived racist and sexist views and conduct. As President Trump acts on global issues by, for example, ramping up tensions around nuclear

weapons, imposing a discriminatory international travel ban, and withdrawing US support for the Paris Agreement on climate change, UK street choirs are bound to respond alongside progressive political movements. Meanwhile, terrorist attacks and hate crimes around the world continued on an almost daily basis throughout 2016 and 2017. However, the number of deaths from terrorism fell in 2015 for the first time since 2010 from a 2014 peak of 32,765. Although attacks in Europe tend to receive most mainstream media attention in the UK, Iraq, Nigeria, Afghanistan, Syria and Pakistan dominate this grisly league table.[29]

We catalogue some of these major events because they have inevitably affected the mood of our interviews with street choir members, which spanned from November 2014 to June 2017. For example, our interviews with members of Birmingham Clarion Singers took place in the days following the Manchester Arena bombing on 22 May 2017. You may want to bear in mind the timing of the interviews when comprehending the stories that street choir members told us. Then, while it would be foolish to suggest that all street choirs and their members are of one analytical voice on all the political events we have listed during this period, there would undoubtedly be a measure of movement consensus. The most significant exception to this claim may well be Brexit. As well as right-wing libertarian and nationalist arguments in favour of Brexit there is also a left-wing case, in theory if not in practice. Writing in *The Guardian* of 16 May 2016, for instance, Paul Mason wrote: 'The EU is not – and cannot become – a democracy. Instead, it provides the most hospitable ecosystem in the developed world for rentier monopoly corporations, tax-dodging elites and organised crime.'[30] Of all the political issues in flux during the course of our research, Brexit seems to be uniquely divisive. That said, we are unaware of any instances of members leaving any street choir or of feuding between street choirs over the issue.

PARTICIPATING CHOIRS

The following profiles of the choirs that took part in this project are presented chronologically in the order that we visited them and interviewed their members. In most of these short introductions, we have tried to include some of the impressions that we carried away with us from our encounters.

Red Leicester (interviewed in November 2014)

Born out of a Workers' Educational Association evening class, 'Songs of Struggle and Celebration from Around the World', Red Leicester was formed in 1996. They are 'an enthusiastic group of about 30 people with a passion for singing in unaccompanied four-part harmony' and they 'join together with other members of the Campaign Choirs Network to sing at demonstrations and political events'.[31] Their repertoire includes 'historical and contemporary songs expressive of social and political protest, and songs of worldwide celebration, struggle and change' and they cite their influences as 'the peace movement, civil rights, women's movement, gay rights, workers' rights and environmental issues'. The choir is embedded in the community and proud of their history and Labour movement roots. When we visited we got the impression that they have a real feeling for 'their' Leicester, which they want to be a city that is identified with inclusivity and fairness. Any attack on that vision of place (such as the English Defence League marching in their streets or refugees being refused sanctuary) is strongly challenged by the choir. Several choir members are, indeed, actively involved in refugee support. Red Leicester are enthusiastic participants in the Street Choirs Festival, which they hosted for a second time in 2016. As they had not covered their costs when they hosted it in 1998, the choir made this move with some trepidation! (It's okay, everything worked out fine.) Red Leicester was the first choir we, rather nervously, approached to interview for this book. They responded enthusiastically and invited us to join their weekly practice, giving us a chance to talk about the project with the whole choir

before undertaking the interviews with some members the following day. This was to become a very enjoyable format for engaging with street choirs throughout our research: meet, sing, talk, sing and, more often than not, follow up the practice with an outing to a pub. Visiting Red Leicester greatly encouraged us to pursue our research project.

Liverpool Socialist Singers (interviewed in February 2015)

This relatively new choir has been going since May Day 2010. They sing on picket lines, at rallies and demonstrations, community events and street festivals. Liverpool Socialist Singers do sing on the streets, but don't busk for money. Newish they may be, but the choir consciously build on a long tradition of music in working class struggles against oppression and have rapidly become a recognised voice in Liverpool. Karen Jonason, born in Bromley in 1950, told us: 'I think we're part of the political culture of Liverpool. Whether we make a difference, I don't know, but I know that when we have done, for example, the NHS stuff, those people who're on strike there are very, very pleased to see us and really think it's great.' The choir is inclusive and describes its members as 'students, pensioners, teachers, trade union activists, peace campaigners, artists, office workers, volunteers, community activists and people looking for work'. They welcome new recruits, noting that 'nobody is turned away and everybody's talents and skills are valued.'[32] Liverpool Socialist Singers are prolific songwriters, known particularly for writing political lyrics to well-known tunes. Their compositions often find their way onto the song-sheets when street choirs come together at demonstrations. Many of the songs are composed as a collective and credited as such (see Chapter 3). Liverpool Socialist Singers are very active in the Campaign Choirs Network and, in addition to their local engagements, can be found singing at most national demonstrations. Lotte Reimer recalls: 'They were the second choir to be interviewed and they were curious, interested and most welcoming. A rowdy bunch, we enjoyed their rehearsal and the follow-up singing in the pub. We came away with a distinct feeling of a Liverpool identity, and it is no surprise that they have adopted local

singer-songwriter Alun Parry's "The Limerick Soviet" as one of their trademark songs.'[33]

Strawberry Thieves Socialist Choir (interviewed in July 2016)

Strawberry Thieves took their name from a design by Victorian socialist William Morris, when they formed in 1996, appropriately enough on the centenary of his death. They profile themselves: 'We are a choir of about 25 based in SE London who enjoy singing for change. We sing at demos, Stop The War events, labour movement meetings, birthday parties and at the biennial Raise Your Banners Festival of political song. Our repertoire draws on modern songs, as well as the wealth of political song which chronicles the history of struggle over the centuries, both in Britain and abroad. We bring a musical dimension to protests about the cuts in public spending.'[34] Deeply embedded in their London community, Strawberry Thieves support the local library, hospital and social housing projects. They organised the 'Chants for Socialists: Festival of Political Song' for street choirs in 2017, arguably the first Campaign Choirs Network gathering (see Chapter 1). The Thieves are well connected across the UK with close links to, among others, Oxford's Sea Green Singers and Nottingham Clarion Choir of which John Hamilton, the Thieves' principal founder and Musical Director, was once a member. They have also forged links with French, Italian and Belgian choirs and have attended the annual *Rencontres de Chorales Révolutionnaires* (meeting of revolutionary choirs) every year since 2008. Two of our writing collective were fortunate enough to be able to interview Strawberry Thieves in France during the *Chorales'* meeting of 2016, living alongside them and the other choirs, singing, cooking, talking, and walking together. With always lively banter and geographically appropriate *joie de vivre*, Strawberry Thieves extended to us a warm and friendly welcome. 'A strong-willed group of individuals, Strawberry Thieves have forged a special choir identity with a devil-may-care attitude and a fierce loyalty to their principles and each other,' Lotte Reimer observed following that shared experience in France.

Raised Voices (interviewed in December 2016)

Raised Voices describe themselves as 'a London-based political choir of men and women which has been in existence since 1986'. They sing 'a continually developing repertoire of left, social justice, environmental, anti-war, feminist, internationalist, anti-racist and other political songs, including songs from other cultures and languages.' Like other street choirs, Raised Voices sing for a number of causes, busk in the street, sing at political and cultural events and benefits, join demonstrations and take action in a variety of ways, though always involving singing. Raised Voices' events calendar for part of 2017 is revealing: 21 Jan: Women's March on London; 4 Mar: Our NHS demo in London; 30 Mar: Performance of a collection of protest songs at 'Radical Voices Aloud' at the University of London; 8 Apr: Singing at the AGM of the Women's International League for Peace and Freedom (WILPF); 22 Apr: March for Science, London; 23–25 Jun: Singing with 48 other choirs at National Street Choirs Festival in Kendal, UK; 20 Jul: Busking in support of Medical Aid for Palestinians at Highbury & Islington tube station, London; 6 Aug: Performing two songs at Hiroshima Day commemorations, London; 9 Sep: Singing at the blockade of the biennial UK Arms Trade Fair, London. This clearly very active choir is 'run as a collective, with shared responsibility and decision-making'[35]. From the inception of both, Raised Voices have played a major part in the Street Choirs Festival and the Campaign Choirs Network. They have been the initiators of several 'Big Choir' sings at political events, with the 2012 London anti-cuts demonstration being a seminal moment in the formation of the Campaign Choirs Network. With their many original and always politically pertinent songs, Raised Voices are one of the choirs that most seasoned Street Choirs Festival-goers make certain that they hear. Lotte Reimer recalls: 'When we arranged interviews, instead of joining the choir practice as was by then our usual practice, we were invited to join Raised Voices in street singing at Earl's Court Tube Station, raising awareness and collecting for Medical Aid for Palestinians. Somehow permission to sing *in* the station had not been secured, so,

undeterred, Raised Voices sang outside. Throughout the singing there was always somebody available to explain the action, hand out leaflets and rattle the collection bucket. On a cold December evening, this was a really heart-warming experience of welcome, camaraderie and action.'

Velvet Fist [1983 – 2013] (interviewed in December 2016)

'Velvet Fist is an all-women, socialist *a capella* singing group based in London. We have been singing songs about women's issues, human rights, peace, equality and other struggles for over 25 years. We sing at gigs for trade unions, human rights, anti-war, women's and other organisations, as well as the occasional wedding, birthday party and funeral. We have also performed at the National Portrait Gallery, Royal Festival Hall and the Roundhouse in Camden.' Velvet Fist sent this description to the organisers of the 2013 Street Choirs Festival, their last before the choir disbanded following a final performance for the Older Feminist Network that same year. By then, the choir had been going for thirty years and was something of an icon among street choirs. They were always guaranteed a full auditorium when, although usually a small group, they delivered their razor-sharp lyrics in pitch-perfect harmonies at Street Choir Festivals.[36] A little more digging reveals that the 'choir originated in an arts project by the Communist Party.[37] A radical mixed gender choir, Artery Choir was first founded as Artery Band in 1983 along with several other Party arts groups. In 1990 the choir became a women-only choir and changed their name to "Velvet Fist," inspired by the Peggy Seeger song "Carry Greenham Home"[38] and the role of women in the Greenham Common protests'.[39] 'The members of Velvet Fist are feminist and socialist and have come together through political activity to find a voice in music. They sing of struggle, liberation, peace and equality.' With their musical professionalism and strong trade union links, Velvet Fist clocked up an impressive list of performances, which included 're-opening of London's Royal Festival Hall, the 150th birthday of the National Portrait Gallery, Tony Benn's 70th Birthday Party in the House of Commons, Oliver Tambo's memorial service with the ANC

choir, a performance on BBC Radio 4 of Graham Knight's haunting arrangement of the Red Flag,[40] and supporting Holly Near at the Raise Your Banners festival of political song in Sheffield.' [41]

Out Aloud (interviewed in March 2017)

'Out Aloud is Sheffield's LGBT Choir. It was formed in 2006 and enables lesbians, gay men, bisexual and transgendered people in Sheffield to enjoy singing as a community. There are no auditions and you don't need to be an experienced singer or read music.'[42] The choir has a membership of around seventy people and is, as far as we are aware, the only street choir with a waiting list! They reveal a little more of themselves in their 'biog' for the Street Choir Festivals in Leicester (2016): 'Singing together has been a great way for us to build our community and to raise awareness of LGBT lives and issues. In addition to singing, the choir has brought about friendships, romances, babies and a host of outfits many of us never thought we'd be willing to wear when performing at various events and venues! Street Choirs Festival is one of our favourite events and we're looking forward to being out and proud on the streets of Leicester this year.' Out Aloud have taken part in the annual Street Choirs Festival since 2008 and theirs is another of the performances that no Festival-goer in the know wants to miss. Singing beautifully, they always move the audience, often by giving a well-known song a simple but profound political twist. Nina Simone's 'Black is the colour of my true love's hair', for instance, is arranged so that the women sing 'she' of their true love and the men sing 'he' of theirs. Sonorous male voices crooning 'I love the ground on where he stands' caused many a tear to be shed in the concert hall. And Out Aloud's costumes *are* the stuff of legend! As we write, however, it is the political and not musical or theatrical aspect of Out Aloud that is to the fore in our minds and theirs: On 23 October 2017 one of their members, Patricia Simeon, was taken into detention at Yarl's Wood Immigration Removal Centre, threatened with deportation.[43]

Sheffield Socialist Choir (interviewed in March 2017)

Sheffield Socialist Choir has been singing 'since the spring of 1988 for freedom, justice and peace around the world. We are not affiliated to any political party but sing in support of campaigns in harmony with our vision for a society, which cares about such issues as asylum-seekers, the future of the NHS, the welfare state, climate change, and freedom for Palestine.'[44] Leni Solinger, born 1943 in New York City, who has been in the choir from the beginning, told us that 'it was a WEA [Workers' Education Association] class to start with.' In the important early days 'it gave you some stability being in the WEA.' The choir's weekly rehearsal space has moved from the pop music venue The Leadmill to St Mary's Church Community Centre. An integral part of the grassroots political network of their city, Sheffield Socialist Choir has an extensive network that includes many former members. With their politically savvy songs and engaging performances that are their hallmark, Sheffield Socialist Choir are always popular at Street Choirs Festivals, which they rarely fail to attend. In one memorable performance in Whitby, the choir sang NHS SOS, voicing a siren while following the progress of a small radio controlled ambulance making its way across the stage.[45] Involved in the Campaign Choirs Network from the outset, Sheffield Socialist Choir is active in song sharing and organising. Lotte Reimer remembers: 'Joining their practice was a great experience, very inclusive and welcoming. We were impressed with their simple technological innovation and so "paperless" rehearsal: lyrics were projected onto the wall behind the Musical Director, resulting in everybody looking up while singing even new songs! We left with a strong sense of a group that was immersed and engaged in their community as well as internationally, with particularly strong links to Cuba, but also a group who were comfortable with each other and who enjoyed being together.'

Côr Gobaith (interviewed in April 2017)

Born in 2006 out of the Social Forum movement, Côr Gobaith (translates as Choir of Hope) is committed to sing for peace, justice and environmental sustainability. Based in Aberystwyth, Côr Gobaith attracts members from a swathe of West Wales.[46] The choir has strong links with Côr Cochion in Cardiff and the Pales Peace Choir in mid-Wales, which is led by Côr Gobaith's founding Musical Director, Susie Ennals. With Nest Howells now at the musical helm, Côr Gobaith have added more Welsh-language songs to their repertoire, including a number of well-known songs adapted with new political lyrics. Jenny Patient recalls her April 2017 research visit to Aberystwyth: 'One of my strong impressions was just how embedded the choir is in many campaigns, events and networks around their town – especially through their monthly Saturday street singing, which raises funds for Médecins Sans Frontières and other causes. They are a very friendly bunch and clearly enjoy each other's company. We headed to the pub after the practice and I heard stories from those I would be interviewing and many others. Côr Gobaith seems to live out its principles well – in its consensus decision-making processes, its avoidance of singing religious songs, and its belief in mutual support and collective action. The latter is exemplified by Côr Gobaith's leading role in the Campaign Choirs Network, formed during Street Choirs Festival in Aberystwyth. This network of the more radical street choirs brings choirs together to support demonstrations and actions around the country. This is something Côr Gobaith has done organically itself through singing against Trident replacement at Faslane and in Cardiff, at Aldermaston, on a Stop The War demo in Manchester, on anti-cuts protests in London – acts of defiance, in the name of a resistant hope that is captured in the choir's name.'[47]

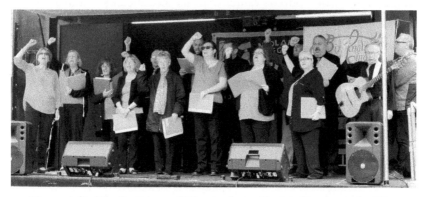

Figure 1: 'Solidarity Forever!' Birmingham Clarion Singers at the Women Chainmakers' Festival, commemorating the 1910 ten-week strike, led by Mary Macarthur, which successfully established the right to a minimum wage. Cradley Heath; July 2nd 2016. Credit: Adrian Banham

Birmingham Clarion Singers (interviewed in May 2017)

This choir was formed by Colin 'Doc' Bradsworth, a Birmingham GP and a field surgeon in the Canadian section of the International Brigades during the Spanish Civil War. Returning to Birmingham in 1939, Bradsworth announced during a *Daily Worker* social dance that he wanted to start a workers' choir, and his call was taken up by a number of Communist Party members. Founded in 1940, on their website Birmingham Clarion Singers outline the context of the choir's 'long and illustrious history: From its beginnings as a small group in the fight against fascism, it has seen Hitler's rise and defeat, the revolution and trade blockade of Cuba, the historic impact of various world leaders: Franco, Churchill, Mandela, Castro, Lenin, Stalin, Mao, Martin Luther King, Pinochet, Chávez, Thatcher, et al, and many influential individuals who shaped our ideas, and the freedoms we now enjoy: Rosa Parks, Joe Hill, Emily Davison, Angela Davies, Noam Chomsky, Michael Moore, Chelsea Manning...' To the best of our knowledge, Birmingham Clarion Singers is the only street choir that has a president, a role that, according to the website, 'is not one

which necessitates a great physical input, (but) it is a key role, warranting an individual who upholds values of peace and socialism, and a love of music.'[48] Set up to bring music to working people, in their early days Birmingham Clarion Singers performed excerpts from *The Marriage of Figaro* on the back of a lorry at a bombsite in Balsall Heath and treated civilians, service-women and men to *The Beggar's Opera* in a destroyed area of the city centre under 'The Big Top' marquee. During the Cold War, the choir visited Romania, Czechoslovakia and the German Democratic Republic through working class cultural exchanges. In the 1960s and 1970s they sang in anti-National Front demonstrations in Birmingham. The choir is currently based in All Saint's Centre, a busy community hub in King's Heath. Every year they sing at the commemoration for the women chainmakers' strike of 1910 in Cradley Heath (see Figure 1) and for a mesothelioma support event organised by trade unions.[49] The choir maintain a connection with other Clarion choirs, Nottingham, East Lancs and Bolton. During our visit to the choir we were struck by their challenging repertoire, which they tackled with discipline and a real desire to sing to the highest musical standard, honouring their roots. We came away somewhat humbled by their extraordinary history and ability to change with the times without losing their core identity, of which they were fiercely and joyfully proud.

Côr Cochion Caerdydd - Cardiff Reds Choir (interviewed in May 2017)

The feisty embodiment of the term street choir, since 1983 Côr Cochion 'have raised our voices in song, campaigning for peace, freedom and justice. We have collected many thousands of pounds to support people struggling for basic rights both at home and abroad. We sing, leaflet and collect on the street on a regular basis. We also sing at demonstrations, on picket lines, in concert halls and at music festivals. Our voices have been heard in Wales, England, Ireland, Palestine and across Europe. Among the campaigns we support are: Amnesty International, Liberty, Cymru Cuba, Nicaragua Solidarity, Campaign Against the Arms Trade, CND, Voices in the Wilderness, Women for Peace, Medical Foundation for Victims of

Torture, Palestine Solidarity Campaign, Greenpeace, UNITE, Searchlight and Colombia Solidarity.'[50] Côr Cochion are tireless campaigners and members have taken part in more direct actions than any other street choir that we know of. Join a blockade at Faslane Trident submarine base, for instance, and they will more than likely be there, with some members arrested for blockading before most other people have got out of bed![51] Côr Cochion have sung at Drumcree peace camp in Northern Ireland, at the Atomic Weapons Establishment in Burghfield, at the drone testing centre at Parc Aberporth, at Ffos-y-Frân opencast coalmine in Merthyr Tydfil, at the proposed nuclear power station Hinkley Point C,[52] at the No-NATO demonstration in Newport…The list goes on: They are everywhere![53] We were lucky enough to time our visit so we could attend their weekly Friday practice as well as join them in their Saturday street sing. Like most other choirs we visited, Côr Cochion have a meeting during their rehearsal. Participating was an 'interesting' experience, one choir member describing the process as 'ordered chaos'. Perhaps more than any other choir we visited, Côr Cochion have the feel of being a 'family', mainly harmonious but also very happy to have a good argument! The choir have an interpersonal history that goes back many years, yet it seemed to us that they welcomed and absorbed new members seamlessly. Côr Cochion care for each other, as they care for the rest of the world, with seemingly boundless energy. Our visit left us truly inspired, if a little exhausted.

Protest in Harmony (interviewed in June 2017)

Protest in Harmony is a radical singing group based in Edinburgh. They say about themselves: 'We sing songs of protest and struggle. We sing about peace, justice, the environment and human rights. We sing at events and demonstrations. We believe that song can be a powerful, positive force.'[54] Protest in Harmony meet once a month on a Saturday for a three-hour practice session. Their three Musical Directors, Jane Lewis, Penny Stone and Shereen Benjamin, share the teaching and conducting. There is a committee which helps to run things, and the fifty or sixty

people who typically attend can choose to pay a small amount on the
day to cover room hire and to pay the Musical Directors. Everyone is
welcome and there are no auditions. There is a full diary of singing at
demonstrations and at more formal performances, always in support of
a campaign or cause. Protest in Harmony have supported anti-Trident
campaigns, including Faslane 365, and protested in song outside the
Scottish Parliament many times.[55] Each year they mark Workers'
Memorial Day and the anniversary of the 1984 Bhopal disaster in India,
expressing the spirit of solidarity which Pablo Neruda (quoted on the
choir's website) describes as: 'the affection that comes from those whom
we do not know, from those unknown to us, who are watching over our
sleep and solitude, over our dangers and our weaknesses.' Jenny Patient
recalls: 'I had the joy of singing with Protest in Harmony at their Saturday
practice and at an extra rehearsal on the Friday evening to polish their
songs for Street Choirs Festival. The sun shone on Edinburgh, but it could
hardly compete with the warmth that came from the group. This is clearly
a community of people linked through activism and singing, many with
long roots tangled together, but offering an open door to newcomers or
those who want to be more casually involved. And their songs are great!
The repertoire is so varied, and includes many topical songs developed
by the Musical Directors or other members to express current themes.
I love the way their politics enfolds the non-human world and human
rights and solidarity, and blends in Scottish culture and history too. We
sang "Light Up Your Buildings Green" which celebrates how US mayors
are responding to their President's withdrawal from the Paris Climate
Agreement, and "All Jock Tamson's Bairns Are Coming Home", which
expresses well how refugees can be welcomed "home, to a family they
have never known." I would say that Protest in Harmony not only sing
about this tradition of hospitality, they know and practice it too.'

AS WE COME MARCHING, MARCHING...

Rather than trail geographically or chronologically from choir to choir in a singing safari around Britain, the chapters of S4OL are arranged thematically. In Chapter 1, 'The warm-up', we unpack the notion of a 'street choir'. Elaborating on aspects of street choir life, we include descriptions of the annual Street Choirs Festival, Rise Up Singing and Big Choir initiatives, and thence the Campaign Choirs Network. This profile of the wider street choirs movement is outlined in relation to the features of an ethics of care: relationships between people, values, practices and taking responsibility. In preparation for the next chapter, we explain a little more about how we carried out our research, our approach and our methods. In Chapter 2, 'Finding our notes', we present the family stories of street choir members, exploring their geographic and social origins as well as early musical and political influences. We hear about memorable songs and musical events, initial and influential encounters with politics, and then significant political events. Overall, we trace the nexus of music and politics in people's lives from infancy to adulthood.

In Chapter 3, 'Bursting into song', we enquire into the social practices of choirs: how people organise and take action together, including the attention choirs give to aspects of performance beyond singing.[56] We also consider the different spaces in which choirs take action from busking, through taking part in pickets and marches, to giving concerts in more orthodox choral settings. Here too we consider the materiality of choirs: sheet music, costumes, props, banners, posters, leaflets etc. People tell us why some songs are favourites and others are more of a challenge, politically, musically or sometimes linguistically. Relationality is the focus of Chapter 4, 'Harmonising'. Exploring the emotions of singing in a street choir, interviewees share their inspiring and moving moments as well as low points. We look at how participation in the choir seeds other social relations, political and cultural, from other shared activisms to friendship groups and manifestations of mutual aid. How care extends its reach from the personal to even the global is also considered when

we enquire into networks of solidarity and choirs' campaigns and causes.

'Imagining the future' is the theme of Chapter 5. We begin with street choir members' observations on how their choir and wider society have changed over time. Recognising the longstanding political commitments of many Gay Men's Choruses and LGBT choirs around the world, we are particularly excited about LGBT choirs joining the Campaign Choirs Network. This, we believe, could represent an opportunity for transformative political solidarity emerging within the street choirs movement. Our attention then turns to the future with choir members trying to imagine their utopias. We chose this focus because most of the choirs that we interview self-identify as seeking social change. So, in our interviews, members ponder whether their choirs would still be singing in the event of a perfect world; if so, what songs they would be singing and, given that progressive social change had been effected, what might they then be singing for? In Chapter 6, 'Street choirs 2.0', we discuss how the Campaign Choirs initiative might develop. We are concerned with learning from the emotions and rationalities that street choir members have given voice to and, indeed, how coherently these expressions are integrated. We ask whether popularising street choirs is desirable and, if so, how that might be achieved. More generally, we're interested in how cultural creativity might be increasingly mobilised in social movements. We return to the ethics of care to evaluate the practices of street choirs and so propose 'better ones' for consideration. To conclude, we discuss how street choirs seek to attract fresh audiences and recruit new and more diverse members. We consider potential solidarities, for instance with black, environmental, and youth social movements.

[Spoiler alert] Some of the issues that emerge are: movement commitments to 'non-violence' and 'peace'; how different groups experience similar oppressions across axes of social class, gender, race, ethnicity, nationality, sexual orientation, physical and mental health – so-called intersectionality – and so how solidarities might be forged through cultural practices like choral singing.[57] Some tensions exist between community and street or campaigning choirs that become most apparent in the organisation and performance of the annual Street Choirs

Festival. Internally, street choirs negotiate a balance between musicality and inclusivity, as well as between musical quality and political intents. We are also interested in the balance of reason and emotion within an ethics of care, and how that stands up to the challenge of co-option by capitalism in theory and practice.

Postscript: The heading of this section – 'as we go marching, marching' – is a line from 'Bread and Roses.' Originally, 'Bread and Roses' was a poem by James Oppenheim, a North American writer and editor. Published in 1911, the poem celebrates the women's rights movement, and it became the rallying call of the Lawrence textile mill strike of 1912. Protesting against a reduction in pay, the women mill workers quoted the poem on placards that read: 'We want bread, and roses, too'. The poem was reportedly inspired by a line in a speech by feminist and union organiser Rose Schneiderman: 'The worker must have bread, but she must have roses, too.' Mimi Fariña first set 'Bread and Roses' to music in the 1970s and it has since become an anthem for the rights of working women in the United States and around the world. Recorded by singers such as Judy Collins and Joan Baez, it has even been musically charred and exfoliated by John Denver. An arrangement of the song featured movingly in the 2014 film *Pride*, which depicted the story of the organisation Lesbians and Gays Support the Miners, founded in 1984 by Mark Ashton and Mike Jackson, which brought together the struggles of striking miners and gay rights activists in Britain.[58]

James Oppenheim's original poem is reproduced below. Interestingly in terms of the analytical framework of the ethics of care that we have set out, contemporary street choir arrangements of 'Bread and Roses' in the UK typically feature lyrical changes. Verse two is often changed to depict gender relations and women's solidarity with men in a different light. One choir, Aberystwyth's Côr Gobaith, for instance, change the line 'For they are women's children, and we mother them again' to 'If they will be our brothers, we'll stand with them again' – a more equal and demanding gender relationship. In most versions we have heard sung by street choirs, the lines in the last verse 'As we come marching, marching, we bring the greater days / The rising of the women means the rising of

the race' has been changed to 'As we come marching, marching, we bring you hope at last / The rising of the women means the rising of the class.'

Bread and Roses

As we come marching, marching in the beauty of the day,
A million darkened kitchens, a thousand mill lofts grey,
Are touched with all the radiance that a sudden sun discloses,
For the people hear us singing: 'Bread and roses! Bread and roses!'

As we come marching, marching, we battle too for men,
For they are women's children, and we mother them again.
Our lives shall not be sweated from birth until life closes;
Hearts starve as well as bodies; give us bread, but give us roses!

As we come marching, marching, unnumbered women dead
Go crying through our singing their ancient song of bread.
Small art and love and beauty their drudging spirits knew.
Yes, it is bread we fight for – but we fight for roses, too!

As we come marching, marching, we bring the greater days.
The rising of the women means the rising of the race.
No more the drudge and idler – ten that toil where one reposes,
But a sharing of life's glories: Bread and roses! Bread and roses!

Pat Richards, born in Manchester in 1953, brought 'Bread and Roses' to her street choir and when they sing it she introduces it to the audience: 'I love this song and love singing it with Côr Gobaith. It remembers, recognises and celebrates women's struggles that have often been ignored or treated with contempt, both historically and currently. It shows us what can be achieved when we stand together and support each other even when we feel powerless and ignored. It encourages us to resist and not be silenced. It demands that we have more than labour and struggle in our lives. I have especially loved singing this with my sisters on International Women's Day!'

ENDNOTES

1 Kate Nash, "On the interplay between music and politics". The World This Weekend (BBC Radio 4). May 28 2017. http://www.bbc.co.uk/programmes/b08rp2t6#play (from 53 mins). Accessed June 16 2017.

2 Other search engines are available.

3 Kelvin Mason and Lotte Reimer. "Raised Voices: The campaign Choirs movement". *Red Pepper* 205, January (2016): 42-44. http://www.redpepper.org.uk/raised-voices-the-campaigning-choirs-movement/. Accessed March 1 2016.

4 Composer: Petrus De Geyter (Public Domain), Original Words: Eugène Pottier (Public Domain), New Lyric 1990: Billy Bragg (PRS), Publisher: Sony/ATV Music Publishing.

5 See, for instance, Sheila Whiteley, Andy Bennett and Stan Hawkins, (Eds.) *Music, Space and Place: Popular Music and Cultural Identity* (Ashgate: Farnham, 2005).

6 Street choir members, among others, often refer to 'Singing for Our Lives' as 'Gentle Angry People'.

7 Penny Stone, "Gentle Angry People". *Peace News*, August-September, 2596-2597 (2016). https://www.peacenews.info/node/8455/gentle-angry-people. Accessed 15 June 2017.

8 Randy Shilts, *The Mayor of Castro Street: The Life and Times of Harvey Milk* (New York: Macmillan, 1982).

9 Rob Epstein (Director) *The Times of Harvey Milk*, New Yorker Films: New York, 1984.

10 See, for instance, Shiv Ganesh, "The Orlando shootings as a

mobilizing event: against reductionism in social movement studies." *Communication and Critical/Cultural Studies.* 14, 2 (2017): 193-197.

11 "Sustainability transitions: rethinking everyday practices, identities and livelihoods." http://www.researchcatalogue.esrc.ac.uk/grants/ RES-451-26-0824/read. Accessed 15 June 2017.

12 Virginia Held, *The Ethics of Care: personal, political, and global* (Oxford: OUP, 2006), 16.

13 As so compellingly portrayed in Ken Loach's award-winning 2016 film *I, Daniel Blake*.

14 Held, *The Ethics of Care*, 16 and 19, our emphasis.

15 See, for example, Alice McIntyre, *Participatory Action Research* (London: Sage, 2007). Also Sara Kindon, Rachel Pain and Mike Kesby, *Participatory Action Research Approaches and Methods.* (London: Routledge, 2007).

16 Kelvin Mason, "Participatory Action Research: Coproduction, governance and care." *Geography Compass* 9, 9 (2015): 497-507, and passim.

17 Gavin Brown, "Mutinous Eruptions: Autonomous spaces of radical queer activism." *Environment and Planning A*, 39 (2007): 2685-2698.

18 Rob Perks and Alistair Thomson (Eds.) *The Oral History Reader* (London: Routledge, 1998), xi.

19 Sherna Berger Gluck and Daphne Patai (Eds.) *Women's Words: The feminist practice of oral history* (London: Routledge, 1991).

20 Lynn Abrams, *Oral History Theory* (London: Routledge, 2010).

21 Allesandro Portelli, "What makes oral history different." In Rob Perks and Alistair Thomson (Eds.) *The Oral History Reader* (London: Routledge, 1998), 64-73, our emphases.

22 See, for instance, John Jordan, "Clandestine Insurgent Rebel Clown Army." In Andrew W. Boyd (Ed.) *Beautiful Trouble* (Or Books, 2016).

23 See Paul Routledge, "Sensuous Solidarities: Emotion, Politics and Performance in the Clandestine Insurgent Rebel Clown Army."

Antipode, 44 (2012): 428–452.

24 Kelvin Mason, "No Names, No faces, No Leaders: The risible rise and rise of CIRCA, an obscene army of the deviant, dangerous and – er – deeply democratic!" In Stelllan Vinthagen, Justin Kenrick and Kelvin Mason (Eds.) *Tackling Trident: Academics in Action through Academic Conference Blockades* (Irene Publishing. Sweden, 2012).

25 Kelvin Mason and Kye Askins, "COP15 and beyond: Politics, protest and climate justice." *ACME Special Issue*: The Politics of Climate Change, 12, 1 (2013): 9-22.

26 Kelvin Mason, "A Dirty Black Hole: Open-cast coalmining." *Red Pepper*, August, 184 (2013): 16.

27 Kelvin Mason, "Decades of Devastation ahead: Fracking and open-cast mining in Wales." *Planet: The Welsh Internationalist*, 212, Winter (2013): 57-65.

28 In 1936, mass unemployment and extreme poverty in the north-east of England drove 200 men to march 300 miles from Jarrow to London to petition parliament for development and job creation.

29 Institute for Economics and Peace. "Global Terrorism Index 2016." New York: Institute for Economics and Peace. 2016. http://visionofhumanity.org/app/uploads/2017/02/Global-Terrorism-Index-2016.pdf. Accessed 21 June 2017.

30 Paul Mason, "The leftwing case for Brexit (one day)". https://www.theguardian.com/commentisfree/2016/may/16/brexit-eu-referendum-boris-johnson-greece-tory. Accessed 11 October 2017.

31 Red Leicester Choir. https://redleicesterchoir.com/. Accessed 11 October 2017.

32 Liverpool Socialist Singers. http://liverpoolsocialistsingers.net/. Accessed 11 October 2017.

33 Alun Parry. http://parrysongs.co.uk/the-limerick-soviet/. Accessed 11 October 2017.

34 Strawberry Thieves Socialist Choir. www.strawberrythieveschoir.org.uk. Accessed 12 January 2018.

35 Raised Voices. http://www.raised-voices.org.uk. Accessed 29 September 2017.

36 Listen, for example, to 'The Dance of Zalonghos' on the Voices Now website. https://voicesnow.wordpress.com/2011/03/14/choir-a-day-day-10-velvet-fist/. Accessed 23 October 2017.

37 Velvet Fist https://archiveshub.jisc.ac.uk/search archives/9c6a044f-65e7-3c79-8a19-6b4ff638aa87. Accessed 23 October 2017.

38 "Woman tiger, woman dove / help to save the world you love/ Velvet fist in iron glove / bring the message home." Carry Greenham Home. *Greenham Songbook* (no date). http://www.aldermaston. net/sites/default/files/Greenham%20Songbook1.pdf. Accessed 23 October 2017.

39 http://www.bishopsgate.org.uk/Library/Library-and-Archive-Collections/Labour-and-Socialist-History/Velvet-Fist. Accessed 23 October 2017.

40 Graham Knight was the founder of the Artery choir.

41 Velvet Fist Biography on last.fm. https://www.last.fm/music/Velvet+Fist/+wiki. Accessed 23 October 2017.

42 http://www.outaloud.org.uk/. Accessed 24 October 2017.

43 Patricia Simeon is a lesbian from Sierra Leone who has been in the UK since 2012. She is a victim of trafficking, sexual exploitation, forced child prostitution and torture and faces a continued risk of female genital mutilation, FGM. Her sexuality adds to the danger of persecution in her homeland. Patricia is active in trying to secure the rights of lesbian and other women asylum seekers in the UK and co-founded Lesbian Action Support Sheffield (LASS). She is also a member of African Rainbow Family, Lesbian Immigration Support Group (LISG) and other support groups and churches in both Sheffield and Manchester. Change.org. petition. https://www.change.org/p/amber-rudd-mp-urgent-end-the-detention-of-patricia-simeon/. Accessed 26 October 2017; Alex Moore, "Campaign launched after Home Office detains Sheffield-based lesbian asylum seeker," *The Star*. 22 October 2017. http://www.thestar.co.uk/news/

campaign-launched-after-home-office-detains-sheffield-based-lesbian-asylum-seeker-1-8817687. Accessed 26 October 2017.

44 Sheffield Socialist Choir website. http://user53266.vs.easily.co.uk/about-us-3/about-us/ http://www.socialistchoir.org.uk/. Accessed 23 October 2017.

45 NHS SOS was written and arranged by Tracey Wilkinson.

46 First held in Porto Alegre, Brazil, in 2001, the World Social Forum is an annual meeting of civil society groups coming together in solidarity to develop alternative futures to counter hegemonic globalization. In 2006 activists organised Social Forum Cymru in Aberystwyth, one of a number of 'regional' forums. See http://www.jillevans.net/jill_evans_speeches_social_forum_060429.html. Accessed 2 November 2017.

47 Côr Gobaith translates into English as 'Choir of Hope' or 'Hope Choir' (it sounds better in Welsh). The name was inspired by Rebecca Solnit's book *Hope in the Dark: The Untold History of People Power.*

48 While Birmingham Clarion Singers may not self-identify as a street choir, ever since the 1940s they have regularly sung in the street for political campaigns and causes. These days they sing in the street for, among other causes, the libraries campaign, trade union movement and anti-austerity. https://birminghamclarionsingers.wordpress.com/history. Accessed 24 October 2017.

49 Mesothelioma is an asbestos-related cancer.

50 Côr Cochion Caerdydd website. http://www.corcochion.org.uk/. Accessed 27 October 2017.

51 Labour Councillor, campaigner, activist and founding member of Côr Cochion, Ray Davies (1930-2015) was renowned for early blockades and arrests and, on occasion, managed to get arrested, processed and be back again at the demonstration ready to sing before it ended!

52 Hinkley Point C is set to be the most expensive material object in the world with its cost forecast to exceed £50 billion according to Jillian Ambrose writing in *The Telegraph*, 18 July 2017. https://

www.telegraph.co.uk/business/2017/07/18/hinkley-points-cost-consumers-surges-50bn/. Accessed 21 May 2018.

53 Borrowing from *Notes From Nowhere*'s book title: "We are everywhere."

54 Protest in Harmony website. http://www.protestinharmony.org.uk. Accessed 27 October 2017.

55 A year-long, daily blockade of the nuclear submarine base by groups from across the UK and beyond. http://tridentploughshares.org/faslane-365/. Accessed 27 October 2017.

56 Elizabeth Shove, Mika Pantzar and Matt Watson, *The Dynamics of Social Practice: everyday life and how it changes* (London: Sage, 2012).

57 See, for instance, Kimberlé Crenshaw, *On Intersectionality: Essential Writings* (New York: The New Press, 2017). Also Patricia Hill Collins and Sirma Birge, *Intersectionality* (Cambridge: Polity Press, 2016).

58 See Diarmaid Kelliher, "Solidarity and sexuality: Lesbians and gays support the miners 1984-5." *History Workshop Journal*, 77, 1 (2014): 240-262. Also Daryl Leeworthy, "For our common cause: Sexuality and left politics in South Wales, 1967-1985." *Contemporary British History*, 30, 2 (2016): 260-280.

CHAPTER 1

THE WARM-UP

> When we sing together our hearts start to beat together. We feel closer to each other. We lose ourselves and at the same time gain a louder voice by joining ours with the people around us.[1]

So, what is a street choir, what exactly are we talking about? Conventionally, a choir is an organised group of singers who perform in a bounded public space such as a concert hall. Choir concerts are typically sheltered, insulated and sometimes marketised spaces for the production and consumption of music. In western society, at least, choirs are particularly closely associated with Christian churches and cathedrals. Bob Porter records that the origins of 'the choral tradition' in Britain lie 'in medieval monastic foundations, in which boys and lay singers joined the regular monks as they observed their religious duties.'[2] So, British choirs have a gendered origin too. Many British schools have nurtured choirs as part of their offer of musical education and as a way of increasing self-confidence and promoting team building.[3] There is, then, already something anomalous about locating a choir in the street. According to Voices Now, an organisation promoting choral singing in Britain, 2.4 million people sing regularly across the UK in around 40,000 choirs.[4] An estimated 15,000 of those choirs are church choirs and 18,000 are school choirs. Voices Now concede the limits of their survey, however: 'The real numbers are likely much higher as many new groups continue to fall under the radar, and we continue to seek out new choirs and new data.'[5] That said, the Voices Now survey does give us a feel for the widespread popularity and so cultural significance of choirs

in contemporary British society.

British choirs consist of between 6 and 700 members, Voices Now report, with their ages ranging from 6 to 100. Most popular are community choirs, then choral societies, chamber choirs and 'others'. It is unclear how these categories overlap with the data for church and school choirs. Moreover, we don't know whether the street choirs in which we are interested are numbered among community choirs, others, or not at all: the online questionnaire does not feature 'street choir', 'political choir', 'campaigning choir' nor yet 'LGBT choir' among its multiple choice options. Specifying a choir in the 'other' category *is* possible, however. Voices Now report that choirs in Britain sing a spectrum of music, modern being top of the pops followed in order of popularity by classical, folk/traditional, musical theatre, early music and gospel/soul. Again, if a choir in the survey sings another musical genre, say, as a wholly apposite instance, 'protest songs', then that could only be recorded under the 'other' category in the survey. As we'll see later, when we discuss the Street Choirs Festival, there is a distinction that can be made between community and street choirs. This distinction is not signalled by a sharp dividing line, however. Rather it is a fuzzy, liminal space of usually sumptuous harmonies but occasional grating clashes.

Now that we've considered what street choirs are, we explore some of the specifics of street choir life in order to, well, bring street choirs to life. In this vein, we'll describe and explain a little about the annual Street Choirs Festival. Then we'll untangle the history of the Campaign Choirs Network initiative from its meeting minutes and our own recollections of participation. As precursors to the Campaign Choirs Network, we'll unearth the stories of the various 'Rise Up Singing' and 'Big Choir' actions that have been organised. In addition to the Campaign Choirs Network, we'll look beyond the UK to initiatives that foster international solidarity between street choirs. Musically, we'll consider the ethos of the Natural Voice Network and its relationship to street choirs. To conclude this chapter and raise the curtain for the next, we'll say a little more about our 'methodology': how we understood street choirs in the context of political activism, and how we then framed

our research in terms of the ethics of care. We'll also elaborate a little on our research methods.

STREET LIFE⁶

In one sense, the street is merely a public thoroughfare in a human settlement, a town or city. Considered thus, the street is a space of transit or a technology for making relatively short intra-urban journeys from A to B.[7] But the street is also where we encounter people beyond our immediate family and friends, beyond our homes and private life-worlds, outside of our workplaces. As John Urry shows in the context of mobilities, walking is 'part and parcel of multiple socialities, in countrysides, suburbs and cities.'[8] On foot on the street is where we might meet our fellow citizens, a space in which we could pause to discuss the events of the day and so politics. And it is a space where we buy and sell 'stuff'. These co-practices of the street, politics and commerce, date back at least to ancient Greece where the *agora* was primarily the hub of social life and only thereafter the marketplace: 'If in the fifth-century economy the agora can be properly called a market place, its oldest and most persistent function was that of a communal meeting place.'[9]

If the social, meeting and discussion - and so politics - came first in that ancient public space, the contemporary street tends to embrace the market but despise politics. Lewis Mumford attributes the culmination of this spatial shift from society to economy to the advent of the supermarket, though that singular identification is surely meant to represent deeper and more complex processes of social change. Music on the street is typically for entertainment and, in contemporary Britain anyway, most often involves musicians busking. As a pertinent anecdotal aside, Côr Cochion were once prohibited from standing to sing in a privately owned shopping mall in Merthyr Tydfil. They were raising awareness of the multi-scale environmental injustices of the nearby Ffos-y-frân opencast coalmine.[10] Warned off by the mall's security guards and obedient as ever (*sic*), Côr Cochion did not stand: instead

they walked - *ever so slowly* - all around the mall, singing almost every song in their extensive repertoire at the tops of their voices! Regimes may prefer the street as a place of increasingly fleeting contact, where people pass each other by, intent on transit or consumption, rather than stopping, talking to each other - or singing - and so potentially fomenting dissent. To be on the street with the *wrong* people doing the *wrong* thing is transgression.[11] To be on the *wrong* street at the *wrong* time, even on the *wrong* side of the street, we are told, can be dangerous. The street is a space of tension between the attempts of authorities to impose order and people's will to contest authority, whether that be culturally, for instance via a carnival, or politically via a demonstration. It is the hallmark of repressive regimes to place politically sensitive public spaces off-limits, to impose curfews and to curb freedom of assembly as well as freedom of movement.

Thence, it is most often on the street and in town and city squares that people's politics come to a head in protest.[12] Across history and geography, some street and urban place names have become synonymous with political action, for example Place de la Bastille, Cable Street, Plaza de las Tres Culturas, Wenceslas Square, Tiananmen Square and Tahrir Square. Sometimes too, the streets are both the site and subject of politics, as in actions such as Reclaim the Streets and Critical Mass bicycle rides. Such deliberately carnivalesque protests reclaim public space from cars and commerce in the name of the social and the environment.[13] Although they may also seek to foment revolt or change government policies, the purpose of such protests is often partly fulfilled by the act itself. As Chris Carlsson writes: 'The beauty of Critical Mass – one of them anyway – is the chance it provides for people to face each other in the simmering cauldron of real life, in public, without pre-set roles and fixed boundaries.'[14] What we are most interested in is the street as an arena where citizens come together to voice their dissent, to protest and demonstrate: to contest politics at some geographical scale or other. In this, we note that: 'The employment of street music in the very specific context of political protest remains a curiously under-researched aspect of cultural politics in social movements.'[15] Here, we recognise the political

role of public display and the fetishisation of the space of 'the street' in this regard.

SIDE STREETS[16]

At the time of writing, we could find no reference to 'street choir' in conventional dictionaries, nor yet in Wikipedia. Internet searches for 'street choir' resulted in many links to 'His Band and the Street Choir', an album released in 1970 by Irish singer-songwriter Van Morrison, which features the song 'Street Choir' as it closing track. Almost needless to say, Van Morrison's song has nothing to do with the sort of street choir that interests us! Scrolling through our search results, it was not until number 16 that we found a different result, namely a hit on the 2017 Street Choirs Festival hosted by Lakeland Voices in Kendal. Subsequently, some previous Street Choirs Festivals also featured in our hit-list. Intermingled with these search results there were a number of hits on choirs of homeless people across the world, from Norfolk in the UK to Dallas and San Diego in the US and Sydney, Australia. Such street choirs are church or civil society projects with a range of, broadly speaking, apolitical objectives. Some feature music as a therapeutic activity, while other projects extend this approach to the rehabilitation of homeless people.[17] The Dallas Street Choir, a registered non-profit organization, includes in its vision seeking to 'improve the way society views those experiencing homelessness.'[18] Arguably this aim might set the project 'on the shores of politics', to misappropriate a quotation from political philosopher Jacques Rancière.

FASCINATION STREET[19]

Street choirs in the Campaign Choirs Network, the focus of this book, are definitively 'political'. What constitutes 'being political' is the subject of debate between scholars tuned to different world views.

Dictionaries' rationalist definitions of politics still tend to focus on 'the art of government'. With our ethics of care conceptual approach in mind, the feminist perspective is popularly expressed using the shorthand 'the personal is political.'[20] Although the personal can surely be political, that isn't analytically sufficient for our project, which is set, for the most part, in public space. While multiple other framings of politics are available, we find that proposed by Engin Isin to be most useful: 'Being political, among all other ways of being, means to constitute oneself simultaneously with and against others as an agent capable of judgement about what is just and unjust.'[21] For Isin, being political means calling into question dominant virtues and values in a society. Similarly, Naisargi Dave understands political activism as a critique and creative practice that challenges social norms.[22] Interestingly for our research, Dave considers the questions that arise when political activism has succeeded and social arrangements *are* changing. In Chapter 5 we'll ask street choir members what they would do if they won the struggle for the world that they're singing for. Meanwhile, constituting oneself *with and against others* and calling into question the moral basis of society indicates that Isin's framing of the political is relational and thus in tune with the ethics of care.

Choirs in the Campaign Choirs network are concerned with and critical of the ways that power is used in society, especially by governments. The street choirs we research among and act with seek to influence the uses and especially misuses of power at the local, national and international levels, often by supporting other social movements. While some UK street choirs have journeyed far afield to sing in areas of conflict and support oppressed peoples, others focus their efforts on struggles closer to home, for example supporting campaigns to defend public services. Choirs in the Campaign Choirs Network are concerned with the pursuit of social, economic and environmental justice. Indeed, better terms for the street choirs we engaged with might be campaign or campaigning choirs. However, as we've already noted, 'street' as an epithet does tend to confer on a choir a political credibility invested with grassroots urban nous and grit. Whether this is appropriate for the choirs that we engage with we'll leave for the reader to judge. We suggest, though, that 'street' does

serve quite well in representing the class consciousness and community identities of at least the bulk of choirs in the Campaign Choirs Network.

That said, not all of the street choirs that we researched even consider the street as their principal space of action! In fact, some may only perform on the street at a Street Choirs Festival, otherwise concentrating their efforts on indoor gigs and actions. If they do sing on the street, not all the street choirs in the Campaign Choirs Network busk to raise money for causes and campaigns. Not all of the Campaign Choirs share the same ideology. Some self-identify as, for instance, socialist or LGBT. There are also, we venture to suggest from our participation, distinctly feminist, pacifist and anarchist perspectives in play. Moreover, a number of Campaign Choirs have a discernible green tinge to their politics, taking in environmentalism in some form or other. In the end, most of the choirs in the network probably have a mixed membership: people who identify as being somewhere on what we might call a red, black, green, purple and – chromatically confusingly – rainbow political spectrum. In smaller towns, street choirs necessarily tend to accommodate people with a range of broadly 'progressive' political views. The range of political choirs in such places is limited by population density, and so there isn't a choice between, for instance, exclusively socialist, LGBT or green musical groupings.

As we've seen already, when they are on the street, choirs are out of place and can therefore be unsettling.[23] They are also a marginal political practice. Following Tim Cresswell, we believe that considering the transgressive practices of marginal groups such as street choirs can reveal a new perspective on the established spaces and practices of everyday life. But what are the transgressive practices of street choirs? Singers are not primarily seeking to engage in dialogue with fellow citizens, although we note that street choirs often sing in conjunction with other activists who support them, for instance by distributing flyers. Sometimes too, street choir members themselves take on the responsibility for this aspect of public engagement. Street choirs are not making a political statement in the form of a speech, as occurs on Speakers' Corners in various cities around the world: street choirs are not simply media for propaganda.[24]

Although music and song are powerful forces in inspiring and sustaining social movements,[25] street choirs are also more than inert media for melodies and lyrics: they are active, often proactive, political agents.

What street choirs *do* on the street might be considered a form of street theatre,[26] seeking through art to engage with various publics as actors do with an audience. If art can be considered as presenting a vision of a different world, it is political when it suggests how transformation might be brought about – or, indeed, how it is being deferred. To use Côr Cochion as an example once again, the Reds Choir frequently include costume and theatre in their street singing, for instance dressing as nurses and the Prime Minister Theresa May at the People's Assembly demonstration against austerity in Manchester on Sunday 1 October 2017. The demonstration was timed to coincide with the Conservative Party conference in the city. Côr Cochion's costumes and pantomime, including of course singing, served to dramatise the struggle to defend Britain's National Health Service against government imposed budget cuts and privatisation (see Figure 2). Arguably, Côr Cochion's pantomime was overshadowed by that of the Conservative conference itself, where prankster Simon Brodkin delivered a P45 to Theresa May during her leadership speech. Ostensibly the delivery came from Foreign Secretary Boris Johnson and signified May's sacking. The farce continued as the Prime Minister was plagued by a coughing fit and the 'F' fell off the 'FOR EVERYONE' slogan on the wall behind her, an incident cited by wags across some sections of the media as a sign that she should F-off.[27]

SOMETHING FOR THE WEEKEND? THE STREET CHOIRS FESTIVAL

The Street Choirs Festival is an annual event held in either June or July and hosted by one or more choirs in the same town or city. Typically, around 35 choirs come together to perform in a variety of set-pieces over a weekend. For many street choir members, the weekend begins with registration followed by a Friday night cabaret featuring musicians from

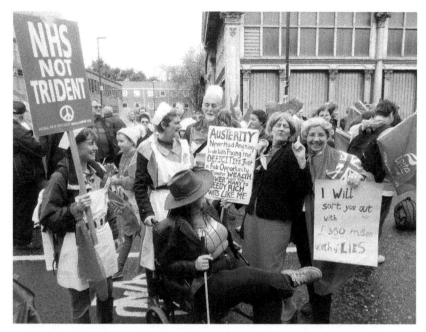

Figure 2: Take Back Manchester: Côr Cochion's 'NHS staff with Theresa May' perform at the Manchester Tory Party conference demonstration 1 October 2017. Credit: Lotte Reimer

the local area and/or others whom the hosts enlist. Finding a suitable and affordable venue for a Street Choirs Festival can be a major headache for the hosts. Then there are multiple other tasks to perform and issues to deal with, including settling on a programme of songs for the mass sing and often writing some new ones, getting bags made and T-shirts printed, considering disabled access, drinking water provision, recycling etc. In most cases, the host choir recruits volunteers from their wider community to help with registration, stewarding and so on over the weekend. If there are funds left at the end of a Festival, they are passed on to the following year's hosts. Although the current model means that recent Festivals haven't lost money, in the past host choirs have suffered financially from taking on the responsibility. Once the Festival is over, incumbent choirs typically also share their experience with the designated hosts for the following year. Thereafter, organisation of the Festival is

solely down to the next hosts, an appreciable undertaking that defines that choir's (or choirs') year.

It has become tradition for the weekend programme to include a 'mass sing' of around six songs. These are performed in a city square or similar public place on Saturday morning. Although all participating choirs have had access to the songs comprising the mass sing in order to practise them in advance, the rehearsal, early on Saturday morning, typically involves a confessional moment where a significant number of participants own up to not having had time to learn their parts. Nevertheless, when the song leaders and the assembled choristers get down to some concerted hard work, the rehearsal in itself is most often an enjoyable part of the Festival. Generally, street choir members recognise that the mass sing itself is as much for the enjoyment of the some 600 participating choristers as it is for the audience.

Following the mass sing, street choirs spend the early afternoon busking, rotating to sing in allocated spots around the host town or city. Saturday evening involves a lengthy concert in which each choir is allotted a scant and quite rigorously enforced time, typically 7 minutes, to showcase two or three songs on stage. Allowing for an additional 3 minutes to get on and off the stage, readers will quickly calculate that, with 35 choirs, the concert will last almost 6 hours! In the past, hosts have attempted to deal with this issue by running two parallel concerts. However, many people want to hear *all* the other choirs, so that is not a totally satisfactory arrangement. Even though it's something of a marathon, most participants thoroughly enjoy the concert. There are always brilliant performances, moving moments, musical highs, and songs or arrangements that people fall in love with. Often one choir will ask another for the arrangement of a song and then learn it with their own choirs when they get back home. It's unusual for everyone in any particular choir to be able to attend a Festival, so the choirs who do sing there are actually portions of a choir, albeit often quite large portions. Always well represented, Manchester Community Choir typically bring more than 40 people on stage. At the other end of the numerical spectrum, the three-woman choir Yorkshire Broads performed at the

Festival in Bury in 2012. After the concert, people usually socialise and sing together – in various, variegated and fluid huddles – into the early hours. The programme for Sunday morning features a wide range of workshops, predominantly musical rather than political. Again, it has become the pattern for the Festival to conclude with a picnic lunch before everyone winds their way home to the near and far reaches of Britain.

PITCHING THE PAST, PRESTO!

The origins of the Street Choirs Festival can be traced back to Sheffield in 1984. Images on photographer Martin Jenkinson's archive show 'National Street Bands Get Together on Fargate, during Defend Sheffield Week of Action 25/02/1984.'[28] While it looks as if there is singing going on in these images, they clearly feature band musicians, complete with a range of brass and percussion instruments. Among those musicians in 1984 were the Celebrated Sheffield Street Band, of which Jill Angood of Sheffield Socialist Choir remembers: 'Celebrated Sheffield Street Band was one of several bands formed around that time, certainly by 1982, who would play at local demonstrations, and support peace camps, for example at Molesworth and Upper Heyford. Others were the Fallout Marching Band in London, Bristol's Ambling Band, and Peace Artistes in Bradford. A recent anniversary of Celebrated Sheffield Street Band led to a Facebook page being created to share photos of those days, and the band reformed briefly to celebrate.'[29]

For the first few years, then, the Festival amounted to a get-together for street bands. A pivotal moment in the development of street choirs was when, in 1984, CND held a national demonstration at Barrow-in-Furness on Saturday 27 October. Jill Angood recalls practicing songs with a group at a long since demolished pub in Sheffield and joining them on the coach to Barrow for that demonstration. The Celebrated Sheffield Street Band put together a book of songs such as 'B52 and the F16', 'H-Bombs Thunder', and 'Fence busters' and it was printed at Lifespan Community, where Jill lived. On hearing Jill's story, Jenny Patient remembered that,

coming from Leamington Spa to join the CND demonstration, she had actually heard the street choir singing in Barrow and been inspired by the 'funny and pertinent songs': '1984 was a bleak year for peace, and Barrow was a community wedded to jobs in building arms – far out of the comfort zone of most CND demonstrators. Songs rising in that place were a beacon of hope and creativity for me.'

Figure 3: 'How long must we sing this song?' Sheffield Socialist Choir at the National Street Music Festival in London in 1991. Credit: Sheffield Socialist Choir, courtesy of Celia Mather.

In 1991 the National Street Music Festival was held in Hackney (see Figure 3) and, according to Sheffield Socialist Choir's 10th anniversary songbook, it was there that participating choirs first learned Billy Bragg's alternative words to 'The Internationale' for performance in the mass sing. Asked by Pete Seeger[30] to perform 'The Internationale' at a concert, in honour of the people who sang it in Tiananmen Square, Billy Bragg didn't feel the words (of the English version) were understandable, so he re-wrote them, explaining: 'What I wanted, I guess, was to give the Internationale more legs, so we can take it with us into the next century'.[31]

As we've noted previously, Billy Bragg's 'Internationale' has become the unofficial anthem of the Street Choirs Festival and is traditionally sung as the finale to the mass sing.

Whilst the 1991 National Street Music Festival was the first to be organised jointly by a band and a choir[32] (Big Red Band and Raised Voices), by 1997 there were separate festivals for bands and choirs, with the choirs meeting in Morecambe. Though the participants were all choirs, the Festival was still called the National Street Music Festival until Gateshead 2006, when the name was changed to National Street Choirs Festival (see Appendix 1 for a brief historic overview of the Festival). Thus, in the end, there was an amicable divorce of street bands from street choirs. If they still broadly shared a political agenda, there was a volume difference between street bands and choirs that made their musical performances irreconcilable. The bands aimed to be part of demonstrations, making a loud sound to cheer up the protestors, while the choirs perhaps sought to convey more nuanced political messages via their lyrics or, at the very least, wished for their voices to be heard above the drums and trumpets! Spatially, street choirs were not altogether suited to performing at mass demonstrations where union brass bands, street bands and, more recently, samba bands and vuvuzelas can drown them out. Indeed, some street choirs find it more rewarding and effective to stage their independent street actions or take their songs indoors.

Many of the street choirs participating in the Street Choirs Festival were also devotees of the Raise Your Banners Festival. Raise Your Banners was first held in Sheffield in 1995 to coincide with the 80th anniversary of the execution of Joe Hill, the US labour activist and songwriter.[33] Raise Your Banners was a festival of distinctly political music, the brainchild of Nigel Wright, a former Musical Director of Sheffield Socialist Choir. The festival was held in Sheffield in 1995, 1997, 1999 and 2001. It featured busking slots for choirs as well as performances from many different singers, for example Coope Boyes and Simpson, Holly Near, and Roy Bailey. Clearly imbued with the tradition of political folk music, then, Raise Your Banners was ticketed and open to the public rather than constituted mainly by street choir members themselves, as is the case

with the Street Choirs Festival. In 2005 Raise Your Banners was held in Norwich, then in 2007, 2009 and 2011 in Bradford. The biennial festival skipped a beat in 2013 and the gathering planned for 2014 in Bradford had to be cancelled 'due to financial issues'. And no one has taken up the challenge of organising a Raise Your Banners Festival since (but watch that space). One notable feature of the Raise Your Banners festivals held in Bradford was the diversity of ethnic groups from across the city's population who were visibly involved. Moreover, numerous political groupings had stalls at the festivals, and the focus was patently on international struggles 'for liberation, equality and justice, in defence of the environment, and for a better world.' [34]

BONES OF CONTENTION: TENSIONS TO MENTION

The radical history of the Street Choirs Festival is still apparent at the annual gathering. The connections that formed through singing together there are key to sharing events and organising other combined street choir actions throughout the following year. However, many of the choirs who currently attend the Street Choirs Festival self-identify as community choirs, and some have no tradition of singing in support of political causes. In Isin's terms, these choirs are not constituting themselves with and against others around a collective take on justice. That said, many community choirs are patently well aware of and take a position on political issues. Manchester Community Choir, for example, write on their website: 'While we are essentially apolitical, the choir has a commitment to issues relevant to the local and national community, which are concerned with equality, humanity and respect and celebrate the rich diversity of life in and around our communities.'[35]

Evidently, then, any political dividing lines between community and street choirs are blurred and the picture can be confusing. For instance, some community choirs sing on the street to raise money for 'good causes', while, as we've seen, some street choirs neither perform on the street nor busk. Moreover, the Festival as a whole clearly welcomes the participation

of LGBT choirs, whose identity politics may not be expressed overtly in rousing revolutionary anthems (see Chapter 4).[36] While perhaps not explicitly proclaiming a feminist politics, women-only choirs have also taken part in the Festival. Similarly perhaps, an emerging category of refugee and asylum seeker choirs would be welcomed across the board, though they *might* be singing ostensibly non-political songs mainly as a social bonding activity[37] with health benefits for the individual.[38]

Although the tension between street choirs and community choirs isn't as obvious as open factional conflict – crotchets at dawn?! – it reveals itself in two crucial spaces of the Festival. Established street choirs know that the festival is rooted in political protest. They suspect, however, that this history is not always understood nor appreciated by new participants, particularly community choirs. So, street choirs feel it is important to relate the history in the Festival programme and website as more than just a list of locations. This history has, however, only appeared twice in Festival programmes from 2013 to 2017, when the omission was made despite the Campaign Choirs Network drafting and providing the organisers with a copy-ready text. The second space in which the tension manifests is at the finale of the mass sing. Considering only a similar spread of festivals as we did *vis-à-vis* programmes, in 2014 and 2017 Billy Bragg's 'Internationale' was omitted from the selection of songs for the mass sing. Undeterred, many of the street choir members present sang the anthem anyway.

Actually, tensions around 'The Internationale' even permeate the network of explicitly political choirs that we have considered as street choirs. A number of those street choirs hold the English version of the original dear and resolutely resist Billy Bragg's re-wording with its arrangement by John Abraham, a former Musical Director of Côr Cochion. Other street choirs prefer to sing the original in French, while others still have versions in a number of languages, including Côr Cochion's rendition in Welsh. Sheffield Socialist Choir have been recorded singing 'The Internationale' in Chinese. All sorts of questions can be posed around 'the Internationale tension': are the street choirs that reject Billy Bragg's version clinging to the past, refusing to politically

reimagine the future? Conversely, does Billy Bragg's version undermine the pedagogy of history – is something politically vital in danger of being lost in rewriting?

Perhaps street choirs are more poetically than politically divided in expressing their preferences for different lyrics? There is often argument among street choir members about rewriting any song, for instance to make it relevant to current events, particularly songs historically invested with political meaning. Whatever the source of tension *within* street choirs is, though, the tension *between* street choirs and community choirs is surely political, though it too has a musical edge. Anecdotally, even some of the self-professedly political participants at Street Choirs Festivals have confided they find 'The Internationale' in all its forms something of a dirge. Many others, needless to say, are firm fans, eternally captivated and heartened by their preferred version of the anthem.

As we'll hear in upcoming chapters, some street choir members have reservations about aspects of the Festival, and not every choir that we interviewed is a regular attendee. Reservations range from criticism of the formula for the weekend, especially the marathon concert, to street choir members who don't feel the Street Choirs Festival any longer provides them with a political 'home': it does not make the space for sharing and doing their politics. In the past, participating street choirs, unaware of the strict regime in operation, have exceeded their allotted time on stage and have subsequently felt shamed and even ostracised. At the 2013 Festival in Aberystwyth, the host Côr Gobaith made a noble attempt to address some of the perceived problems. To shorten the concert, for instance, they suggested that some street choirs get together in regional assemblies to learn and perform their songs. This radical suggestion wasn't widely taken up, however. Then, Côr Gobaith organised for the mass sing to be preceded by a procession through the streets of the town to the seafront, patently homage to a political form, the protest march. This initiative emerged from discussions about staging the mass sing as a demonstration, echoing back in the history of street choirs all the way to Barrow-in-Furness. Indeed, the Festival had as its theme 'peace', and the much-loved veteran CND activist Bruce Kent took part in the

march and addressed the assembled participants.[39] As we write, Brighton's Hullabaloo Quire are planning changes to the 2018 Festival format to address some of the problems voiced. Whatever its drawbacks, the Street Choirs Festival formula has resulted in many choirs returning year after year. And, if we've tended to labour the negatives, guilty perhaps of nit-picking, we must state that overall the Festival is always a joyous, euphonious and inspiring gathering.

THE CAMPAIGN CHOIRS NETWORK

In 2005 the Edinburgh based street choir Protest in Harmony organised a mass sing at the 'Make Poverty History'[40] weekend of actions in Edinburgh.[41] Make Poverty History was one event in a week-long programme of protests organised by a number of coalitions, including G8 Alternatives and Dissent![42] Protest focussed on the G8 summit taking place in the luxury Gleneagles Hotel in Auchterarder. Consulting their list of contacts, Protest in Harmony invited singers whom they'd met at Street Choirs Festivals, choral singing weeks at Laurieston Hall,[43] and on Trident Ploughshares actions.[44] London's Raised Voices street choir was especially helpful with mobilising choristers. Encouraged by their successful Make Poverty History action, in 2007 Protest in Harmony organised a street choirs weekend focussed on Faslane, the Trident nuclear submarine base in Scotland. That weekend culminated in a singing blockade at the base as part of Faslane 365 under the banner 'Rise Up Singing'.[45] From 2007 to 2017 there have been several more Faslane singing actions organised as Rise Up Singing events (see figure 4). Unrelated to Protest in Harmony's Rise Up Singing initiative, in 2015 Julia Clarke, a former member of Raised Voices, started a group in London also under the banner of Rise Up Singing. A precursor, 'We Are Walthamstow Forest Voices', had been organised as a singing group to counter an English Defence League march in Walthamstow in September 2012. Conceived to be a monthly event rather than a choir, London's Rise Up Singing is nevertheless signed up to the Campaign Choirs Network. At the United Nations conference

of the parties in Paris (COP21) in December 2015, Rise Up Singing banded together with members of some UK street choirs to sing for climate justice.[46] Rise Up Singing choristers have also joined with the Campaign Choirs Network for demonstrations in London, including an anti-Trident demonstration in 2016 and a Defend the NHS rally in 2017.

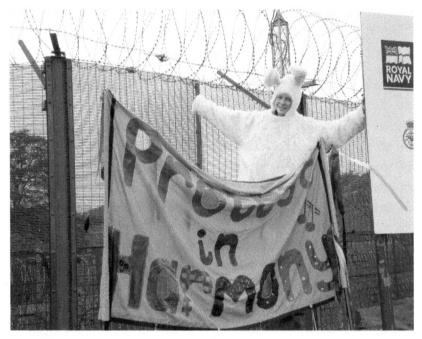

Figure 4: 'White Rabbit'. Protest in Harmony's banner adorns the razorwire fence at Faslane naval base, home of Trident. September 2012. Credit: Jane Lewis

In addition to the Rise Up Singing initiatives, the formation of the Campaign Choirs Network was inspired by 'The Big Choir' gathering at a Trades Union Congress anti-cuts demonstration in London on 20 October 2012 ('A Future that Works'). Organised by Raised Voices, The Big Choir drew about 120 people from at least 12 UK street choirs. The call to join The Big Choir was made through a combined list of choir representative contacts from the 2012 Street Choirs Festival held in Bury and the contacts held by the organisers of the Raise Your Banners

Festival.[47] Such festival-focussed lists are always in need of updating and are thus unreliable. Used indiscriminately they can also be too wide-reaching to use in calls for street choir actions. The Street Choirs Festival list would include community choirs whom, as we've seen, do not take overtly political action. Moreover, Raise Your Banners' contacts would include musicians and other people who were not in street choirs. Believing that there was a need for a different way of organising, then, the 2013 Street Choirs Festival organisers made space in the workshop programme in Aberystwyth for an exploratory meeting of interested parties. The call-out for the meeting ran: 'Bring your diaries, dates, causes and actions and let's get planning!'

Côr Gobaith member Lotte Reimer, a prime-mover in the initiative for the meeting, remembers: 'I knew that there was interest, particularly from Cynthia Cockburn[48] and Raised Voices, but I had no idea how many people would turn up and it was great to see twenty four participants, representing twelve choirs. We crouched on the dimly lit cinema stage, probably the least appropriate workshop space in the Arts Centre,[49] and shared ideas for how we could create a network of political street choirs. So, really, Campaign Choirs Network started on that Sunday, 21st July 2013.' As the minutes of the meeting concluded: 'There was lots of consensus and enthusiasm about what we can achieve together to make singing an integral part of all our campaigns!' Participants resolved to organise a Campaign Choirs Network email list and a website. An invitation to join was sent to all known choirs taking part in Street Choirs Festivals, not only the Aberystwyth participants. By May 2014 there were 42 members on the Campaign Choirs list, representing 20 choirs. In 2015, the initiative was nearly derailed, or at least delayed, when the organisers of the Street Choir Festival couldn't find workshop space for the Campaign Choirs Network meeting.[50] Somewhat ironically, the Festival was themed 'Use Your Voice'. Not to be silenced, though, the Campaign Choirs Network held their meeting in the open air and the experience invested the network with a sense of stubborn solidarity. By March 2018 the number of members had risen to 126, with 43 choirs signed up. As well as street choirs who would collectively identify as

political, the membership of the Campaign Choirs Network includes individuals and groups who sing with community choirs that do not take collective political action. See list of Campaign Choirs in Appendix 2.

The initial website introduction to the Campaign Choirs Network read: 'Some 35+ community-based choirs in the UK meet up every year at the Street Choirs Festival. There, we do massed singing, busk on the streets, and share songs, skills, and friendship. At the 2013 Festival hosted by Côr Gobaith in Aberystwyth, www.streetchoir2013.org.uk, we decided the political urgency of our times means we want to alert each other to events, demonstrations, etc., and share our songs more often and more widely'. At the time of writing, Campaign Choirs remains a self-organised network of choirs. Each street choir that has signed up is encouraged to have at least two representatives on the mailing list. These representatives (should) communicate information between the Campaign Choirs Network and their own street choir. Meanwhile, individual members who aren't in street choirs that are signed up to the initiative can still keep their own choir informed. Campaign Choirs Network meetings are always open to anyone, members and non-members alike.

Between annual meetings, one volunteer maintains the website and another the email list. The network relies on the involvement of willing individuals to take responsibility for tasks that need doing. Still held during the Street Choirs Festival because of the convenience of having many members already assembled, the meeting's overarching agenda is to review the past year (what was good, what could be improved etc.), share up-coming events, and decide on collective actions for the coming year. As we've observed, not all the street choirs nor all the individual members of the Campaign Choirs Network attend the Street Choirs Festival, or they only do so irregularly. Thus, the Festival isn't quite the ideal forum for organising the Campaign Choirs Network. One challenge is how to ensure the continuation of the Network without recourse to a more formal structure that, for instance, could include elected officers with specific roles and responsibilities. The one concession to a formal structure to date has been opening a bank account, which is held in trust by one of the participating choirs. This was a necessity for securing and

handling funds for any project enacted under the Campaign Choirs Network banner. Members are wary about whether a more formal structure would best suit the effective, creative and flexible operation of a network initiative.

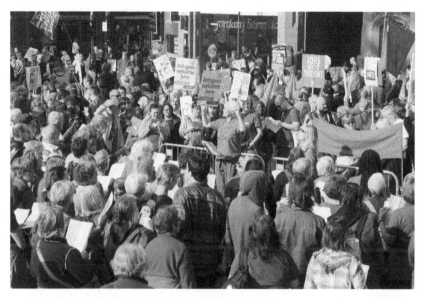

Figure 5: A Big Choir. Assembled street choirs sing to demonstrators demanding an end to austerity at the Manchester Tory Party conference demo in October 2015. Credit: Hannah Mann

Campaign Choirs Network information and events are shared on the website and Facebook,[51] while communication is mostly through email. The network also has a Twitter account. Invitations to join local street choir actions in different locations, requests for songs on particular topics, calls to joint mass action, and various organising tasks are all circulated via the email list. Numerous actions and demonstrations have been shared, notably Big Choir actions to coincide with events in London, including in reverse chronological order: a mobilisation to participate in four days of action co-ordinated by the Campaign Against Arms Trade in 2017; a Health Campaigns Together march to defend the NHS ('no cuts, no closures, no privatisation') also in 2017; CND's 'Stop Trident'

demonstration in 2016; the Campaign Against Climate Change 'Time to Act' march in 2015, and the People's Assembly 'End Austerity Now' demonstration in 2014.[52]

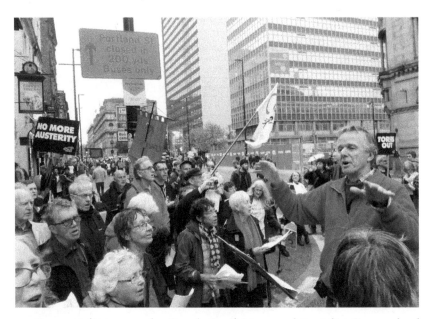

Figure 6: 'Bring on the Revolution!' Liverpool Socialist Singers lead Campaign Choirs in 'Wave bye-bye to PFI' at Manchester Tory Party conference demo October 2017. Credit: Lotte Reimer

Elsewhere in the UK, street choirs have gathered together to support anti-austerity protests at Conservative Party conferences in Manchester in 2015 and 2017 (see Figures 5 and 6) and in Birmingham in the intervening year. Other combined actions have included participating in demonstrations at Burghfield in 2014 and 2016, opposing the Atomic Weapons Establishment. At Faslane in 2016 street choirs sang against Trident and its replacement. Campaign Choirs also participated in anti-fracking actions at Balcombe in 2013 and at Preston New Road in 2017. In Wales in 2015, the Campaign Choirs Network mobilised for a 'No to NATO' demonstration in Newport, Gwent. This was timed to coincide with a NATO summit held at the luxury Celtic Manor Resort Hotel,

which, although geographically nearby, is a world away from the city of Newport in terms of economic justice (see Figure 7).[53]

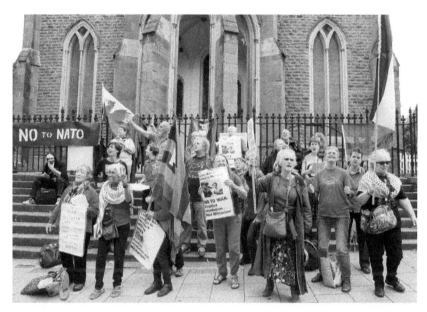

Figure 7: 'No to NATO!' Campaign Choirs sing in Newport (Gwent) to protest a NATO Summit meeting, 30 August 2014. Credit: Marian Delyth

Taken altogether, actions around the UK suggest that the Campaign Choirs Network is united in its opposition to: austerity; privatisation; war, militarisation and particularly nuclear proliferation; fracking and other activities likely to contribute to environmental injustice and climate change. Reviewing this list, some shared values of the Campaign Choirs Network are apparent: social justice; communal ownership of public services; peace; non-violence; environmental justice and sustainability. In tentatively compiling these statements, we're not suggesting that all the street choirs in the Campaign Choirs Network, nor certainly all their individual members, share all these values. Ours is not the sort of quantitative research that could support such a claim. Nor are we saying that this is the sum total of values held by street choirs in the Network

nor, again, the individual choir members. Rather, what we *can* say is that the Network is able to evoke these values and take action without them being 'a deal breaker', i.e. members either concur with or are able to live with how the Network acts as an inclusive collective identity.

Recognising that the Street Choirs Festival has limited scope for political action, the 2015 annual meeting mooted the idea of a separate Campaign Choirs Network gathering to share songs, skills and actions as well as to socialise and strengthen relational bonds. The demise of the Raise Your Banners festival, in particular, had deprived street choirs of a more political collective space. Any bespoke political gathering, the 2015 meeting suggested, should keep organisation to a practical minimum, mainly providing a venue for self-organising in terms of workshops, planning and socialising. Revisiting the subject in 2016's meeting, it was agreed to pursue possibilities of piggybacking on existing events that might provide appropriate space. The 2017 Peace News Summer Camp was actively pursued as a possibility but the initiative was not massively supported by members of street choirs, seemingly because of a combination of the camp's timing clashing with other events, its location in Norfolk, which was quite remote for most street choirs, and the physical rigours of camping, which some people were not able to contemplate. Leslie Barson of London's Red and Green Choir reported back on the camp: 'There was a singing workshop done by Penny but that was all. Yes, let's keep thinking for future years. Maybe a whole singing camp sometime?'[54]

The initiative of London street choir Strawberry Thieves to celebrate their twentieth anniversary with a gathering of political choirs suggested another format for future gatherings. Speaking about the 'Chants for Socialists' celebration, Strawberry Thieves Musical Director John Hamilton, born in 1955 in London, said: 'If we follow the principle of: "Give more than you take" and bear William Morris' dying words in mind: "I want to get the mumbo jumbo out of this world", then I hope we can build new friendships, learn new songs and feel strengthened in our co-operation to rid the world of greed and war.' After problems with organising and finding a time to suit everyone, the event was finally

held in London over the weekend of 10-12 March 2017 (by which time Strawberry Thieves' twentieth anniversary had almost become their twenty-first!) Members of choirs from as far north as Manchester and as far west as Aberystwyth learned songs together, socialised, staged a public concert, and sang as a massed choir in the streets of central London. Incidentally, both the original English version and Billy Bragg's rewrite of 'The Internationale' were sung at the concert, with the combined choir forming two sections to render alternate verses. Invigorated by the gathering, street choir members returned home with a renewed resolve to find ways of repeating the experience.

BEYOND CAMPAIGN CHOIRS?

Internationally, the Campaign Choirs Network has only begun to consider how to forge solidarities and take actions. The *Rencontres de Chorales Révolutionnaires* (Meeting of Revolutionary Choirs) is an annual gathering in France in which some Italian, Belgian and British choirs, primarily Strawberry Thieves, join political choirs from across France in a week of communal living and sharing songs. Lamenting the lack of time for socialising during the packed programme of UK Street Choirs Festivals, something also mentioned by other interviewees in our research, John Hamilton noted: 'In fact Strawberry Thieves has much closer ties with singers from the revolutionary choirs of France plus some Italians through participating in the annual week-long summer camp since 2008.' As we recorded in the Introduction, two of our Campaign Choirs Writing Collective, Lotte Reimer and Kelvin Mason, attended the 2016 and 2017 gatherings in France, taking the opportunity in 2016 to interview members of Strawberry Thieves.

Featuring a very full programme of song-learning workshops that come to fruition in a number of concerts, usually staged outdoors in public space for local communities, *Rencontres de Chorales Révolutionnaires* is intense.[55] The camp is run on a self-organising basis with everyone signing up to cover all the tasks required. Apart from the year of planning

and organising between gatherings, communal tasks range from the
initial setting up and final striking of the camp to cooking, clearing,
washing-up, cleaning bathrooms, and maintaining compost toilets.[56]
And, of course, every night the informal singing continues into the wee
small hours, featuring songs from many cultures rendered in multiple
languages! Collective decisions are made through consensus at meetings
open to all. In 2017, we were particularly impressed with the space made
for children to feed back on the gathering. This they did alongside
constructive critiques from adult groupings, including vegans and a
lobby for a safe(r) space of non-violent communication. While wishing
to participate more in activities with adults, the children also wanted
to maintain their own communal and creative spaces. Readers familiar
with movements such as the Camp for Climate Action or Occupy will
recognise the consensus network organising model of *Rencontres de
Chorales Révolutionnaires*, which could provide a template for future
Campaign Choirs Network gatherings. From taking part in the camps in
France, with our observant participator research hats on, it was clear to
us that making time to socialise opened up possibilities for forming new
friendships as well as cementing existing ones. It was also an opportunity
to appreciate other ways of thinking and other knowledges, alternative
ways of communicating and of acting. The format also lent itself to the
sharing of various campaigns and causes. Moreover, the space that was
created served to facilitate people learning to care for each other, both
through the formality of the collective work required and also via the
informal efforts that people made to attend to one another's needs. One
of the discussions that we were party to contrasted people doing equal
shares of the work of the camp with trusting people to do as much of
that work as they felt able to do. This perhaps served as an illustration of
a distinction between justice, or at least a particular formulation thereof,
and care.

In our engaged research we have encountered a number of examples of
international cooperation between street choirs on political issues. One
notable instance was the 'Say No' project organised by the Brecht-Eisler
Choir from Brussels.[57] Encouraging choirs to record and share a song

in solidarity, 'Say No! aims to contribute in a creative fashion to the debate concerning strategies for peace. Participants in the project are choirs and smaller vocal ensembles from all over the world. Together we sing "No to war" and "Yes" to the refusal to collaborate to war and destruction. Our songs want to honour deserters and all those refusing to participate in war. Both the live performance and the international project represent a call to "Flee the Frenzy": say NO to the utter madness of war and weaponry.' An invitation to participate in the project was circulated to, among others, the Campaign Choirs Network. Ultimately, six street choirs from across the UK participated: Côr Cochion, Côr Gobaith, Protest in Harmony, Strawberry Thieves, Red Notes Socialist Choir (a Bristol-based socialist choir), and Sea Green Singers (an Oxford-based activist choir).[58]

NATURAL VOICE NETWORK

Musically, street choirs in the Campaign Choirs Network have in common singing mainly in four-part harmony. The Musical Directors of six of the ten active street choirs that we interviewed are members of the Natural Voice Network.[59] In 2016 the Natural Voice Network held the first 'Songs of Change' weekend. The workshop was trailed as 'creating and singing songs for social change', and a number of Campaign Choirs Network members took part. The connection between these two networks interested us, especially in relation to the affinity between the musical ethos of the Natural Voice Network and the politics of the Campaign Choirs Network. The Natural Voice Network is the result of singer-songwriter and voice teacher Frankie Armstrong's passionate belief that everyone can sing. A peace and justice activist with her musical roots in British folk, Frankie's interest in traditional singing – particularly the representation of women's lives through song – took her on 'a sonic journey' across the UK and beyond. Her odyssey led Frankie to initiate what was originally called the Natural Voice Practitioners Network. The core value of the Natural Voice Network is inclusivity, and it is founded

on the belief that everybody can learn to sing by ear without being able to read music.[60] Auditioning is a strict Natural Voice 'no-no'.

In 2015 the Executive Committee of the Natural Voice Practitioners Network wrote a letter in response to Twenty Twenty Television, a UK-based Warner Bros. TV production company, who were recruiting community choirs for an *a cappella* contest. The resulting TV programme would be a vehicle for Gareth Malone, the celebrity choirmaster. We should say at this point that, in the view of at least one of our interviewees, Gareth Malone has done much to boost interest in choir singing in Britain. However, the Natural Voice response picked up on the uncaring nature of competition:

> We cannot help feeling that the element of competition which has all but taken over from the actual joy of singing in the most recent programmes featuring Gareth's skills has created a distorted picture of what actually happens in the expanding world of community choirs and why so many people want to sing...A failed audition can blight someone's willingness to sing with others for many years – sometimes a lifetime. A huge potential source of human connection is then lost and society is impoverished. As a Network we are passionate about making singing accessible to everyone, and bringing it back into the heart of our communities, not as something fashioned into an elite activity which separates people into winners and losers...We would urge you however to think deeply and carefully about other, future projects. There are some fantastic human stories to be told, both individual and at a community level. Dare to do something different and consider a format other than the increasingly hackneyed competition and jeopardy formula. Instead of heading to the *Hunger Games* how about being really creative and showcasing something that feeds everyone?

Twenty Twenty Television did not respond to the Natural Voice Practitioner's Network. Broadcast on BBC Two in the autumn of 2015,

'The Naked Choir' was hosted by Gareth Malone and featured eight *a cappella* groups who competed to be chosen as the UK's best.[61] The eight groups were reportedly chosen from four hundred choirs who auditioned. There was only one winner, Sons of Pitches, whose set featured Britney Spears' song 'Toxic': 'You're toxic I'm slippin' under / With the taste of a poison paradise'.

TAKING OUR SWEET TIME: ACTIVISM AND RESEARCH

In our research for this project we didn't use any kind of survey methodology to obtain our 'sample', we simply contacted street choirs in the Campaign Choirs Network and asked for volunteers. Deliberately, we sent our invitation to street choirs that were spread throughout Britain, from Edinburgh to London, Leicester to Aberystwyth. We also made an effort to include choirs of different ages, from very well-established to quite new groups. A typical section of our invitation to participate ran: 'Ideally, we are looking for 4 choir members, ranging from "founder member" to "newcomer" – and a gender balance if at all possible. The questions range from how you got into singing, what inspires you to sing in the street and the causes for which you sing, to your vision of the future that you are singing for.' We also asked whether we could join each street choir in their rehearsal or on an action such as singing on the street, a request which all the ten active choirs that we visited facilitated for us. At the times when they told us their stories, between November 2014 and July 2017, all but one of our interviewees was an active member of a functioning street choir.

We have interviews with forty-two members of street choirs, thirty-two women and ten men. If, when we visited Out Aloud in Sheffield, we hadn't specifically asked for male volunteers to replace two of the women who had come forward in advance, our survey would have been even more 'gender skewed', with only eight men. So, many thanks to the two courageous (finally!) men and even more so to the two understanding women from Out Aloud who good-naturedly stepped

aside. It remains the case, though, that our interviewees totalled more than 75% of people identifying as women.

While ours is not a quantitative survey, our observant participation with the Campaign Choirs Network and from moving among choirs attending the Street Choirs Festival suggests that the gender ratio of our survey is similar to that in street choirs generally. If anything, as we specifically asked for a gender balance for our interviews, the proportion of men who responded might actually be higher than their representation in street choirs beyond our survey. The gender imbalance in street choirs clearly has musical and surely political significance, as it will affect both the sound produced by the choirs and likely the power relations within them.[62] Here we can also note that only two of the ten active street choirs in our survey had male musical leaders at the time when we undertook our interviews with them. By 2017, one of these leaders had been replaced by a woman. Voices Now do not record the gender balance of the choirs in their survey so we can't speculate on whether the gender imbalance in street choirs is typical among the various types of choirs in the UK. However, it is popularly acknowledged that choirs across the board in the UK have a problem recruiting men.[63] That said, there are numerous 'male voice' choirs throughout the UK, even beyond the famously sonorous valleys of South Wales. Moreover, something of a new generation of men's choirs has emerged as quite trendy in recent years via cultural initiatives such as the Spooky Men's Chorale, Only Men Aloud, and Chaps Choir.[64] There is also an older history of gay men's choruses, as distinct from LGBT choirs. Russell Hilliard, for example, studies the San Francisco Gay Men's Chorus, 'the world's first gay men's chorus' (established from 1978). Among other research questions, Hilliard asks how the chorus has reflected or shaped social and political issues.[65]

Our interviewees ranged in age from 31 to 82. Only three of our interviewees were under 40, however, and only a further 3 were between 40 and 50. Three people were in their seventies. Meanwhile, *twenty of our respondents were between 60 and 70 years old and a further 10 were in their fifties*. Cumulatively then, people between 50 and 70 make up more than 70% of our interviewees. Again, while we can't say this age

profile is statistically representative of all street choirs, or even only those in the Campaign Choirs Network, our experience suggests that it is not unrepresentative: street choirs do appear to have an ageing membership. We did note that, while some have been street choir members for 30 years, others have come to it later. One explanation on women joining later in life was offered by Red Leicester's Julie Burnage, born in Leicester in 1950. Julie had a 30-year singing gap, raising a family: 'You tend to put other people first and your own interests go on the back burner.'

COMING OF AGE: LIFE COURSE ACTIVISM

Given the age profile of our interviewees, we became interested in political activism over the life course. In Chapter 2 we consider the political agency of children and young people in the stories of street choir members. There, too, we'll discuss activism and older people. Before we elaborate on that, though, let's first look more closely at what we actually understand by political activism: what is an activist? Inconveniently for social scientists but typical of life, there is no simple answer. From a geopolitical feminist perspective Kye Askins writes that 'what constitutes "activism" and "activist" is multiple and emergent, operates through diverse sites and processes… activism/activists of various kinds are everywhere.' Askins notes that: 'There is a tendency, when imagining "activist" to consider the rebellious figure fighting oppression in demonstrably physical acts against hegemonic regimes.' Not all activisms are revolutionary, however, 'many take action within a dominant system rather than to change that system.'[66] When we think about activism, Askins argues, we should consider politics even more widely, far beyond public protest and direct action, focussing on the embodied practices of everyday life. Activism can be mundane as well as spectacular, and it can include almost any kind of activity: taking part in a White Ribbon Day silent vigil to oppose gender-based violence in all its forms; foot dragging in the face of the workplace oppression of zero-hours contracts; signing e-petitions to lobby a government to ban disposable plastic; participating in a protest

camp action, such as Occupy.[67] And so it goes on. We should also be aware of the spaces and scales of activism, whether activism happens in, for instance, the home or the street, and whether its focus is local, regional, national or international. Then, conceptualising activism must take account of the material and discursive contexts, political economy and entanglements of power.[68] Askins concludes that 'we should avoid naming others' "activism" in our own mirror image', for instance judging the actions of people living in very different cultures by our own western political positionalities.

Sevasti-Melissa Nolas, Christos Varvantakis and Vinnarasan Aruldoss concur with Kye Askins that 'activism' is an ambiguous term both in theory and in practice: 'Activism has been used to refer to high-cost, high-risk protests and revolutionary movements... as well as the everyday practices of environmental protection'.[69] However, Nolas et al observe that we tend to ignore time when considering activism: people's ages, their generation and their life course.In short, we assume that activism is the preserve of youth and young adults. Older people, meanwhile, are often pathologised as ill and incapacitated. Noting the emergence of values-based definitions of political activism in the social science literature, Nolas et al observe that: 'values-based approaches seek to understand activism as an assemblage of meanings and practices that express relationships of concern to the world.' [70] And people's relationship to the world is determined by the things that matter to them, the things they value, i.e. the relationship is a normative one.[71] In values-based approaches, then, ethics and emotions are recognised as vital drivers of political activism. Moreover, values-based approaches to political activism resonate with relational approaches to understanding all aspects of 'personhood'. Yet, Nolas *et al*, record 'much of this scholarship has remained silent on the relationship between activism and age'. As a values based approach, an ethics of care can address this shortcoming: understanding people in terms of what matters to them, challenging the distinction between private and public space, as well as any separation of morality from politics in theory and practice.

Nolas et al wonder where younger children and older adults fit in our

discourses and practices of social change. They ask: 'How does a life course approach to political activism expand the ways in which political activism might be defined? How might political activism across the life course be studied?' These authors write that 'genealogies of care and concern are manifest and can be mobilised in everyday life across all ages, and so the question remains: how do those who are not "young people" or "young adults" fit into the imaginary normative distribution of political participation, which sees the onset of political identity in the teenage years and its trailing off at the end of young adulthood?' Highlighting the relationality of all human life, including political activism, Nolas et al record that 'people of all ages are interdependent on each other'. These authors conclude that our understanding of political activism across the life course 'could be enriched through granular, qualitative research approaches such as life history, ethnographic and action research methods all of which engage to a greater or lesser extent with time'. They propose that we can better understand political activism in all its manifestations, from the spectacular to the mundane, by engaging with activists' *pasts, presents and imagined futures*.[72] And that, dear reader, is pretty much exactly what we set out to do in this book.

ENDNOTES

1 Roderick Williams. "Singing for solidarity." A choral history of Britain. BBC Radio 4. 20 September 2017. Accessed 29 September 2017. http://www.bbc.co.uk/programmes/b0952str

2 Bob Porter, "The British choral tradition: an introduction." https://bachtrack.com/british-tradition-choral-month-article. Accessed 29 September 2017.

3 Javier Espinoza, "Why it's no longer 'cool' to join the school choir." *The Telegraph*, 13 July 2015. http://www.telegraph.co.uk/education/educationnews/11736981/Why-is-no-longer-cool-to-join-the-school-choir.html. Accessed 10 October 2017.

4 Voices Now. "The Big Choral Census." Voices Now. June 30, 2017. https://voicesnow.org.uk/wp-content/uploads/2018/03/FINAL-Voicesnowreport-July-2017.pdf. Accessed 21 May 2018.

5 Voices Now Choral Survey. https://www.surveymonkey.co.uk/r/VoicesNowSurvey, Accessed 2 October, 2017.

6 "Street Life" by Roxy Music

7 E.g. Genevieve Giuliano and Susan Hanson (Eds.) *The Geography of Urban Transportation* (New York: The Guilford Press, 2017).

8 John Urry, *Mobilities* (Cambridge: Polity, 2007), 90.

9 Lewis Mumford, *The City in History* (London: Penguin, 1987), 175.

10 Mason, "A Dirty Black Hole."

11 Nicholas Fyfe (Ed.) *Images of the Street: Planning, Identity and Control in Public Space: Representation, Experience and Control in Public Space* (London: Routledge, 1998).

12 E.g. Paul Mason, *Why it's kicking off everywhere: The new global*

revolutions (London, Verso, 2012). Also Gavin Brown, Anna Feigenbaum, Fabian Frenzel and Patrick McCurdy (Eds.) *Protest Camps in international context* (Bristol: Policy Press, 2017).

13 E.g. L.M. Bogard, "Tactical Carnival: Social Movements, Public Space and Dialogical Performance." In: Jan Cohen-Cruz and Mady Schutzman (Eds.) *A Boal Companion*, 46-58 (London: Routledge, 2006). Also John Jordan, "Reclaim The Streets." In: Andrew Boyd and Dave Oswald Mitchell (Eds.) *Beautiful Trouble: A Toolbox for Revolution*, 350-353. Or Books, 2012 and Giorel Curran, *21st Century Dissent: Anarchism, Anti-Globalization and Environmentalism* (London: Palgrave Macmillan, 2007).

14 Chris Carlsson, *Critical Mass: Bicycling's defiant celebration* (Oakland, AK Press, 2002), 6.

15 George McKay, "A soundtrack to the insurrection: street music, marching bands and popular protest." *Parallax*, 13, 1 (2007): 20-31, 20.

16 'Side Streets' by Saint Etienne

17 E.g. Oliver Sacks, *Musicophilia: Tales of music and the brain.* London: Picador, 2007. Also Myra J. Staum, "A Music/Nonmusic Intervention with Homeless Children." *Journal of Music Therapy*, 30, 4 (December 1993): 236–262.

18 Dallas Street Choir, Vision. https://www.dallasstreetchoir.org/about-2/. Accessed 2 October, 2017.

19 'Fascination Street' by The Cure.

20 See, for instance, Rahila Gupta on 'the journey of a feminist slogan'. https://www.opendemocracy.net/5050/rahila-gupta/personal-is-political-journey-of-feminist-slogan. Accessed 8 October, 2017.

21 Engin Isin, *Being Political: Genealogies of citizenship* (London: University of Minnesota Press, 2002), x.

22 Dave Naisargi, *Queer Activism in India: A story in the anthropology of ethics* (Durham: Duke University Press, 2012).

23 Tim Cresswell, *Place: A Short Introduction* (Hoboken: Wiley-Blackwell, 2013).

24 R.S. Denisoff, "Protest Movements: Class Consciousness and the

Propaganda Song." *Sociological Quarterly* 9, 2 (1968): 228–247.

25 E.g. Ron Eyerman and Andrew Jamison. *Music and Social Movements: Mobilising traditions in the twentieth century.* Cambridge: Cambridge University Press, 1998; J.C. Friedman (Ed.) *The Routledge History of Social Protest in Popular Music* (Abingdon: Routledge, 2013); Ian Peddie (Ed.) *The Resisting Muse: Popular Music and Social Protest* (Farnham: Ashgate, 2006); Rob Rosenthal and Richard Flacks, *Playing for Change: Music and Musicians in the Service of Social Movements* (Boulder CO: Paradigm, 2012); W. G. Roy, *Reds, Whites and Blues: Social movements, folk music, and race in the United States* (Princeton: Princeton University Press, 2010).

26 Augusto Boal, *Theatre of the oppressed* (London: Pluto, 1979). Also Augusto Boal, *Games for actors and non-actors* (London: Routledge, 1992).

27 'Everything that went wrong during Theresa may's speech'. https://www.theguardian.com/politics/video/2017/oct/05/everything-that-went-wrong-during-theresa-mays-speech-video. Accessed 29 September 2017.

28 Martin Jenkinson Image Library. https://martinjenkinson.photoshelter.com. Accessed 14 September, 2017.

29 Celebrated Sheffield Street Band on Facebook. https://www.facebook.com/groups/298649060158251/. Accessed 14 September, 2017.

30 The acclaimed US folk singer and activist died in 2014 aged 94.

31 "With One Voice: Sheffield Socialist Choir 10th Anniversary Songbook", 1999, 82.

32 According to Calder Valley Voices. http://www.caldervalleyvoices.org.uk/2002-street-choirs-hebden-bridge. Accessed 10 October, 2017.

33 William M. Adler, *The Man Who Never Died: The Life, Times, and Legacy of Joe Hill, American Labor Icon* (New York: Bloomsbury, 2012).

34 As described by The Living Tradition, 'the home of folk music on

the web'. http://www.livingtradition.co.uk/node/781. Accessed 10 October, 2017.

35 Manchester Community Choir. https://manchestercommunitychoir. org.uk/about-us/. Accessed 10 October 2017.

36 Indeed, Festival supported charities have included Amnesty International's LGBT Network (Sheffield 2010) and Leicester's Pride Without Borders, a local group supporting LGBT refugees and asylum-seekers (Leicester 2016)

37 E.g. E. Pearce et al, "The ice-breaker effect: singing mediates fast social bonding." *R. Soc. open sci.* 2, 150221 (20015), 1-9.

38 Rosie Stacy, Katie Brittain, and Sandra Kerr. "Singing for health: an exploration of the issues", *Health Education*, 102, 4, (2002) 156-162.

39 In 2018 in Brighton host choir Hullaballoo do plan changes to the Festival format. A member of the Campaign Choirs Network, Hullaballoo exemplify that here is no stark divide between being a community or a street choir, nor yet an exclusive conception of what is political. Hullaballoo bill themselves as community choir 'singing together for celebration, protest, passion, work and play, building and bonding the wider community with a profound impact on the individual.' http://www.hullabalooquire.org/. Accessed 4 January 2018.

40 Make Poverty History persists as a global coalition of aid and development agencies. In 2005 the emergent coalition set out its demands and mobilised more than 225,000 protesters on the streets of Edinburgh.

41 Ten years on from the Make Poverty History weekend, the campaign and advocacy organisation ONE reported some progress but much more to do on the eight "big promises" made by world leaders at the summit, a verdict broadly shared by development charities such as Oxfam.

42 David Harvie et al (eds.) *Shut Them Down! The G8, Gleneagles 2005 and the movement of movements* (Leeds: Dissent! 2005).

43 Laurieston Hall is a long established co-operative living project in Scotland. An annual People Centre programme features musical

events. http://www.diggersanddreamers.org.uk/communities/ existing/laurieston-hall. Accessed 20 October 2017.

44 Trident Ploughshares is non-violent, direct action campaign to disarm the UK's Trident nuclear weapons system. http:// tridentploughshares.org/. Accessed 10 October, 2017.

45 A year-long campaign of daily blockades at the nuclear submarine base. See Angie Zelter (Ed.) *Faslane 365: A year of anti-nuclear blockades* (Edinburgh: Luath Press, 2008).

46 The Mary Robinson Foundation offers a widely recognised definition of climate justice, viewing climate change as an ethical and political issue rather than only as a physical science phenomenon. https://www.mrfcj.org/principles-of-climate-justice/. Accessed 14 September 2017.

47 Raise Your Banners is a biennial festival of political song that, in 2017, is dormant. http://www.ryb.org.uk/. Accessed 12 October 2017.

48 Feminist researcher and writer Cynthia Cockburn sings and composes songs with Raised Voices.

49 Aberystwyth Arts Centre generously donated spaces for the 2013 Street Choirs Festival free of charge. https://www. aberystwythartscentre.co.uk/. Accessed 20 October 2017.

50 Festival organisers Whitby Community Choir are actually members of the Campaign Choirs Network, so the failure to allocate space for a meeting was not construed as an exclusionary political act. Organisers did, indeed, allocate space for a Campaign Choirs Network stall in the foyer area of the venue.

51 Campaign Choirs Network http://campaignchoirs.org.uk/ and on Facebook https://www.facebook.com/groups/247380928978923/. Accessed 20 October 2017.

52 The action was timed to coincide with the Defence and Security Equipment International (DSEI) arms fair held in London's Docklands.

53 Newport was one the ten overall most deprived areas in the Welsh Government's 2014 Index of Multiple Deprivation.

http://gov.wales/statistics-and-research/welsh-index-multiple-deprivation/?lang=en. Accessed 17 September 2017.

54 Penny Stone of Protest in Harmony from Edinburgh.

55 In 2016, the combined choir sang in the village of Tarnac, home of the Invisible Committee, authors of the contemporary anarchist tracts "The coming Insurrection" and "To our friends."

56 The venue, near Limoges, has dormitory facilities as well as space for camping.

57 Brussels Brecht Eisler Koor. http://bbek.vgc.be/index.html, Accessed 17 September 2017.

58 Say No! http://www.sayno.be/. Accessed 17 September, 2017.

59 Caroline. Bithell, *A Different Voice, A Different Song: Reclaiming Community Through The Natural Voice And World Song* (Oxford: Oxford University Press, 2014).

60 Inclusivity chimes with 'welcome', which we will discuss in Chapter 3. It also resonates with values and practices of care such as attentiveness, sensitivity and responding to needs.

61 None of the choirs were naked.

62 See Doreen Massey, *Space, Place and Gender* (Cambridge: Polity, 1994); Paula Nicolson, *Gender, Power and Organization* (London: Routledge, 2015); Kathy Davis, Monique Leijenaar and Jantine Oldersma (Eds.) *The Gender of Power* (London: Sage, 2009); P. S. Tolbert et al, "Group gender composition and work group relations: Theories, evidence, and issues." In: Gary Powell (Ed.) *Handbook of Gender and Work*, 179-202 (Thousand Oaks, CA: Sage, 1999).

63 Chris Samuel, "Why don't men join choirs?" *The Guardian*. 13 June 2013. https://www.theguardian.com/music/musicblog/2013/jun/13/how-to-get-men-to-sing-in-choirs. Accessed 12 October 2017.

64 Spooky Men's Chorale. https://spookymen.com/; Only Men Aloud, http://www.onlymenaloud.com/; Chaps Choir. http://www.chapschoir.com/. Accessed 12 October 2017.

65 Russell E. Hilliard, "A Social and Historical Perspective of the

San Francisco Gay Men's Chorus," *Journal of Homosexuality* 54, 4 (2008): 345-361.

66 Kye Askins, "Activists." In: K. Dodds, M. Kuus and J. Sharp (Eds.) *The Ashgate Research Companion to Critical Geopolitics,* 530-537 (Farnham: Ashgate, 2013). See also Notes from Nowhere (eds.) *We are everywhere: The irresistible rise of global anticapitalism* (London: Verso, 2003).

67 Sam Halvorsen, "Losing Space in Occupy London: Fetishising the protest camp." In: Gavin Brown, Anna Feigenbaum, Fabian Frenzel and Patrick McCurdy (Eds.) *Protest Camps in International Context,* 163-178 (Bristol: Policy Press, 2017).

68 Joanne Sharpe, Ronan Paddison, Chris Philo and Paul Routledge (Eds.) *Entanglements of Power: Geographies of Domination/ Resistance* (London: Routledge, 2000).

69 Sevasti-Melisssa Nolas, Christos Varvantakis and Vinnarasan Aruldoss. "Political activism across the life course." *Contemporary Social Science,* 12, 1-2 (2017): 1-12, 4.

70 See also G. Yang, "Activism." In: Benjamin Peters (Ed.) *Digital Keywords: A vocabulary of information society and culture,* 1-17. (Princeton, NJ: Princeton University Press, 2016).

71 Andrew Sayer, *Why Things Matter to People: Social science, values and ethical life* (Cambridge: Cambridge University Press, 2011).

72 Nolas et al, "Political Activism."

CHAPTER 2

FINDING OUR NOTES

I grew up in Perth in Western Australia and we lived there till I was fourteen. And my dad's family was quite political, left-wing. My uncle ended up being a politician.[1] Both my grandmothers sang quite a lot. My dad's family was from Ireland and my mum was born in Persia and her family were from England, and my grandmother on that side also sang quite a lot. But it was especially my dad's family – I did a lot of singing with my grandmother. They had a very big family, lots of cousins, and we were always round at my grandmother's house on the weekends. And the uncles especially were talking about politics, and I would always sneak up to the table, want to join in, hear about everything. So I had really strong links between singing and politics from a very early age…I used to sometimes go to demos with my dad.

Maxine Beahan of Protest in Harmony

Who are the people singing in street choirs? Where did their politics and political aspirations come from? Why do they choose singing as a means of political expression? In an attempt to address such questions, we asked members of street choirs about their family backgrounds, their communities and the places where they were born and brought up. In particular, we asked about singing and activism in people's early lives. Were there, we wondered, influential political and musical events or moments? What we were most interested in was where, when and how

music and politics came together for street choir members. Of course, we were also interested in the stories of people for whom music and politics *did not* mesh, nor even meet, in their upbringings. We wondered, too, whether some street choir members who sing as adults weren't exposed to very much music at all while they were growing up. Similarly, we were attentive to the stories of people who weren't much influenced by their family politics, or who were exposed to a very different politics as children to that which they now practice. Ultimately, what we sought was a sense of what made people political and what sort of political it – a multifarious *it*, of course – made them. Likewise, we were fascinated by what made people musical. Then, how did the various influences which made people political and musical come together, specifically in the act of them joining a street choir?

SOUNDING OUT GENDER, RACE AND ETHNICITY

Given that there are substantially more women than men among our interviewees and, indeed, singing in street choirs generally, at least in the UK, we are alert to any gender differences in political socialisation. In a US study, Nicholas Alozie, James Simon and Bruce Merill find that: 'girls surpass boys in political interest and activity, and this persists without a significant drop in teen years as might be expected.' These researchers also state that their findings persist among white, Native American, black, Hispanic and Asian American sub-groups. They acknowledge that research from the 1960s and 1970s generally reported that girls were less interested in and less well informed about politics. This they attribute to different socialisation processes during that time, while they suggest that the change their own study records may be attributed to the increasing influence of feminism and the women's movement. Alozie and his co-authors also record that 'not nearly enough is known about gender-related political differences in childhood in the early feminist era because research on childhood political differences and on the secondary consequences of gendered political socialisation is sparse'.[2]

In another US study, conducted between 1965 and 1973,[3] Darren Sherkat and Jean Blocker record that both psychological dispositions[4] and socialisation are important factors in producing politically active people. The gender differences that Sherkat and Blocker observe in social movement participation are said to be largely a function of socialization, social psychological disposition and the, *then*, lower rates of college attendance by women. In Britain by 2015, women were 35% *more likely* to go to university than men with 94,000 fewer men than women applying, figures reported as a 'scandal' that set 'alarm bells ringing.'[5] In their research, Sherkat and Blocker argue that girls are actively socialised away from politics, which is perceived as a male preserve. Hava Rachel Gordon considers how gender shapes teenagers as political actors in terms of their development, involvement and visibility.[6] Gordon's research is, once again, with US communities, this time 'two high school movement organizations on the west coast', namely in Oakland and Portland. Gordon is very aware of how *the history of place influences the ways that these organisations frame their progressive political demands*, something we'll explore further in Chapter 4. She finds that girl activists are more inhibited in their political action than boys due to 'parental power'. In short, parents anticipate and allow greater levels of independence and defiance from male offspring, while girl children are expected to be more dependent and passive. Moreover, parents are more concerned for the safety of girls. Thence, parental constraints steer girls away from 'higher-risk politics' such as public demonstrations towards 'softer' political actions. Parental power and gender, Gordon notes, are embedded in the intersections of race, class and ethnic contexts that shape youth activism. Further impeding the involvement of girls in political action, sexism is in play in the peer networks of the teenagers whom Gordon researches.

We didn't ask our interviewees explicit questions about their personality, gender, race or ethnicity, so we aren't able to extract stories that focus exclusively on these qualities. Only where someone touched on or chose to expand upon them in the context of encountering politics and music did we glean insights. Though they may not be expressed

directly, however, these fundamental qualities are surely woven through each sentence of every story that we heard. Moreover, by the time people tell us their stories their identities are already imbued with family, place and community. Music too. We must observe here that, from the race perspective, the Street Choirs movement in the UK is visibly very white. Because of our focus on care and, once again, as so many of our interviewees were women, when we re-read people's stories, we were alert to the influence of parental power, sexism in peer group attitudes, and feminism in all its variants, not least liberal and socialist.

Jane Bursnall is Musical Director of Red Leicester. Born in London in 1964, her father was very musical and almost turned professional as conductor of the BBC Review Orchestra. In 2014, in her eighties, Jane's mother is co-Musical Director of her own choir. Jane was raised in Lincolnshire and went to the same school as Margaret Thatcher: 'She was held up to us a bit as an example, which is odd now when I consider that I'm actually a Musical Director of a *socialist* choir. I think what I took from that was that women can achieve rather than, you know, join the Conservative Party.' Jane studied music at Leeds University and became a music teacher. 'As far as politics was concerned, I was interested but I wasn't active until I joined Red Leicester and that sparked off – er – I suppose the fact that I could do something as well... I always described myself as being pink rather than dark red when I joined Red Leicester, but over the last – however many years it is? Thirteen? Fourteen? – I've deepened in colour, become redder and redder...It's been life-changing, actually, if I'm honest; it's been life-changing in many ways. Firstly, it gave me an awareness that there were other people like me about, who were bothered about the environment or who were bothered about what was going on with things. Also, people with slightly unusual views – in inverted commas, slightly alternative, that had credence. Because so often, if you have a view that is slightly different from the other people around you, it can be labelled as barking or bonkers or whatever, and it was nice to come into a community where everybody was accepted for who they were...I've loved singing all my life, and now I earn my living doing it and bringing it to other people. And what could be nicer

than that?'

Eileen Karmy was born in Santiago de Chile in 1980. In 2017 she was living in Edinburgh, while researching for a PhD in Glasgow. Eileen sings with Protest in Harmony: 'Both of my parents are Chilean, but the background of my mother is English. My father's background is Palestinian. In a way they encourage[d] me to learn music since childhood, like a hobby or something like that. Neither of them are musicians but both of them enjoy music. And they encouraged me and my brothers as well in political thinking maybe. Not always, but it was common to have a political discussion in the house. Since I was at school I enjoyed the choir of the school and the band of the school. Then, when I was at uni, I, together with some friends and my brother as well, we create[d] a band. So, since then I was playing in this band, playing instruments and singing. And most of them were songs of political – radical songs... Maybe because I was born during the Pinochet dictatorship, my parents talk[ed] about that all the time. But it was nothing particularly that I can remember like: oh this day or this issue, no. But I think it was something of the everyday life, of my family, particularly of my parents and my brothers...Also I think it was a combination of the musical heritage that we had, of the music we used to listen [to] when we were young, like Chilean music or Latin American music: Víctor Jara... So, we were raised with that kind of musical background. I think it was always a combination of both things [music and politics]. For me, for example, and I think for my friends, we were doing music to communicate a message. We didn't sing just political songs, but I think it was the majority of the songs that we made. Also, if they were political songs in the lyrics, we tried to use, for example, some kind of instrument that gained the attention of the public to communicate something. For example, using an ancient indigenous instrument in a song that wasn't normal. So for us it was always something. We didn't like just singing pop songs of love and stuff like that. We did it to communicate and to do some political activity in a way. I think that's my way of participating in politics. I've never been in a political party.'

Born in Ammanford in South Wales in 1951, Nest Howells shifted

from being a singing member of Côr Gobaith in Aberystwyth to being
the choir's Musical Director when the previous incumbent stepped down:
'Well, I suppose, I grew up in, what I would think, a typical small Welsh
village, mining community plus farming, so from a mining family…quite
a musical family, you know, brought up in chapel to music… So, I suppose
I just got into it, naturally, really. Quite a lot of the family were talented -
unfortunately it didn't pass that down to me [laughs]. I was given piano
lessons, which I really didn't like when I was a child: I didn't appreciate
it because I was having to practice and what have you, but obviously
I appreciate it now…And I've always belonged to choirs because I enjoy the
music and being part of something like that…and it went on from there.
[I] went to college and joined a choir there. So, it's been part of my life,
really, all along…I got used to politics, as well, being in a sort of political
environment, because my father was very interested, and he was a Labour
councillor for many years, and – um – well I knew what was going on,
and heard the discussions within the village and I suppose I went with
my parents everywhere, whatever was happening in the village when I
was small – because I didn't have any siblings so I was dragged along. Got
aware of things like that. And I used to help him with his leafleting, the
practical things like filling envelopes and stuff like that – for something
like a ha'penny every ten I did, or something – so, an awareness like that…
After I left home, I went to college, it was a Welsh college in Bangor, and
there was a lot of the Welsh Nationalist thing going on, and the language
issues…So, I enjoyed that and got involved with some of the things going
on – not necessarily combining music and politics… [Interviewer: Did
music and politics come together in your village, e.g. in brass band culture
like in Yorkshire mining villages?] Well, I think in parts of South Wales
but…like the politics of the mining community, I don't remember it being
strong like that, maybe because it was slightly different to being totally
immersed in it like in the valleys. Although there had been brass bands…
It had died out by the time I was growing up. That's quite interesting.
It's a pity, because my Father died when I was eighteen or nineteen, by
then I'd moved away from home to go to college and then nursing, and
it's a shame, you know, because now, well a few years later, it would have

been interesting to discuss all this stuff with him.'

The three extracts we've featured are from the stories of university-educated women. On gender and parental power, Eileen Karmy and Nest Howell's stories, although continents, cultures and decades apart, reveal parents encouraging girl children to participate in politics, though not necessarily of the higher-risk variety. That said, Eileen Karmy's parents did encourage her to think politically and even make political music while living under the brutally repressive right-wing dictatorship of Augusto Pinochet. As an ironic connection in our research, Pinochet's staunch ally Margaret Thatcher served as something of a feminist role model for Jane Bursnall, though that evidently had no straight-forward political influence. Openness to experience seems to be a personality trait that Jane has carried into her adult life as social interaction in her choir influences the shade of her politics. Ethnicity is a significant part of political socialisation for Nest Howells who enjoyed engaging with Welsh nationalism and language issues at university. Meanwhile, Eileen Karmy reveals a fascinating link between culture and politics with her account of using indigenous instruments that weren't normally associated with a song in order to express something more than the lyrics. Apart from Chilean singer and activist Víctor Jara, Eileen highlighted the political influence for her of other musicians, for instance Daniel Viglietti from Uruguay and Mercedes Sosa from Argentina, evidence of an international political solidarity of music in play in Latin America[7]. Coincidentally on this theme, Nest Howells' choir, Côr Gobaith, always sing at El Sueño Existe, a regular festival held in the small mid-Wales town of Machynlleth to celebrate the life and music of Víctor Jara.[8] Typically, each El Sueño Existe festival has a contemporary political theme. It always features musicians from Chile and other Latin American countries alongside performers from Wales and other nations.

FAMILY, PLACE AND COMMUNITY

Turning our attention to nurture and the influence of family, community and place on our interviewees, their politics and music, we'll begin with family. Considering 'individual orientation towards engagement in social action', Alexandra Corning and Daniel Myers develop a measure of propensity that covers a range of behaviours, ideological positions and social issues.[9] They note a number of studies which find that the children of politically active parents are more likely to be politically active themselves.[10] Drawing on the data of a major study,[11] Elias Dinas writes that: 'Although they are not the only agent of socialisation, families play an important role in inspiring children to take an interest in the political world.' He reports that children are more likely to adopt the political views of their family when politics is important to the parents. What might happen where different parental figures held divergent political views is not explored. He also records that the children of politically engaged parents tend to grow up to be politically engaged adults.

In his own research, Dinas looks at the paradoxical connection between these two probabilities, what he terms 'the apple falling far from the tree'. His research findings support the hypothesis that the children who are most likely to adopt the political views of their parents and become politically engaged adults themselves are also most likely to abandon those views. 'The reason politicised parents are more likely to end up with children who have divergent partisan preferences is that, by facilitating political discussions at home, they make the offspring more attentive to the political issues of their times.' On the other side of the coin he observes that 'low levels of parental politicization, however, may foster more affect-laden partisan orientations'.[12] Dinas observes that once they leave home, attuned to the world of politics, the political education of fledgling adults is likely to continue via their experiences in further education and work. In this regard, he also marks the influence of 'mass media communications'. Here, we must emphasize that the study form which Dinas draws his data from is located in the US, seems to feature only heterosexual nuclear families, and limits its political perspective

to the Republican versus Democrat voting preference of parents and their young adult offspring. Nevertheless, his findings alert us to at least some of the intense and variegated potentialities of political socialisation in families. Unsurprisingly, family was a major theme in our interviewees' accounts of their childhood and background.

Claire Baker Donnelly sings with Out Aloud. Born in Liverpool in 1976, Claire's mother is a big Beatles fan from The Cavern era.[13] So, at home Claire recalls: 'there was a lot of Beatles talk.' Claire moved to Sheffield to go to university when she was 18 and stayed: 'Politically, well, with my grandmother who looked after me a lot when I was younger, she used to talk a lot about Thatcher – "milk snatcher"[14]– and about how she'd taken my Nana's pension and so on. But my immediate family are much more right wing, my dad in particular: He's very pro-Brexit. I don't think he's ever voted UKIP, but…Oh we do argue! [laughs] They read the *Daily Mail* and believe it without questioning.'

A member of Birmingham Clarion Singers, Rod London was born in Hessle near Hull in 1956. He moved to Birmingham to study in 1986 and subsequently worked as a teacher. Rod has retrained, and in 2017 he was working as a psychotherapist. His father was a minister in the United Reformed Church tradition. Though he always enjoyed singing, Rod didn't join the church choir because it 'mostly consisted of fairly elderly people.' Rod's childhood exposure to politics is striking: 'In terms of its political aspect, the church itself wasn't overtly political, but there was an element of political awareness to some of the performances I saw in church and my dad's background. My dad's political background was really very active and quite unusual in some ways. He was a pacifist and a conscientious objector during the war and that really cast a distinctive… I was going to say shadow, but *shape* in family life, really. And [it shaped] our notion of what it means to be political and to really live by your political principles. He was probably disowned by certain members of his family. He went to prison at the beginning of the war as a result of it, until his hearing took place, and then he was placed in a non-combatant part of the army for the rest of the war.[15] I think, maybe as a result of that he retrained as a minister. In the run up to the war he was in lots of

organisations, principally the Peace Pledge Union, which campaigned for disarmament. And then, after the war, he was an active member of CND. He told us about having been on the Aldermaston march, which I think was one of the first ones.'

Christopher Norris (Chris) is a Professor of Philosophy at Cardiff University. Born in London in 1947, he has written on literary theory, epistemology *and* music. Chris has lived and worked in South Wales since 1978, and he sings bass with Côr Cochion. He did not have the political background we might expect, however: 'My parents were very conservative, Conservative voters, certainly not activists, but I guess life-long Tories. I don't know if I reacted against that?'

A singer with Sheffield Socialist Choir, Andy Dykes also takes on the role of the choir's Social Secretary. Born in Northampton in 1954, Andy grew up in Harlow, and went to college in Cheshire to study music and drama. He was involved in youth and community work with Essex County Council for twenty-three-and-a-half years before moving to Sheffield in 1999. Growing up, Andy experienced a singular political and musical socialisation: 'I was brought up in a home that had Salvation Army running through it: Dad was a Salvationist, his parents were Salvationists and [pauses] I didn't know anything different, to be honest. [I] went to Sunday school, played junior band, went to junior choir - progressed to senior band, senior choir, and it was only about the sort of time of teenage, late teenage, fifteen-sixteen-seventeen, that I then sort of thought: well, hang about, all these rules and regulations, it's not really me. And my younger brother and I used to go down the local hostelry on a Friday night and we'd be aware that *The War Cry* [the Salvation Army newspaper] would come around and they'd be shaking the tin and we'd be thinking to ourselves: "It's a raid!" and dive into the Gents to avoid being seen in the pub, because we were not supposed to drink.'

'And you just get to a point where you think: this is a nonsense. And so, over a period of time you just sort of lapsed, I think the phrase is: in Sally Army parlance, you become a backslider. Cos I did the whole bit, you know, uniform, played cornet, streets at Christmas, carols, all that

stuff, but then, yeah, you just think: well hang about, you know, if Jesus could turn water into alcohol, what's so wrong with it? But, anyway, for one reason or another, I just came out, but I'd got the bug about music and art and creativity through that and also the social caring, nurturing. Family – mum, dad, brother, sister – are Tories, and I'm [laughs] – I'm the different element, I suppose. Mum was a carer. She had all sorts of things that she did, with and for other people in terms of charity, Oxfam... And in that sense, I suppose I picked up some of her "stuff." Brother and sister both went down the private rather than the public sector route. I ended up in education and, what I would call, the broad spectrum of the caring profession side of things.'

Retired from the Probation Service, Charlotte Knight sings with Red Leicester. She was born in 1950 in St Albans, Hertfordshire: 'My father was a life-long socialist. So, I grew up with [it] ingrained, really. It was never something I questioned. He belonged to the Labour Party and he would be out campaigning and things in the village where we lived, and I'd go with him sometimes. He had some very fiery opinions about all sorts of things. But he had passion, so I suppose that's where I got my politics from: more the feelings than perhaps the detail, you know. And really that's never shifted. So I've never shifted from that perspective all my life.'

Harriet Vickers sings with Strawberry Thieves in London. One of the younger members of street choirs whom we interviewed, Harriet was born in 1986. She is active with the Radical Housing Network, which is where she heard of Strawberry Thieves as their Musical Director, John Hamilton, is also involved with housing issues. Harriet's aunt was with the BBC Singers and her father sang with the church choir, which Harriet also joined: 'I used to sit there with my fingers [crossed] behind my back. But I really liked the music because it was a bit of a challenge – satisfying to sing even if I didn't agree with what it was saying.' Harriet learned music at school: choral singing and playing the violin. 'Yeah, we're a musical family but quite an apolitical family. My mum isn't interested in politics. My dad's side of the family are kind of broadly lefty. They analyse the news in a lefty way rather than being active. I didn't get into

politics until I was about twenty-five because I always saw it as this thing that was populated by old shouty men. I thought, it's not for me, it looks really dry, and you don't feel like you have much control over it. I got involved in the union [GMB/NUJ] at work because I saw how democracy could work at the really local level, how you get the workers together and you make a fuss about something and you get it changed. I got involved with young [union] members and that's when I first started doing social justice outside the workplace. So, we did some campaigns on housing – as an autonomous group with a bit of union support. And we managed to change the law within our first six months of our first campaign! Just a little thing: it was on revenge evictions via a Private Members' Bill.[16] We did a demo. Jeremy Corbyn came down. You know, before he was Jezza.'

If we can take it that our research participants are politically active people, if only because they sing in street choirs, the above extracts from their stories illustrate no blanket correlation between their parents' political engagement and their own activism. Among *all* our interviewees some, like Charlotte Knight, did adopt and retain their parents' political views. In the extracts of stories reproduced above, though, we have a number of cases where, in Dinas' terms, the apple has fallen some distance from the tree. Claire Baker Donnelly, Chris Norris and Andy Dykes have made quite radical shifts from the political world views of their parents. Though Andy's shift is from his family's Christian religious engagement to his own left-wing political activism with Sheffield Socialist Choir, he has retained and incorporated a commitment to *care*, which we'll discuss further in due course. Like Andy, Rod London's formative political experience with family is thoroughly entangled with religion or religious values, in his case enacted as pacifism by his father. Rod's story reveals how political or ethical engagement can cause rifts in a family.

Recalling Dinas' work again, we note that here is a conceptual gulf between switching party allegiance between Democrat and Republican in the US and shifting away from a socialist perspective experienced in Britain in early family life via values and practices such as equality and the collective action of campaigning or going on strikes. That said,

we should also record that we would not expect to find folk who had shifted politically to the right singing with a street choir in the Campaign Choirs Network. We saw earlier in Nest Howells' story the influence that participating in further education can have on people's politicisation, and Nest's experience is similar to that of a number of our informants. In Harriet Vickers' telling of her story, politicisation came mainly through the workplace and later interaction in a peer-group of young union members. Along the way, Harriet's politicisation has been influenced by left-wing feminism.

Charlotte Knight, in common with Nest Howells and several of our other interviewees, highlighted the particularly powerful politicising influence of *dads*. This seems to be the case with daughters especially, but then our 'sample' – like UK street choirs themselves – contains significantly more women than men. That said, we note that, in the era when most of our interviewees were growing up, the man in the family was likely to be the dominant figure in terms of active involvement in politics. Via membership of a trade union especially, work and politics were strongly linked in a number of people's stories, and in the 1950s and 1960s it was most likely to be the father in a family who went out to work. The Office for National Statistics records that: 'Over the past 40 years there has been rising employment for women and falling employment for men, but men have consistently higher employment rates age 22 and above.'[17] The biggest shift towards women working happened between 1971 and 1992, probably due to an economic turn from manufacturing to service industries in combination with several pieces of new legislation on equal pay and discrimination. We wonder whether there is a connection between women who grew up in an era where politics was still viewed as predominantly a male domain and them later choosing street singing as a political practice: were some women influenced away from other forms of 'higher-risk' political engagement that perhaps retain an air of male preserve?

CLASS CONSCIOUSNESS

A recurrent theme in the literature on children, young people and socialisation is *class*. Sherkat and Blocker, for instance, found that social class influenced whether children grew up to be politically active people.[18] Sidney Verba and his co-authors conclude that the transmission of class advantage across generations renders US children economically and politically unequal from 'the starting line.' The transmission of class advantage, they state, is driven by parents' education. Well-educated parents provide a politically rich environment which has a 'potent impact' on their offspring's political activity. Verba et al. conclude that: 'Most of the proximate causes of political participation have their roots, at least in part, in social class background'. [19] Many of our interviewees mentioned class and/or a family history of involvement in the labour movement as factors in their political socialisation.

Born in Glasgow in 1968, Val Regan moved to Sheffield in 1991. She is Musical Director of Out Aloud, a role she formerly fulfilled for Sheffield Socialist Choir. Val grew up in Durham and Newcastle before going to university in London. Both her parents were music teachers and her father became a psychologist. 'There was always music being played in the house. I played an instrument from an early age, and it was just part of what we did at home. They [parents] were both Labour voters, both socialists, and both born and brought up in Glasgow. And they had lived in Glasgow until they were in their forties. They'd never been anywhere else; they'd studied there as well, and it was a very big deal for us to move to England. And part of why that's important, I think, is because of the attitude there is within Glasgow. So, they were both from working-class backgrounds who then got a higher education, the first in their family to do that. But there certainly, at that time, was a real attitude that education was for everyone and that that was the way that you got on in life. And there was a real aspiration amongst working class Scots for education – a real appetite for it – and it was very egalitarian. Except that Glasgow is a very sectarian city and we were Catholics… So, we were not practicing Catholics but there was no way I would have

gone anywhere other than the local Catholic school. And there was a strong sense of being a minority, and there was a very insular Irish immigrant community that we were part of. So, I didn't know anybody who wasn't Catholic.'

Born in 1964 in Middlesbrough, Annie Banham moved to Birmingham to study in 1985, and then: 'I started to work for the City Council which kind of sucked the life out of me [laughs] but it was the kind of time in life when I thought, you know, I've got to settle down and do something sensible. And I did that for fifteen years, which is quite a prison sentence [laughs with interviewer]. But it was during that time that I started to explore, and that's how I found Clarion [Birmingham Clarion Singers], eventually. [It was the] end of 2001, beginning of 2002, that I joined Clarion.' [Interviewer: Family background in music and politics?] 'I always say we didn't have much music, in fact we didn't even talk very much [laughs]. I come from quite a…[a] very working-class family. My dad was a construction worker, my mum was a cleaner. My dad didn't work from me being about nine, so it was a fairly kind of austere time, really, when I was growing up. Um, but everybody was kind of in a similar situation: parents either not working or didn't have much money. So, it was very much a kind of hand-to-mouth existence and, as I said, we didn't have much in the way of music at home, but we did at school, and that's really what got me into singing. It was just kind of the joy of school choir and all of those things around school. So I joined the choir, got used to being on stage, and just found a voice. So it was very much that kind of early, outside the home, you know, and singing with people felt like…It was just an experience I'd not really kind of had anywhere else in my life. But singing was definitely a kind of coming together with other people. Yeah, and it was also, I think it was a great leveller, cos it didn't matter if you didn't have access to things, or, when I got older I met kids that had had access to music lessons and all the rest of it, da-di-da. We didn't have any of that but we could make a noise. We had recorders [laughs], drums, you name it, we could make a noise, and that to me was the key really.'

Politics came early to Annie with her father being chief steward

on building sites [at the] height of the construction industry 'lump' protests.[20] 'I can remember being four or five and, actually, putting leaflets in envelopes for my dad, and I can remember saying: "what's the lump?" and my dad explaining to me what that was all about. And [he] regularly came home with his steward's armband on… So there was always that feeling of – that we've got to make sure that everybody gets what they should have in life. That was very much my mum and dad's philosophy. They were very kind… Everything had to be about looking out for other people, and, if you had anything, it got shared. It wasn't about personal wealth or trying to get more than anyone else, which is interesting looking at today [where] that seems to be the main, um, narrative, whereas it was very much about the sharing things… I do feel very much that's shaped everything I've done since, really, yeah.'

Out Aloud's Andrew Wilcox was born in 1968 and grew up in Norwich. Andrew told us that he didn't come from a musical family, although he remembered that his father sang around the house. While he did sing in a choir in primary school, Andrew decided that singing in a choir in secondary school would 'not have been a good survival strategy,' implying that choirboys could have been singled out for bullying. He moved to Sheffield as a mature student in 1996 and works in the city's famous Crucible Theatre as Company Manager for Sheffield Theatres. 'We were socialists, both my parents voted Labour – I was very aware of that. I was reasonably aware of politics when I was growing up. I mean, I remember Margaret Thatcher becoming Minster for Health, well I vaguely remember that. I remember the milk thing. I can remember people like Callaghan. There was an active interest in the house. Not in terms of being a member of the [Labour] Party and going out. They were members of the Party in the benign sense and they used to do the Labour Tote[21] and things like that. My dad had been a more active member before marriage. I think he'd been a member of the Communist Party for a very short time in the fifties, which I think is quite common. We were a working-class, socialist family. My father was a postman and my mother worked…She worked most of the time, when I was a child, in a garage, just serving petrol or working in the shop.'

Self-identification as working-class or as having working-class origins is a notable theme in many of the stories we gathered. In tune with that theme, a good number of people identified their families and then themselves as socialists. Identifying as working-class did not universally relate to parents being poorly educated, however. As with Val's parents, a working-class aspiration to education was apparent in a number of stories, and many of our interviewees from across Britain were university-educated or had received a professional training. Our respondents are plainly all in street choirs, so we wouldn't expect to find any relationship between working class identification and low levels of political participation. That said, we can't spot much connection between Verba et al's observations on social class in the US and the stories we gleaned from people who were children of working class and socialist families in Britain.

In passing, we note that the perception of what working class means in contemporary Britain may have been politically transformed in the public mind, from 'salt of the earth' to 'scum of the earth.'[22] If only from the stories of childhood we've recounted so far, it's plain that Thatcherism left its mark on the political countenance of a number of our research participants, and for the most part that mark is a livid scar. In addition to class, place and religion are evidently significant in Val's political socialisation, and religion is thoroughly entangled with her 'Irish immigrant' ethnicity. Place and community are important in Annie's childhood too, side by side with her parents' commitment to equity and sharing. As with Andy Dykes, we'll return to evident resonances with the ethics of care in Annie's story.

A SENSE OF RHYTHM

Music is of varying prominence in these three story extracts, from 'always there' in Val's family, to 'didn't have much' in Annie's, while Andrew told us that he wasn't from a musical family. However, Annie does push open a door that is ajar in many of the stories of childhood that we heard: the

classroom door. Participation in school choirs and, to a lesser extent, church choirs has been vital in the musical socialisation of many of our participants. We make this observation against the background of musical education in the UK's state funded schools being under threat. For example, on 28 June 2017 the Joyce Frankland Academy in Newport, near Saffron Walden, cut weekly music lessons for children aged between 11 and 13 from the timetable. According to head teacher, Gordon Farquhar, this was due to budget cuts. In response, the Department for Education maintained that: 'The core schools budget has been protected in real terms since 2010 and is set to rise.' Contradicting this official line, the National Association of Head Teachers published a 2017 report entitled *Breaking Point* that details a 'school funding crisis.'[23]

A macho prejudice against choral singing among his school peers was apparent in Andrew's story. Whether that prejudice was entwined with class and/or community in place may well be worthy of further study. Research that *has* been carried out found that boys are especially likely to be bullied if they manifest as too bright.[24] Becky Francis analyses 'The Boffin as pariah, and as "queer" in the classroom,'[25] highlighting a prejudiced and pejorative, as well as wholly irrational, use of the term queer. There is a significant body of work analysing gender and achievement in British schools.[26] Annie's account of music being 'a great leveller', an aspect of childhood that could evade the deprivations of class and poverty, may reveal a vital facet of the complex relation between music and politics. Other stories that street choir members told us revealed the varied part that music has played in people's socialisation.

Claire Baker Donnelly, for instance, said: 'I used to sing a lot at school. I was in various school choirs and a madrigal group that the school had, *and I loved it.* But I couldn't read music and I still – I can sit there and stare at it, [then] I can read it, but I generally can't. And that was a problem because as soon as I left home I stopped singing in choirs or anything else because all the ones I tried to go to sort of shoved a piece of sheet music in your hand and expected you to sight-sing from that. And it felt very different to what I was used to, which was singing by ear. I don't have anything against sheet music, but it felt like it lost a lot of the spirit of it.

It sounded musically and generally flat. Obviously, going to university, as you might expect, I got a lot more politically active. I had been before I left: I would sneak away to go to Pride in London and, you know, tell lies to my mum and dad about where I was going. Do you know, I didn't come out to my mum until I was thirty-two?' Politically active in the Socialist Workers Party at university, Claire saw street choirs on marches: 'Terrible thing to say now, cos, you know… But I thought they were a bit of an odd thing, really. And I didn't think that I would fit in with that, and I'm not sure why. And I wasn't sure how they learned music and stuff and I was nervous. And some of my comrades at the time [said]: 'Well, that's not real activism, they're just singing! You're actually marching and chanting and giving leaflets out and talking to people, and singing's not really doing that, is it?' [But] it looked quite fun; [but] I was still too nervous at the time to do anything about that either.'

Charlotte Knight: 'My father loved Gilbert and Sullivan. So, again, I grew up with Gilbert and Sullivan. He used to take me to Gilbert and Sullivan concerts and things, and I've always enjoyed that. And my mother sang in a choir: she sang in the WI [Women's Institute] choir. So, you know, there was some [music], but it wasn't a time when people had a lot of music systems. I don't think my parents had any sort of music system in the house. They eventually got a record player, I think, when I was in my teens, you know. It wasn't something we had. We had the radio but we didn't have music playing. For me, it was joining the school choir, I suppose, secondary school, and singing with the choir through till I was eighteen. And my abiding memory is singing the *Messiah* in St Albans cathedral when I was eighteen and it was fabulous, I still remember that. And that was the last time I sang in a choir until I joined Red Leicester [in 2008]. So it seems a bit amazing, looking back, because I clearly liked music, and I played a range of instruments as a child, rather badly: the recorder and oboe and French horn; I never managed any of them very well. So, I always had an interest in music, and the school used to have classical music every morning before Assembly: they'd play a piece of music. So in that way music was part of my life. But when I think about it now, most of my adult life I haven't made much effort to follow that

through until quite recently.'

Elaine sings with Protest in Harmony.[27] She was born in Edinburgh in 1963 and has lived in the city 'pretty much' all her life. Elaine grew up listening to pop music and some of her teenage pals were into 'indie': pop and rock music with a DIY ethic that is produced independently from major commercial record labels. [Interviewer: Politically?] 'The influence I would say was a lot to do with my dad, who was a socialist, would have described himself as a socialist. And so in terms of my thinking about the world – um – by "the world" I suppose, actually I mean more locally as well, just about how life is and where there may be social injustices. I would say I was introduced to those ideas by my dad, and my dad was a social worker and I am a social worker. So, I think there's a lot there about wanting, sort of, justice and fairness for people wherever we are. In terms of singing: didn't do a huge amount as a child. I've got a big sister and we both learned instruments at school, pretty much everybody did. I did the piano, she did the viola. Dad kind of sort of sang around the house; Mum's very involved with the church and sings at church. But we didn't kind of sing as a family or... I mean, my sister and I would sing in the back seat of the car on the way to holidays and back. But there was no real, kind of, singing. And I don't even know [thinks for a moment]... I wasn't even in any of the school choirs, I don't seem to recall. I think I'd always really wanted to sing a bit more than I did, rather than [just] around the house. And it was as an adult really that I made a conscious decision: Right, come on, get on with this. And it wasn't particularly based in any kind of social activism. It was based in that I want to go sing.'

Ian 'Onion' Bell was born in 1962 and grew up in Harrogate. A health visitor, Onion joined Côr Gobaith in Aberystwyth in 2015. 'I grew up in Yorkshire, working-class family, middle of three boys. [My] parents liked music: Dad was passionate about big bands, Frank Sinatra; my mother liked Elvis, but I liked Dad's music. I didn't know much about classical music. I heard a little bit at school but didn't know what it was. That was all quite alien, really. I was in the church choir for a short time at eleven, but mostly too scared to sing in public. Later on I got into Morris dancing. The first street performance I did was with Border Morris in

Otley, before I moved to Wales. Well, no, actually, I used to – things come back to you, don't they – I was involved in Oxfam campaigning groups: we did a bit of busking that involved me singing in the street. Singing at football matches too: Leeds United was too violent, I turned my back on it, but I was singing with other people. I was kind of aware of politics and I went to uni and got interested in left politics, read a bit of Marx, but have never joined a political party. It [politics] was linked to music. In my formative years, you know, there was punk. I liked punk, and that was political: "Anarchy in the UK." There were big marches in the eighties, CND, but before that I was drawn to Rock against Racism and marches against [the] National Front in Leeds. There were some good marches that would end in a gig in a park with the Specials...'

'I went to a CND Conference – in London in 1985 or later, the year when Freddie Mercury died [1991]. The 1984-5 miners' strike was big thing as well. Yeah, and I've always felt music and campaigning were linked – singing on marches. I spent a lot of time inside and outside Menwith Hill base around the first George Bush's war on Iraq.[28] I met a lot of women there who'd been at Greenham, who sang round campfires, and I remember noticing how empowered they were, and the songs were a key part of that. I recently dug out audio tapes from Sheffield Socialist Choir: "Which Side Are You On" [a collection]; and I have one from Greenham too, "We Have a Dream." I was in Leeds and I remember Sheffield Socialist Choir was held in high regard. I think there were some people in Leeds who started a socialist choir, and I was tempted to join, but [didn't], maybe because I was young, and I still had some shame!'

These stories underscore the pivotal role that school and church choirs played in children's musical socialisation. Claire Baker Donnelly's story also reinforces the influence that going to university can have on young people's political socialisation. Claire's experience as a member of the Socialist Workers Party illustrates how music is not always taken seriously by political groups. Indeed, society more widely often disassociates music and politics. On the morning of writing this paragraph, in fact, James Naughtie on Radio 4's *Today* discussed music with the conductor Simon Rattle as an 'alternative challenge' to politics in troubled times.[29]

Disassociating politics and music is a phenomenon that we have observed in audiences at times in our participation in street choirs, and indeed from elements *within* the Street Choirs Festival. The bulk of our experience is of the two as thoroughly entangled, however. To reinforce that experience, numerous authors have recorded the significant part that music plays in politics, not least in social movements.[30] In our stories, some points emerge about the technologies of singing and music, from Claire visiting the vexed issue of sheet music (see Natural Voice, Chapter 1) to Charlotte Knight noticing how access to music and the way it is reproduced have changed so radically in a relatively short space of time. Street choirs are confronting such technical challenges every day, as we'll see in our next chapter. Charlotte's experience, along with that of Harriet Vickers, highlights the musicological anomaly of religious music being able to communicate an aesthetic appeal even to the most atheist of ears. The emotional pull of music is evident in the language our interviewees used to describe their experiences, in their yearning to sing, and in the affective associations they make between music and beloved family members, meaningful places and impactful political events.

There is, though, a marked contrast between the stories of Elaine and Ian 'Onion' Bell vis-à-vis the way they communicate the relationship between music and politics in their lives. While political and musical socialisation seem to be separate vectors for Elaine until she joins Protest in Harmony, for Onion politics and music are closely connected from his youth onwards. The relationship between music and politics varies throughout all the stories that we heard. We opened this chapter with a quote from Maxine Beahan (born 1963) who encountered both politics and song in her family when she was growing up. Though she makes a close association between the two, Maxine does not say that the songs of her childhood recollections were political, nor indeed that the politics were musical. A point to make here, then, is that songs can be political via explicit lyrics, because of who sings them and how the performance is framed, the context, or because the music has become associated with an event or campaign in the mind of the listener.

Onion's story also spotlights the lasting connections between music,

place and politics that can be forged. In this regard, our research revealed that Greenham Common is a vital spatial node in the story of the development of the street choirs movement. So historically significant was the role of music in the women's peace camp at Greenham Common that the Guardian Media Group have archived a downloadable Greenham Songbook.[31] The Danish Peace Academy (Fredsakademiet) has collected a more extensive Greenham song archive, along with a mine of information about the peace camp.[32] There is also a complete songbook, 'Greenham Women Are Everywhere Songs', on the Aldermaston Women's Peace Camp(aign) website.[33] Music has often played an important part in CND protests, and Colin Irwin goes so far as to claim that the Aldermaston 'ban the bomb' march 'gave birth to the British protest song.'[34]

Unexpectedly, for us anyway, Gilbert and Sullivan made a cameo appearance in the musical socialisation of more than one street choir member. While some of us might recall with horror our school productions of *The Mikado*, *The Pirates of Penzance* or another of the so-called 'Savoy' Operas, the film director Mike Leigh makes a case for Gilbert and Sullivan being 'outrageously subversive.'[35] We remember their operas as bland, sentimental and boring only because of 'camp productions', Leigh contends. Having written and directed the film *Topsy-Turvy* (1999) about Gilbert and Sullivan, Leigh writes of Gilbert, the lyricist of the partnership: 'his merciless lampooning of the heartless constraints of laws and etiquette reveal him, underneath it all, to have been a genuine free spirit and a true anarchist… within the framework of the story, he makes bizarre things happen, and turns the world on its head'. Moreover, what Sullivan's music did to Gilbert's words was 'to challenge and subvert them, and to enhance them by bringing out their flavour and meaning by interlacing and surrounding them with unpredictable succulent riches.'[36] So, who knows what radical seeds Gilbert and Sullivan may have sown in the heads of gonna-be street choir members?

Another musical force mentioned in several people's stories, including those that don't feature in this chapter, is The Beatles. We can speculate that distinctly musical connections made in childhood may have been

politicised for some of our participants by the subsequent political actions of 'the Fab Four'. John Lennon opposed the US war in Vietnam, famously staging 'bed-ins' with his wife Yoko Ono, whereby the couple stayed in bed for days, holding meetings and press conferences. During a bed-in in Montreal, Lennon and Ono recorded 'Give Peace a Chance' (1969), which became an anthem of the anti-war movement. Lennon also wrote 'Imagine' (1971), one of the best-selling singles and most popular songs of all time. It conjures a radical world at peace with no borders, no religion, no hunger and no possessions. In Chapter 5 we will explore our interviewees' imaginaries of the future, be they utopian, as in 'Imagine', cautionary dystopian, as in 'Hiroshima Song',[37] or persistently quotidian, unchanging and perhaps unchangeable. Here we should probably note that there is a Marxist or scientific socialism argument against utopian thinking, viewing it as a political distraction not grounded in the existing material conditions of the world.[38] On the other hand, Marx himself is sometimes analysed as a utopian thinker.[39] Such is the world of ideas.

Getting back on the Beatles track, former bass guitarist in the band, George Harrison, co-organised benefit concerts for refugees fleeing war in Bangladesh. More politically contentious perhaps, Paul McCartney and Wings recorded 'Give Ireland Back to the Irish' in response to the Bloody Sunday massacre. So, although the Beatles may not have begun as protest singers, the group's members did go on to make their various political marks. Pursuing the Liverpool connection, Karen Jonason of Liverpool Socialist Singers was strangely alone among our interviewees in citing music that was definitely protest music as a childhood influence. Karen told us: 'The family was very into Pete Seeger, the Weavers and later Joan Baez. We didn't have a television, so we used to listen to that sort of music.'

THE AGENCY OF CHILDREN AND YOUNG PEOPLE

Thus far, we've considered our stories as if children were passive in the processes of their own political and musical socialisation, mere sponges

soaking up slogans and songs. There is, however, a burgeoning literature on the agency of children and young people. Considering research on children, young people and politics, Tracey Skelton reminds us that, for a start, it is 'nigh on impossible' to precisely theorise or entirely conceptualise 'politics'.[40] As with most terms when intellectuals try to grasp and hold onto them, politics turns out to be as slippery as an eel. Moreover, there is usually an electric sting in the tail for any academic naive enough to proclaim it caught and safely in the landing-net: they will likely suffer the caustic opprobrium of their peers, honed by what can be an uncaring culture. Skelton proposes that the project, for human geographers at least, is to research where politics 'touches down and works its way through spaces and places. Such a critical approach is about deconstructing the very meaning and taken-for-grantedness of politics and who or what can be political'.[41] When it comes to children and young people, Skelton notes that, though they may do politics differently, they are still very much political agents and actors. They are subjects who are particularly vulnerable to political violence and victimisation. Among her examples of children and young people as both agents and victims of politics, Skelton mentions kids in Palestine engaging in street protests against the Israeli occupation forces. She also exemplifies the shooting of Malala Yousafzai by the Taliban in response to her campaigning for access to education for girls.

Skelton directs researchers' attention towards the 'every-day contexts of carelessness and disregard of youthful lives'. In our view, however, attention also needs to be focussed on care and regard for such lives. In Rio de Janeiro in 2017, for instance, a class of young children sang together in response to a gang-war shoot-out taking place outside their school. Their teacher, Roberto Ferreira, said: 'I think I am a mediator between two different worlds. Through music, my students get to know a universe beyond the one that they see, which is full of violence.'[42] We wonder if this is an example of practicing care through music, and whether it is a political act? Paraphrasing Rebecca Solnit writing on hope, the incident perhaps illustrates the visionary potential of music to help us imagine a better future while performing some of that future

in the meantime.[43]

In tune with Skelton's proposals, Kirsi Kallio and Jouni Häkli attempt to conceptualize children's agency and the spaces of their politics. They identify three overlapping forms of children's politics. In the first, adults facilitate children's participation in policy-making forums by way of education for citizenship. The second form of participation is driven by conflict, wherein children become actors in wars, economic and racial struggles, as with Skelton's examples from Palestine and Afghanistan. 'Lastly, children practice politics in their seemingly apolitical everyday environments by exercising a degree of autonomy in their mundane practices, whichever they may be'.[44] Tellingly, Kallio and Häkli note that the term 'children' no more defines a unique political group than does the term 'adult'. These authors do not trace the caring or inter-relational aspects of children's politics. They do, however, make us aware of how children's political socialisation and political action can be played out in everyday practices such as play, jokes, graffiti and, indeed, song. Tangentially, we note that composers in street choirs often reword traditional children's songs to comment on contemporary political issues. For example, Liverpool Socialist Singers rewrote 'Teddy Bear's Picnic' as an act of resistance against the privatisation of the NHS by the Conservative government. So, the line 'At six o'clock their Mummies and Daddies will take them home to bed 'cause they're tired little Teddy Bears' becomes, in the finale, 'Your time is up, grim-reaper is coming to take you all away because you're sick little Tory – sad little Tory – cruel little Tory Boys'.[45]

Anne E. Bartos examines how children express their political agency through acts of caring. Her research was carried out in New Zealand and draws on Joan Tronto's ethics of care framework to explore how children *maintain, continue* and *repair* their worlds. Noting the methodological challenge of researching political identity formation, via their own photographs Bartos considers the important relationships, respect and mutuality that children value in their worlds. With care as a framework, she is cognisant of children's development not in terms of developing independence but of *cultivating interdependencies.* Culture is socially

produced and, as such, may be founded more on relationships than on personal freedoms: 'These relationships are crucial in the development of their (children's) political identities and in many ways lay the groundwork for political decisions they make now and in their futures'.[46]

Singing and song-writing with Raised Voices, Morag Carmichael is a 'lifelong Londoner' who was born in 1945 and grew up in Kingston Vale: 'My mum always voted Labour, my father voted Liberal. We hardly ever talked about politics, though. When I began to get interested in politics I couldn't get a proper conversation with them about it. I found it frustrating. In the sixth form at school we'd listen to a current affairs broadcast. And I remember being absolutely furious. The head teacher took this [lesson], and after a thing about the British nuclear deterrent and joining NATO, she said: "Oh I'm sure you've all made your mind up about this, shall I show you a card trick?" And I didn't dare put my hand up and say: "No, I want to discuss it." I was too meek and mild in those days. I went to the Quakers when I was about fifteen in Wimbledon. School was in Wimbledon. We used to pass it [the Friends Meeting House] on the way to the hockey field and I saw where they met. And I decided to go. One thing I really liked about them was that they were supportive of CND. I went on a march when I was sixteen.'

Lowenna Turner sings with Côr Cochion Caerdydd. Another of the younger people from street choirs whom we interviewed, Lowenna was born in 1985 in Truro, Cornwall: 'My grandfather was a staunch Labour member. He was a London dock worker from Woolwich. I never got to meet him, he died before I was born, but mum was always glad he never saw the worst of Thatcherism. So, we were always brought up with the idea that we should be going back towards socialism...That was from mum's point of view. When I was very, very young, I went to play-group and there was an incident where I was shouting: "Maggie, Maggie, Maggie, Out, Out, Out!" Which I have no recollection of. I remember Mandela walking out of prison and that was a big thing. I was three or four,[47] but mum put me on the sofa, pointed at the TV and said: "Watch this because you'll remember it forever." And she's quite right, I have remembered it forever.'

Although the family aspect of her story is not typical of our stories, Morag narrates the possible limits of family as source of political socialisation for an actively enquiring child. Generally, our interviewees, in common with Morag, reported that school as an institution did not much feature in their political socialisation. This is in stark contrast to the role that we observed that schools play in children's musical socialisation. Noting this 'strange neglect of political education' in Britain, Will Carter opines that: 'A lack of guaranteed political and economic education at school devalues our democracy and disenfranchises our youth.'[48] In Bartos' terms, Morag seeks out political education through the Quakers in order to *continue* our world, i.e. before taking action against the threat of nuclear war. Lowenna's story illustrates the inevitable entanglement of political socialisation and agency in a child's life. Her mother's act of political care in sharing the moment of Mandela's release invests Lowenna with a consciousness of the emancipatory struggles of distant others and an indelible sense of international solidarity, which emerged further as the interview continued. In chanting against Margaret Thatcher, Lowenna's young school-girl participation in politics is surely conflict driven. The 'Iron Lady' presided over one of the most divisive periods in British political history,[49] finally resigning as Prime Minister when Lowenna was around five years old [28 November 1990].

BECOMING POLITICAL AND THE ETHICS OF CARE

The majority of people would probably agree that part of parents' care for their children is teaching them to care for others. This education becomes political when parents encourage their children to consider those who are *not* cared for by society, and, critically, to ask '*why not?*' How parents address such questions with their children, particularly whether they valorise individualism or community, determines the reach and quality of that invested duty of care. For example, Flanagan and Tucker find that young people in the US who viewed unemployment, poverty and homelessness as societal rather than individual problems also had more

altruistic life goals and said that their families emphasised compassion as a value.[50] Proposing care as both value and practice, Virginia Held states that: 'Although this has not been acknowledged in traditional views of the household, the potential for creative transformation that occurs there, and in child care and education generally, is enormous. Care has the capacity to shape new persons with ever more advanced understandings of culture and society and morality and ever more advanced abilities to live well and cooperatively with others.'

Held is adamant that the ethics of care is characterised by viewing people as relational and interdependent. She writes that 'caring relations extend well beyond the sorts of caring that take place in families and among friends, or even in the care institutions of the welfare state, to the social ties that bind groups together, to the bonds on which political and social institutions can be built, and even to global concerns that citizens of the world can share'. Viewed as both value and practice, care can operate across space and time. Moreover, the imagination of relations with geographically distant others or future generations need not be a barrier to value or action. For example, on one of the most spatially and temporally vexed political issues confronting contemporary society, Held writes: 'if we really do care about global climate change and the harm it will bring to future generations, we *imagine* a connection between ourselves and those future people who will judge our irresponsibility and we change our consumption practices or political activities to decrease the likely harm.'[51] For Held, the caring person values and practices care in both the personal and public realms, caring for themselves and their familiars and also oppressed and vulnerable strangers.

Laura Wray-Lake and Amy K. Syvertsen analyse the developmental roots of social responsibility in childhood and adolescence, stating that these lie in the growth of executive function, identity, empathy and emotional regulation. For these authors: 'Responsibility implies feeling accountable for one's decisions and actions, reliable and dependable to others, and empowered to act on issues within one's own control.'[52] Social responsibility is, they say, 'a value orientation' that drives a person's moral and civic behaviours. They cite research

positively correlating values that prioritise 'the greater good' with community, service, pro-environmental behaviour, and political activism. In tune with our focus on the ethics of care, Wray-Lake and Syvertsen place relationships with others (known and unknown, human and non-human) and a moral sense of care and justice at the heart of their conception of social responsibility. They exemplify family, peer, school and community environments as relational spaces in which 'the seeds of social responsibility' can be nurtured: 'everyday relationships founded on trust, reciprocity, and democratic dialogue are likely to influence children and adolescents' developmental pathways towards social responsibility.'[53] Encouraging academics to broaden their horizons, the authors note that most developmental research is carried out with middle-class youth in the US, an observation that we have also made herein.

A number of our interviewees referred to the commitment to care that they had derived from their familial socialisation, often expressing that commitment via the adoption of a socialist politics. Andy Dykes took on the practice of his mother's caring for people in the community into his own 'caring profession' of youth and community work: 'I always knew from pretty early on that I wanted to be someone who worked on an inclusive, um, caring basis.' Andy found a home for himself and his caring politics, invested with a sense of 'social awareness' from his time with the Salvation Army, through joining Sheffield Socialist Choir: 'And I just thought: here's a golden opportunity to be amongst people who are like-minded and, maybe, in a tiny way, you can make a difference.' Another interview stands out as explicitly framing those values such as justice, equality and solidarity that are traditionally associated with socialism within an ethics of care. Recall that Annie Banham told us her parents were very kind: 'Everything had to be about looking out for other people, and, if you had anything, it got shared.'

Charlotte Knight said: 'Everything that I've done in my life has been motivated by my basic political beliefs, you know. My work has been with offenders and with people who are often the most disadvantaged in society. So, I've always had a sense that, you know, we didn't look after them well enough, and that no government ever has done, really. And this

[David Cameron's Tory] government least of all.' Charlotte's observation resounds with Held's contention that better and more extensive practices of care would mean the state could shrink. Elaine told us her decision to work in social work was, for her, a political decision: 'My dad was a social worker and I am a social worker. So, I think there's a lot there about wanting, sort of, justice and fairness for people wherever we are.' Elaine also raised the global potential of care: 'by "the world" I suppose, actually I mean more locally as well, just about how life is and where there may be social injustices.' Held writes that we can 'develop caring relations for persons who are suffering deprivation in distant parts of the globe' but, in tune with Elaine, she does not mean for us to neglect the local – family, friends nor community – in extending our networks of care. Held concludes that extending caring relations from smaller societies of family and friendship has utopian potential: 'A globalisation of caring relations would help enable people of different states and cultures to live in peace, to respect each other's rights, to care together for their environments and to improve the lives of their children.'[54]

STRIKING SOME FINAL CHORDS

Although we're certainly not musicologists, another member of the Campaign Choirs Network, Lizzie Shirley, who in 2017 was Raised Voices Musical Director and also sang with Strawberry Thieves, assured us that it's 'the done thing', in Western music anyway, to end a tune on the dominant chord. As street choir singers ourselves, we did at least know, even without Lizzie telling us, that a chord is a number of notes that agree, combining harmoniously, even if we can't always achieve that in practice! So, which notes from people's stories of their political and musical upbringings combine harmoniously into resounding final chords? Let's try to address the questions we posed at the outset in this chapter by way of summarising the quite epic journey of political and musical socialisation that we have been on.

First, we can consider what made people political, where their politics

came from, influential events or moments, and what sort of political they became. Family evidently had a major influence on the politics that children adopted and took with them into adult life. Prominent values circulating in a number of our interviewees' families included kindness and compassion, solidarity, social responsibility, equality and social justice, all of which we proposed could be enfolded by an ethics of care. We did not, however, find that street choir members had universally adopted their political views from their parents: some had seemingly reacted against conservative, parochial and politically apathetic upbringings. Religious institutions also influenced the values that shaped people's politics, for example the Salvation Army in Andy Dykes' case. In a similar vein, Chris Booth (born in 1960 in Edinburgh and brought up in Aberdeen) sings with Protest in Harmony and credits involvement in church groups, latterly the Iona Community, with much of his political socialisation. Through church groups he first learned about issues such as Fairtrade, oppression in Pinochet's Chile and Apartheid. The influence of the Quakers is apparent in our research, and it serves to invest the Campaign Choirs Network with peace as a value that manifests in taking action against, particularly, nuclear weapons. One choir in the Campaign Choirs network, the Pales Peace Choir from Mid Wales, is founded upon Quaker values. Values of non-violence and peace also come to be invested in the Campaign Choirs Network via the women's movement and feminism, which notably overlap with the peace movement and CND at Greenham Common.

We saw signs of ethnicity influencing people's politics. This was most apparent among street choir members with a Welsh, Scottish or Irish ethnic background. Histories of oppression by the British state contribute to people holding fast to their culture as a value. This observation stands for the regional and city scale too, we believe, with marked cultural steadfastness in Yorkshire and Liverpool, for instance. As we'll see later in some stories from Wales and Scotland, however, politics perceived as nationalist can be divisive in street choirs. Similar tensions around race in UK street choirs are not apparent but, as we observed previously, the membership is predominantly white across the piece. The places where

street choir members were brought up influenced their politics, often through living histories of class struggle. Certainly, place influenced the politics of the street choirs themselves via such discourses. Interviewees such as Eileen Karmy and Maxine Beahan exemplify the infusion of people from other cultures into British street choirs, and they embody possibilities for developing international solidarities.[55] Interestingly, David Featherstone discusses Chilean solidarity work in Scotland explicitly, picking out the role of song in that process.[56]

On gender, we took special note of the influence of dads on the politicisation of our interviewees, perhaps women in particular. We also noted the influence of changing times on expectations around women's political participation. An increasing number of women entering further education seems certain to be significant with respect to how many women are active politically in future as well as *how* they act politically. Our interviewees across the board largely confirmed the impact that going to university can have on people's politics. Similarly, a number of the stories that we heard featured workplace politicisation, especially via involvement in trade unions. While we did record some examples, we couldn't really trace the influence of mass media communication on the politics of street choir members. We assume, however, that all our politics is thoroughly permeated by the influence of mass media in some way or other.[57]

Memorable political moments and events in people's childhood and youth that we've recorded in this chapter include Thatcherism, Pinochet's Chile, the release of Nelson Mandela, party political campaigning, Pride marches, Greenham Common and other anti-war or anti-weapons protests of various kinds, prominently featuring CND. One indication of the influence of mass media is in how the moments and events we asked people about were communicated: Lowenna, for instance, watched Mandela's release on TV; Morag listened to 'a current affairs broadcast' about nuclear weapons and NATO; Harriet's family analysed 'the news'... While music entered into a number of the significant moments and events in people's lives in diverse senses, it actually led the political way in campaigns such as Rock Against Racism, to which Onion referred.

We've noted already the influence of pacifism and feminism on the politics of certain street choir members and thence on the combined ethos of the Campaign Choirs Network. Then, a considerable number of the people singing in street choirs identify as working class and socialist. As a political orientation, socialism enfolds many of the values that people were exposed to in their families, churches, university groups and workplaces. Observant participators in street choirs, we have on occasion heard some of our fellow singers express dissatisfaction with the failure of some of the institutions of socialism, specifically trade unions and the Labour Party, to take on board feminism and/or environmentalism in more meaningful ways.

Turning our attention to music, we saw that families and, vitally, schools played a huge part in making people musical, i.e. more able and confident to appreciate, play and sing music. The correlation between musical ability, indeed any intellectual brightness, and peer group victimisation in some cases 'blots the copybook' of schools in this regard. Through choral singing, churches also made a marked contribution to the musical socialisation of some people whom we interviewed. In passing, we touched upon how changing technologies of reproducing music will surely have an influence on street choirs and hence on the development of the Campaign Choirs Network. As children, street choir members were exposed to a range of music in their families and schools, as well as hymn singing in church. The spectrum of musical influences reported by our interviewees is broad, from 'didn't have much', through folk music, which a number of people cited, and the musicals of Rodgers and Hammerstein and Rodgers and Hart which Chris Norris recalled, to the classical music evidently present in the childhoods of interviewees Val Regan, Jane Bursnall and Harriet Vickers. Music and musicians who were not explicitly political may have influenced street choir members politically. We picked out Gilbert and Sullivan and The Beatles as recurring musical influences in some of the childhood stories that we heard. Apart from Karen Jonason, exposure to explicitly protest music as a child did not loom large, although it has obviously been a profound lifelong influence for Jane Scott, born in Birmingham in 1949,

whose parents were founder members of Birmingham Clarion Singers. In terms of influential musical events, though, 'Onion' Bell brought music together with politics in his youthful encounters with punk, ska and the input of those musical genres within Rock Against Racism. Onion also recalled Sheffield Socialist Choir and Greenham songs. Elsewhere, however, we saw that music was not universally equated with serious politics in the experience of street choir members.

When we consider how music and politics came together in people's lives or why people chose singing as a means of political expression, we mustn't miss the obvious. For many of our interviewees what brought music and politics together for them was encountering a street choir. Most often, this encounter was on the street rather than online or via someone else's account of a performance, although these media were in play. Born in 1956, Wendy Lewis, Musical Director of Côr Cochion, told us: 'It's always going to be a small number of people who are politically and musically interested. On the whole, the people who have stuck with us are the people who didn't think they could sing but were interested politically and then learned to sing. As opposed to the people, in the past, who had lovely voices but…Well, they're not going to stick around if they don't agree with the politics.'

Nicholas Cook stresses music's potential as means of personal *and* social transformation and, following extensive work on music by the theorist Theodor Adorno, sociologists analyse music in terms of the values embedded in it and the social relations it thus tends to perpetuate. John Street proposes that Ron Eyerman and Andrew Jamison have begun to provide the theoretical grounding for a political theory of music, i.e. an understanding of 'the part music plays in constructing the collective consciousness that mobilises political action, and how this action in turn shapes aesthetic sensibility.'[58] As we've seen, for example, Jane Bursnall was politicised through music, i.e. the process of making music: singing with and relating to others in Red Leicester.

What is needed now, Street says, is *a musical theory of politics*. In this vein, recall that Annie Banham said of singing: 'it was a great leveller, cos it didn't matter if you didn't have access to things.' Harriet Vickers,

who used to sit with her fingers crossed behind her back to signal her disagreement with the sentiments of hymns, reminds us that music can be aesthetically pleasing even when it plays *against* our politics. But, in a parallel vein, Eileen Karmy said: 'if they were political songs in the lyrics, we tried to use, for example, some kind of instrument that gained the attention of the public to communicate something. For example, using an ancient indigenous instrument in a song that wasn't normal.' We proposed that El Sueño Existe might be a space wherein an international political solidarity of music was being developed. Visits to Palestine of Côr Cochion and San Ghanny, along with Sheffield Socialist Choir's exchanges with Cuban choirs, are also spaces of such solidarity.[59] And we suggested that Roberto Ferreira in Rio de Janeiro was practising care through music with the schoolchildren in his charge. We'll return to these observations in Chapter 6 when we discuss how the Campaign Choirs Network initiative might develop and how politics mobilises us to make music.

ENDNOTES

1 Michael Beahan, Australian Labor politician.

2 Nicholas Alozie, James L. Simon and Bruce D. Merrill, "Gender and Political Orientation During Childhood". *The Social Science Journal*, 40, 1, (2003): 1-18, 3.

3 Darren E. Sherkat and T. Jean Blocker. "The Political Development of Sixties Activists: Identifying the influence of class, gender and socialisation on protest participation." *Social Forces*, 72 (1994): 821 -842.

4 Sees for instance De Neve, J.-E. "Personality, Childhood Experience, and Political Ideology." *Political Psychology*, 36, 1 (2015): 55–73.

5 Nick Hillman and Nicholas Robinson. *Boys to Men: The underachievement of young men in higher education – and how to start tackling it*. Higher Education Policy Unit (12 May 2016), Report 84.

6 Rachel Hava Gordon, "Gendered Paths to Teenage Political Participation: Parental Power, Civic Mobility, and Youth Activism," *Gender and Society* 22, 1 (2008): 31-55.

7 See for instance: Ana Gutierrez, "Peace profile: Víctor Jara." *Peace Review*, 10, 3 (1998): 485-491; Gabriel San Roman, *Venceremos: Víctor Jara and the New Chilean Song Movement* (Oakland: PM Press Pamphlets, 2014); J Patrice McSherry, "The Political Impact of Chilean New Song in Exile." *Latin American Perspectives 44, 5* (1 December 2016): 13-29; Jan Fairley, "Annotated bibliography of Latin-American popular music with particular reference to Chile and to nueva canción." *Popular Music* (1985): 305-356;

Nancy Morris, "Canto porque es necesario cantar: The New Song movement in Chile, 1973-1983." *Latin American Research Review*, 21, 2 (1986): 117-136.

8 El Sueño Existe https://elsuenoexiste.wordpress.com/

9 Alexandra, F. Corning and Daniel J Myers, "Individual Orientation Towards Engagement in Social Action". *Political Psychology*, 23, 4 (2002): 703-729.

10 B. Park, "An Aspect of Political Socialisation of Student Movement Participants in Korea." *Youth and Society*, 25 (1993): 171-201; J. L. Wood and Wing-Cheung Ng. "Socialisation and Student Activism: Examination of a Relationship". In Louis Kriesberg (Eds.) *Research in Social Movement, Conflict and Change*, 21-44 (Greenwich, CT: JAI Press, 1980); Joseph R. DeMartini, "Social Movement Participation: Political socialisation, generational consciousness and lasting effects." *Youth and Society*, 15 (1983): 195-233.

11 M. Kent Jennings, Gregory B. Markus, Richard G. Niemi and Laura Stoker. *Youth-Parent Socialization Panel Study, 1965-1997: Four Waves Combined.* ICPSR04037-v1. Ann Arbor, MI: Inter-university Consortium for Political and Social Research [distributor], 2005-11-04. https://doi.org/10.3886/ICPSR04037.v1.

12 Elias Dinas, "Why Does the Apple Fall Far from the Tree? How Early Political Socialization Prompts Parent-Child Dissimilarity." *British Journal of Political Science*, 44, 4, (2014): 827-852, 848-849. See also M. Kent Jennings and Richard Niemi, *The Political Character of Adolescence: The Influence of Families and Schools* (Princeton, NJ: Princeton University Press, 1974).

13 The Cavern Club https://www.cavernclub.org/history/

14 As education secretary in Edward Heath's government her decision in 1970 to stop the provision of milk for junior school pupils prompted the playground taunt "Thatcher, Thatcher, milk snatcher".

15 Michael Mears' one-man theatre piece 'This Evil Thing' tells the story of the men who said no to war very effectively, asking many questions about values and compromise.

16 In 2014 Liberal Democrat MP Sarah Teather presented the Tenancies (Reform) Bill. The Bill was "talked out" by Conservative MPs and did not complete its Second Reading. However, in 2015 the Coalition Conservative/Liberal Democrat Government published a policy statement setting out an intention to add clauses to the Deregulation Act 2015 that would "protect tenants against the practice of retaliatory eviction."

17 ONS. "Women in the labour market: 2013." Office for National Statistics. 2013. https://www.ons.gov.uk/employmentandlabourmarket/peopleinwork/employmentandemployeetypes/articles/womeninthelabourmarket/2013-09-25 Accessed 14 September 2017.

18 Sherkat and Blocker, "The Political Development of Sixties Activists."

19 Sidney Verba, Kay Lehman Schlozman, Nancy Burns, "Unequal at the Starting Line: Creating Participatory Inequalities across Generations and Among Groups." *American Sociologist*, 34 (2003): 45-69, 58.

20 In 1972 there was a building workers strike in Britain in protest at the 'lump' system of taking on only self-employed workers for each new project. Groups of workers from different trades who had not worked together before, 'the lumpers', had to negotiate with the employers over pay and conditions on each individual site. Employers made it deliberately difficult for unions to organise on sites where the lump system was in force. In September of 1972 the unions negotiated basic national rates for labourers and craftsmen but failed in their effort to reduce the 40 hour working week.

21 We believe this was form of gambling that the Labour Party used to raise funds from its members.

22 Owen Jones, *Chavs: The demonization of the working class* (London: Verso Books, 2012).

23 NAHT. "Breaking Point: A report of the school funding crisis in 2016/17." National Association of Head Teachers. 2017. https://www.nga.org.uk/News/NGA-News/Sept-16-Feb-2017/School-budgets-%E2%80%98close-to-breaking-point-says-NAHT.aspx.

Accessed 14 September 2017.

24 See Hilary Wilce, "Bullied boys: Why bright lads are being picked on." *Independent,* 13 May 2009. http://www.independent.co.uk/news/education/schools/bullied-boys-why-bright-lads-are-being-picked-on-1684266.html. Accessed 14 September 2017. Also Christine Skelton and Becky Francis, "Successful Boys and Literacy: Are "Literate Boys" Challenging or Repackaging Hegemonic Masculinity?" *Curriculum Inquiry,* 41 (2011): 456-479.

25 Becky Francis, "The role of The Boffin as abject Other in gendered performances of school achievement." *The Sociological Review,* 57 (2009): 645-669.

26 See for example: Becky Francis, *Boys, Girls and Achievement: Addressing the Classroom Issues* (London: Routledge, 2000); Becky Francis, "Relativism, Realism, and Reader-Response Criticism: An analysis of some theoretical tensions in research on gender identity." *Journal of Gender Studies,* 11, 1 (2002): 39-54; Becky Francis and Christine Skelton, *Reassessing Gender and Achievement: Questioning Contemporary Key Debates* (London: Routledge, 2005).

27 For a variety of personal and professional reasons, Elaine preferred for us not to use her surname.

28 Menwith Hill Royal Air Force station near Harrogate is a key part of the global network of the US' National Security Agency (NSA), intercepting or 'eavesdropping' on countless communications.

29 *Today,* 11 September 2017. http://www.bbc.co.uk/programmes/b0930zgw. Accessed 19 May 2018.

30 See: Ron Eyerman and Andrew Jamison, *Music and Social Movements: Mobilising traditions in the twentieth century* (Cambridge: Cambridge University Press, 1998); George McKay, "A soundtrack to the insurrection: street music, marching bands and popular protest." *Parallax,* 13, 1 (2007): 13-21; Ron Eyerman, "Music in Movement: Cultural politics and old and new social movements." *Qualitative Sociology,* 25, 3 (2002): 443-458; Mark Mattern, *Acting in Concert: Music, Community, and Political Action*

(Rutgers University Press: New Brunswick, 1998); Ian Peddie (Ed.) *The Resisting Muse: Popular Music and Social Protest* (Ashgate: Farnham, 2006); Rob Rosenthal and Richard Flacks, *Playing for Change: Music and Musicians in the Service of Social Movements.* (Paradigm: Boulder CO., 2012); W. G. Roy, *Reds, Whites and Blues: Social movements, folk music, and race in the United States* (Princeton University Press: Princeton, 2010).

31 The Greenham Songbook. https://www.theguardian.com/yourgreenham/songbook/0,,2071798,00.html. Accessed 19 May 2018.

32 The Danish Peace Academy http://www.fredsakademiet.dk/abase/sange/greenham.htm. Accessed 20 September 2017

33 "Greenham Women Are Everywhere Songs" Aldermaston Women's Peace Camp(aign). Accessed 10 October 2017. http://www.aldermaston.net/sites/default/files/Greenham%20Songbook1.pdf

34 Colin Irwin, "Power to the People." *The Guardian*. August 10, 2008. https://www.theguardian.com/music/2008/aug/10/folk.politicsandthearts. Accessed September 15 2017.

35 Mike Leigh, "True Anarchists." *The Guardian*. November 4, 2006. https://www.theguardian.com/music/2006/nov/04/classicalmusicandopera.mikeleigh. Accessed 6 August 2017.

36 We recall here Eileen Karmy story of the way different instrumentation and so music affects the way audiences receive messages from songs.

37 'Hiroshima Song' (We Will Never Allow Another Atom Bomb to Fall) by Ishiji Asada and Koki Kinoshita (1955). English words by Ewan MacColl. http://unionsong.com/u236.html

38 David Leopold, "Socialism and (the rejection of) utopia." *Journal of Political Ideologies*, 12, 3 (2007): 219-237.

39 David Lovell, "Marx's Utopian legacy." *The European Legacy*, 9, 5: (2004): 629-640.

40 Tracy Skelton, "Children, young people and politics: Transformative possibilities for a discipline?" *Geoforum*, 49 (2013), R4-R5.

41 See for example: Claire Shaw and Lucy Ward, "Dark thoughts:

why mental illness is on the rise in academia." *The Guardian,*
Thursday 6 March 2014. https://www.theguardian.com/
higher-education-network/2014/mar/06/mental-health-
academics-growing-problem-pressure-university. Accessed 12
February 2018. Also Natascha Klocker and Danielle Drozdzewski,
"Career progress relative to opportunity: How many papers is a
baby 'worth'?" *Environment and Planning A* 44 (2012): 1271-1277.

42 Luiza Franco (translated by Lloyd Harder). "Professor in Rio's
Public School System Uses Music to Calm Children in the Midst of
Shoot-Outs in an Area Beset by Drug Trafficking." *Folha de S.Paulo.*
06 August 2017. http://www1.folha.uol.com.br/internacional/en/
brazil/2017/06/1891301-professor-in-rios-public-school-system-
uses-music-to-calm-children-in-the-midst-of-shoot-outs-in-an-
area-beset-by-drug-trafficking.shtml. Accessed 15 September
2017.

43 Rebecca Solnit, *Hope In The Dark: The Untold History of People
Power* (Edinburgh: Canongate Books, 2005), 163.

44 Kirsi Pauliina Kallio and Jouni Häkli, "Tracing Children's Politics."
Political Geography, 30 (2011): 99-109, 105.

45 Liverpool Socialist Singers sing 'Tory Boys' Picnic' https://www.
youtube.com/watch?v=VoSB2T0tYyQ and lyrics http://www.
hackneykeepournhspublic.org/tory-boys-picnic.html. Accessed
19 May 2018.

46 Anne E. Bartos, "Children Caring For Their Worlds: The politics of
care and childhood." *Political Geography*, 31 (2102): 157-166, 158.

47 Actually, born in 1985, Lowenna would have been 4 or 5 years old.

48 Will Carter, "The strange neglect of political education - and
how to revive it." *New Statesman*, 18 August 2016. http://www.
newstatesman.com/politics/education/2016/08/strange-neglect-
political-education-and-how-revive-it. Accessed 11 September
2017. See also Matteo Bergamini, "Compulsory political education
is a must if we are to stem the flow of disengagement from politics."
Shout Out UK. http://eprints.lse.ac.uk/63169/. Accessed 18
May 2018.

49 See: Martin J. Smith, "From consensus to conflict: Thatcher and the transformation of politics." *British Politics*, 10, 1 (April 2015): 64-78; Jane Pilcher, "The Gender Significance of Women in Power: Women Talking About Margaret Thatcher." *European Journal of Women's Studies*, 2, 4 (1995): 493-508; Stephen Wagg and Jane Pilcher (Eds.). *Thatcher's Grandchildren? Politics and Childhood in the Twenty-First Century* (Basingstoke: Palgrave, 2014).

50 C. A. Flanagan and C. J. Tucker, "Adolescents' explanations for political issues: concordance with their views of self and society." *Dev Psychol.*, 35, 5 (1999): 1198-209.

51 Held, *The Ethics of Care*, 30-32.

52 Laura Wray-Lake and Amy K. Syvertsen. "The Developmental Roots of Social Responsibility in Childhood and Adolescence." *New Directions for Child and Adolescent Development* (2011): 11-25, 12.

53 Daniel Mayton and Adrian Furnham, "Value Underpinnings of antinuclear political activism: A cross-national study." *Journal of Social Issues*, 50 (1994): 117-128, 15.

54 Held, *Ethics of Care*, 168.

55 David Featherstone, "Towards the Relational Construction of Militant Particularisms: Or Why the Geographies of Past Struggles Matter for Resistance to Neoliberal Globalisation." *Antipode*, 37 (2005): 250-271.

56 David Featherstone, *Solidarity: Hidden Histories and Geographies of Internationalism* (London: Zed, 2012).

57 See for instance: Edward S. Herman and Noam Chomsky. *Manufacturing Consent* (London: Vintage, 1994).

58 See John Street, "Fight the Power: The Politics of Music and the Music of Politics". *Government and Opposition*, 38 (2003): 113-130, 127; Nicholas Cook, *Music: A very short introduction* (Oxford: OUP, 1998); Theodor Adorno, *Essays on Music.* (Oakland: University of California Press, 2002); Theodor Adorno, *Philosophy of Modern Music* (London: Bloomsbury, 2016); Tia DeNora, *After*

Adorno: Rethinking Music Sociology (Cambridge: Cambridge University Press, 2010).

59 A choir from Scotland, of which more in subsequent street choir members' stories.

CHAPTER 3

BURSTING INTO SONG

The question driving this chapter is how street choirs emerge, sustain, develop and disappear. To begin to answer this multi-faceted question we need to understand how people organise and act together to constitute (themselves as) a street choir. So, we asked members not only about the musical skills required to maintain a street choir, but also about all the organisational competences: the treasurers and minute takers, the social secretaries and a variety of committees or working groups; the sort of stuff that usually goes on behind the scenes, beyond the public gaze.[1] We also consider all the material things that street choirs need: the banners and posters, T-shirts and costumes, flyers with information about the choir and the cause or campaign it's singing for, and so on.[2] Sheet music could be added to that list in some cases, although their use runs counter to the ethos adopted by a number of Musical Directors and their choirs. The material needs of a street choir include clothing appropriate for the prevailing weather conditions – most often cold and wet in the UK, obviously – drinking water, food, throat lozenges, and the special requirements of some members such as, for example, wheelchairs.

In this chapter too, we examine the meanings that street choirs invest in their practices, their ideas of themselves and the hopes of their members. Moreover, the songs that street choirs sing are chosen – or indeed written – by the choirs to express those ideas and hopes. So, we asked people about the songs too, those they like and those they have problems with, perhaps because of the sentiments expressed or

the technical challenge (or lack thereof) of the music. Finally, we're interested in the times, timings and spaces of street choirs: when and where they sing, for how long and how regularly.[3] Hence, we asked street choir members how they organise themselves spatially in terms of rehearsals, meetings, and activities such as away-weekends and socials. Whether and how street choir members interacted beyond singing was also something we enquired about.

SOCIAL PRACTICES

> We suggest that aspects of human and non-human relations can be *better* understood when located in terms of a more encompassing, but suitably materialized, theory of practice.[4]

A useful way of thinking about all the facets of street choirs we've mentioned is to consider a street choir in all its aspects as a social practice. Social practices can be understood as enduring *entities* reproduced through recurrent *performances* that involve recognisable conjunctions of *elements*. For example, to reproduce the practice of miners going to work in a coalmine requires a performance that includes waking, washing, dressing, eating breakfast, travelling to work etc. And, of course, this performance must be incentivised or motivated in some way: it must have meaning(s) for the worker, e.g. yield a wage, constitute an identity. Then, the performance will likely involve an alarm clock, soap, selecting appropriate clothes, food preparation, transport infrastructure…It may all sound terribly obvious, but identifying the performances and elements that reproduce any practice can be revealing.[5]

Following the work of Elizabeth Shove and her co-authors, the elements that are combined in a performance can be grouped together under the headings of 'materials', 'competences' and 'meanings'. Practices change when new elements are introduced into performances, different connections are made between elements, or elements are lost. In a study of pro-environmental behaviour change, Tom Hargreaves observes that

whether practices emerge, sustain or die out is a function of the links between elements being forged, reinforced or broken. He notes that this observation can be applied not only to forming and nurturing a practice such as street choir, but also to what we might identify as 'counter practices'. So, if we want to encourage street choirs, we might also look at discouraging practices that deter people from joining and sticking with them. Such practices may be found within the street choir itself, perhaps having auditions as an element of a wider practice of musicality but, in so doing, putting some potential new members off.[6] Counter practices could also be present in in wider society. As Claire Baker Donnelly told us in the previous chapter, for instance, practices of radical political activism may disparage street singing. Hargreaves proposes a focus on 'communities of practice and the relationships between them, because it is within these collective groupings that practices are always being negotiated and transformed.'[7] Clearly, the Campaign Choirs Network can be considered as just such a community of (street choir) practices. As a term, Communities of Practice was first coined in the works of Jean Lave and Etienne Wenger who used it to describe groups of people who share a passion for an activity that they do together and interact regularly to learn to do better.[8]

As we present people's stories, we'll look at concrete examples of materials, competences and meanings in the everyday practice of street choirs. A little confusingly in the context of street choirs we're using the term 'performance' to represent, say, the practice of a rehearsal or meeting as well as in the more familiar sense of a public performance of songs. Meanwhile, people are viewed as the *carriers* of social practices and they have agency in this regard, i.e. they can be more or less reliable or faithful. For instance, someone may fail to turn up at a meeting or street choir members may decide not to sing at a time or place which has become habit or tradition. Tom Hargreaves notes that practice theory emphasises that it is through engagement with practices 'that individuals come to understand the world around them and to develop a more or less coherent sense of self.'[9] He also argues that the identities and experiences of 'practitioners' are important to understanding how

practices are reproduced and transformed. We believe that this is an important argument for making the connection between social practice theory and our oral history research.

As elaborated by Shove et al, social practice theory is supported by a little more jargon that we needed to get our heads around before we analysed the stories of street choir members. 'Circuits of reproduction' are the ways in which practices, elements and the connections between them are generated, renewed and reproduced. What is termed a 'bundle of practices' is a loose-knit pattern based merely on coexistence and co-location. Meanwhile, a 'complex of practices' is a more cohesive, integrated and co-dependent arrangement. Think, for example, of a group of people on a demonstration who know 'We shall overcome' and sing that song together. This can be considered as a bundle of practices, a coming together of individuals who decide to protest against something, make their way to an organised demonstration, and then, at some coincidental point in time, begin or join in a song. By contrast, a Campaign Choirs Network action to support a demonstration with a combined choir will likely involve a complex of practices: collective discussion and decision-making between choirs from across Britain beforehand, liaising with the demonstration organisers, arranging places and times to meet and sing, and so on. Indeed, in August 2017, in response to an expressed collective need in the Campaign Choirs Network, Raised Voices produced a checklist guide – 'Organizing a Campaign Choirs "Big Choir" Event' – to facilitate exactly such a complex of practices. To illustrate the integration of arrangements in this complex of practices, below are some of the points taken from that checklist which refer *only* to song selection:

> 7. Next, e-mail the CC (Campaign Choirs) e-list with a list of six or eight songs your choir would like to propose singing on the occasion, with links to their lyrics, notation and music files on your own or another website.

> 8. Ask other participating CCs to vote for or against each of these songs being included on the shared song-sheet.

9. Ask them at the same time to put forward their own suggestions of other songs they would like to be included on the song-sheet.

10. Note that any choir proposing a song should be ready to provide a leader on the day who knows all the parts and is ready to lead it.

11. From these preferences, decide, not later than three or four weeks before the event, on not more than six or eight songs for the day. We find it best that they are well-known tunes, or that the main part is easy to pick up.

12. Prepare a final song-sheet and circulate it as early as possible, as an e-mail attachment to the CC e-mail list. Indicate the name of the leader against each song.

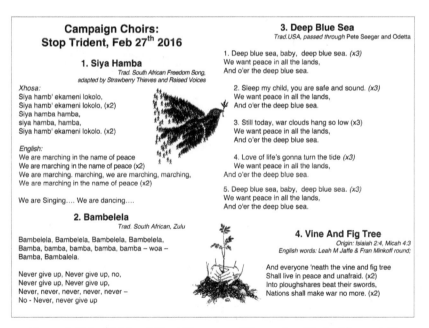

Figure 8: Take (Trident) Two! Top page of Campaign Choirs Network 'Stop Trident' songs, collated by Protest in Harmony for the demo in London 27 February 2016.

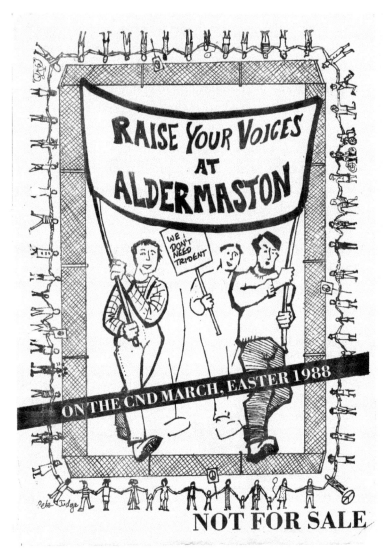

Figure 9: Sing Trident Out! Raised Voices have been organising songs for protests and demonstrations for over thirty years, as evidenced by their songbook for the 1988 CND Easter March to Aldermaston. It was a collective work organised by Raised Voices and they included a special thanks to 'Greenham Women everywhere who have created so many exciting songs and sounds, and inspired so many of us to sing out our opposition to the nuclear nightmare.' Courtesy of Julia Clark.

A quick-fire analysis of the elements in the social practice of Big Choirs just from this slice of the checklist reveals the explicit material elements involved to be a song-sheet (see Figures 8 and 9), email lists and the internet. The competences needed include being computer and IT savvy and (some people) being able to lead a combined choir. Potential participants being able to sing is also implicit, of course! The meanings entwined in this social practice are also implicit in these extracted points from the checklist: the Big Choir will be supporting the organisers of 'the occasion' and their campaign and, hopefully, entertaining and rousing the spirits of other participants; the combined street choirs will, as they do individually, also sing to reinforce the symbolic place of music in politics, specifically radical social movements. You can probably pick out other implied materials, competences and meanings in the practice of a Big Choir just from this section of the checklist. The first draft runs to 31 points, by the way, so there are clearly going to be a lot more elements in play in this ostensibly straightforward social practice.

Elizabeth Shove and her co-authors record how social practice theory is attentive to space and time: 'Since we are interested in the trajectories of practices-as-entities, as well as in the performances of which these are formed, we are interested in how the spatial and temporal reach of "working configurations" is constituted and how it changes.'[10] While subscribing to the view that political solidarity is a spatial relationship that reworks the connections between places,[11] Gavin Brown and Helen Yaffe have extended this perspective by theorising solidarity as a complex of related social practices. Elsewhere too, they argue that 'the discursive ways in which solidarity is framed politically cannot be separated from how it is performed.'[12] By way of exemplifying solidarity when it is conceived of in this way, let us consider a story from Côr Cochion. The Cardiff street choir have forged political solidarity with people in Palestine, including via singing politically on visits to that beleaguered place. Wendy Lewis, Musical Director of Côr Cochion, told us: 'A woman in the refugee camp said: "Don't just come here and look at us and go away and do nothing." And so we said, well, we've got to sing to raise money for Palestine every week. So every Tuesday there's another stalwart

group that raises money outside the market.'

So, in addition to singing every Saturday outside Cardiff Central Market for a variety of causes, those members of Côr Cochion who can make it are also committed to singing in that same spot every Tuesday, specifically in solidarity with Palestine. This expression of solidarity has its own particular symbolic meaning, demands the usual competences associated with street singing *plus* learning specific songs and acquiring knowledge of the politics of Palestine in order to be able to communicate with the public. It also requires particular material support, including a specific song-sheet, available public transport and appropriate flyers. So, it seems more than reasonable to view this performance by Côr Cochion as a social practice. It can then be seen as one of a complex of practices that constitute the choir itself as a practice.

Brown and Yaffe talk of meanings as offering 'motivational knowledge' for participation in a social practice. Elizabeth Shove and her co-authors certainly place meaning front and centre of their social practice theory. They discuss the success or otherwise of a social practice in terms of how strongly the behaviour it involves is anchored and judged normatively, i.e. as good or bad. In the light of such takes on meaning, we understand it to be an element of social practice theory that is invested with values. As such, social practice theory resonates strongly with the focus on relationships, values and practices that we outlined as the concerns of the ethics of care. What social practice theory can bring to the ethics of care, we suggest, is an attentiveness to materiality, to the infrastructures, technologies and objects that enable – or inhibit – practices of care. Returning to our driving question, let's now consider how street choirs emerge, sustain, develop and disappear as social practices.

A STREET CHOIR, APPARENTLY

We begin with some stories of the emergence of street choirs. Jane Scott is 'the conductor'[13] of Birmingham Clarion Singers. A teacher, Jane has an extraordinary history with the choir: 'My mum was a piano teacher

and my dad was a railway man and they were both members of the Communist Party, and they were founder members of Birmingham Clarion Singers in 1940.' Jane has been involved with Birmingham Clarion Singers since the age of two. At six years old she was roped in when the choir needed a child to stage a play about 'Mozart and his work in the revolutionary movement.' (The idea of Mozart as a political figure whose work was infused with radical sentiment is an enduring one in some quarters, though it is largely dismissed as 'myth' among scholars.)[14] Jane joined Birmingham Clarion Singers 'properly' as a singer at around thirteen years of age. At that point her mother had just taken over as the conductor. Apart from when she was at university in Aberystwyth, doing a music degree, Jane has been a member of Birmingham Clarion Singers ever since, taking over as conductor when her mother fell ill.

'We were actually formed by Doctor Colin Bradsworth, a Birmingham GP, who was a field surgeon in the International Brigade, and he came back from that in 1939 fired up with how he'd seen song used as a tool in that fight, in that struggle.[15] And he was determined to form a workers' choir. He stood up and announced in a Communist Party social that he wanted to do this, and that was when my parents came forward and said, yeah we'll have a go at that... It was a symbol of the labour movement, wasn't it, the clarion. I think it's most known for the Clarion Cycling Club and Clarion walking clubs, and of course there's that lovely Clarion tearoom in Calderdale, which was built for members of the Clarion clubs to walk to on a Sunday.[16] The main thing that I remember them [parents] saying about what they [Birmingham Clarion Singers] did in the war [WWII] was that they would go, in the night, to the night shifts in the factories and give performances to the workers and then go back home to bed, I suppose, and then go and do their own day's work. And they used to go and sing in air raid shelters. And, I think, particularly at that time, even just singing good honest sort of music, as opposed to music at a profit, was a political act in itself: to do that for working people.'

Morag Carmichael told us about the emergence of Raised Voices in London: 'It started in 1986 and I can tell you it was originally some singers that went along with the Big Red Band and they got fed up with

always being drowned out by the band, so they separated and became Raised Voices.[17] It started off with no musical leader, no paid musical leader, and different people used to take turns to lead.' In 2017 Chris Booth sings with Protest in Harmony, but he recalled the early years of Raised Voices: 'When I was part of it, it was completely decentralised. Everybody took a turn in leading songs, which maybe had its drawbacks, of course, as well, because not everybody had the skills. And everybody took a role in all the decision-making. Raised Voices felt like it was a really great degree of involvement in that process but sometimes it could be very, very laborious. If a song was controversial, we would discuss it and discuss it and try and come to a consensus on it. There was one song in particular where I think we discussed it for over a year before we could actually make a decision.'

John Hamilton relates the musical-political journey that led him to form Strawberry Thieves. On his odyssey John also encountered Raised Voices. On returning from two periods working as a teacher in East Germany for a total of seven years, in 1988 John went to live in Nottingham 'and heard about a political choir there, which was quite young, actually, it had only been going about seven months when I joined it, that's Nottingham Clarion Choir. And I became very active in that, and wrote songs, which we sang, and conducted some songs, and really enjoyed using song as a part of politics, and I'm still in touch with those friends in Nottingham. And then, when I moved to London to live with the woman who is now my partner, Katie, I obviously wanted to carry on singing political songs. I had heard of and met some people from Raised Voices, which is a London-based choir, and I went along to their rehearsals, but I felt there was scope for more than that choir in London and they weren't brilliantly organised at the time; I'm not meaning to be nasty... So I thought it was worth starting up a second choir, you know, a choir in my neighbourhood, and I just put some signs around in shop windows and, twenty years ago, we set up the Strawberry Thieves. It was in the anniversary [centenary] of the year of William Morris' death: he died in 1896... Strawberry Thief is one of his better known wallpaper designs. And it's vaguely anarchic and red, and so it seemed to be a

reasonable name and we thought of it for a while and it just stuck. And, especially, as our first ever gig was in the William Morris' pub [laughs] in Wandsworth near the site of his dyeing works, so it really did work out quite well.'[18]

Gay rights activist Sean Maddison Brown was born in Sheffield in 1954 and worked in the city, first as a teacher and then in Student Services at Sheffield University. Sean described the advent of Out Aloud in 2006: 'The choir came out of what was called Spring Out, which was a festival in Sheffield that brought sort of gay things together. And there was a workshop, a singing workshop, and it was from that germ that the choir established. And a number of people got together, and from the outset it was very unclear what the choir was going to be: it was just some people getting together to sing, and it's evolved into what it is now. So I don't think – well, I know – there wasn't any clear strategy of what the choir was going to do or how it was going to be or whether it was political or even whether we were going to perform...Once the choir decided to perform, which was pretty early on – it was within the first few months of the choir coming into existence, I think – immediately then it took on a political edge. Because, I think – well certainly from my perspective – you're political by just being who you are. And so the choir, if it's going to perform in public, has a political stance just by its existence. And I think we were all very conscious of that. And, although the choir can be directly political with some of the material we sing and sometimes we use music to illustrate a point politically... it's a balance between that and also enjoying [it] and having fun. So, the two things go side by side. But I think that we're very conscious that we're a political entity within Sheffield. And we very much try to raise our profile as a result of that. When we do perform we publicise ourselves as who we are.'

Diana Bianchi, who told us about the emergence of Côr Cochion, was born in Aberystwyth in 1957 and grew up in nearby Llanbedr Pont Steffan (Lampeter), the smallest university town in the UK. Diana sings with Côr Cochion in Cardiff and was a founding member along with her then husband, Tony Bianchi, and Ray Davies. Ray Davies was a doughty figure in grassroots activism in Wales, appearing in Ken Loach's

documentary film *The Spirit of '45*.[19] The founders decided to start a political choir in Cardiff 'because there had been a demonstration in London and when people were coming back on the bus…I think it was a Cymru-Cuba march. Anyway, there were some people on the bus singing political songs and all the Welsh contingent knew were hymns, and they thought, well, we've got to start something new. So that was the start of the choir, really.' Côr Cochion was always politically broad-based and not aligned to any political party, and Diana told us that it was open to all 'as long as they didn't have right wing ideas [grins]. There were five people at the first meeting, six the next and thirteen the following week. Tony Bianchi researched songs, mostly American union songs, and the first choir engagement was singing – in unison – for a Soviet friendship delegation in Newport. And then, of course, the choir became involved with the miners' strike and we collected more to our repertoire, and we were very active as well in the anti-apartheid movement.'

Street choirs, it seems, tend to start from meaning: the ideas and aspirations of an individual or group which relate to wider ideas in society. In the stories presented herein and most, if not all the stories of other street choir members whom we talked with, these driving ideas and aspirations stem from communities of practice. To name just some of the communities of practice invoked, we have Colin Bradsworth having served with the International Brigade; Raised Voices' origins in the Big Red Band; John Hamilton's involvement in a network of street choirs; and Tony Bianchi turning to the songbook of American union struggles to fuel Côr Cochion. Sean Maddison Brown reminds us that emergence isn't a one step process. Performing in public space is a distinct change of meaning from a group of people getting together to sing in private, especially if the group's meaning is political. There is a space-time relational shift in the group too as singing together in the moment becomes rehearsing and then performing publicly. The materials needed for a choir to emerge we suggest, are quite minimal, the most important initially, at least, is a place in which to meet. The competences required at first are also limited: people need to organise to meet, be able to sing or have the determination to learn to sing, and

it's useful if one or more of the group can teach songs!

In the story of Raised Voices, though, we saw how quickly more organisational skills can be required. We also got a clue as to how the connections between elements are forged differently for the emergence (and sustaining) of different choirs. While Chris Booth valorised the early democratic decision-making practices of Raised Voices, John Hamilton experienced a disconnect between democratic organisation and musical proficiency, which was part of what led him to start another choir. We should say at this point that, while retaining their collective commitment to democracy, Raised Voices have changed their practice significantly, employing a professional Musical Director from 2002 and developing a more structured decision-making process. Strawberry Thieves, meanwhile, remain ideologically opposed to money entering the material practice of the choir – they do not, for instance, pay any subscriptions and the choir does not have a bank account. They run on principles of voluntarism and mutual aid, with minimal formalisation of processes, and John Hamilton performs the role of Musical Director. Raised Voices and Strawberry Thieves retain a close relationship.

HOLDING THAT NOTE

Let's turn our attention to how street choirs sustain and develop in different ways. Having been around since 1940, Birmingham Clarion Singers stand out in this regard, but many of the other choirs also have quite long histories. To choose excerpts from these stories, we've focussed on how choirs attract and retain members and are especially attentive to welcome, community, organisation and repertoire. Each of these aspects of the social practice of a street choir brings into play elements of competences, meanings and materials.

WELCOME

So, what are the meanings, competences and materials involved in the practice of street choirs extending a welcome to new members?[20] Born in Birmingham in 1958, history teacher Ilona McCulloch returned to her home city after a spell in London. Ilona sings with Birmingham Clarion Singers and she told us what it was like coming into the choir as a new person: 'It's great because everybody was so friendly and welcoming. There are quite a few members so, even if it looked a bit daunting, it wasn't, because you're absorbed in a choir, aren't you.' Rosemary Snelgar of Raised Voices, who was born in Fareham, Hampshire, in 1953, heard the choir singing, 'took one of their leaflets and started going along… They are very, very welcoming…Quite quickly it felt…This is what I actually said to somebody: It feels as if I was coming home, which is quite an interesting experience.' *Coming home* and feeling *at home* are frequently repeated expressions among members in relation to their street choir. We note that using such terms also implies that people must have felt somehow not at home, prior to making that investment, perhaps emotionally uncomfortable and/or out of place.

The welcome given to people is part of the conscious practice of street choirs as another member of Raised Voices, Ziba Nadima made plain. Ziba was born in Iran in 1950 and came to the UK aged 25, 'just for a few months.' Well, time flies and Ziba has worked as a librarian in the NHS for thirty-five years. She joined Raised Voices in 2011: 'I went to a demo one day, about seven years ago, around this time, November December, in Gower Street, and I saw a group of people on the pavement and they're singing. So, I just went in and said: Who are you? And they said: Raised Voices. The rest is history…Actually, Cynthia [Cockburn][21] was my mentor when I came in: we do that with new members. So Cynthia very kindly took me on and welcomed me, everybody was welcoming but… Because it was a bit overwhelming, you know… But I wanted to sing, and the first question they asked me was: Politically, where do you stand? This is a socialist choir. And I said yes, this is my way of thinking and that's what I wanted. So that was it, and there wasn't really any other question

asked. I very soon felt part of the group and comfortable.'

Eileen Karmy (Protest in Harmony): 'The first time I went, everyone [Eileen pantomimes people grabbing her]. I think I was the youngest person in the room. And it was: "Why are you here? Please bring your friends!" It was really very welcome because they were really nice. And I really like it because they only sing political songs, radical songs. And also they explain, for example, before singing or before learning songs, they explain what this is about… I've learned a lot.'

Though choirs are generally welcoming and many organise elements of their practice to be so, joining a group as a new member remains daunting in many aspects. Born in 1972, George Askwith had a strict religious upbringing as a Jehovah's Witness in Pembrokeshire. Having only moved to Sheffield in 2015, George, as far as she remembers, Googled 'something like "gay Sheffield"' and found Out Aloud. Because the choir limits its numbers, George put her name down on the waiting list and then joined in September 2016: 'I found it hard initially because the choir's been going for ten years, so they have this vast back catalogue. And, um, having to suddenly learn an awful lot of stuff was quite difficult. I've got a pretty good ear, but not necessarily a good memory.' All the choirs we visited have extensive and constantly evolving repertoires and a number of people whom we interviewed were intimidated by that, at least initially. People also commented on the difficulty of learning songs in different languages, as many choirs explore and express international solidarity via their choice of songs. While it puts some people off, several street choir members reported that they actively enjoyed rising to the challenges, musical and linguistic.

Relatively new to Strawberry Thieves, having joined just nine months before our interview, Harriet Vickers revealed another potentially daunting facet of joining a choir with an established culture: 'I think it can be tough for new people to come into because everyone's very open and there's a lot of strong-willed personalities in there… Stuff is debated pretty openly. I think decisions have been dragged a bit towards one – er – kind of camp or the other just depending on how dominant they are in the choir, which is hard to get rid of, but I think people are…

I've never seen anything be particularly unfair, it's just that you have to shout about it if you want them…We do do some rough minutes. It's fairly democratic…I really liked it, coming into it. A lot of it was to do with how many strong women there were, because other groups that I've gone into, there has been a lot of men sounding off, but there were a lot of challenging women challenging things that were said.' Harriet's story begins to blur the – admittedly imaginary – line that we set up between our consideration of welcome and community in street choirs.

Maxine Beahan of Protest in Harmony explains how group cultures can deter new arrivals, albeit perhaps unintentionally: 'So, it was just like a complete freedom moving here [to Edinburgh from Queensland, which Maxine found politically repressive]. But kind of getting into political activism [generally, rather than explicitly with Protest in Harmony] was a little bit difficult as well, because sometimes you'd go along to a meeting, but, because you weren't from the place, people weren't always very inclusive or they didn't trust you because you didn't have the right accent. Or they'd say things like: "Oh, we'll meet at teatime," and you didn't quite know when that was, or where the places were. So, it took me quite a while to get involved in anything very much.'

The practice of welcome by street choirs involves a range of materials from the introductory flyer or 'business card' handed out on an action to giving new members access to songs on the printed page or via various internet platforms. Meaning can be communicated explicitly, as in Ziba Nadima's introduction to the politics of Raised Voices. However, meaning is also implicit in Raised Voices' use of the mentor system to care for new members. A number of street choirs employ the practice of mentoring. Some of the newer choirs, with perhaps more links to the global justice, peace or environmental movements than to socialist traditions, term the practice a 'buddy' system. Members of Protest in Harmony reported using the affinity group and buddy systems when participating in a Campaign Choirs action at a big demonstration in London, for instance. Welcome, of course, also involves embodied knowledges, social skills if you will, which are employed to put new members at ease. Unfortunately, we did not get to interview people who had not stuck with a street choir,

but members report that they suspect the choir's extensive repertoire of songs and/or a group culture that might be experienced as 'cliquey' are likely explanations for why some people are deterred. When we discuss community, we'll consider economic deterrents to participation in street choirs. Meanwhile, Harriet Vickers' interview makes it clear how impossible it would be to tailor community to everyone's taste. Harriet was happy with, for instance, having to shout to be heard in Strawberry Thieves' decision-making process. Saying this, we don't want to represent Strawberry Thieves as excessively confrontational. Our experience with the choir is that strong wills are matched by big hearts, and they are a very welcoming group.

COMMUNITY

We now turn our attention to the practice of community *within* a street choir, or rather within the social practice of a street choir. To avoid confusion, we are not now talking about communities of practice, whereby practices of singing and/or politics are linked to others in time and space. In a sense, what we're concerned with here is the extension of welcome over time. There are many ideas of what community means that circulate in society and which are dissected by various branches of academia.[22] One traditional view is of community as a group of people living in a particular place that may, through sharing space over time, exhibit common characteristics such as dialects, attitudes and practices. Recalling Maxine Beahan's experience, community viewed thus can be either inclusionary or exclusionary, whether by accident or design. This traditional view of community is under pressure due to major social, political and cultural changes in the world: changes most often summed up under the rubric of 'globalisation'.

We do not want to lose that sense of place nor an awareness of the local communities that street choirs are embedded in because it is evidently important for many of the singers we know, including those we have interviewed. For instance, Janet Bennet (born in Stockport in 1951) of

Liverpool Socialist Singers told us: 'Liverpool is quite a political place, you know. That was another thing I enjoyed about coming to Liverpool. Because I sort of fitted in with the place and the people. I think Liverpool is like a huge village in that everybody seems to have a connection. I never go more than ten, fifteen yards before bumping into someone I know. Liverpool has this wanting to help people, there's more of that; it's not just a socialist thing…People, whether they realise it or not, a lot of people are socialist in their personality.'

Community as people in place isn't our main focus here, however. Rather, we concentrate on community viewed as shared political consciousness and collective action. Clearly, this overlaps with our understanding of solidarity. Although this is certainly a major part of how members define their street choir-as-community, what we're more interested in is how people inhabit the space of the street choir itself: how they relate to one another, support one another, resolve – or not – tensions. In short, we are interested in how the members of street choirs practice care for each other. If community retains an 'essence' through all scholarly attempts to pin it down, that essence is 'belonging.'[23] We've already mentioned that some members regard their street choir as home, arguably the ultimate space generally associated with belonging.[24] Like welcome, fostering community in a street choir requires meanings, competences and materials.

With reference to the ethics of care, we would stress that it also requires work: 'To be a caring person requires more than the right motives or dispositions. It requires the ability to engage in the practice of care, and the *exercise* of this ability.'[25] We may join a choir with the intention of doing politics and singing rather than engaging in caring relationships, but then 'many of the relationships in which we find ourselves entangled are ones we did not choose but simply found ourselves in.'[26] Once we are in a group we will develop relationships involving levels of responsibility, trust and support. Inevitably, not all the relationships that we develop will be equal. The ethics of care recognises both unchosen relationships and those between persons of unequal power. When we engage in relationships with others, Diana Meyers observes, 'people share in one

another's joys and sorrows, give and receive care, and generally profit from the many rewards and cope with the many aggravations of friendship, family membership, religious or ethnic affiliations, and the like.'[27] Held notes that a person as a moral agent is 'always already embedded in relations with flesh-and-blood others and is partly constituted by these relations.'[28] By this account, then, to some extent *how we exercise care defines who we are.*

Genuinely caring relations must be two-way: mutuality is key. Gavin Brown and Jenny Pickerill consider space for emotion in activism, finding that affective relationships in groups can be undervalued by activists' single-minded pursuit of political agendas.[29] Virginia Held proposes that 'we need moral evaluations of relations, not just dispositions. And we need moral recommendations for whether to maintain, change or try to break them.'[30] Held reasons that a caring person will seek to transform relations to make them more (mutually) caring. She also acknowledges that caring relations can feature a large degree of mutual autonomy. So, caring requires both being sensitive to the feelings of others *and* taking action. One could push the wheelchair of a fellow street choir member on a demonstration without any sensitivity to the feelings of that person or any intention of seeking their well-being: One could, for instance, do it merely to impress other people, for self-aggrandizement. On the other hand, the person who tries to be caring but who is instead selfless to the point of servility, becoming a martyr, is not in a caring relationship because that would demand both mutual and self-respect.

Jane Bursnall: 'If a choir is working well, it becomes like an extension of your family. I think Red Leicester has always been a tightly-knit choir, that's always been my impression, but it absorbs new people in and they become part of the family fairly quickly…I know that when somebody is having difficulties, whether it be health difficulties or personal difficulties, I do know that the choir rallies round, and I do feel part of that…Because we sang together so often, and would go out on the streets together, and we'd go to Street Choirs Festivals together and Raise Your Banners together, a choir comes together and they come together more than the normal. You do become emotionally attached to each other. So, you

have a support system there. And because people are accepting you, whoever you are, that support system is there whoever you are. I think that's remarkable' (See Figure 10).

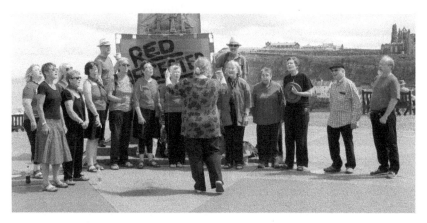

Figure 10: 'Beside the Seaside'. The dramatic backdrop of Whitby Abbey provides a magnificent setting for some passionate alfresco busking by Red Leicester Choir at Whitby Street Choirs Festival, July 2015. Credit: Gillian Spraggs

When she lost her job and was feeling low and in poor health Lowenna Turner turned first to her choir, Côr Cochion: 'And I just got messages of support and people saying: come on, come out on the street, we haven't seen you in weeks, you need to come and do something and you'll feel better...It's lifting each other up and taking care of each other. It's, it's a strange family unit. When Meic [a choir member] was ill in November, he was in hospital. I got a lift half-way to the hospital from one of my colleagues and he was: "Aw, are you seeing a family member, is he your uncle?" And it was: "No, but if I could have picked anyone to be my uncle, it would have been him."'

A member of Côr Gobaith born in 1946 in London, Ruth Owen told us: 'There are parties, and they go to the pub, but I can't go to the pub, because it's too loud [laughs]. So, personally, I don't know people as well as I'd like to, but there are one or two I know well. We do socialise within the town. If you live near somebody, they might drop in for a cup of tea.'

[Interviewer: If somebody has problems, like health problems, has there been mutual support there?] 'Yeah, I have, it's very complicated, but they have tried to help me…Yes, oh yes, I think people are supportive, there's always a card if someone's away for a while or they are ill. And I have noticed, and it's lovely, we've got people who don't come at all often because they've got other responsibilities – some who came when they were students and now they've got families – but if they see us on the street they will stop and have a sing. And I think that's quite nice, cos it's always there.'

Returning to Red Leicester, Charlotte Knight told us about her choir's relationship with one of its members, Martin: 'What was very difficult was singing at Martin's funeral last year. There were two things about that… The inspiring one was singing in his back garden when he was dying. He was in Glenys' house, he'd moved to her house, and he was in bed in her living room. And he didn't know we were going, and we just turned up and sang in his back garden and it was lovely. That was really hard for obvious reasons. We all walked in and he said goodbye to us all. It was the most amazing experience. He was a man who just was able to die really well…I've never met anyone who has done it as well as Martin did…The fact that he could kiss us all goodbye and we knew that was what was happening: it was extraordinary. And then we sang at the crematorium, literally, what, only two or three weeks later, when he died. So, all that was very moving and very hard and very significant.'

Finally here, we can ponder just how community is forged and reproduced through the collective practice of singing together. At an affective level, is there something powerful in the way we feel harmonies and resonances in our bodies when we sing in a group? While we street choir singers might be tempted to answer, 'Duh, obviously!', the musicological jury is still out on emotions and meaning in music. Adam Ockelford, for example, concludes his study of how we make sense of music thus: 'a piece of music is not an absolute thing but a somewhat fuzzy set of experiences…it is in music's fuzziness that its charm lies; it is the very imprecision of its message that ultimately makes a piece of music, as an object of human interpretation, interesting, sustainable

and enjoyable.'[31] Specifically on singing together, Oliver Sacks notes the 'emotional power' of music to transform patients who sing together from being 'torpid', expressionless and many of them 'virtually speechless': 'Together' is a crucial term, for a sense of community takes hold, and these patients who seemed incorrigibly isolated by their disease and dementia are able, at least for a while, to recognise and bond with others.'[32] However, bonding and community aren't the inevitable result of people singing together. The overarching question driving our project is, in essence, how the street choirs can develop individually and, especially, together as a social movement. When we come to address this, we non-musicologists will have to do our level best to take into account the affective power of music on ourselves as well as on our audience and especially potential new members therein.

ORGANISATION

Turning our attention to how street choirs organise, we observed and recorded many variations in practices. Although it is by no means a straightforward thing to analyse, we can at least say that the material 'intrusion' of money into the relationships in a street choir matters. Most street choir members pay a subscription, Strawberry Thieves being a notable exception. Again, most street choirs pay for a rehearsal space, for example in a community hall or college. Some find venues for free, however, for instance in a member's home, a flexible (or oblivious) institution or a community café. Choirs mainly choose rehearsal spaces on the grounds of affordability and availability, but for some there is a connection with the choir's history or politics. There is, for instance, clearly meaning for the choir in Red Leicester's choice of the Secular Hall, which is associated with a civil society campaign 'for an inclusive and plural society free from religious privilege, prejudice and discrimination.'[33] Charlotte Knight told us: 'The Christians in the group may feel a bit squashed occasionally. I mean, it's never been a big issue: we've never fallen out that I'm aware of. And I guess they choose to

come to the secular choir because they have political views that are similar to ours.'

Strawberry Thieves, Côr Cochion, Côr Gobaith and Birmingham Socialist Singers have members who serve as unpaid Musical Directors or conductors. While Jane Scott and Nest Howells are adamant about being members of their choirs who also happen to lead and both refuse payment, Birmingham Clarion Singers and Côr Gobaith have both employed musical leaders in the past. Some choirs subsidize their unpaid Musical Directors to attend training courses and the like in lieu of payment. Sheffield Socialist Choir, Out Aloud, Raised Voices, Liverpool Socialist Singers and Red Leicester all pay their Musical Directors at professional or union rates. In the case of Raised Voices, we've seen that having a paid Musical Director wasn't always their model, however. Protest in Harmony is the only choir we talked to which is treading what might be precarious middle ground, though everyone seems happy about the arrangement with three 'song leaders' who share the responsibility and rotate. Elaine told us: 'They are paid. They're paid, frankly, a nominal amount. You know, you couldn't actually call them being paid for the time they put in, but they're paid for the session that they do. I mean, it just doesn't reflect the hours that they put in…We [the committee] have had discussions with them about: "Oh, you don't even get the minimum wage! This does not fit with our ethos." But they've been very clear that it's not about that.'

At some point during their rehearsal most street choirs will make space for a meeting, which is usually kept relatively short and varies from choir to choir in formality, for instance whether there is a chair/ facilitator or minutes are taken. Typically, choirs will discuss their upcoming gigs and members will flag up political and musical events likely to be of interest to others. In some cases, these meetings overlap with a refreshment break with, variously, cups of tea perhaps and/ or sharing biscuits or cake. It is at this point in proceedings that we expected Campaign Choirs Network initiatives and actions to be discussed but found, as yet, quite low awareness among street choir members. Each street choir has one or two Campaign Choirs Network

'reps' responsible for passing information back and forth. But how do choirs understand themselves in relation to a network of other street choirs? How might reps engage better and become more proactive in the Campaign Choirs Network? Street choirs hold a variety of other meetings: in many cases an Annual General Meeting, and in some cases topic group meetings, notably song selection and song writing groups. Reflecting their choir's acute consciousness of place, it seems, Liverpool Socialist Singers combine local street names, 'Catherine Percy Huskisson', from the Georgian Quarter of the city in which they meet to rehearse, to credit the authorship of their collective compositions. Choirs who host the annual Street Choirs Festival typically appoint a bespoke organising group. Some choirs have committees with elected officers and they hold bank accounts. Several choirs reported that the role of treasurer is hard to fill. The most contentious choir group we heard of was Out Aloud's costume committee, which some members dub, at least half-jokingly (we think), 'the style police.' Out Aloud are renowned among street choirs at the annual festival for their most often startling costumes, as well as their always brilliant singing (See Figure 11).

To sum up on organisation would be impossible, but we enjoyed these quotes from members of two choirs, both of which function very effectively. We asked: How is the choir organised, how do you make decisions? At the word 'organised' Lowenna Turner of Côr Cochion bursts out laughing: '[Interviewer: You laugh?] Um...sometimes very democratically as in we will over-discuss it. There was an incident I hear legend of, where there was...a big language discussion going on in the choir. And, in the middle of a protest, they were sat on the floor, and they had to have a vote as to which language they were going to sing in, Welsh or English.[34] So, when we make these *Life of Brian* jokes, we do mean it: it's ridiculous. I haven't seen anything quite that ridiculous, but sometimes we do vote on points I would think very minor, which isn't necessarily a bad thing. If we're for democracy, we're for democracy. But we probably put far too much on Wendy [Lewis, Musical Director], I think we do...Herding cats is Wendy's favourite expression [laughs],

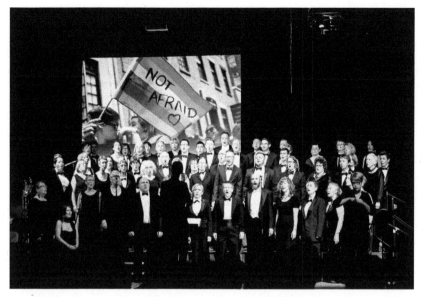

Figure 11: 'Not Afraid!' Out Aloud outfits have memorably included Hawaian shirts for Aberystwyth's seaside and Dracula-inspired vampire attire in Whitby. Here they appear in grand style at their 10th Anniversary concert at the University of Sheffield Octagon Centre in May 2017. Credit: Nelly Naylor

but when we get organised and we get everything right, it works and it's fabulous… Sometimes I think if we had a little more willingness to organise, we'd have a little more direction. But I don't know that we need a lot of direction. I think I like the simple basis of: what are we gonna sing for? Well this is a problem, let's go and sing for that. OK, great: posters, leaflets, let's sing. Done! It doesn't have to be complicated.'

Andy Dykes of Sheffield Socialist Choir told us: 'We have, probably once a year, a songs meeting where people can identify particular issues or things that they maybe want the choir to be involved with, whether environmental or Palestinian or whatever. Yeah, and then on the back of that they might come with some suggestions from our back-catalogue for those of us who've been involved a little while, or, we're very fortunate to have Janet [Wood] as our MD [Musical Director], because she is writing stuff. And we're also adapting traditional music and re-writing

the words, like where something else happens and the fracking song,[35] like our version of 'Jerusalem'[36]...When I first joined I thought: this is a very sort of collegiate way of operating and it almost felt...I'm used to somebody who waves the stick in my past, and then being in control. And this was a case of joining a group where everybody had the opportunity to input, which I think works very well...There's a committee in the background that meet independently maybe once a month. Four or five people get together and talk about choir stuff. There's somebody who holds the gigs diary; there are a couple of people who work on the website...Sometimes, I'm sure, Janet will go to those meetings as MD, and sometimes the committee will just meet because it's administrative choir stuff.' Andy facilitates certain social events that take place during the year, usually at somebody's house: 'I'm the designated mojito maker, as a fundraiser: I learned that in Cuba [on choir visits]. Yeah... it's a family in some sense, um, of like-minded people who support each other, are there for each other outside of the choir, but also who do lots of social stuff together as well.'

Generally, street choir members develop caring relationships and do 'social stuff' together. Apart from going to the pub post-rehearsal, as sections of a number of choirs that we visited do,[37] we heard of choir-based walking groups, reading groups, running groups, spin-off singing groups and lap over choirs, notably San Ghanny choir,[38] which draws members from Protest in Harmony and which has been to sing in Palestine. To conclude our discussion of organisation, we note that one common material challenge is always economic inequality. Some people cannot afford to go to street choirs festivals, away weekends or even to the pub after rehearsals. Street choirs try to address this inequality via both formal and informal subsidies, but there seems to be a persistent problem of establishing a meaning for 'subsidy' that is satisfactory to all. Some street choirs know that members have been lost because they could not afford to continue attending and/or felt uncomfortable with being subsidised. Another aspect of this economic inequality is child-care, with some street choir members unable to participate in activities due to such family commitments. Clearly, it can be a similar story with care

of elderly relatives. Moreover, disabled street choir members and those simply feeling the effects of age are sometimes excluded from trips and actions, albeit unwittingly. While it may be difficult to extend care beyond the confines of the physically active membership, street choirs might consider the meanings, competences and materials that could facilitate more equality of participation.

Maxine Beahan: 'In the early days when my children were younger, it was a bit harder to do things. I would tend to be able to get to the rehearsals but then very rarely go to the other things. But I always wanted to, and I quite often put them in my diary, but couldn't quite manage. But sometimes I'd drag them [her children] along with me.'

Steph Howlett (born Harwich 1951): 'Around the time I decided to leave (Sheffield Socialist Choir) for a while the choir was going to Cuba and there were a number of us who just couldn't go – we were single parents. Um, and all the effort of the choir was going towards this event that sounded really exciting. And we couldn't go and couldn't be part of it, and that felt really hard. So, it wasn't that I didn't want them to go, but that was one of the things that propelled me towards: well, maybe it's time for something else?'

In future, street choirs may want to consider the 'intrusion' of money into their social practices. They may want to reframe the sort of future that many members desire via practising a part of that future in the meantime. In tune with an ethics of care, reframing for a diverse economy means: 'imagining the economy differently. It means taking notice of all the things we do to ensure the material functioning and well-being of our households, communities, and nations. It means finding ways of framing the economy that can reflect this wider reality. In such a reframed economy we might imagine ourselves as economic actors on many different stages – and as actors who can reshape our economies so that environmental and social well-being, not just material output, are addressed.'[39] Peter North writes: 'If we trust the other members of our community, and our trust is borne out in practice, we can create money as long as we don't create too much of it in comparison with the real resources we want to share, and work we want to facilitate.'[40]

REPERTOIRE

Turning our attention to repertoire, let's consider the songs that choirs choose to sing and how that affects their ability to sustain. We've seen already how extensive repertoires can be off-putting for new members. Meanwhile, musically and linguistically complex and diverse repertoires may either attract or deter members, depending on their personal competences, resources to rise to the challenges, and the support they receive from the choir. But what about the songs themselves? We're interested in the political meaning – lyrical and musical – attached to songs in the social practice of street choirs. When we asked street choir members about their favourite songs, we received almost as many different answers as the number of people we interviewed. And it was much the same story with least favourite songs, although people came up with fewer of those. It would be impossible, therefore, to compile a 'Top Ten' or conversely to give some songs the *Juke Box Jury* label of 'Miss!'[41] It's more informative, we believe, to listen to the people who told us about the meanings they attached to songs.

Let's begin with Elaine and the song we chose for the title of this book: 'In the early days of Protest in Harmony, it's the first time I'd learnt "Gentle Angry People."[42] And I just adored singing that and it did make me cry. It's that real sense of…I mean the arrangement's lovely that we have, anyway. So, there is a bit about how, musically, something touches you… But… The things that I like singing the most is the message that says we are all in this together, and "Gentle Angry People" does that. You know, saying we are all here together, "we are gay and straight together:" I mean that just demolished me the first I don't know how many times I sang it.'

Describing her Jewish American parents as 'liberal Democrats,'[43] Leni Solinger sings with Sheffield Socialist Choir: 'I guess Plegaria [*Plegaria a un Labrador*] is one of all of our favourites, we love it. It was a Víctor Jara song and we learned it oh so many years ago, and we've always loved singing it. We're very attached to that song. We sang it in Cuba every time. It's very meaningful in Cuba…We were invited to speak at a trade union congress in Havana, an international one, and we sang that song

and the Chilean delegates got up and waved a flag. It was so moving!'

Diane McKinlay was born in Dundee, spent her teenage years in North Wales, moved to Sheffield to go to university and stayed. Diane retired in 2014, which was when she joined Sheffield Socialist Choir after seeing them perform along with a Cuban choir. She told us her story of singing with Sheffield Socialist Choir at a May Day rally in Chesterfield, an annual choir commitment: 'The first time I went on it and stood on a stage, with my [choir] T-shirt on, singing "The Internationale," having retired as a headteacher six months before, was a really special moment for me, cos I thought: I wouldn't have done that 6 months ago…That is a political statement from me: that I'm prepared to stand up on stage and raise my fist and sing "The Internationale"; and for me that was a going back to the values moment…Liberating, really liberating!'

Particularly active in the Campaign Choirs Network, Dee Coombes was born in Liverpool in 1948 and sings with Liverpool Socialist Singers: 'I don't like crude politics. I like songs that are inviting people in to do something somehow: that are giving them an idea about how they might resist or how they might change things. And also there's celebrational songs, like "Rosa's Lovely Daughters,"[44] which are saying "yes you can resist and yes you can change things." I much prefer that to songs that are ridiculing anything, because they may be fun for a moment, but what they don't do is take people on to another idea, another way of doing things… Anger is really important because it does generate change, but it has to be directed into something beyond anger…Making people laugh is fine, but the best songs make people laugh *and* think.'

Harriet Vickers: "One thing that really struck me when I joined the choir is how they [the songs] are really straightforwardly powerful. So with like "Danse des Bombes"[45] [laughs] I mean it's quite violent but it was…I think it was really refreshing to say things that simply but that strongly, which I guess is what music and songs are like…[There's] something great about short, direct songs that get a message across. There's some great women's ones as well. There's an Italian one called "Cinturini," which is basically about weavers demanding respect. I like the feminist ones…That's the other great thing about learning songs:

I've learned so much history.'

Perhaps the main theme to emerge from our interviews about choirs' repertoires was solidarity. In the stories presented here we have solidarity across divides of gender and sexual identity, solidarity with Cuba, with the working class, and feminist solidarity. Other interviewees also cited solidarities when discussing their favourite songs, notably international solidarities with Palestinians, South Africans under Apartheid, and the disappeared in Chile and Mexico. Diane McKinlay's story illustrates how important the personal freedom to express political solidarity in public is to the individual. Reading her story, you can feel the relief and the joy of that liberation. Diane's story also highlights a counter social practice in public service life in the UK, whereby people are denied and perhaps also deny themselves that freedom of political expression. Another theme in the stories we heard was commemoration, which can often be viewed as a historical expression of solidarity. Some notable commemorations in the stories we heard were of the Spanish Civil War, Greenham Common, Hiroshima and Nagasaki, and all victims of war, but especially conscientious objectors.

Dee Coombes was one of a number of interviewees who commented on both the cathartic and problematic qualities of anger and violence in song lyrics. Dee also picked up on other common and contested threads in our research into songs: propaganda versus lyricism, and the use of humour and parody. On propaganda versus lyricism first, Harriet Vickers' story exemplifies the pedagogical power of song – recall, too, Eileen Karmy's story: at its best, song can bring politics, history and geography to life, seeding questions in the minds of the audience. However, some street choir members registered dissatisfaction with the sort of songs that Martin Vickers (born Oldham 1962) of Strawberry Thieves labelled 'preachy.' Conversely, Moira Harbord (born Dublin 1948), also of Strawberry Thieves, commented: 'If it's got a message, it could be really quite a boring song, but I'd still want to sing it.' In this vein, Chris Norris was one of a small but enthusiastic group of people from various street choirs who championed songs by Bertolt Brecht and Hans Eisler: 'We do a couple of Brecht-Eisler songs, which are absolutely

terrific, I think, and which were designed for street singing, which are maybe a bit didactic for some tastes.'

Considering the use of humour and parody raises another issue that divided street choir opinion: re-writing the lyrics of well-known songs to represent contemporary causes. Some choristers believed catching the ear with a recognisable melody was a good way to get people to listen to the words. Andy Dykes: 'there's almost like a raised listening if somebody hears a tune that they know and somehow there's different words to it, they almost sort of like: What are they singing? Why are they singing like that? So I think, like the fracking song [to the tune of "The Laughing Policeman"] if we can hook into things that are there and rewrite the words for our purposes: that's sometimes as good as coming up with something that's completely, you know, from a blank sheet.' Other people had a number of criticisms of such a tactic, however. First, melodies and not just lyrics carry meaning, so a passer-by could hear the melody of 'Jerusalem' and assume the street choir was conveying a religious or even nationalistic message. Another objection is that rewriting songs that carry historic meaning, that indeed commemorate, is a travesty, almost a secular form of sacrilege. Wendy Lewis: 'I'm sorry, [but] "Bella Ciao"[46] is so well known I don't want to squeeze some English words into it… I'd rather sing the original.'

Apart from using well-known tunes to carry new messages, a kind of musical 'retconning,' another reason for street choirs re-writing lyrics is when songs have religious words or are historically or culturally invested with prejudices, notably sexist, racist or homophobic sentiments.[47] Generally, street choirs police songs in terms of, for want of a less jaundiced term, their 'political correctness', either discarding or re-writing those with any offensive lyrics. These matters are seldom without controversy. In an uncompromising stance against a masculinist valorisation of violence, for example, Côr Gobaith changed the lyrics of Billy Bragg's 'Internationale', re-writing the line 'When we fight provoked by their aggression' as 'When we *sing* provoked by their aggression.' The same choir debated whether songs with reference to an earth goddess were any more acceptable than other religious references, which Côr

Gobaith avoid. Without wishing to label Côr Gobaith as pedants, the choir does take the issue of meaning seriously and so, for instance, debated and changed the lyrics of 'Singing for Our Lives' from 'We are gay and straight together' first to 'Lesbian, gay and straight together' and later to 'LGBTQ and straight together' to better reflect diverse sexuality. Political inclusivity and lyrical scan-ability are not always easy bed-fellows!

Among the favourites of Welsh and Scottish street choir members were songs that expressed a sense of internationalism, anti-imperialism, oppressed nationhood or the desire for independence. Sung by both Côr Cochion and Côr Gobaith, Dafydd Iwan's 'Yma o Hyd' (Still Here) celebrates the survival of the Welsh nation over centuries and against the odds. Hamish Henderson's 'Freedom Come-All-Ye', which Protest in Harmony sing, is an anti-imperialist song expressing hopes for freedom, peace and friendship.[48] However, as Chris Booth told us: 'The one thing that we didn't sing about as Protest in Harmony was the independence issue, because I think there were people taking both sides on that. There was an independence choir started up, which was something separate from Protest in Harmony, and it was clearly, clearly separate.' Among all the street choirs that we know, Côr Cochion have experienced the most internal tension with respect to attitudes towards nation and language. At one point, some people left to start another choir at least partly because they were unable to reconcile their international socialist views with sustaining a regard for the politics and culture of Wales. Somewhat ironically, Côr Cochion has gone on to forge many relational solidarities with international socialist groupings. We note the difference between contested views of nation and how place is regarded on the municipal scale, where many street choirs proudly celebrate the city or town they are from and its culture without controversy.

Returning briefly to the topic of humour and parody specifically, street choir members were divided on the efficacy of the tactic. In part, the choice of songs to effectively convey meaning depends on the space of performance. For example, a sit-down concert audience is much more likely to listen long and closely enough to 'get' a satirical lyric or the ironic use of a tune. When singing on the street, most of the audience will catch

only a snippet of a song, and so subtleties of meaning are likely lost. So, the relation between song selection and space is, to borrow a phrase, a matter of 'horses for courses'. Raised Voices clearly appreciated this when they put together the guide checklist for Big Choirs. They also highlighted another aspect of song selection that street choir members mentioned in interviews, namely choosing at least some songs that the audience can join in with: 'We find it best that they are well-known tunes, or that the main part is easy to pick up.' As a number of interviewees noted, songs circulate in the network of street choirs with one choir adopting a song from another, an evident effect of communities of practice. Finally on song selection, a number of interviewees noted the need for variety in a street choir's repertoire, to both keep the audience entertained and the choristers stimulated. With respect to one song in the repertoire of Birmingham Clarion Singers, Annie Banham voiced a common concern heard in our research: 'if you hear it once, great. But we did it to death a few years ago, and don't want to hear that for a long time.'

We'll leave the final word on repertoire to Dee Coombes: 'It'd be really good if there were more really melodious protest songs being written. And I would really like to see peace songs and anti-nuclear songs that weren't so dated, cos there's only so many times you can listen to things to the tune of "Daisy-Daisy." It just makes me want to curl up in a ball and disappear in a corner somewhere. There's a real need for that to happen. People aren't writing enough protest songs at the moment. Or we're not hearing them.'

DEVELOP

Evidently street choirs do change over time, their memberships swelling and sinking somewhat as people come and go. Repertoires, too, vary as new songs are adopted, others maintained, some lost, some actively discarded, and some reclaimed. One change that is always significant for street choirs is when an Musical Director/conductor/song-leader leaves for any reason and has to be replaced. Similarly, it can be a problem

for choirs that lose their rehearsal space. Overall, though, from the oldest choir we visited, the venerable Birmingham Clarion Singers, to upstarts like Liverpool Socialist Singers, the social practice of street choirs demands a fairly predictable and quite static arrangement of the elements of competences, materials and, arguably, even meanings. The practice is also made predictable in terms of the demand on space and time. Hence, street choirs tend to emerge and sustain rather than, say, grow exponentially, diversify their practice radically, or make major spatial shifts. Some street choirs did report developing stagecraft and movement as well as their singing skills. Others were making themselves more visible with bespoke banners. None of the choirs we talked to had made fundamental shifts of meaning, however. In 2017, both Raised Voices and Strawberry Thieves were debating whether or not to include 'socialist' in their choir names. The parameters of embracing a progressive politics beyond LGBT rights and identity politics is also an issue for Out Aloud. One obvious development for all the street choirs we talked with was, of course, their (hopefully) burgeoning involvement in the Campaign Choirs Network.

DISAPPEAR

In our research we conducted a single interview with a former member of a choir, Velvet Fist, which had disappeared in as much as the members no longer constituted themselves as a choir nor practiced singing together. As noted in our Introduction, Velvet Fist was a socialist feminist women's *a cappella* choir active in London form 1983 to 2013. The choir originated in an arts project by the Communist Party. Although Velvet Fist were clearly a political choir, they performed on the street only at protests, notably right from the time when bands and choirs came together in the Street Band and Street Music Festivals (see Figure 12) and at the later Street Choirs Festival, where busking is part of the schedule, albeit voluntary. The normal practice of Velvet Fist was to perform at events such as fundraisers for peace, socialism, women's or human rights

campaigns. The choir was paid for some of the gigs they sang at.

Lesley Larkham was born in Oxford in 1965 and conducted Velvet Fist from 2005 until she left the choir in 2012. Lesley told us that the choir was once very present and popular on the left-wing political scene: 'Tony Benn was a great fan of Velvet Fist,' introducing them at a Stop The War rally as 'a wonderful choir.' On her decision to leave the choir and Velvet Fist's disappearance thereafter, Lesley explained that the demands of her day job had become too much and that her health has suffered. She felt unable to give the choir her full attention and so withdrew: 'I did use to give it my all, but in the end it was just quite exhausting and I felt I wasn't able to give my all to it. Having said that, I think the choir as well was starting to wind down, or rather wasn't as effective as it might have been once…In a way it came to a logical end…In its form it wasn't serving what it had been – the function it had been before.' Though Velvet Fist tried to adapt to changing times on the political left, Lesley concluded that they: 'just weren't getting the gigs.' Velvet Fist was always a small choir with no more than a dozen members at any one time. They maintained a high musical standard and auditioned prospective members. Velvet Fist was democratically organised, and Lesley told us about the special dynamic of the choir: 'Friends have mentioned, from watching things like *The Apprentice*, how women fight and don't know how to get on. It's interesting when you are with a group of progressive women, it's a whole different thing: it's a transformative thing. I think women have a real power, they have a real strength about them as a collective, and I always loved that about the choir…What you saw in Velvet Fist was a way forward, where women work well together and can really sing with, literally sing with, one voice and there's a real power in that, real strength in that.'

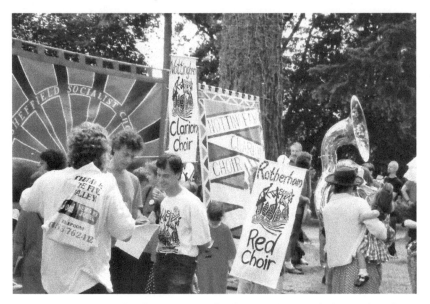

Figure 12: Brassed Off? Gaenor Kyffin from Velvet Fist believes this photo is 'from the Street Music Festival that took place in Stroud in 1995. This is the last time I remember the bands and choirs together.' Credit: Velvet Fist

In terms of social practice theory, Velvet Fist's disappearance can be seen in terms of the circuit of reproduction involving the practice of Velvet Fist as a political choir: there were shifts in some of the elements that constituted that practice, namely of competences and particularly meanings. As Lesley Larkham told us, her own forced withdrawal from Velvet Fist, that loss of the vital competence of the conductor, coincided with a seeming shift in the practice of a particular left-wing politics.[49] For those singers and choirs with a background in or an association with the Communist Party, we can only speculate on how geopolitical events such as the fall of the Berlin Wall or the collapse of the Soviet Union might have impacted on the 'meanings' they attached to their political singing.[50] Judging by Velvet Fist no longer getting enough gigs, some left-wing political groupings do appear to have shifted in the meaning that they previously attached to the choir. We can hazard that choral singing was no longer viewed as such a significant part of the struggle: the practice of Velvet Fist may have ceased to be entertaining, empowering

practice of Velvet Fist may have ceased to be entertaining, empowering or otherwise meaningful. In any event, as the connection between the practice of the choir, its elements and other practices weakened, the circuit of reproduction was evidently broken.

Shove et al state that the primary value of social practice theory is simply that it is a different way of framing how the world is understood and how problems are defined.[51] Throughout this chapter we believe that this different way of seeing has helped us to get a fresh perspective on street choirs, to see them (ourselves) with fresh eyes.

MATERIALS:	COMPETENCES:	MEANINGS:
The actual stuff that we use when we're doing something, e.g. objects, infrastructures, technologies.	*What people know how to do: e.g. embodied skills, know-how, techniques*	*Ideas, aspirations, symbolisms, and values. The significance of a practice and how it relates to wider ideas in society; whether the practice is seen as empowering, entertaining, confrontational, calming*
Music stands, sheet music, drinking water, throat lozenges, songs, money (subscriptions, donations etc.), rehearsal space, performance space, internet, social media, email lists, T-shirts and other costumes, song-sheets, posters and flyers, transport, banners, telephones and telephone-trees, chalk, marker pens… AGMs, weekly meetings, away weekends, workshops etc.	Teach and learn by ear; possibly read music; sing in tune; breathing; possibly movement/ performance skills. Musical Directors, Song-writers, singers, costume committees, publicity, banner and sign makers, buddies, event organisers, 'techies' – from sound engineers to IT experts, chair persons, treasurers, secretaries…	Non-violence; peace; social justice; equality; environmental sustainability; mutual respect; welcome (e.g. to refugees and asylum seekers); inclusivity; publicly owned social services; universal health care; social housing; demilitarisation; nuclear disarmament; diversity; anti-racism; anti-fascism; freedom; solidarity… Appreciation; creativity; entertainment; stimulation; challenge; pleasure; sense of belonging/ home/connectedness/ community; humility; friendship; responsibility; mutual aid; unity; care; self-respect/confidence; political and artistic self-expression; empowerment; inspiration; joy; learning/ openness; sense of purpose; humour; perseverance/ resilience; courage; tradition; connection to radical history.

Table 1 (left): The Social practices of a street choir

In Table 1, we've attempted to summarise the materials, competences and meanings in play in the social practice of street choirs. What we are *not* trying to do is to claim that every street choir whose members we interviewed has in their practice *all* the materials, competences and meanings that we have presented. Again, it's extremely unlikely that any single street choir or any member thereof is imbued with *all* the elements of this agglomerated social practice. Particularly in the instance of meanings, we are even aware of members of street choirs who explicitly told us they did not share an aspiration or value that we have listed. As a concrete example, one interviewee told us they did not place much stock in the concept of peace. The meanings we've listed in Table 1 are arbitrarily divided into, first, those that relate most to public space and others that we associate with the more private space of the choir and its individual members. These points and caveats noted, we feel that, at least, most of the street choirs whose members we interviewed could largely pick themselves out in Table 1. In Chapter 6 we'll return to mull over the various points that we've noted in the course of this chapter and, indeed, everything that we've learned herein about how street choirs emerge, sustain, develop and disappear.

ENDNOTES

1 Andrew D. Davies, "Assemblage and social movements: Tibet Support Groups and the spatialities of political organisation." *Transactions of the Institute of British Geographers*, 32, 2 (2012): 273-286.

2 See, for instance: Jason Dittmer, "Geopolitical assemblages and complexity". *Progress in Human Geography*, 38, 3 (2014): 385-401.

3 See for instance: Doug McAdam and William H. Sewell, "It's about time: Temporality in the study of social movements and revolutions." In *Silence and voice in the study of contentious politics* In: Ronald R. Aminzade et al (Eds.) 89-125 (Cambridge: Cambridge University Press, 2001).

4 Shove et al, *The Dynamics of Social Practice*, 10.

5 See for instance, Andreas Reckwitz, "Toward a Theory of Social Practices." *European Journal of Sociology*, 5, 2 (2002): 243-263.

6 In the strictest sense of the concept, a social practice is broader than what is done by any individual choir: a social practice is singing in the streets, it is not how a particular street choir arranges their rehearsals.

7 Tom Hargreaves, "Practice-ing behaviour change: Applying social practice theory to pro-environmental behaviour change." *Journal of Consumer Culture*, 11, 1 (October 26, 2011): 79-99, 96.

8 E.g. Jean Lave, "Situating learning in communities of practice." Perspectives on socially shared cognition, 2 (1991): 63-82; Étienne Wenger, *Communities of practice: Learning, meaning, and identity* (Cambridge: Cambridge University Press, 2000).

9 Hargreaves, "Practice-ing behaviour change," 83.

10 Shove et al, *The Dynamics of Social Practice,* 11.

11 E.g. Doreen Massey, "Geographies of Solidarities." In Doreen Massey et al (Eds.) *Material Geographies,* 311-362 (London: Sage, 2008); Featherstone, *Solidarity.*

12 Gavin Brown and Helen Yaffe, *Youth Activism and Solidarity: The non-stop picket against Apartheid* (London: Routledge, 2017); Gavin Brown and Helen Yaffe, "Practices of Solidarity: Opposing Apartheid in the Centre of London." *Antipode,* 46 (2014): 34-52, 7.

13 Jane rejects the term 'Musical Director'.

14 E.g. Peter Culshaw, "Mozart was a political revolutionary." *The Telegraph.* 03 Jul 2006. http://www.telegraph.co.uk/culture/music/classicalmusic/3653580/Mozart-was-a-political-revolutionary.html. Accessed 18 August 2017. See for instance William Weber, "The Myth of Mozart, the Revolutionary." *The Musical Quarterly,* 78, 1 (1994): 34-47.

15 Doctor Colin Bradsworth served for two years on the Republican side during the Spanish Civil War. He was part of the medical team for the Canadian section of the International Brigades, the MacKenzie-Papineau. On his return to Britain, he was the founder of a Birmingham branch of the Socialist Medical Association.

16 Formed in 1894, the Clarion Cycling Club is still going strong https://clarioncc.org/. The homepage of the Clarion House (tea room) website records (in August 2017) the gathering there in July 2016 of the UK's four Clarion Choirs from Birmingham, Bolton, Nottingham and East Lancashire http://clarionhouse.org.uk/index.htm. The Clarion Movement grew out of the influential socialist newspaper *The Clarion*, which was founded by Robert Blatchford and published its first edition on 12 December 1891. https://radicalmanchester.wordpress.com/2010/08/11/the-clarion-movement/. Accessed 18 August 2017.

17 Still going, the Big Red Band describe themselves as 'A bunch of reds who play traditional socialist marching music on demonstrations and protests'. https://www.facebook.com/thebigredbandlondon/

Accessed 19 September 2017.

18 The Victoria and Albert Museum profile William Morris "textile designer, artist, writer, and socialist" http://www.vam.ac.uk/page/w/william-morris/. Accessed 19 September 2017.

19 'Red' Ray Davies obituary https://www.theguardian.com/uk-news/2015/jun/24/red-ray-davies-obituary. Accessed 19 September 2017.

20 See for instance: David C. Ogden, "The Welcome Theory: An Approach to Studying African American Youth Interest and Involvement in Baseball." NINE: *A Journal of Baseball History and Culture*, 12, 2 (2004): 114-122.

21 Cynthia Cockburn is a feminist researcher and writer, associated as honorary professor with the Department of Sociology, City University London, and the Centre for the Study of Women and Gender, Warwick University. Her most recent book is *Looking to London: Stories of War, Escape and Asylum,* published by Pluto Press (2017).

22 See for instance Gerard Delanty, *Community* (London: Routledge, 2003).

22 Delanty, *Community.*

24 See for instance: Yi-Fu. Tuan, *Cosmos And Hearth: A Cosmopolite's Viewpoint* (Minneapolis: University Of Minnesota Press, 1999); Alison Blunt and Robyn Dowling, *Home* (London: Routledge, 2007).

25 Held, *The Ethics of Care,* 51.

26 Held, *The Ethics of Care,* 50.

27 Held, *The Ethics of Care,* 47.

28 Held, *The Ethics of Care,* 47.

29 Gavin Brown and Jenny Pickerill. "Space for emotion in the spaces of activism." *Emotion, Space and Society*, 2, 1 (2009): 24-35.

30 Held, *The Ethics of Care,* 52.

31 Adam Ockelford, *Comparing Notes: How we make sense of music* (London: Profile Books, 2017), 296.

32 Oliver Sacks, *Musicophilia: Tales of music and the brain* (London:

Picador, 2007), 344-345.

33 Leicester Secular Society http://leicestersecularsociety.org.uk/aboutus.php. Accessed 19 September 2017.

34 See Polletta, *Freedom is an endless meeting.*

35 "You won't be fracking long" to the tune of "The Laughing Policemen" with words by Marie Walsh of Côr Cochion with some adaptations by Catharine Percy Huskisson (Liverpool Socialist Singers).

36 "In David's Big Society" by Sheffield Socialist Choir to the tune of 'Jerusalem', music written by Hubert Parry https://www.youtube.com/watch?v=aZ5MPMXE59o. Accessed 19 September 2017. There is also an anti-fracking song to the tune of "Jerusalem" with words by Simon Welsh, written for protest at Balcombe in 2013.

37 In some cases this practice could be a barrier to involvement for people who do not drink or who don't like pub culture, and – as we have seen on occasion in our own choirs – for people who cannot afford to go out drinking. On the other hand, many people will find going to the pub – an often taken for granted practice on the British political left – to be an incentive to join a street choir.

38 Edinburgh-based San Ghanny ("We shall sing" in Arabic) Choir first came together for a visit to Palestine in 2012 and has been acting in solidarity since then.

39 See J.K. Gibson-Graham, Jenny Cameron and Stephen Healy, *Take Back the Economy: An ethical guide for transforming our economies* (Minneapolis: University of Minnesota Press, 2013), 24. Also Gerda Roelvink, Kevin St. Martin and J. K. Gibson-Graham (Eds.) *Making Other Worlds Possible: Performing Diverse Economies* (Minneapolis: University of Minnesota Press, 2015).

40 Peter North, *Local Money: How to Make it Happen in Your Community* (Cambridge: Green Books, 2010), 1.

41 Readers of a certain age may need to Google 'Juke Box Jury'. Other search engines are available.

42 Widely known as "Gentle Angry People," the song's title is actually "Singing For Our lives."

43 Where "liberal democrats" clearly has a quite different meaning in US context of the 1940s than it does in contemporary Britain.

44 "Rosa's Lovely Daughters" was written by Robb Johnson, a contemporary British political song-writer, and features on his 2000 album "Margaret Thatcher: My Part In Her Downfall." It is a celebration of women's struggles internationally, not sacrificing the poetic for the prosaic or didactic.

45 "Danse des Bombes" is a revolutionary song composed by Michèle Bernard and based on a poem written by Louise Michel during the Paris Commune de Paris in 1871.

46 A song of the Italian anti-fascist resistance movement from WWII. Composer unknown, "Bella Ciao" sung to a traditional folk tune.

47 For readers who aren't fans of comic books and the multiple universes that writers create for some characters, to retcon is to revise some aspect of a plot retrospectively, typically via introducing a new piece of information that suggests a different interpretation of previously described events. The technique is also used in film and TV.

48 Dick Gaughan's Song Archive notes on "Freedom Come All Ye" http://www.dickgaughan.co.uk/songs/texts/freecaye.html Accessed 19 September 2017.

49 We note that many other street choirs are inundated with requests to sing from a variety of left-wing and progressive groups, including notably trade unions, People's Assembly groups opposing austerity, and local campaigns defending public services.

50 See for instance: Raphael Samuel, *The Lost World of British Communism* (London: Verso, 2006); Evan Smith and Matthew Worley (Eds.) *Against the Grain: The British Far Left from 1956* (Manchester University Press, 2014).

51 Shove et al, *The Dynamics of Social Practice.*

CHAPTER 4

HARMONISING

Music has always been a way of expressing dissent and strength when there is little other way to do it. From the chain gangs, slaves and mine workers to rastas and rappers, from punk rockers to peace ballads, trade union brass bands to the New Song movement, music and dance has been key to building social movements.[1]

Focusing on how street choir members relate to one another and to the wider world, in this chapter we consider street choirs, specifically the Campaign Choirs Network, both as a social movement and as part of wider social movements. In that context, what we're most interested in is how emotions are in circulation in and around street choirs. We're intent on stories that reveal the reach of care, from the personal and proximate to distant others in space, time and materiality. We ask people about their choir's networks and solidarities, their campaigns and causes. Our interviewees share with us their best and worst experiences with their choirs, both musical and political: inspiring and frustrating moments, deflation and exultation. And they explain more about the relational and emotional whys and wherefores of their favourite and least favourite songs. To help us frame and illuminate people's stories, we'll begin by introducing a few useful terms and concepts from studies of social movements.

SOCIAL MOVEMENTS, CULTURAL ACTIVISM AND CONVERGENCE SPACE

There is a rich and voluminous academic and activist literature on social movements.[2] Despite the many theories and empirical accounts of social movements, however, this fascinatingly fluid topic can never be signed off as 'done and dusted'. Social movements tend to be evolving constantly, not least in response to the tactics of the institutions that they set themselves up to transform, changing technology and shifts in society.[3] So, however we set out our theoretical stall, we don't expect to fully and neatly accommodate the street choirs that we engage with. Surprise-surprise: 'Social movement is not a clearly defined or well agreed upon category for collective action and organising for social change'.[4] However sketchy and contested it is, however, we still find social movements to be a very useful frame within which to consider the characteristics of the Campaign Choirs Network. Political geographer and peace and justice activist Sara Koopman brings a space-relational focus to a relevant summary of academic work on social movements, spotlighting solidarities and emotions. Koopman necessarily leaves hanging a range of questions about the scale, relationality/connectivity, effectivity, organising structure and commitments on violence or non-violence that might 'define' a social movement. She also problematises social movements' relation to electoral politics and to formal constitution and payment of staff. In addition to the 'social movements' designation, Koopman points out that researchers variously consider political groupings as: 'networks, grassroots groups, NGOs, contentious, collective, or connective politics'. Rather than seeking to make further distinctions, Koopman argues for making more connections between people studying political groupings under such labels. In conclusion, she expresses the hope that researchers will pay more attention to how groupings think about themselves in the world.

In Chapter 1 we discussed the Campaign Choirs Network commitment- as evidenced by its practices – to eschewing formal structure, set roles and responsibilities, and certainly hierarchy. We also touched on the Network's vexed but seemingly unavoidable relationship with money.

Via our vocabulary we've let slip already that we view social movements as a way of 'doing politics', of seeking social change in opposition to the values and practices of the state and/or corporations and/or society at large. Although, as we've indicated, any definition could be restrictive, as something concrete for us to *work around* rather than *fix to*, the *Encyclopædia Britannica* helpfully describes a social movement as a 'loosely organized but sustained campaign in support of a social goal, typically either the implementation or the prevention of a change in society's structure or values. Although social movements differ in size, they are all essentially collective. That is, they result from the more or less spontaneous coming together of people whose relationships are not defined by rules and procedures but who merely share a common outlook on society'.[5]

Having begun to set out our analytical stall, we'd like add to our study of the Campaign Choirs Network as a social movement the dimension of 'cultural activism'. We consider cultural activism as strategic creativity in forms such as fine and public art, political theatre, carnival and, of course, music and singing. Once again, it will come as no surprise to readers that 'culture' is yet another slippery customer. Definitions range from UNESCO's 'the set of distinctive spiritual, material, intellectual and emotional features of a society or social group' to writer Aimé Césaire's more succinct but even more daunting 'everything'![6] For our purposes, we're pleased to note that UNESCO's definition of culture goes on to include 'value systems' and 'ways of living together'. Cultural activism, meanwhile, is defined by Michael Buser and Jane Arthurs as 'a set of creative practices and activities which challenge dominant interpretations and constructions of the world while presenting alternative socio-political and spatial imaginaries in ways which challenge relationships between art, politics, participation and spectatorship'.[7] Further, performance activist Jennifer Verson believes that: 'An insurrectionary imagination is at the heart of cultural activism. It is a sense of possibility. Insurrectionary imaginations evoke a type of activism that is rooted in the blueprints and patterns of political movements of the past but is driven by a hunger for new processes of art and protest'.[8] Our project was originally sub-titled

'the *future* life histories of the street choirs', and people's visions of the future remain a key tenet of our research interests.

Analysing the Campaign Choirs Network as a social movement, we will be attentive to relational space, solidarities and emotions in people's stories. In the realm of solidarities, we are acutely aware of Routledge and Cumber's view of social movements as extended networks of place-based struggles. In this regard, 'militant particularism' and 'convergence space' can be helpful concepts. Militant particularisms we can consider as place-based struggles that have resonances beyond the local. Such struggles may then engage with others on the national and even international level. Convergence space denotes spaces in which militant particularisms interact, where people engaged in related struggles learn from each other and form solidarities.[9] We can consider the Campaign Choirs Network as working to construct convergence spaces for the militant particularisms of street choirs. Such space may be at a meeting during a Street Choirs Festival or via electronic technologies and virtual spaces of interaction that thereby facilitate national actions such as 'Big Choirs' or 'Rise Up Singing'.

SOLIDARITIES, EMOTIONS AND MUSIC

David Featherstone defines solidarity as 'a relation forged through political struggle which seeks to challenge forms of oppression'.[10] At its heart, Featherstone contends, solidarity has unity of thought and feeling, common interest and mutual support, all of which combine to drive collective action. Solidarities are important in the construction of relations between places, activists and diverse groups. Moreover, they are constructed *in* as well as *between* sites. A vital practice of the left, solidarities can be forged from below by marginal groups. They can transcend national borders and power relations. That is, solidarities can be formed between groups in different nation-states who are not equally subject to exploitation or oppression. Thereupon, one group can exert 'pressure from without' on behalf of the other, often via economic

strategies such as boycotts. Featherstone notes that solidarities are 'inventive', capable of reconfiguring political relations and spaces. As social relations, solidarities are diverse and dynamic, able to change over time as they serve to politicise and foster mutual understanding between and within groups. Crucially, then, solidarities are more than goal-based politics. Featherstone's use of terms such a 'constructing' and 'forging' reveal a vital aspect of solidarities: they are a practice produced and reproduced through attentive *work*. Solidarities are embodied and passionate, involving physical and material support. They mobilise emotions and values, for instance shame, anger and justice. From an avowedly partisan position, Featherstone concludes that 'solidarities can be a powerful force for reshaping the world in more socially equitable and just ways.'[11]

Echoing Featherstone's theorising, anthropologist and social movement activist David Graeber claims solidarity as 'the ultimate working class value'.[12] And solidarity, he reasons, stems from caring. Drawing heavily on feminist theory, Graeber contends that working class people care more *about* others than do the bourgeoisie. Via empathy, they also care more *for* others. Compellingly, this would mean that working class people actually care about (and so perhaps for) those who exploit them. Most of the work that people do, specifically the working classes, is not actually industrial production but caring for other people. The left, Graeber concludes, needs 'to think seriously and strategically about what most labour actually consists of, and what those who engage in it actually think is virtuous about it.' Activist, organizer and political theorist Leah Hunt-Hendrix traces the history of the idea of solidarity and conceptually locates it firmly in the realm of social movements, concluding that it signals 'a path between the twin threats of atomistic individualism and statist collectivism. Solidarity expresses a desire for new kinds of collectivities, in which individual freedom and the common good are reconciled'.[13]

Brown and Yaffe emphasize that solidarities are not only forged between, for example, a choir in Cardiff and a group of people resisting oppression in Palestine, but potentially also between that Welsh choir

and a choir in Edinburgh with similar links: solidarities move not just back and forth, but also laterally. Sara Koopman discusses the emotional work involved in 'the spatialities of solidarity', i.e. in forging, maintaining and strengthening these multifarious relationships. Fernando J. Bosco considers solidarity as an emotion alongside others such as love and outrage, claiming that social movements grow via the mobilisation of such emotions in their networks. Paul Routledge is similarly concerned with the emotional dimensions of activism as constituent of a potentially liberating intervention in political performance.[14]

Apart from the strategic mobilisation of emotions, though, Brown and Pickerill note the need to make space for emotions that are key to caring for proximate others and for the self *within* social movements.[15] These authors argue that 'emotional sustainability' in social movements requires emotional reflexivity, which means consciously creating space for emotions in activism, especially those that can be difficult to acknowledge and to manage. We note that 'burn-out' and trauma have been acknowledged among some activist groupings as 'legitimate' manifestations of emotional exhaustion.[16] However, social movements are not always good at making space for emotions, positive as well as negative, both individual and collective, that do not fit strategically within a political campaign, or indeed within certain conceptions of solidarity. Here we interject to observe that street choirs commonly attract people who need particular care that the wider community, including the state, is failing to provide. Amid a generally acknowledged crisis in services in the UK, mental health is a notable area where street choirs, doubtless in common with other community groups, are playing an active role in supporting people. That observation made, Brown and Pickerill note that an ethics of care *can* be missing from conceptions and practices of social movements. Crucially vis-à-vis our project, they highlight the vital concept of prefiguration with respect to emotions in social movements: if we are going to be the change we want to see in the world, that includes looking after one another's emotional needs, and indeed our own, in the here and now.

There is a wealth of writing on emotions in social movements, a good

deal of it attributable to sociologist James M. Jasper. In 2011, Jasper reviewed twenty years of theory and research on emotions and social movements. In summary, he noted that:

(i) Not all emotions work the same way

(ii) A single appellation can encompass multiple emotions (there are, for instance, numerous different types of 'anger')

(iii) Emotions are not irrational - 'feeling and thinking are parallel, interacting processes of evaluating and interacting with our worlds'

(iv) Emotions constantly interact with each other

(v) Emotions can both help and hurt protest movement mobilisations and the achievement of their goals.[17]

Jasper presents a 'crude typology' of emotions according to how they are felt and how long they last. *Urges* are bodily impulses like hunger, thirst and fatigue; *Reflexes* or reflex emotions are quite rapid, 'automatic' responses such as fear, rage and joy (commonly considered as *being* emotions); *Moods* are longer lasting feelings, negative or positive, that can energise or enervate (moods can extend into the territory of temperament, for example from despair to cynicism); *Affective orientations*, allegiances, commitments or loyalties are relatively stable feelings, such as trust and solidarity, which are closely linked to values, and on the other side of the coin, distrust and antipathy; *Moral emotions* or sentiments include the likes of compassion, outrage and pride, and are based on moral intuitions and intimately linked to cognition.

Although urges and reflexes are vital in in activism, as they are in other aspects of everyday life, it is the longer lasting and relatively stable emotions that interest us most when we review stories from street choir members, especially Jasper's affective orientations and moral emotions. There are more complex and even contradictory analyses of 'affect' and 'affects', particularly in the context of politics. A number of authors argue that affects are more fleeting and unstable than emotions, visceral shifts in feelings and sensations rather than lingering moods or orientations.[18]

With regard to music, Jasper notes its 'mysterious influence' on moods.

Brown and Pickerill obsrve that the influence isn't always mysterious. It can, indeed, be located and strategic: 'Music, especially that created by activists themselves, can help transform places – from one of official parliamentary politics and organised marches to one of new rhythms, dance, joy and alternatives'.[19] Brown and Yaffe spotlight the joyous and rousing work that singing can do, lifting the spirits of people in social movements and unifying them, as in the following example from a non-stop picket of the South African embassy in London during the apartheid era:

> The practice of collective singing brought picketers together. It helped activate the Picket when energy was flagging, providing focus and impetus to keep going with the political work of petitioning, fund-raising and engaging passing members of the public in dialogue. If the Picket was under threat from police intervention or fascist attack, choral singing could help cohere the Picket as a collective, so that it was better able to defend itself against attack. Singing songs from the struggle against apartheid was itself a form of solidarity, a means of spreading a political message and symbolically sharing a culture of resistance with those resisting racist rule in South Africa.[20]

In the passage above, the interactions between urges ('flagging'), reflexes ('under threat', fear), moods ('impetus', energising, optimism), affective orientations ('cohere', affinity) and moral emotions (the compassion and outrage that caused the picket to assemble in the first place) are all very clearly in play.

Both social movements and those opposing them consciously seek to mobilise emotions and the emotional connections between people. From Jasper's typology, the main target of such tactical interventions would be affective orientations, though we remain acutely aware of the constant interaction with more transitory emotions. This means that such feelings may be stable, but they are not static. Noting 'affinity' as a key emotional and organisational principle, Nathan Clough writes: 'the

particular emotional-affective couplings that social movements create as an aspect of oppositional consciousness building and mobilisation require as much attention as the other organisational and tactical forms that movements build'.[21] Clough notes that 'convergence spaces' are where affective relationships can be forged and affinity built. Here we observe that a street choir might be considered as an affinity group with a defining modus operandi, similar to the case of local 'battytallions' of the Clandestine Insurgent Rebel Clown Army who come together for international actions:

> Affinity groups are small, semi-independent groups of like-minded-activists (they may live in the same neighbourhood or have similar political or aesthetic tastes) which typically coordinate their actions with other, similar affinity groups. Coalitions based on affinity groups are inherently more difficult to direct and control than more centralised forms of organisation.[22]

Moving on to moral emotions, Jasper asserts that when we do the 'right thing' we are driven by emotions and it feels good. Notice here that we can have emotions about our emotions, for instance we can feel pride at our outrage or shame about our anger. Moral emotions, Jasper contends, are necessarily social. It is changes in power relations, whether those in which we are directly implicated or those of others, that often trigger emotions. Emotions that follow from a sense of compassion, outrage or condemnation are common motivations to engage in politics, serving to impel one through daunting obstacles. The vertiginous sensation of a 'moral shock', where the world is shown not to be as one thinks it should be, frequently leads to action.[23] Via the feelings associated with a moral shock – horror, indignation, outrage – our moral emotions are intimately tied to our sense of justice. Revisiting the ethics of care, Held believes that, as 'the more basic moral value', 'caring relations should form the wider moral framework into which justice should be fitted'. Resonating with Jasper's perspective on moral emotions and 'doing the right thing', the ethics of care 'appreciates the emotions and relational capabilities

that enable morally concerned people in actual interpersonal contexts to understand what would be best'. [24]

FESTIVALS, GATHERINGS AND NETWORKS

Our interviewees told us about attending Street Choirs Festivals as well as other choir gatherings, including Raise Your Banners, the *Rencontres de Chorales Révolutionnaires*, Strawberry Thieves' 'Chants for Socialists', and Sheffield Socialist Choir's one-day singing workshop to celebrate the legacy of US labour activist Joe Hill. Some members of Sheffield Socialist Choir also told us of the 'conglomerate choir', Northern Lights, which they formed with other choirs from the North of England in 2003, inspired by their visit to Cuba. We understand that Northern Lights was set up to avoid all the energies of Sheffield Socialist Choir being focussed on a future visit to Cuba that not all members would be making. A few of our interviewees commented, too, on their impressions of and experiences with the Campaign Choirs Network. Some of the stories we heard are presented below, including people's more negative observations, their positive stories, and a number of nuanced accounts. In truth, the majority of the stories people told us about gatherings, particularly the Street Choirs Festival, were nuanced. We don't want the reader to think that anyone's critical remarks reproduced below were all that they had to say. Likewise, with the most positive accounts that we've picked out. The stories we've selected focus less on organisational and musical aspects of street choir gatherings, rather, in the context of this chapter, we sought out stories that featured relational aspects of people's political experiences, where solidarities, relational space and emotions were in play. What follows is a good number of stories that we decided to let flow before sticking our analytical oar back in.

Martin Vickers: 'I enjoy doing them [Street Choir Festivals]. They're not as political as I'd like them to be. I've only done a few of them, six or seven in total. They tend to be a bit... They stay off dangerous topics...Oh what's the mass singing? "Oh well we're all happy together, we're having a happy time..." I don't go for those sorts of songs. And

they're nice, but they haven't really got a context, and they're not political at all, generally. So, I'm not really a fan. At Leicester [2016]... This was an opportunity. I mean, Red Leicester are actually quite political, but the mass singing songs...Nothing political about them at all. And even when the choirs were on stage in that venue [Curve] even some of the images were vetted, they weren't allowed to show [them] because the venue said you can't show those images. I think you get that when you have a venue that's, say, council controlled.'[25]

Andy Dykes: 'It [Street Choirs Festival] certainly seems to have become less political, which I think is a shame, but then I wouldn't want to deny people the opportunity to come together and sing for the joy of singing. And if they want to do that without the politics, then that's fine. And, as I said earlier, maybe we need to capture the fact that we've got a message to put across and here's a golden opportunity at Street Choirs [Festival] to do it.'

John Hamilton: 'The street music festivals that I have been to in the last fifteen years, it's only been about three, have been so rushed; rushed affairs and no communal time. And the massed sing: a lot of the massed songs have not been very exciting, I feel. They are lowest common denominator, probably, something that everybody will be happy to sing, so that not very challenging musically or politically...The last time we went was Brighton [2008], until this year in Leicester, because Brighton is very close, so we just went for the day, we didn't sleep there. And, in fact, the kind of thing we wanted to organise,[26] if we'd done it, and we didn't do it, is very much what we found here in France.[27] It's cheap: 110 Euros for all the food and drink for the week, you know. Yeah, you have to get here, but there's lots and lots of time for mingling, as you know, and for just singing casually, both formally and casually. We love it!'

Nest Howells: 'When we hosted Street Choirs Festival [Aberystwyth 2013] that was inspiring; so much hard work. There were a few disagreements, but everything worked out...In the preparation stage, some people dropped out, but it pulled us together and gave us a sense of achievement in the end. Most people were involved in doing something. We were smaller then. [It] certainly pulled us together, made people

appreciate what others had done. Small group, all amateurs, but [we] did it with help from the Arts Centre and the Met Office [because the festival was blessed with warm and sunny weather]!'

Lesley Larkham: 'The Street Choirs [Festival] we regarded as progressive, something which you wanted to support, and it was also a vehicle for meeting other choirs, making contacts, making your contribution to whatever was happening.'

Pat Richards: 'We ran Street Choirs [Festival] ourselves [Aberystwyth 2013]. I was one of the people who voted not to do it, but I ended up doing masses! It was loads of work, but a brilliant weekend. We made it as political as we could. We took peace as our theme. Oddly, I phoned up CND and said do you think Bruce Kent would come to our festival, she said, "I'll give you his phone number." He came…He opened it on the Friday night. Then we had our peace parade.[28] We wanted to move it – we had some concerns about Street Choirs – the softer edge, we wanted it to be more political…If Raise your Banners still existed, then I think people would have less feeling that maybe Street Choirs [Festival] is a bit too soft, too poppy, sort of. There are lots of choirs you can sing in, and I think the Street Choirs [Festival] should look back at its roots a bit more, perhaps, see where it came from, and that it is a political movement, or was. I'm not so keen when it's show songs, or whatever. But then you've got that big moment with Out Aloud, for instance: they sing all kinds of songs, but it's definitely political.'

Val Regan: 'Certainly when the Street Choirs Festival came to Sheffield [2010] that was amazing. That really felt amazing, because there just felt like a huge sense of solidarity… It was lovely to just gather together with all those people in *our* city, it felt so important… It was an important moment in just sort of saying 'we belong' in something, in a movement bigger than us.'

Charlotte Knight: 'I love the Street Choirs Festival. And again I was very nervous about going the first year. I was still feeling very, very bad in myself [following a bereavement] and the idea of going to Sheffield – I think it was Sheffield the first one. Sue [also of Red Leicester] was very supportive of me then. I went very

tentatively, and very anxiously, and ended up loving it, you know… The mass singing. I love that. I think the best, for me, was Hebden Bridge this last summer [2014], because there's something about the songs we were singing, they were just very powerful, very moving songs. And when you hear – I don't know how many of us that were there – six, seven hundred people probably? All singing so well, you know. Aah! Just magical, really. Really lovely.'

Ian 'Onion' Bell: 'I really enjoyed the weekend [2016]. Again it was pretty exhausting, but again it's that empowering thing to be out with so many people singing the same song. I really enjoyed the concert, hearing all the different choirs. The massed sing was good, it was the bit I was waiting for, so many people out singing together. But the concert was really good, seeing the variety that came out, from all the different choirs.'

Chris Booth: 'It's a great fun weekend. It's really interesting to meet all these other choirs and to hear what they're singing. I think it's become less political choirs. Certainly the last year I was at there were a lot of community choirs there that, you know – it's good to sing, whatever – but it didn't have that political focus. There were maybe only, sort of, five or six choirs that see themselves as having that political element.'

Andrew Wilcox: 'I loved it. It's a really great event. It's really good fun. I like the busking… I enjoyed the Hebden Bridge one a lot, actually, it was nice. And it was a nice small venue, the hall we were singing in… Although I think we made a big… I think we might have fucked one of the songs up!' On the issue of some forms of political singing Andrew noted: 'Particularly in Brighton, I think it was… I'm just going to say it… there were a lot of Choirs, it struck me, singing about oppression in other places, particularly in Africa and stuff, who weren't from those experiences… I think there's a tension between singing about things that are experienced and aren't experienced. That particular time, it slipped over to feeling it was quite long and quite worthy.'

Elaine: 'I think that's one of the things about Protest in Harmony, we tend not to do what I would consider a formal gig. So, when we're seen standing on a stage at Street Choirs Festival, that's not often our usual habitat, at all. It's quite rare for us to be on a stage singing…We've sung

on the top of buses at the beginning and end of marches or at the side of something, you know, just sort of in a huddle, but it tends not to be that formal: "We are standing in front of you and singing…" Sometimes I get it a bit muddled up with Raise Your Banners, which has kind of come and gone and come back, and I think it's resting at the moment, which had a very clear kind of…you know, it was a political song festival…So I've been less aware of its history and what's it's about. And I'd kind of made an assumption that it was political because you were on the street: so why were you on the street, kind of thing? And I've been part of the various debates about it. So, I've heard from some people who believe it kind of was more political before. I'm not sure it has a terribly strong political flavour. I think it depends on who's hosting it, actually. Because there's been some very strong political street choirs, and some where people have been singing nice things but on the street.'

Steph Howlett: 'I suppose I've always felt – maybe from going to the choirs' week at Laurieston – very much part of a national network of campaigning choirs. And, you know, it's a time for meeting up and seeing what other people are doing and getting inspired…I love the mass sing, actually. And that rehearsal…When you've got this hall full of people: it just gives you that oomph! So, I love the mass sing, but I like all of it, really, and meeting up with people. And I know some people find the big concert absolutely interminable, especially if there are several choirs singing the same song, but I actually really like it. There's some choirs you really look forward to every time.'

Cynthia Cockburn: 'It's a very good thing that it happens. It's a good thing that it's growing and not fading out. It's a good thing that Campaign Choirs [Network] has come out of it. I do think that you need to address the question of community choirs and their popularity. They are growing faster than ours are growing. That's what the [increasing] size of the street music festival is responding to. The way I would sum up the difference is that community choirs' message is: "come together and sing, it's good for you; singing's good for you, coming together to sing is good for you." Whereas the street choirs might well feel that, but what they're saying is: "Singing is a good way to get a political message across, let's get out

and do it." I do think that there is something very draining about the community choirs' involvement within the Street Choirs Festival, that it does tend to drag the politics out of it.'

Annie Banham: 'So to me that's key, really, that there's all these like little disparate groups but we're all working in the same direction, so that to me is the important bit and the political, um, direction as well, particularly where we are at the moment. It's so important that people know there's a voice out there and that they hear that voice. I think the more that the campaigning choirs can do to push that out there, the better... I think it's good to feel you've got this whole force behind you at times. Sometimes we forget that, don't we? We're all in our little groups and then suddenly: hang on a minute, we're also in the same thing, really, yeah. I think that's really powerful. It really struck me in Whitby [2015], when we did the mass sing there, just looking out – I mean, Whitby I know really well from childhood – to kind of see this mass of people was phenomenal, and the same at Aberystwyth. And just sort of the power of that is just amazing. And if you can channel that in the right way, I think that touches people a lot more than straight political speech...Singing...gets to people's hearts, which to me is so important.'

Although organising the Street Choirs Festival, or indeed any of the gatherings we've discussed, inevitably puts emotional strains on a choir, the experience does seem to build solidarities within the group and indeed laterally as the hosts liaise with other choirs through the process. Generally, people attending the Street Choirs Festival for the first time are more positive about it than seasoned attendees. As Elaine pointed out, the designation as a *street* choirs festival and the habitual inclusion of singing in *the street* in the programme does not automatically qualify the convergence as a political space. Meanwhile, a tension between solidarity and representation, particularly across cultures, was noted by Andrew Wilcox, and we'll discuss this at the end of the chapter.

A combination of the format, the crowded programme and the increasing participation of 'apolitical' choirs means that the Street Choirs Festival seems not to be working very well as a convergence space for militant particularisms: street choirs are dissatisfied with the

lack of space in which to build solidarities between them. However, this spatial limitation is not actually confined to street choir gathering. It may, rather, be a function of a wider 'competition' for space between music and politics. While some street choirs do strive to make space for politics in their internal practices, it is a musical ethos or commitment to singing that tends to dominate.

As Jenny Patient observed on space for politics: 'I would say that in Sheffield Socialist Choir, outside of singing, we don't have that space either; it's not just the Street Choirs Festival that is too crowded.' Cynthia Cockburn found that the Festival could be draining, dragging the politics out of the event, and the collective mood likely to result from such an experience may have negative impacts on the development of street choirs as a social movement. Contradicting this fear, however, a collective mood of dissatisfaction has actually resulted in the formation of the Campaign Choirs Network.

On a methodological point, we must reinforce our earlier observation that *these written stories are not the oral histories themselves.* And, in choosing excerpts from people's stories, we are always in danger of misrepresenting them. So, for example, in the above excerpt from her interview Cynthia comes across as dismissive of community choirs, judging them apolitical. In our wider participatory research with the Campaign Choirs Network, we know that this impression is not representative of Cynthia's much more nuanced and sympathetic views. The broader point, however, is how a number of our interviewees seem to have expressed very narrow understandings about what constitutes the 'the political'. Once again, this is surely down to the context of the interviews and how we have excerpted them to represent people's views. In our interviews we focussed on the political as being how social movements resist the injustices and oppressions of *government*. Hence, we are in danger of reproducing from the stories we elicited a narrow and problematic categorisation of what is political.

However, we have observed that street choir members do, in practice anyway, understand 'the political' as any relational space wherein people take a stance on what is just and unjust (see Chapter 1). Such spaces are

not, then, restricted to the realms of resistance to government. They can include not only resistant street choirs and other social movements but also the home, the workplace, the community and so on. Fascinatingly, as we heard in many of their stories, relating to LGBT choirs is challenging any narrow conceptions of the political that persist among street choir members. That said, such conceptions, even preconceptions, *can* persist. Martin Vickers' recollection of the mass sing selection at Leicester Street Choir Festival disregards the fact that five of the six songs were political by even the narrowest categorisation, having obvious anti-war, intersectionality, solidarity and refugee themes. The mass sing concluded with Billy Bragg's 'Internationale', a call to revolution ('not political at all?') (See Figure 13).

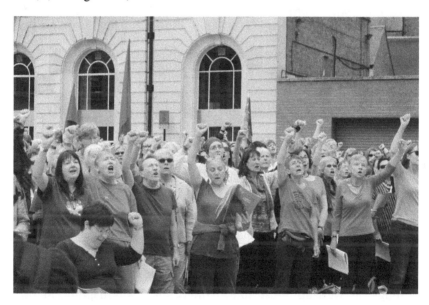

Figure 13: 'Unites the World in Song'. Participating choirs sing 'The Internationale' at the mass sing during Street Choirs Festival in Leicester June 2016. Credit: Gavin Brown

We observe that some street choir members value the musical variety of the Festival, while others find the inclusion of 'poppy' songs, perceived as apolitical, dispiriting. In a parallel vein, we note that music itself served

both to build solidarities and exert its more 'mysterious influence' on the emotions of street choir members, i.e. they were moved by and responded to songs with no political message, either explicit in the lyrics or, arguably, implicit in the performing choirs' presentation of their own identity. On this theme, Jeanette Bicknell concludes that our experience of music is thoroughly social with deep emotional and cognitive roots.[29] That explains, she proposes, why we *might* be moved by any sort of music, be it syrupy pop ditty, patriotic anthem, didactic refrain or highbrow classical concert. One theory is that music evokes not feelings, but memories of feelings. Cue our next section.

'MEMORIES ARE MADE OF THIS'[30]

Emotional experiences impact on relationships, not least on solidarities within street choirs and between street choirs and distant others. We asked our interviewees about memorable moments with their street choirs, both good and bad, highlights and low-points, the inspirational, the embarrassing and even the dispiriting. Again, we've concentrated on predominantly political memories, but again these too are often intimately linked to the songs people were singing. Links between memory and emotions are apparent in the stories we were told. A partial record of the campaigns and causes supported by street choirs emerges via the memories of individual members.

Dee Coombes: 'On N30 we had a massive demonstration in Liverpool. We were up on the top of the steps of St George's Hall.[31] We sang lots of songs, but we sang "Raise Your Banner," and it was magnificent: this absolute sea of banners just shot into the air, and it was so moving.[32] It was a brilliant, brilliant demonstration that. On all the big demonstrations, we've been there, usually at the front, and we're always there at the rally, and we're always singing. And if we weren't there, there would be a lot of people looking around, you know…Because in five years we have become a real institution.'

Maxine Beahan: 'When we went to London for one of the first

[Big Choirs] – I think it might have been before the Campaign Choirs, but maybe it was kind of leading towards that? And it was a big anti-austerity demo, and I think we had all the London choirs.[33] I think Sheffield Socialist Choir went too: I remember them being there. So, that was the first really, really big demo that I'd been to and quite a few people that I was talking with from Protest in Harmony hadn't been before. So we formed austerity… Oh no, not *austerity groups*, it was anti-austerity! *Affinity groups*! So, we had little groups of people to watch out for each other. And had lots of talks about how we would keep safe and what we would do…But it was *so* good to get all the choirs together and singing the same thing. It was one of my best ever days.'

Diane McKinlay: 'Hebden Bridge, the sing-song after the concert in that chapel, we all stood up in the pews…singing "The Internationale"… the whole thing, cos I'd only been with the choir a few months at that stage, that to me was just: I loved this, it was great…and you [Côr Gobaith] sang Sosban Fach, and, of course I knew the words, so I started singing Sosban Fach, cos I learnt Welsh at school…So, that was a lot of fun, but it was also a feeling of togetherness and strength and solidarity and we're all here for the same purpose and, you know, there's a serious point to what we're doing but we also want to enjoy ourselves and just be together because we're like-minded people.[34] And that for me was just another moment, and I remember you [Lotte Reimer] were there conducting people [laughs]. It was great, absolutely great.'

Andy Dykes: 'Sometimes it's not necessarily the big stuff. Sometimes it's, like Greenwich the other weekend [Chants for Socialists], that er, that hackles, that sort of tear-jerk moment when you're seeing something that really, you know, there's a bunch of you, the warmth and the compassion and the…and the sense of solidarity in the room. It just makes you, lump in the throat, and before you know where you are, you're…"I'm not sure I should be having a little moment" here [laughs], that's the way, that's the way it sometimes affects you.'[35]

Rod London: 'These songs are not ambivalent, they are very much about welcoming and upholding the ideals of internationalism and social justice. I like that about the choir, but, yeah, I like that ballsyness of the

choir: this is what we think, this is what we believe and we're damn well gonna sing about it! It appeals and it really... I feel that same ambivalence myself about these political issues and it's quite nice to have a forum in – I notice I'm getting quite, I think, quite, choked as I'm saying this – actually, it's nice to have a context in which that part of me, however ambivalent I might feel about it, that there's some support and solidarity and unity about that part which is often the hardest part to voice. I really believe this is important, however challenging it might be.'

Recall Jasper's assertion that when we do the right thing it feels good, i.e. enacting something that we understand as morally right brings us pleasure. In the experiences of street choir members recorded above, solidarity and joy are mutually constitutive: Street choir members find it pleasurable to construct solidarities, which then bring their own pleasures. Throughout the stories we heard, singing together engendered powerful emotions and so helped street choir members to emotionally connect with each other. Moreover, this emotional power of music also served to connect people with distant others who were suffering oppression, often the subjects of street choir songs: women, refugees, Palestinians...Meanwhile, Dee Coombes' story is an illustration of how a group such as a street choir can become an integral part of a militant particularism and thence develop and shape that local politics. Let's look now at how street choir members experience the likes of fear, anger, outrage, defiance, humour and pride in relation to solidarity.

Julie Burnage joined Red Leicester in 2005, inspired by a chance meeting with a choir member attending the 2005 'Make Poverty History' march in Edinburgh. She told us: 'I was born in Leicester. I love my city. I love the fact that it is a very diverse city with people from all over the world living here... and I was really very angry when we heard that the EDL were coming and they were going to have this march through Leicester. Red Leicester joined the League Against Fascism in a counter march. If you're a member of a political choir that is as good as it gets.'[36]

Lowenna Turner told us about Côr Cochion countering an EDL march in Cardiff: 'The really defining moment was when Beaty was sort of

edging us closer to the fascists and flicking through her book, because she was conducting us that day, and a police officer came and tapped her on the shoulder, asking her to move back. She just went: "Go away, I'm busy!" without even looking up and he just shrunk away, this big policeman: "Sorry, sorry, very sorry"…And Miela stood there right at the police line, going: 'Go home racists, go back to where you came from!'… It was just so funny to see her just subvert what she had clearly had shouted at her [over] quite a lot of years…I think that was quite a day!'[37]

Charlotte Knight: 'We sang when the EDL came to Leicester… That was a very memorable event because we were divided. The Police had put one of these big steel barricades across the street and we were on a bandstand on one side and the EDL supporters were on the other. And they were throwing, lobbing stones over the top and we were singing and it felt very powerful. I mean, it was quite scary, actually. Even going through town on the bus: the town was deserted, everybody'd gone; the Police had warned people to stay at home. So there was basically us and the EDL. And, I mean, there were other anti-fascist campaigners there. But that felt powerful, singing in response to them throwing stones. So, I could see myself agreeing to do more of that. [It] was a bit scary, but it felt a good way of resisting their, you know, ignorance and bigotry.'[38]

Diana Bianchi: 'There were comic incidents as well as serious ones. The choir [Côr Cochion] was arrested in Merthyr [Tydfil] on an anti-fascist rally… A week before that we'd been to an event in Merthyr where Desmond Tutu was being given the freedom of the borough and we were singing African songs and he joined in with us. And, a week later, we were arrested on the streets of Merthyr for singing our songs!'

Wendy Lewis: 'My first inspiring moment was when we were singing – I'd recently joined – and Thatcher had refused to talk to Daniel Ortega when he came to London.[39] He had a rally in Westminster Hall and, before then, we were gathered outside and we were singing "Mandela" just to prove who we were so we could get in. And then, all of a sudden, the rostrum outside was taken over by the Young Conservatives and BNP, you know, neo-fascists, and they were trying to stop us: shouting and hurling abuse and, I think, maybe a few cans or something.[40] And

we started singing and they melted away. It was like magic. It was like the power of singing completely overpowered this negative reaction and after the second song they just disappeared.'

Elaine: 'There was an event outside the [Scottish] parliament for Syria, and I remember singing – tears seem to come up rather a lot in this! But that's my litmus test about if something actually kind of is real and matters. And whatever we were singing, I can't remember what we were singing, but there was a woman who was Syrian and we'd been singing something and she just mouthed: "Thank you." And you're in this big sea of whatever's happening and you just think: Okay, it's right to be doing this: it's not frivolous, it's not nothing…It's moments like that where you know that you've touched somebody – you've reached out and said "we're here," you know: we might not be able to change the world but we're actually here.'

Chris Norris: 'We've encountered some opposition. I think you'd expect that too. When we're singing for Palestinian causes, for instance. People either have very strong feelings for or against or they feel undecided, uncertain, and so mistrustful and resistant. You get all sorts of reactions… It's very difficult sometimes, actually, on the street, when you do get abusive comments from passers-by, to sort of keep your cool, marshal the facts and come back with some sort of reasoned response and just point out the illogicalities and falsehoods being peddled. It's very difficult to do that. Some choir members who are particularly good at keeping their cool and just taking people aside and quietly explaining without getting worked up and agitated. And others who can't do it. I'm one of those who find it really difficult to keep my cool!'

Post-Brexit, the UK has seen a significant rise in hate crime as an expression of racial and religious intolerance. Satnam Virdee and Brendan McGeever argue that 'an invisible driver of the Brexit vote and its racist aftermath has been a politicization of Englishness'.[41] Anthony Ince has identified political events such as the election of Donald Trump in the US and the UK's vote to leave the European Union as 'fascist enabling', serving 'to legitimise attitudes, discourses and agendas that contribute to the mainstreaming and normalising of far-right politics'.[42] Thinking

'beyond electoralism', Ince proposes that, increasingly, anti-fascism must be the frontline of struggles for progressive social transformation, which would clearly include social movement struggles. Recalling Brown and Yaffe, our interviewees are in harmony on the power of song to construct solidarities. Clearly, from their stories, song also has the power to move people in numerous ways: to comfort, to provoke, even to physically disrupt and repel, it would seem. Emotionally, interviewees variously overcame the reflexes of fear and rage, gave defiant voice to their moral outrage, and experienced the pride and pleasure of solidarity. Let's now consider a few stories which, in one way or another, touch upon the issue of solidarities with others and on representation. In just these few instances, 'others' includes both close comrades and people who are distant in space, time and culture.

Jane Scott: "Going back to the fifties, well to the end of the forties actually, we have performed with Paul Robeson in Birmingham Town Hall. We did a piece by Earl Robinson called 'The Ballad for Americans'... When he [Robeson] went back and lost his passport, we campaigned.[43] We did a lot of campaigning, on that. And when his passport was returned and he came over it was, coincidentally, just at that time that Colin Bradsworth died... So, we asked Paul Robeson to be our president, which he was gracious enough to do. So, he was our president then from, was it 1959 or '60.'

Claire Baker Donnelly: 'We argued quite hard to be allowed to sing at Holocaust Memorial Day and we've done it, I don't know, must be six or seven times. But there was an issue when we first tried to do it. They didn't think it was appropriate for an LGBT choir... It was more around the idea that they [Sheffield Council], or one person in particular to be honest, thought, because we were an LGBT choir, that we only sang Shirley Bassey or pop and would trivialise the holocaust...Of course, we do a bit of that. But that was never what we were planning to do, and the fact that they just assumed that was quite offensive.'

Chris Booth: 'One thing that comes to mind is the weekend we organised at Faslane. And we invited other choirs to come to that. So, a few other choirs came to that, and we had a day when we were singing

outside the gate… It was pouring with rain most of the day, as it often does. And we'd talked about it beforehand, and there were some people prepared to get arrested: I think it was three from Protest in Harmony and three from Sheffield [Socialist Choir]. We'd worked out what we were going to say to the police: "We want to sing one song in the middle of the road." So we started singing and then the people that were prepared to get arrested all sat down and carried on singing, and the police arrested them. So, it was all very sort of choreographed, really. And then it was only when they got them all in the police van that we realised it was all the song-leaders who'd been arrested! But we came back the next morning and we sang nonetheless without our song-leaders, and we made a good job of it. So, I was very proud of us then.'

A number of people mentioned rehearsals as memorable highlights, whether those of their own choirs or rehearsals for a mass sing at a Street Choirs Festival. People also told us that the everyday practice of singing with their street choir was always a highlight, especially the aspect of taking action communally with others. Some of people's quotidian highlights of rehearsal and performance included: 'being with like-minded people'; 'I get emotional about people working together'; 'every time we sing in the street I feel inspired'; 'in terms of inspiring me personally that's a really good thing…knowing that other people share my views'; 'it was really moving for me, learning the songs and experiencing how songs are learned for everybody – like just with these signs, some body language.'[44]

THIS IS MY SONG[45]

As we reported in Chapter 3, the number and range of songs that our interviewees revealed as their favourites were quite vast, and there were no songs that stood out as universally popular. There were fewer songs that people didn't like. 'Variety' was noted as being key to a street choir's repertoire. Altogether, though, it would be impossible for us to construct a top- or indeed bottom-ten. One set of reasons for loving songs stood

out, however, and it was emotional. People favoured songs that they found 'beautiful', 'heart-warming and moving', 'poignant' or 'lovely', especially when this appreciation was shared not only within the choir but also via making a connection with the audience. Another set of reasons for liking or not liking songs was more technical: their musical complexity rather than their musical aesthetic, with some people enjoying the challenge of songs that were more difficult to learn and others, by contrast, feeling daunted. Some choristers, especially first-language English speakers, reported struggling with songs not written in their native tongue. Singers from the different musical sections of choirs reported on songs that, while sounding good chorally, were problematic to sing in their part. Bass parts are particularly prone to such criticism:

Chris Norris: 'Some songs have a very boring, plodding bass, very repetitive and rather mind-numbing, really, after a while. I won't name them.'

Like Chris, most people were respectful of the songs themselves, even those that they personally had little liking for. Quite predictably, we suppose, people reported getting bored or jaded with songs that their choir sang too often or, in other words, 'did to death'. In some cases, our interviewees noted songs that had proved lyrically problematic for at least some members of their choir. All the street choirs debated their song choices, questioning them both politically and musically against some consensually decided measures. As we've noted elsewhere, violence in lyrics is cause for considerable debate in some street choirs, particularly those which have constituted peace as part of their collective identity. Humour in song lyrics is also a persistent bone of contention: one person's hysterically funny is another's heretically offensive. The validity of lyrical attacks on specific persons and their physical qualities, however humorous, is a quite frequently contested topic. Politically appropriating music that carries distinct cultural meaning, for instance a hymn tune, can also be problematic. Street choirs, at least those that we spoke with, generally avoid religious songs.

Ian 'Onion' Bell: 'You might have to sing words you don't one-hundred percent agree with. Maybe there's some compromise. There's also a strand

of doing it together in that community…I just think about the community of it, really: the nice ones to sing are the songs that other people enjoy singing as well, and feeling it.'

Lowenna Turner: 'I really like the story-telling songs, because we hold the collective memory of so many movements and protests, and I think songs like "Diggers"[46] are important, songs of the working classes…also songs like "Yma o Hyd"[47] for the Welsh identity…I'm not too crazy about some of the song parodies we do. I know a lot of people like them because of the changes of the words, but I'm not a hundred percent on that. But I do understand the importance of getting a familiar tune into somebody's head for the attention of it. I would see it more of a tool than a beautiful song, I'll be honest, but that's ok: that's what we do!'

Ruth Owen: 'One of my favourite songs is "The Internationale." I like both [versions], and in London we sang a bit of both, which was a really nice compromise. No, I do, it's because my father used to sing it, you see, it's got a history.'[48]

Steph Howlett: '[Sheffield] Socialist Choir party was at our co-housing place at Shirle Hill…and we sang "You're Not Doing It In My Name." We hadn't sung it for years and it just really moved me, and upset me about how pertinent it is, and we were doing it twenty years ago… Some of the union songs feel that they were of a time, and I suppose there's other struggles that I'm more keen to sing.'[49]

Pat Richards: 'During the late 70s early 80s I went to Greenham Common quite a lot although I was working full-time…Those Greenham songs are something special [to Côr Gobaith] but they're special to a smaller group, as well.'

Jane Bursnall: 'Even if it makes one person stop and think, it [singing a song] has done its job…. Choirs work on various levels, you have to feed the songs of your members as well as looking outside and seeing how you're relating to the rest of the world.'

Jane Scott: 'When people sing an expressly choral piece I think they get a lot of satisfaction out of it, in four-part harmony. And also it's good for the voice. It's quite good to do stuff like that in between the more agit-prop

type tunes, which tend to be a bit rough on the voices sometimes.'

Andrew Wilcox: 'The big one for me, which we don't do at the moment, which I really loved from the first times I thought the choir really came into its own, though they haven't sung it while I've been with them, is Labi Siffre's "Something Inside So Strong"…I quite like it when we do the odd pop song but we did 'Shake it Off' and I sort of enjoyed that and sort of didn't, actually. You sound a bit ridiculous. One of the lyrics was "I feel something like a plastic bag floating in the breeze." And you're going: How can I imbue this with anything?'

The excerpts of stories that we selected are diverse and link people's feelings about songs to their affective orientations. 'Onion' Bell highlights how a level of compromise on song selection and lyrical content can be vital to sustaining solidarity in a street choir. A number of other stories touched upon the emotional hook of meaning in song lyrics, especially songs that narrate histories of past oppressions, resistant struggles, defeats and victories. Again, many of these histories centre on solidarities. In Chapter 3 when we discussed meaning in street choirs' repertoires, Elaine recorded how moved she was by 'Singing for Our Lives', specifically the verse celebrating intersectional solidarity between gay and straight people. Also in Chapter 3 we related how Côr Gobaith has long debated and finally (?) changed the lyrics of this verse to 'LGBTQ and straight together'. As cognisance, intersectional and trans-material solidarities develop, it would be a foolish researcher who speculated upon the likely changes to lyrics and additional verses for this song in the future. For many street choir members, the message a song carries is at least as important as its musical qualities. While some messages stand the test of time, however, others reportedly do not, at least not for everyone. Street choirs in Scotland and Wales were committed to songs celebrating national cultures and sustaining languages. A couple of the comments we picked out focussed less politically on the messages of songs and more aesthetically on their musical and lyrical qualities.

SPACE FOR MOVEMENT[50]

In the context of bringing about social transformation, we're interested in how street choir members relate to each other, to wider social movements, and to their communities. Considering the Campaign Choirs Network as a social movement, we can begin to build up a picture of the social transformation its members have in mind and how the Network might pursue bringing it about. Sara Koopman's unanswered general questions about social movements can be revealing when posed to our specific case. In Chapter 1, we outlined the scale of the Campaign Choirs Network as a developing grouping with 126 members from 60 choirs of which 43 are signed up. Earlier in this chapter we restated the Network's loose and informal organisational structure. Our research within the Campaign Choirs Network reveals that it isn't directly involved in electoral politics. While individual street choir members have a variety of party political affiliations, for the most part the choirs themselves avoid party politics, although they may support campaigns and events in which political parties are involved. Meanwhile, although the Campaign Choirs Network is a fledgling manifestation of campaigning solidarity among street choirs, many street choirs have sustained their own campaigning over a considerable time. Founded way back in 1940, recall, Birmingham Clarion Singers stand out in this regard, but a number of other choirs are celebrating ten, twenty and even thirty year anniversaries.

Though at least one of our interviewees questioned the viability of 'peace' as a Network aspiration, overall street choirs in the Campaign Choirs Network do appear to value and practice peace and non-violence. While some street choirs relish singing songs of bloody revolt and revenge for injustice, these are mainly songs from the historical record. We are aware of only rare examples of contemporary songs emerging from the Campaign Choirs Network that extol violence. Dee Coombes told us that Liverpool Socialist Singers seriously debated whether or not to sing 'Oh Mr Cameron' by singer-songwriter Alun Parry and his mother Norma Parry because, although it is ostensibly humorous, it has violent lyrics:

Oh Mr Cameron please don't think me mean
But I really think we should bring back the guillotine
For you and Clegg and Osborne and Lady Thatcher too
They're the only kind of cuts I want to see from you![51]

Other interviewees reported on similar debates in their choirs regarding other songs, not only around physical violence but about devaluing earnest political issues, for example by focusing on the foibles of prominent politicians and deploying personal insults. As we've observed, with humour in lyrics, as in all aspects of life, it is impossible to please all the people all the time. According to incongruity theory, humour deviates from or challenges norms and is thus always likely to spark argument. One 'mechanism' street choirs have for dealing with songs that some members have reservations about singing but others support is simply to let them fade from the repertoire. As 'Onion' Bell conveyed, 'the nice ones to sing are the songs that other people enjoy singing as well, and feeling it.' If not all members of a street choir are enjoying singing a song, the 'vibe' is evident in performances, and so the song is likely to be abandoned over time. The same mechanism seems to operate whatever the nature of the discord: ethical, political or aesthetic. Apart from choirs that explicitly cite peace as constituent of their collective identity, we observe that those choirs with a feminist ethos – which is not necessarily synonymous with having a predominantly female membership – are more likely to question violence in song lyrics.

At the risk of re-treading a little of the ground we walked in earlier chapters, it's clear from the story excerpts we've presented that Campaign Choirs Network members support a range of causes. The associated social goals include prominently: social justice, an end to austerity and maintaining the welfare state in the UK; a welcome for refugees; nuclear disarmament and specifically no Trident replacement; freedom for Palestinians; environmental justice and climate change mitigation. In addition, a number of stories of memorable street choir moments featured anti-fascist and anti-racist actions. During these actions, we suggest that

the street choirs were singing for inclusivity, diversity, tolerance and equity as social goals.

Fascinatingly, if repugnantly, the fascist EDL is set up as a street-level, working-class social movement, and it deploys singing as a tactic of cultural activism, often misappropriating songs from the football terraces. In some senses, then, the EDL is the embodied antithesis of the Campaign Choirs Network! Julia Clarke, who leads a Rise Up Singing group in London, noted the similarity between the emotional highs she experienced while attending a mass protest and a football match. We note, too, the heightened emotions associated with conflict and near-conflict situations, and how this seems to serve to make those situations more memorable.[52] An ardent fan of Liverpool Football Club, Janet Bennet of Liverpool Socialist Singers identified football crowds as a strategic audience for street choirs: 'It could be a way of getting a lot more people involved. Some people sneer a bit at football supporters, but it's a very untapped source…Football could be a means of getting the revolution together. I'd like to see a lot of choirs try to make links with supporters.' Here we note Clapton FC and particularly its 'Ultras' fans, who take an active stance against racism and homophobia, support the local food bank, refugees and other community projects. Clapton Ultras are intent on making Clapton FC a politically progressive football club based on the social history of East London, its militant particularism if you will. On the green political front, meanwhile, Forest Green Rovers 'bring together football and environmental consciousness at the highest levels of the game.'[53]

CULTURAL ACTIVISM

Plainly, the Campaign Choirs Network is united via the shared cultural practice of singing. In Chapter 3, we saw how this practice of street choirs was in fact a complex of practices comprised of a host of materials, competences and meanings. Returning to the definition of cultural activism, as offered by Buser and Arthurs, we wonder how do street choirs 'challenge dominant interpretations and constructions of the world'? And

how do we present 'alternative socio-political and spatial imaginaries in ways which challenge relationships between art, politics, participation and spectatorship'? The short answer to both these questions could be 'through song'. As a number of our interviewees highlighted, songs relate histories, as well as having histories of their own in some instances: songs tell stories and they convey messages. Many street choir songs attempt to keep alive and in the public mind the stories of the oppressed and exploited, from black slaves through civil rights campaigners to people living under apartheid, from the Diggers to victims of austerity in the UK today, from the suffragettes to contemporary refugees and asylum seekers. Frequently, these stories contradict the 'official version'. In passing, we note that place often features prominently in both the stories that songs relate (e.g. St George's Hill in 'The World Turned upside Down') and the histories of the songs themselves (e.g. Greenham Common as a site of collective composition) and so the meanings that songs carry.

In themselves as well as through their practice, street choirs challenge the relationship between art and politics. Some street choirs encourage public participation, handing out lyric sheets so the audience can sing along. Julia Clarke told us: 'What I've noticed in the Campaign Choirs [Network] emails leading up to any demonstration: there's much more about "we'll have spare song-sheets, anyone can join in," than there used to be.' Further challenging the relationship between participation and spectatorship – between street choirs and their audiences – could be key to the development of the social movement, a proposal we'll discuss further in Chapter 6. Other choirs, Côr Cochion being a ready example, also regularly bring elements of theatre into their performances via role-plays and costumes. In Chapter 6 we'll explore the potential for street choirs to increase engagement with their audiences, especially how they might engage more with street theatre, exemplifying some techniques of Augusto Boal's.[54] We'll also discuss how street choirs might engage more with stories of the future in song, thereby presenting socio-political alternatives.

CONTESTING CONVERGENCE SPACE

Our interviews revealed that the Street Choirs Festival is contested as a convergence space for street choirs, that contestation leading to the formation of the Campaign Choirs Network. Moreover, that space is not contested politically between street choirs but somehow apolitically between street choirs and community choirs. This apolitical contestation is typically carried out via seemingly mundane but deliberate exercises of bureaucratic authority, notably the omission of the festival's origins in programme notes and of 'The Internationale' from the mass sing. While contestation is vital to politics, passive-aggressive acts of disavowal serve to negate that vitality.[55] We suggest that, facilitated by the host choir, these debates need to be public, involving all the choirs planning to participate in a festival. Patently, street choirs from different places do still interact with each other at the Festival, learning from each other and forming solidarities. As we've recorded, the advent of the Campaign Choirs Network is itself evidence of that developing solidarity. Though there is politics inherent in the songs reviewed and exchanged, however, mutual learning at Street Choir Festival is predominantly musical. The space for forming closer and better informed political solidarities is limited and thus limiting.

On the other side of the coin, anecdotal evidence confirms our own experiences that at least some community choirs find the participation of street choirs in the festival emotionally vexing. Annie Banham, for instance, shared with us the story of staying in bed and breakfast accommodation with her husband at one Street Choirs Festival 'in Whitby with another choir, who were a barbershop quartet in their other lives. And they actually took great umbrage at the political content of some of the choirs, including ourselves [Birmingham Clarion Singers]. But I don't think they realised I was actually one of the singers…And we were treated every morning at breakfast to a further kind of complete outrage [laughs].' Some community choirs may be seeking their own cultural equivalent of convergence space at the Festival, a space seemingly limited for them by the persistent presence of street choirs. Andy Dykes

was one of a number of our interviewees who noted the conundrum of street and community choirs sharing festival space. On the one hand, the choirs may be sapping the energy from each other's event and even enraging each other, while on the on the other 'a golden opportunity' exists for creative engagements and positive interactions. We note the historic precedent of divorce between street bands and street choirs, though music not politics was at issue in that split.

We are, however, curious as to why street choirs are not more intent on finding out why our songs don't appeal more to community choirs. Is it our messages, our musics, or the combinations thereof that miss the mark? Is it our very claim to identities as political activists that is off-putting? On the other hand, too, why aren't we more interested in the community choirs? As we've noted, street choir members do recognise and welcome the politics of LGBT choirs, most obviously represented by Out Aloud. Street Choirs Festivals really could be an opportunity to actively listen to what community choirs are saying and to learn from that. Community choirs generally cohere around more than a shared musical interest. Apart from in rare instances, their members come from a shared place of residence, and so they will likely have a political particularism, albeit perhaps not militantly articulated in their songs. Inequality and injustice are such widely acknowledged social scourges in contemporary Britain that there cannot be many communities of place which are not struggling with austerity: the stripping away of health and care services, the closure of libraries and post offices, homelessness and foodbanks.[56] How many UK communities of place are not riven or vexed by Brexit and its ramifications? Whose schools are not suffering a teacher shortage as an effect of the government's cap on public sector pay? And we could pose similar questions around international issues, for example freedom of movement, climate change, nuclear brinkmanship and so on. In seeking to engage with community choirs to greater mutual benefit, street choirs might do worse than follow the course described by Paul Chatterton as 'learning to walk with others on uncommon ground.'[57] With the festival as our politically uncommon ground, we could develop commonalities beyond that space of encounter.

We mark again the very different responses of street choirs to the participation of 'female and genderqueer' and LGBT choirs in Street Choirs Festivals. In the minutes of their meeting of 13 July 2014, held at the Street Choirs Festival in Hebden Bridge, the Campaign Choirs Network deliberately reached out to welcome LGBT and female choirs into the fold, along with their identity politics, a conscious gesture to intersectionality:[58]

2. Email list
Agreed outreach email to reach all the participating choirs of this year's festival (get list from Calder Valley Voices) as well as all the originally approached choirs, explaining what we are about to attract involvement from choirs such as SHE[59] and specifically invite LGBT choirs (see also 3.1).
3.1 Inclusivity and growing CC
Agreed that there are many struggles, incl. LGBT, race, gender etc. issues, that are all struggles of CC and we should make this clear on the website...

Figure 14: Excerpts from Campaign Choirs Network (CC) minutes, 13 July 2014.

To conclude this section, we observe that the nature of militant particularisms in an age of globalisation has shifted from Raymond Williams' original conception.[60] Militant particularisms stemming from cases such as miners' demands for better wages and conditions directed at the individual owner of a local pit are not common these days, at least not in the UK. Certainly, there are still place-based struggles that have resonances beyond the local, opposition to fracking in places such as the Yorkshire village of Kirby Misperton, for example. There the 'Protection Camp' combines the logics of local environmental justice with those of climate change mitigation.[61] And defending local services such as libraries, hospitals, care homes and post offices has resonances at the

national level. However, we also observe that, increasingly, national and international struggles become localised and define the militant particularisms of in-place communities. Examples from the street choirs are many, but to cite just a few: Red Leicester's militant particularism is partly characterised by their city's involvement with immigration and refugee issues that arise from geopolitics; Protest in Harmony's militant particularism is partly defined by the commitment of a number of members to oppose Trident replacement, a supra-national issue with global ramifications; Côr Cochion have reconstructed their local militant particularism to include a specific practical commitment to the struggles of Palestinians.[62]

'I SECOND THAT EMOTION'[63]

The interplay of emotions and affects is complex and fluid, that much we understand. Attempting to analyse the circulations and transpositions of emotions and affects in street choirs is therefore evidently a fool's errand. *So, here goes!* Our stories reveal street choirs as sites of the full range of reflex emotions, with political anger and musical joy standing out. Especially in street choir members' responses to fascist and racist marches, we heard of the transposition of fear and anger into joyful, humorous and empowered responses. We observe that reflex emotions may develop into affective allegiances and communal moods via shared moral sentiments. Chris Norris' story is revealing of the disciplining of reflex emotions, specifically anger, that may be required to avoid violence and foster communication. Such disciplining of emotions may be enabled by moral sentiments like compassion, which can then generate spaces of mutual understanding.[64] As Chris observed, anger can stem from a lack of trust or a surfeit of hate. Dee Coombes stressed that, while reflex emotions definitely have their place in the public practices of street choirs, including in their song lyrics, they need to go hand in hand with appeals to rationality. Jane Bursnall, too, linked the emotional hook of song to its 'job' of making the listener think.

In conflict situations, at least, singing seems to be a non-violent, rational and upbeat or anyway inspired and potentially inspirational action that responds to and embraces reflex emotions. Similarly, humour is a frequent mood response to emotions such as fear and anger: street choirs do have a lot of fun, even – or perhaps especially – when under pressure. Meanwhile, tears are a common manifestation of reflex emotions, often brought on by a song and/or the act of communal singing. The impossibility of isolating reflex emotions from moods is apparent. Inspiration, we heard, is one mood frequently produced by communal singing. The descriptor 'moving', at least as used by our interviewees, appears to be either synonymous with or a precursor to inspiration, which in turn may herald optimism. In the stories we gathered, inspiration seems to be closely linked to feelings of empowerment or giving street choir members 'that oomph'.

In Elaine's story of her encounter with a Syrian woman we heard how an emotional connection with the audience inspired a realistically hopeful mood. Though clearly not a defining factor, presence, embodying one's moral emotions in place, is closely linked to inspiration. 'Being there' depends on the social construction of a space where moral sentiments such as outrage and shame can be enacted. If presence is important, so too is the persistence of presence in effectively mobilising moral sentiments to affect social change. For example, we recall Claire Baker Donnelly's account of Out Aloud being allowed to sing at Holocaust Memorial Day commemorations in Sheffield. Many street choirs make a regular recurrent presence in public space a feature of their practice. Making (good) music is strongly connected to feelings of satisfaction or fulfilment, as signalled in Charlotte Knight's case by the profound expression 'Aah!' We heard that people's favourite songs were emotionally charged (moving, poignant, heart-warming) and (thus?) aesthetically pleasing (beautiful, lovely).

Andy Dykes testified to the inspiration and sense of solidarity that can stem from warmth, compassion and fellow-feeling. In turn, of course, solidarity considered as an affective allegiance, generates moral emotions. Clearly, solidarity is not the product of a cold-blooded rationalism, nor

does it produce (only) political rationality. In Maxine Beahan's story, we saw how care involved communication, reason, trust and mutual aid, and how that care contributed to Maxine's sense of the 'Big Choir' day being one of the best of her life. We'll pursue care along with affective orientations, allegiances, commitments and loyalties in our concluding section on solidarities.

'SOLIDARITY FOREVER'[65]

From the stories we gathered, street choirs appear to pursue solidarity at all scales, from the local through the national to the international, as a social goal. Indeed, solidarity may be viewed as the unifying social goal of the Campaign Choirs Network. For some interviewees solidarity and (political) community are evidently terms which are virtually synonymous. As we discussed in Chapter 3, noting the resonance with solidarity, for us the meanings that the contested term 'community' encompasses include belonging, relating to and caring for others, shared political consciousness and collective action. Also, in Chapter 3 we touched upon solidarity as a spatial relation that reworks the connection between places. From our stories, it's clear that it also reworks connections between people in the same place. On our journey so far, we've seen solidarity represented as both value and practice – or a complex of social practices, as integration or community, as an emotion or affective orientation. Solidarity is also equated to a social goal or desire for new kinds of collectivities, in other words as a vision of the future or a socio-political and spatial imaginary.

As we've discussed previously, there can be tensions within street choirs over the proximity and reach of solidarity. Brown and Pickerill observed that the welfare of the proximate individual can be neglected, both by the individuals themselves and by other activists operating as a collective. Activist attention can be unwaveringly focussed on solidarity with distant others who are suffering oppression and so may miss the need to care for themselves or close-at-hand comrades.[66] Andrew Wilcox

also raised a considerable point concerning the connection between experience and claiming solidarity. The moral question of how intimately one party in a solidarity relationship must have experienced the struggle of the other before they can politically represent it to the world is one to ponder. Talking about activist experiences of solidarity, Sander Van Lanen argues that targeting the responsibilities of government and corporations in one's own place for oppression in another is a strategy that does not demand direct experience and so, arguably, obviates problems of representation.[67] Via their actions, it's clear that at least some street choirs understand such a strategy. Strawberry Thieves, for example, have written 'Boycott Song', to the tune of 'Bye Bye Love',[68] advocating a UK consumer boycott of Israeli goods in solidarity with the people of Palestine. 'Boycott Song', which has been taken up by a number of other street choirs, gives the barcode number – 729 – of Israeli goods in its lyrics. It also narrates a potted history of oppression in Palestine and the failure of worldwide governments to act effectively.[69]

On the tension between solidarity and representation more broadly, in our stories we saw some of the many relationships that may be performed, from deputising for choir leaders arrested during a political action, through advocacy that crosses national borders, to representing a community of (some) shared experience. Andrew Wilcox's observation pinpointed a particularly problematic area for representation, however, i.e. representing people from other cultures whose oppressions we have not experienced.[70] Indeed, our own material privilege may even be the flip-side of the continuation of those oppressions. Sara Koopman addresses the twin problems of paternalism and neo-colonialism in representation, arguing for struggling *with* rather than working *for* the differently oppressed in solidarities that we construct as part of the global justice movement. In a manifestation of this relationship that is especially apposite for street choirs, Koopman argues for speaking *with*, acknowledging representation as a privilege for those of us who have not been forcibly silenced:

When we speak *together*, we all have a louder voice for speaking truth to power. Instead of speaking as autonomous selves, separate from and able to speak for others, we can speak in a ways that recognise our connectedness. Though this is not always possible, ideally if we tell the story of another we can either read their own words or discuss with them first how to tell it.[71]

Street choirs who have experienced the material conditions of oppressed peoples and/or sing their songs, often in the original language, have consciously worked towards Sara Koopman's ideal. Côr Cochion's solidarity with the people of Palestine is again a ready example. Furthermore, we note that such solidarities may not always be obvious where there is a lack of space for an audience to engage in discussion with a street choir, as, for example, in a performance at a Street Choirs Festival.

In closing, it is our contention that relations of solidarity can be forged only between groups of living human beings. In this view, while we can be sympathetic to, say, the plight of bees, solidarity is the relation we might form with other humans to defend bees: we can't have solidarity *with* bees.[72] That said, we might well express our emotional response to the harm done to bees by certain insecticides as *a sense of* solidarity. Though they can work across difference and distance, then, solidarities can transcend neither materiality nor time: they cannot be forged with past generations nor future humans. Yet, care and representation can transcend those bounds. Many songs that street choirs sing commemorate the dead, for instance. Often the lyrics of such songs extend to representation, even putting words in the mouths of the dead, as with 'Joe Hill' or the 'The World Turned Upside Down.'[73] Less often, street choir songs represent unborn human beings, and other species. A notable example of a song with lyrics which tend towards representing both future generations and a wider nature is 'Seven Generations', written by Morag Carmichael of Raised Voices.

Seven generations hence, is where we look to
Seven generations hence, we need to bear in mind in all we do…
Will the Earth flourish, and all her creatures?
Will the Earth nourish, will the people thrive…
For the future of the people, and the many strands of the web of life.

We observe that, given apocalyptic threats such as climate change, damage to the ecology of the world's oceans and nuclear war, street choir songs may increasingly come to represent others across the bounds of time and materiality. Our song-writers will need to think carefully about how they speak *with* those who literally have no voice rather than, as Sara Koopman phrases it, 'those who have been silenced and unheard'.[74] In Chapter 5 we are attentive to solidarities and representations of material others as our interviewees imagine the future for themselves, their choirs and the wider world.

ENDNOTES

1 La Nueva Canción https://folkways.si.edu/la-nueva-cancion-new-song-movement-south-america/latin-world-struggle-protest/music/article/smithsonian. Accessed 19 May 2018; "The Chilean New Song Movement: Far more than a relic of the past". http://www.socialjusticejournal.org/the-chilean-new-song-movement/. Accessed 19 May 2018; Jennifer Verson, "Why we need cultural activism." In *Do It Yourself: A handbook for changing our world*, edited by Trapese Collective, 171-186 (London: Pluto Press, 2007), 181.

2 See for instance: Jeff Goodwin and James M. Jasper (Eds.) *The Social Movements Reader: cases and concepts* (Oxford: Blackwell, 2003); Donatella della Porta and Mario Diani, *Social Movements: An Introduction* (Oxford: Wiley-Blackwell, 2010); Graeme Chesters and Ian Welsh, *Social Movements: The Key Concepts* (London: Routledge, 2010); David Graeber, *The Democracy Project. A history; A Crisis; A movement* (London: Allen Lane, 2013); Angela Y. Davis, *Freedom Is a Constant Struggle: Ferguson, Palestine, and the Foundations of a Movement* (Chicago: Haymarket Books, 2016); Wesley Lowery, *They Can't Kill Us All: The Story of Black Lives Matter* (London: Penguin, 2017).

3 See for example: Donatella della Porta, *Social Movements in Times of Austerity: Bringing Capitalism Back into Protest Analysis* (Cambridge: Polity Press, 2015); Manuel Castells, *Networks of Outrage and Hope: Social Movements in the Internet Age* (Cambridge: Polity Press, 2015); Lisa Stulberg, *LGBTQ Social*

Movements (Cambridge: Polity Press, 2017).

4 Sara Koopman, "Social Movements." In: John A. Agnew et al (Eds.) *The Wiley Blackwell Companion to Political Geography*, 339-351. (Chichester: John Wiley & Sons, 2015), 340.

5 'Social Movement' by Ralph H. Turner, Neil J. Smelser and Lewis M. Killian. https://www.britannica.com/topic/social-movement. Accessed 16 October 2017.

6 Verson, "Why we need cultural activism,"173.

7 Michael Buser and Jane Arthurs. "Cultural Activism in the Community." Connected Communities, 2013. http://www.culturalactivism.org.uk/wp-content/uploads/2013/03/CULTURAL-ACTIVISM-BUSER-Update.3.pdf. Accessed 16 October 2017. Our emphasis.

8 Verson, "Why we need cultural activism,"175.

9 Paul Routledge and Andrew Cumbers, *Global justice networks: Geographies of transnational solidarity* (Oxford: Oxford University Press, 2013); Originally deployed by the influential cultural theorist Raymond Williams and later taken up by political geographer David Harvey. David Featherstone, "Some Versions of Militant Particularism: A Review Article of David Harvey's *Justice, Nature and the Geography of Difference.*" *Antipode*, 30 (1998): 19-25; Paul Routledge, "Convergence space: process geographies of grassroots globalization networks." *Transactions of the Institute of British Geographers*, 28 (2003): 333-349.

10 Featherstone, *Solidarity*, 5.

11 Featherstone, *Solidarity*, 12.

12 David Graeber, "Caring too much: That's the curse of the working classes." *The Guardian*. March 26, 2014. https://www.theguardian.com/commentisfree/2014/mar/26/caring-curse-working-class-austerity-solidarity-scourge. Accessed 27 October, 2017.

13 Leah Hunt-Hendrix, *The Ethics of Solidarity: Republican, Marxist and Anarchist interpretations*. PhD Dissertation, Princeton University, January 2014. See also: Selma James, *Sex, Race and Class: The Perspective of Winning: A Selection of Writings* 1952-2011

(Oakland: PM Press, 2012), 92 -101; Silvia Federici, *Revolution at Point Zero* (Oakland: PM Press, 2012), 115-125.

14 Brown and Yaffe, "Practices of solidarity"; F. J. Bosco, "Emotions that build networks: Geographies of human rights movements in Argentina and beyond." *Tijdschrift voor economische en sociale geografie*, 98 (2007): 545–563; Routledge, "Sensuous Solidarities"; Koopman, "Social Movements."

15 Brown and Pickerill. "Space for emotion."

16 Activist trauma support. https://www.activist-trauma.net/en/mental-health-matters/burn-out.html. Accessed 20 October, 2017.

17 Jasper, "The Emotions of Protest"; Goodwin et al, *Passionate Politics*; Goodwin et al, "Emotional Dimensions of Social Movements." See also James M. Jasper, "Motivation and Emotion." In: Robert E. Goodin and Charles Tilly (Eds.) *The Oxford Handbook of Contextual Political Analysis* (Oxford: Oxford University Press, 2006); James M. Jasper, "Emotions and Social Movements: Twenty Years of Theory and Research." *Annual Review of Sociology*, 37, 1 (2011): 14.1-14.19, 14.2.

18 See for instance: Nigel Thrift, "Intensities of feeling: towards a spatial politics of affect." *Geografiska Annaler Series B*, 86 (2004): 57-78; Deborah Thien, "After or beyond feeling? A consideration of affect and emotion in geography." *Area*, 37 (2005): 450-454; Margaret Wetherell, *Affect and Emotion* (London: Sage, 2012); Steve Pile, "Emotions and affect in recent human geography." *Transactions of the Institute of British Geographers*, 35, 1 (2010): 5-20.

19 Brown and Pickerill. "Space for emotion," 6.

20 Brown and Yaffe. "Practices of solidarity,"15.

21 Nathan L. Clough, "Emotion at the Centre of Radical Politics: On the affective structures of rebellion and control." *Antipode*, 44, 5 (2012), 1684.

22 Jeff Goodwin and James M. Jasper (Eds.) *The Social Movements Reader: cases and concepts* (Oxford: Blackwell, 2003), 167. See also Mason, "No Names, No faces, No Leaders."

23 Jasper, "Emotions and Social Movements: Twenty Years of Theory and Research"; Jasper, "Motivation and Emotion."

24 Held, *The Ethics of Care*, 10, 71.

25 Martin's comments relate to images that Nottingham Clarion Choir were prevented from showing to accompany their on-stage performance and, in particular, a song about austerity. The images were of members of the Conservative Party hierarchy. The reason given by Curve staff was that the venue was funded by the Arts Council and local government and so could not show images that amounted to "taking a political stance" or that constituted "a personal attack." The Street Choirs Festival in Leicester took place immediately after the Brexit vote and political sensibilities were undoubtedly heightened. Following an exchange of correspondence and a meeting, Nottingham Clarion Choir received a letter of apology from Curve recognising that the intervention was not in line with the venue's policy and normal practice. At an earlier Festival in Gateshead, Cynthia Cockburn recorded that the host Council forbade certain political songs. Raised Voices responded by singing "Bandiera Rossa", an internationally famous song that originated in the Italian labour movement.

26 A gathering of political choirs to celebrate Strawberry Thieves' 20th anniversary (which the choir did actually organise for the following year under the banner "Chants for Socialists").

27 *The Rencontres de Chorales Révolutionnaires* (Meeting of Revolutionary Choirs).

28 The "peace parade" was a march of all participating choirs, singing and waving their banners. It processed from Aberystwyth Arts Centre about 1 kilometre to the seafront and culminated in the mass sing.

29 Bicknell, *Why Music Moves Us.*

30 A 1955 song by Terry Gilkyson, Richard Dehr and Frank Miller who together formed US folk band The Easy Riders.

31 30 November 2011 day of action on public sector pensions.

32 "Unity (Raise Your Banners High)" by John Tams (1984). http://

unionsong.com/u292.html. Accessed 14 October, 2017.

33 20 October 2012 TUC Anti-cuts demonstration in London.

34 Sosban Fach ("Little Saucepan") is a well-known Welsh folk songTalog Williams wrote the version of the song that is sung most often in 1915, adding verses to one written by Mynyddog (Richard Davies) in 1873.

35 Strawberry Thieves' "Chants for Socialists" weekend, 10-12 of March 2016.

36 The English Defence League is a far right-wing "street protest movement proclaiming itself working class and opposed to 'global Islamification'"; Probably 'Unite Against Fascism'. http://uaf.org.uk/. Accessed 17 October, 2017.

37 Sadly Côr Cochion stalwart Beaty Smith died on 4 February 2018.

38 Leicester EDL march 2012. Red Leicester sing the 'Internationale' (Billy Bragg's version). https://www.youtube.com/watch?v=Q82JICT4Tqc. Accessed 21 October, 2017.

39 Daniel Ortega of the Frente Sandinista de Liberación Nacional (FSLN) led a revolutionary government in Nicaragua from 1979 to 1985, later serving as President.

40 The British National Party is an extreme political party in theUnited Kingdom that vehemently opposes immigration.

41 SatnamVirdee and Brian McGeever, "Brexit, Racism, Crisis." *Ethnic and Racial Studies* (2017): 1-18.

42 Anthony Ince, "Anti-fascism: attack as defence / defence as attack." *ACME* 16, 4 (2017): 628-631.

43 Paul Robeson sings "The Ballad for Americans", originally entitled "The Ballad for Uncle Sam", US patriotic cantata, lyrics by John La Touche and music by Earl Robinson. https://www.youtube.com/watch?v=rnXyGr668wg Accessed 21 October, 2017

44 Learning without sheet music is the Natural Voice way.

45 "This Is My Song" is a hymn written by Lloyd Stone to the melody of Finlandia by Jean Sibelius. A non-religious version is sung by some street choirs.

46 "The World Turned Upside Down" by Leon Rosselson.

47 "Yma o Hyd"(Still Here) by Dafydd Iwan.

48 Strawberry Thieves' Chants For Socialists weekend.

49 "Not in my name" by Mal Finch, additional words by John Hamilton.

50 Borrowing a section heading from the title of a book by Building Bridges Collective, Leeds University Press, 2010.

51 Alun Parry sing his "Oh Mr Cameron" at a TUC demonstration outside Lib Dem Conference in Liverpool on 19 September 2010. At the time the Lib Dems were in a coalition government with the Conservative Party. In https://www.youtube.com/watch?v=Hc5GHJg5ag8. Accessed 21 October 2017.

52 See: Mara Mather and Matthew Sutherland. "The selective effects of emotional arousal on memory." *Psychological Science Agenda, Science Brief,* February 2012. http://www.apa.org/science/about/psa/2012/02/emotional-arousal.aspx. Accessed 27 October 2017; Linda J. Levine and David A. Pizarro, "Emotion and Memory Research: A Grumpy Overview," *Social Cognition: 22 Autobiographical Memory: Theoretical Applications* (2004): 530-554.

53 Clapton Ultras http://www.claptonultras.org/ and Forest Green Rovers https://www.forestgreenroversfc.com/. Accessed 22 October, 2017

54 See: Boal, *Theatre of the oppressed*; Boal, *Games for actors and non-actors*

55 Chantal Mouffe, *Agonistics: Thinking the World Politically* (London: Verso, 2013).

56 See: Richard Wilkinson and Kate Pickett. *The Spirit Level: Why equality is better for everyone* (London: Penguin, 2010); Danny Dorling, *Injustice: Why social inequality persists* (Bristol: The Policy Press, 2011); Mark Blyth, *Austerity: The history of a dangerous idea* (Oxford: Oxford University Press, 2015).

57 Paul Chatterton, "'Give up activism' and change the world in unknown ways: Or, learning to walk with others on uncommon ground." *Antipode,* 38 (2006): 259-281.

58 See for instance Collins and Bilge, *Intersectionality*.

59 SHE are 'a vibrant collaborative choir community for all who identify as women'. Beginning in Manchester, there are also SHE choirs in London, Newcastle and Berlin. https://shechoir.com/. Accessed 27 October 2017.

60 Raymond Williams, *Resources of Hope: Culture, Democracy, Socialism* (London: Verso, 1989).

61 See, for instance, Gordan Walker, *Environmental Justice: concepts, evidence and politics* (London: Routledge, 2011).

62 Where 'national' in this instance is used to refer to the UK (rather than Scotland).

63 Smokey Robinson, 1967.

64 Chris' story also shows how street choirs can utilise their collective strengths in caring and doing politics.

65 A song written by Ralph Chaplin in 1915. http://unionsong.com/u025.html. Accessed 23 October, 2017.

66 Brown and Pickerell, "Space for Emotion."

67 Sander Van Lanen et al, "Activist experiences of solidarity work." *Interface*, 6, 2 (November 2014): 216–223.

68 "Bye Bye Love" is a 1957 song by Felice and Boudleaux Bryant.

69 People wishing to enact the boycott actually still have to look for the country of origin of the products as barcodes reveal only the country of origin of the vending company. To counter the boycott campaign, Israeli products are being marketed by companies based in other countries and thus under different barcodes.

70 See for instance Austin C. Okigbo and A. Ezumah Bellarmine, "Media Health Images of Africa and the Politics of Representation: A South African AIDS Choir Counter Narrative." *Journal of Asian and African*, Studies 52, 5 (2015): 705-721.

71 Sara Koopman, "Imperialism Within: Can the Master's Tools Bring Down Empire?" *ACME* [S.l.] 7, 2, (2008): 283-307, 296.

72 We acknowledge that who and what is understood to have "personhood" and the capacity to act politically are live (*sic*) ontological questions that we cannot begin to explore here.

73 "Joe Hill" was written by Alfred Hayes with music by Earl Robinson.

Leon Rosselson's "The World Turned Upside Down" is commonly known among street choirs as "the Diggers' Song."

74 Koopman, "Imperialism Within."

CHAPTER 5

IMAGINING THE FUTURE

In our dreams we have seen another world, an honest world, a world decidedly more fair than the one in which we now live. We saw that in this world there was no need for armies; peace and justice and liberty were so common that no one talked of them as far off concepts but as things such as bread, birds, air, water, like books and voice. This world was not a dream from the past, it was not something that came to us from our ancestors. It came from ahead, from the next step we were going to take.[1]

Time is literally of the essence in this chapter, which ultimately focuses on how street choir members imagine a communal future. We actually asked: 'What world do you want? *What does your perfect society look like?'* In order to help our interviewees ground such a potentially daunting utopian question, we encouraged them to think about their choir: 'What is the world that you're singing for?' And to imagine the choir singing in that future: 'What would they be singing about? What songs would they be singing? Our underlying assumption here was that street choirs must be singing *for* something even if much of their practice was directed at being anti, i.e. at opposing injustice, oppression, exploitation and violence. On a methodological note, asking this BIG question about imagining the perfect future could be difficult, almost embarrassing. Trying to invoke pictures of the future from the context of an oral *history* interview seemed somehow incongruous and so slightly

uncomfortable. Or perhaps imagining the perfect future is – or at least was at the time of our asking – an unfamiliar scenario within street choirs, social movements more generally or even in wider society? As we'll see later, utopian imagining is in itself a vexed political issue. But if we are working for social change, don't we need some vision of how that transformation might look?

That question posed, it certainly wasn't an agreed collective vision of the perfect future that we expected to be able to construct from analysing our respondents' future imaginaries. Rather, our main hope was that something of relevance to the here and now would emerge: some signpost to a direction of travel that would indicate how to act in the present moment. As the Turbulence Collective signal, imagining a future in which we have won our political struggles may serve to nudge hard-pressed and weary social movements in new directions, because imagining such a future means that we have to think about our current politics: *why we do what we do, why we keep doing it, and what else could be done?*[2] We found it helped to liberate interviewees' imaginations if we posed our BIG question thus: 'Close your eyes for a moment and, when you open them, you're in your perfect world: what do you see?'

DYSTOPIA NOW: THE ANXIETY AFFECT

We posed our questions to members of different street choirs over a period of three years. During that time, we're sure most of our interviewees would agree, the future could appear pretty grim (see Introduction). Finding any bright side to look on was a challenge for many of them.[3] Despite statistical evidence that we, to borrow a phrase, 'have never had it so good,'[4] our interviewees generally felt negative about the political present and pessimistic about the future. Moral philosopher and musician Alan Carter believes this pessimism is:

> Because the politically progressive developments dating from the 1960s are currently being systematically undermined. Recent years

have seen the pronounced growth in the West of some of the most reactionary large-scale movements since the 1930s.[5]

So, the improved state of the world that statistics record could all too easily be politically reversed over the next few years. Then, in the longer term, it's likely that climate change will impact negatively on most aspects of human life. Somewhat similarly, street choir members' perceptions of an increasing risk of catastrophic nuclear conflict counters current feel-good statistics. Our respondents were also very aware of increasing income and wealth inequality, especially with respect to the so-called 1%. Economic inequality is detrimental to society across the board, generating myriad injustices, and yet it is pursued with an ideological fervour by powerful elites.[6] The pervading pessimism afflicting street choir members is fuelled by greater than ever media coverage, informing us of the plight of distant others. At some level or other, UK street choirs typically take on a duty of care for those suffering the ravages of war, famine and oppression across the globe.

In the context of 'collective forms of assembly',[7] feminist philosopher Judith Butler notes of the precariousness of our times, dominated as they are by neoliberalism:

> The more one complies with the demand of 'responsibility' to become self-reliant, the more socially isolated one becomes and the more precarious one feels; and the more supporting social structures fall away for 'economic' reasons the more isolated one feels in one's sense of anxiety and 'moral failure'. It involves an escalation of anxiety about one's future and those who may be dependent on one; it imposes a frame of individual responsibility on the person suffering the anxiety; and it redefines responsibility as the demand to become an entrepreneur of oneself under conditions that make that dubious vocation impossible.[8]

For Butler, the process of 'precaritization' is induced and reproduced by governments and economic institutions, and it tends to acclimatise people

to hopelessness. Precarity in this context means that networks of social and economic support fail certain sectors of society more than others, exposing the people caught therein to harm. What, Butler wonders, can public assembly do in the face of social atomisation and a forced responsibility to become self-reliant? Pertinently for us, she also asks what opposing form of ethics is expressed and embodied by public assembly.

HOW HAS SOCIETY AND THE POLITICAL CLIMATE SHIFTED?

Before we ventured into imagining the future, we asked people about their present moments, how they thought things had changed, both within their street choir and in the wider world: 'How has society and the political climate shifted?' It was, we thought, a good idea for people to remind themselves – and us – of the present reality from which we would, ultimately, imagine perfect or, at least, better futures. Let's begin with our interviewees' views on shifts in society and the political climate, the wider world:

Andy Dykes: 'It's a constant, it's not a feeling of dismay, but there is a: How on earth do we get to the point where we have, er, basically a bunch of self-servatives running the country? We have people using food banks, we have child poverty, we have increasing amounts of people on the streets begging, and I just think: What is wrong with people? What on earth is going on? I don't blame Thatcher necessarily, but a lot of what's crap came out of that woman in terms of: "There is no such thing as society, me-me-me-me, I-I-I-I." No, we don't exist without each other, we are here, first and foremost as a human race. We can't ignore what's going on across the pond, much as some people would like to: Ah well, that's America, that's Trump…In some senses I'm a stereotypical white, male, British person, but, where's people's compassion? Where's people's sense of other? Where's people's sense of celebrating difference? The joy of diversity? All that stuff.'

Rod London: 'My god, look at the political times we're in now, when it felt like, ten years ago, it felt like things were reaching this kind of golden

age of social inclusion and social justice and in many ways, perhaps, I think things were a lot better. I'm not saying it was perfect... and that seems to be being dismantled.'

Rosemary Snelgar: 'I get very despairing sometimes because it just seems everything goes down and down and down. When I was growing up there were fields and so on – on the way down to the beach – and now it's just housing estates. People growing up now, that's their baseline and they don't think we're losing more and more. There's a concept: that this is our baseline, the next generation, this is their baseline and more and more has gone, but that's their baseline. So, it just gets eaten away all the time. So, it would be nice if we could have...The human species doesn't seem to have a way of sending that, passing that type of knowledge down the generations. We can build on technical knowledge.... also about how societies relate to each other, within each other. It's really difficult to get that, to pass that down the generations, if we could find out how to do that, that would be wonderful. That's a huge ask, isn't it?'

The snippets we've presented serve to reveal that, parallel to senses of self-worth and fun, despair, dismay, incomprehension and exasperation were moods much in evidence in the stories of our interviewees. And street choir members more widely expressed similar motions. Meanwhile, we wondered whether the answer to Rosemary Snelgar's 'huge ask' wasn't staring us all in the face, or rather booming in our ears. Folk music, in particular, is testament to song's potential to keep stories alive. So, what better medium than song for communicating an ecological audit to future generations? Pete Seeger's 'Where have all the flowers gone?', Woody Guthrie's 'This Land Is Your Land', Tom Lehrer's 'Pollution', Joni Mitchell's 'Big Yellow Taxi' and Jackson Browne's 'After the deluge', are just a handful of ready examples. There are numerous environmental songs to be sung and many more to be written. Let's hear now from some more of our respondents about the changes they've perceived.

Nest Howells: 'I don't know – personally I feel at a bit of a loss – what can you do? Is there any point to any of this? And I think you are bound to have some doubts, aren't you, because things are just awful. But yes, I think working locally: just plod on.'

Elaine: 'Well, the world seems to have got a lot worse. Has it? Has it not? Am I just maybe more aware of it? I don't know. My sense is that there seems to be more instability in the world since we [Protest in Harmony] started. But maybe not, actually, because we'd already had 9/11, that was 2001, wasn't it? So, we started, you know, just couple of years after that. So, a lot certainties, things we thought were certain fifteen years ago, just [are] not there anymore. So, the choir's maybe started in the beginning of some of that. It's hard to tell. Sometimes you think the world has gone mad. And then, other times, you think: "Yeah, that's great!" I mean politically things are a bit crazy right now, just right after the General Election [8 June, 2017] but we've just had some brilliant stuff in the Scottish parliament, you know. So, in Scotland there's been some amazing things happening. And I think there have been developments in the green politics. So, there are some things where people are working away and, you know, just pushing, pushing, pushing – next bit on, next bit on. So, whilst on the one hand you think we're heading for absolute catastrophe, there's still that chipping away and progress being made.'

Steph Howlett: 'It's got worse, it's got much worse. The whole climate of xenophobia and racism. And the wars around the world and the people who are fleeing and the reaction when Trump and Brexit…I think it really has changed. And it feels to me a lot more volatile now…There is a backlash. There is, I think, a real up-welling of solidarity.'

Pat Richards: 'I'm trying to be optimistic in a dark time, really. We know how dark the times are, but I think this is the time when we have to keep going, come together, like the Campaign Choirs. When you're there, it's like "Mark My Words": "there are always more of us", even though we don't have the power, we have to keep going.[9] I don't know, I sometimes look back on my teaching career and think "what a waste of time" [laughs with interviewer]. But I do think education is changing so much. I think our children need more political education, less shopping and kind of mad celebrity stuff…Maybe you just feel like this in your sixties? I look back and I think: I really thought we were getting somewhere with feminism, and for certain people we have. But I look at how young women are still manipulated, and made to think

they should look a certain way. But then I look at my daughter, who is a lesbian, and she's getting married, and someone said to them: "Why are you getting married?" And she said: "Because we can." Because things *have* changed, but you can lose them really easily and that's why I think we need to keep going, because – at a stroke – you can lose liberties. You look at what's happening in the US.'

Chris Booth: 'I think one thing that we've been involved with a little bit are the LGBT issues. The change there has been huge. I remember when I first moved back to Edinburgh in 2000 or so, one of the first demonstrations we went on was against Clause 28.[10] So, still at that point, there was legalised discrimination. And now the change has been so huge, the whole thing around equal marriage and so on.'

Sean Maddison Brown: 'Sheffield's changed. I was born and bred here. But Sheffield is a terribly, terribly conservative city with a small c: very, very, very conservative. And to see the changes that have occurred whilst I've been here is phenomenal. I can remember being in a gay pub only few hundred yards from here [Crucible Theatre] and them having to put shutters down because it was being pelted by yobs. That's not very long ago. And now I've seen young men holding hands in the city. Rare, but it does happen occasionally, and nobody takes any notice. I'm not saying the choir has had a major impact on all that, but it's part of that change.'

Overall, our interviewees typically considered that the world was currently in a dark place and that much recent social change had been for the worse. Although their assessments of the political present were distinctly dystopian for the most part, a number of people did manage a stoic counter to their own despondent moods: 'plodding on', 'chipping away'…Others reacted with a stiffening of their resistant resolve and experienced an increased feeling of solidarity. Voicing an incredulity at the political madness of the world that was echoed by other interviewees, Elaine then reminded us of some of the progressive political gains associated with more devolved government in Scotland, along with progress on environmental issues. By contrast, voices from street choirs in Wales were silent on any gains of devolution.

On the brightest side of dark times, once again street choir members

noted improvements in LGBT rights and a parallel cultural shift in acceptance. While we, too, celebrate some significant advances in this regard, we are aware that they come with real costs attached and the production of new exclusions.[11] On exclusion, Brown notes that marriage equality in parallel with austerity politics in the UK, specifically the Bedroom Tax, serves to isolate and penalise those 'others' whose relationships do not conform to the new norm.[12] Observing that advances in LGBT rights were also fragile, Pat Richards nevertheless took them as an encouraging signal that change might be possible on other fronts, if we 'keep going.' Jenny Patient commented: 'I think it's a "change is possible" story but not an "everything is alright now" story. Like the Berlin Wall coming down showed change was possible, but was followed by privatisation and the rise of the right in Eastern Europe. Overall the changes around LGBT give me hope, both for policy and culture.'

Recalling Butler's observations of precarity, rather than being intimidated into self-reliance and communal silence, street choir members were taking the responsibility, collectively, to act – to sing – for others. Most members with whom we spoke were stubbornly defiant and aware of a need to foster a sense of hope in their wider communities. They kept singing, not only because it felt good, but also because of their principles or values: commemorating past struggles and singing out against current injustices. We observe that the morality embodied and expressed by street choirs can be described as an ethics of care, enfolding compassion, justice, responsibility for self and others, diversity, solidarity, (hard) work, and a defiant, determined and, in some instances, desperate sense of hope.

HOW HAS YOUR STREET CHOIR IN SOCIETY CHANGED?

If society and the political climate had shifted to a darker place, albeit with odd chinks of light, how did our interviewees think their street choirs had changed: had they gone gently into that good night or raged against the dying of the light?[13]

Leni Solinger: 'It was really hard in the eighties, the politics was hard, but there were loads of things to sing at. So, that's what happens, the worse the politics get the more you sing all the time. There's so many things to protest against.'

Moira Harbord: 'I mean, we've [Strawberry Thieves] got busier, there's certainly that. There is no shortage of issues that need addressing, unfortunately, and you can get burnt out quite quickly, you know: it could be like three [gigs] a week, and they might be over the other side of London or they might be in Brighton. I think: do I have the energy for this? I suppose you have to think about balancing your life... You shouldn't feel it is your total responsibility to solve the problem of climate change, actually it's a process, but it's also everybody's responsibility. However, it's also an individual responsibility, that's what gets you out in the pouring rain, the freezing cold, standing on a corner [laughs].'

Ian 'Onion' Bell: 'It's a really difficult time, really scary times...I know some people in the choir find it hard to carry on, but we need the choir, because there's that space, where we can push back against what's happening in the world. I see people are really struggling, especially [when] you get people voting for Brexit and Trump, and we feel like a minority, and then terrible things happening – Jo Cox getting murdered, Syria getting bombed, and being on the verge of nuclear war again – after thinking we'd dealt with that a long time ago! It's really hard for people, but that makes the choir even more important. Hopefully [it's] just a temporary blip in the course of humanity!'

Ilona McCulloch: 'The world has changed in some ways, some for the better as well, but, you know, we still sing those songs where people were striving to get things changed, and things did change. However, we don't stop singing the songs because people need to know what the struggle was.'

Wendy Lewis: 'Well, I think there was a lot of unemployed men at the time [*circa* 1983], which made it easier to recruit basses. [Interviewer: There's quite a few unemployed men now?] Yes, but the sense of community was quite strong then, I think. The new people who are coming in are increasingly like young students and so on. You're always

going to get that, the people who are available are going to be either be students, who have the time before their final exams, or retired people – not very much in the middle…I think there's so much more fragmentation, and Brexit has created these fissures in class and race and identity and so many ways, that it's even more important for us to be singing now, I think. But it's…There's no easy answers. It's like going back to first principles: what do you believe in? What do you support?'

Martin Vickers: 'The invasions of Iraq and Afghanistan were big moments for the choir. We found ourselves having to sing an awful lot more anti-war songs than we might normally like to sing, you know.'

Annie Banham: 'I think the choir always reflects what goes on in society and the wider world. Um, I think also, there has been such an explosion in choirs recently, so people are finding this is a good outlet for protest campaigning… But I think, just naturally, the makeup of the choir changes what we do. So, now we've got a lot more younger members, we can go out and we can do things…We don't just react to things, but I think we kind of absorb a lot of the things bubbling around, and then that does come out automatically in what we sing. And I think we, because we all get on so well, and there's always a lovely feel to Clarion…Almost without knowing, there's this kind of osmosis that we kind of think that'll be a good thing to do, let's try that…I think there is more energy now, and I don't know whether that is about people wanting – in the current climate – to really shout and trying to get those messages out there.'

Charlotte Knight: 'I do feel fairly pessimistic at the moment. It seems greed and capitalism and individualism dominate, don't they. And, you know, I do find that very hard. Because, it's not what I…I grew up just post-war, at a time of, you know, optimism and belief that the world could be better and that, you know, nationalised things was the right way to go and I just had belief that things like we would have a decent education with no more private schools and certainly no faith schools. And we'd have a free National Health…All those things I believed in as a youngster, thought would just get better. And of course they haven't. You know, for all that we've made great strides, for example with gay rights,

there's still a lot that needs changing. And for all that Leicester is such a diverse city, a majority black city,[14] there's still plenty of racism that needs to be dealt with. So, I think we'll always have some things to sing about!'

Ruth Owen: 'Well, it's been a pretty tough struggle, hasn't it: Twenty years of Thatcherism, followed by New Labour, and then we're all going backwards, and then Brexit oh my god! I just think we've got an uphill struggle. It may work in favour of people who believe in fairness, because if people suffer they might listen to alternative ideas. Côr Gobaith need to keep fighting the battle, I can't see how we can change much of what we do, we just need to keep getting out there and telling the story.'

Chris Norris: I don't think that the heart has gone out of politics, well maybe it has – not our [choir's] politics – but there's something sort of dead and inert and people don't seem to care very much nowadays: it's very hard to engage them. That's partly where the singing comes in, in fact. I think very often, even if they're quite opposed to the things we're singing about or singing for, it's – what do you call it? – cognitive dissonance: music appeals and has quite an emotional power, but once they start listening to the words it either doubles the appeal, if they're with us, or it creates this sense of discordant responses. There is the feeling sometimes that people are so apathetic that it's difficult to get them aroused, you know, even to arouse a bit of opposition. Which is a bit depressing. So, as I remember them, at least – it may just be the effect of retrospect, you know – the old days were more, sort of, vigorous and challenging. Things have become so utterly loopy and wildly, extravagantly crazy at the moment, with Trump as President and Boris Johnson as Foreign Secretary, that you can't get your head around it. It's just so weird, so ridiculous. And a kind of despairing feeling that we're heading for some kind of catastrophe, whether it comes from climate change or Trump having his finger on the nuclear button.'

Street choir members recognised that times were increasingly 'hard', 'difficult' even 'scary', specifically for certain others. Some interviewees acknowledged feeling 'pessimistic' themselves and also noticed that mood among their fellow choir members. Moira Harbord noted the need to care for the self when feeling the pressure to be self-sacrificing in worsening

political times.[15] However, Moira also deployed the term responsibility in an almost diametrically opposite sense to Butler's anxiety-induced responsibility for socially isolating self-reliance. Our respondents recognised 'fragmentation' in society, that there were 'fissures' and that people were 'struggling'. Street choirs do what they do to counter this fear and fragmentation in society, not only continuing to sing but consciously singing more. As Chris Norris records, singing can be a way of countering apathy and engaging politically with people. However, Chris' story reveals the complex tapestry of emotions in play on the street. The apathy and lack of engagement he notices are surely related to people's escalating sense of anxiety and their experience of isolation, as observed by Butler. Wendy Lewis and Annie Banham recorded that hard times had actually resulted in younger people joining their street choirs, bringing extra energy and sparking increased creativity. However, Wendy also felt that, in her area at least, there was a diminished sense of community among people, especially people who were neither of student nor retirement age. It may be that people in this 'between' age bracket are feeling the most individual responsibility for dependents and so suffering the most anxiety about their futures. In terms of why we keep doing what we do, all the street choir members whom we interviewed felt good in themselves about taking action against injustice, violence and environmental degradation: street singing remained a fun and worthwhile-seeming action even with the imposition of hard times and increasing pressure on social cohesion.

Before casting our interrogative net more widely, in anticipation of presenting the future imaginaries of street choir members, we picked up from the story of Charlotte Knight, among others, that the post-war period may represent something of a moment of utopian imagining for the left in Britain. Following a landslide Labour Party victory in the 1945 general election, a determined unity propelled the country towards realising a collective vision of a fairer society. In his film *The Spirit of '45*, Ken Loach romanticises this moment, setting it against a dystopian representation of Thatcherism and its legacy of austerity in noughties Britain. Driven by the desire for free healthcare for everyone, establishing a National Health Service in 1948 was *the* vital sign of making

the collective vision a reality.[16] In addition to equity and working-class solidarity, then, care was apparently a core value for a majority of citizens during this period of social transformation. In the future, defending the NHS is very likely to be a frontline position for street choir politics.

IMAGINE ALL THE PEOPLE[17]

Unsurprisingly, when invited to imagine 'a perfect world', a number of our respondents referred to 'utopia'. They did not, however, simply go with that flow as we might perhaps have expected: some evidently found utopia to be a problematic notion and yet others explicitly rejected its political validity. *But what did any of them mean by 'utopia'?* There exists a vast canon of writing on utopia, utopianism and utopian thought in western society,[18] and still other inspiring and informative reads on utopian practices of communal living, sometimes even extending beyond the western purview.[19] Chris Carlsson, for one, has also drawn on utopia to describe a range of prefigurative practices: political, economic and cultural activisms, dubbing them collectively 'Nowtopia'.[20] Lyman Tower Sargent identifies 'three faces of utopianism': literary utopia, utopian practice, and utopian social theory.[21] However, Laurence Davis proposes that these faces are turned away from the 'dynamic relationship between utopia and historical and contemporary grassroots social movements... There is, in particular, a pressing need for interdisciplinary research that successfully combines philosophical and historical analysis of the concept of utopia with an empirical understanding of social movement processes.'[22] Davis writes that utopia may be 'understood as an empirically grounded, dynamic, and open-ended feature of the "real world" of history and politics representing the hopes and dreams of those consigned to its margins. I contend, moreover, that this latter interpretation of utopia is the one best-suited to contemporary, radical democratic grassroots social movements seeking to reclaim control over the conditions of their existence from capitalist, market-driven globalization.'[23]

Encouraged by Davis' exhortation to explore the relationship between

utopia and social movements, we contemplated a utopian framing of our interviewees' imaginings of their perfect futures. Particularly as street choirs perform on the cusp of politics and art, we reasoned that literary utopias would make an appropriate analytical frame: how would street choir members' imaginings of their perfect worlds compare with relevant literary utopias? Could a review of these literary utopias help us understand the perfect worlds described by street choir members? To construct our frame we draw upon some literary utopias that resound with the political traditions with which we've already identified street choirs, namely socialism, anarchism, feminism and environmentalism. Literary utopias in these traditions, or at least those that we draw upon, tend to incorporate – or anyway interrogate – values of non-violence and peace. And, through feminist literary utopias in particular, we maintain a focus on transforming gender relations and sexual norms.[24] Of particular interest in our review are literary utopias that are closely connected with social movements and the politics of the times in which they were written. We observe that there could be something akin to a double hermeneutic in operation here, whence we derive our analytical framework from popular literary utopias that may well have influenced at least some of our respondents' imaginings of their perfect futures.

Whatever social arrangement they propose, utopias typically present different ways of governing society: alternative power relations, politics transformed…Thence, literary utopias are most frequently analysed not only as works of fiction but as critiques of society and/or political blueprints. Because all utopias propose a better world, typically set in the future, they pose normative questions about the way we live in the present: utopia is an ethical concept. Another reason that we are attracted to it as an analytical framework is that, unlike much of political theory, which tends to abstraction, utopian literature is concerned with describing everyday life transformed in very material ways. That said, utopian author Ursula K. Le Guin maintains that the unconscious mind is a partner in writing – and reading – fiction. This contributes to fiction's intellectual inaccessibility (and so its power): it is impossible to reduce to rational ideas. For Le Guin, the prospect of attaining freedom (the

good) means accepting unreality (the intangible, 'no place'). For us, this indicates that 'art' has a special role to play in our attempts to imagine perfect futures. Literary utopias are typically optimistic about the human condition, the intelligence of our species and our ingenuity. (If they weren't, the future imagined would surely be dystopian, at least from a human perspective?) Moreover, utopian literature is resolutely located in place, albeit that place is fictional in some instances. Knowledge and education are key elements of progressive literary utopias. Unsurprisingly, leftist utopias are characterised by being more equitable. Later, we'll discuss some criticisms of utopian thinking.

TURNING THE PAGE ON UTOPIA

At the end of this section we will have introduced some literary utopias to frame the passages of street choir members' stories gathered in this chapter. Because the originator of the notion, Thomas More, presented his eponymous work in a fictionalised account, utopia is rooted in the literary tradition.[25] Utopia literally means 'no place' but More simultaneously invested the term with the quality of being a good or happy place (Eutopia), casting it as a perpetually elusive notion.[26] More's *Utopia* has exerted an influence on progressive thought for more than five centuries and it continues to do so: we are not alone in exploring utopian imaginings in the context of politics and social movements. In a recent themed issue of the 'radical red and green' magazine *Red Pepper*, editor Ruth Potts wrote:

'On the island of Utopia there is no private property; houses are allocated by lot and people move home every ten years. The doors of houses swing open so that people may come and go as they please, gardens are shared, meals are communal, and age is respected. The working day lasts just six hours, which is enough to provide for everyone's needs. Time after meals is spent reading or making music. There are public lectures every morning and manual labour is valued. Society is equal, and gold and silver have no more respect than their intrinsic value

deserves, 'which is obviously far less than that of iron.'[27]

Proposing that imagining a better world is the first step towards creating it, Potts concludes her editorial:

> We can, and we must, be bolder in imagining how the world could be. What we have is, after all, the product of our imaginations. Which is not to discount power, oppression and vested interest, but to recognise the subversive and practical power of imagination. There is a rich territory for us to occupy with bigger, brighter, more confident vision.

Utopia not only seeded a literary genre, it also established many of the themes of radical future imaginaries. Writers of progressive utopian fiction have developed these themes and added strands to the tradition. When we asked Strawberry Thieves' John Hamilton to imagine his perfect world, he responded: 'Oh, read *News from Nowhere*! I want a world without money and without class division, because we've overthrown the ruling class.' William Morris published *News from Nowhere (or An Epoch of Rest)* in 1890.[28] Morris was writing in a period of history marked by the collapse of empires, the revolutions of 1848, and social change across Europe. No coincidence, then, that Marx and Engels published their avowedly anti-utopian *Communist Manifesto* in the same year.[29] As well as being grounded in his familiar London geography, Morris situated his utopia in history, having his characters discuss how the transformed society had been fought for in past reality by Socialists.

Community and equality were central to Morris' thinking. Common ownership and mutuality were the economic basis for his utopia in which money plays no part. While creative work is placed joyfully at the core of the good life and self-realisation, irksome work is done by machines or shared equitably. In Morris' utopia, the products of creative work have two defining normative qualities: they should benefit the community and they should be beautiful. In *News from Nowhere* society has moved beyond the centralized state and a localised participatory democracy holds sway. With air and noise pollution eradicated from a

London of many green spaces, *News from Nowhere* reveals Morris as a proto-environmentalist.[30] In contrast to his prescient environmentalism Morris was apparently blind to the politics of gender: household work in his utopia remains the province of women and is neither mechanised nor regarded as creative work. To his despair, Morris' satirically named protagonist, Guest, is returned to his own time. His experience of the utopian future acts a spur, however, and he realises he must work towards the social transformation he has experienced (or dreamed). Laurence Davis summarises *News from Nowhere* in a way that, we propose, has very clear implications for street choir singing:

Unlike so many utopian writers, Morris did not attempt to prescribe in law-like detail how people ought to live their lives. Rather, he developed a new chastened and anti-perfectionist style of utopian writing that was neither prescriptive nor prophetic but heuristic. It was a style, in other words, meant to help awaken ordinary people's latent hopes and desires for a radically egalitarian, co-operative, and creative form of life; provoke them to reflect on, and discuss and debate collectively, the rationality of hopes and desires; and so give them the courage and confidence necessary to strive for the studied convictions that emerged from the process of constructive imagination, reflection, and democratic dialogue.[31]

Following in Morris' anti-perfectionist footsteps, in *The Dispossessed* Le Guin portrays an 'ambiguous utopia', a world that can never be perfect because perfection tends to oppression and so must always be challenged (whence such challenging actually becomes definitive of perfection).[32] Conceiving her novel at a turbulent moment in history, Le Guin drew on the works of Lao Tzu, Peter Kropotkin and Paul Goodman. The anarchist-communist Anarres is contrasted with Urras where capitalism presides and is portrayed as antithetic to human self-realisation.[33] Anarres is a participatory democracy with local decision-making at its heart. Without actually naming care, Dan Sabia records that: 'Individuals on the account of the anarcho-communist are radically social. They need one another not only when they are in pain, or in trouble.'[34] Common child rearing, public housing, public transport, communal meals, and public service

days are features of Anarresti society. Marriage and the nuclear family have been rejected to encourage more egalitarian gender relations. Environmentally, Anarres features resource conservation and recycling in a geography of scarcity. Paradoxically, the utopian weakness of *The Dispossessed*, in relating how personal autonomy and social solidarity can never be fully reconciled, is also its ultimate strength when read as political theory. Claire Curtis proposes the novel as the philosophical foundation for a different sort of utopia that is premised on scepticism rather than perfection.[35]

Published in 1979, just two years after *The Dispossessed*, care is the essence of Marge Piercy's *Woman on the Edge of Time*.[36] A ghastly, uncaring present, firmly located in Piercy's own time, is contrasted with a future society in which care is taken to a profoundly startling 'extreme'. In Mattapoisett women have given up the power to give birth; babies are genetically engineered; care-giving is shared equally by men, even to the act of breast-feeding; children are raised by three 'mothers', unrelated to the child, who may be men or women. 'Mothering (caring work), then, must be incorporated as a human experience and located at the center of culture, rather than remaining at the margins of culture as women's work, undervalued and/or sentimentalized.'[37] Regardless of their race, citizens of Piercy's future can choose to live in communities based on ethnic cultures. Meanwhile, as people inhabit a more androgynous environment, gender is much less of a cultural and somewhat less of a physical binary. Environmentally, Piercy's novel is an early example of ecofeminism, as the exploitation of women is paralleled by mistreatment of the earth. Piercy's account is clear about the intersectionality of its protagonist's oppression on the basis of her gender, race, class, poverty and mental health. Billie Maciunas writes that 'feminist epistemologies indicate revolutionary changes in knowers, ways of knowing, and to the worlds to be known. They ought to and do show us "the conditions necessary to transfer control from the 'haves' to the 'have-nots.'"'[38] Marge Piercy has said of the novel: 'it's very intentionally not a utopia because it's not strikingly new. *The ideas are the ideas basically of the women's movement.*'[39]

Ernest Callenbach's *Ecotopia* emerged from the same turbulent times as *The Dispossessed* and *Woman on the Edge of Time*, and it picks up many of the same themes, though quite differently.[40] With its advocacy of bioregionalism, local food production, energy conservation and recycling, the novel has been hailed as predicting so-called sustainable cities in the United States. A mixed bag politically and economically, *Ecotopia* is essentialist in its portrayal of gender and race. For us, with Brexit and devolution in the UK in mind, a striking feature of Callenbach's utopia is secession: *Ecotopia* has seceded from the United States in order to be able to achieve environmental sustainability and – *consequently, it seems* – a more participatory democracy. Set in a similar geography but stemming from a different time, Starhawk's *The Fifth Sacred Thing*,[41] published in 1993, unfolds in a post-apocalypse San Francisco in 2048. Another environmental utopia, Starhawk's city is a pagan, eco-feminist variant. The fifth sacred thing is 'spirit,'[42] accessible to humans only once the environment – represented by the four classic elements: fire, earth, air and water – has been balanced. The main contribution to our analytic frame is the novel's defining focus on diversity, represented very differently from the agglomeration of *Woman on the Edge of Time* or *Ecotopia*'s voluntary racial segregation: Starhawk's San Franciscan society takes sexual diversity as a given, actively respects and preserves the distinctiveness of all cultures and religions, attentively practices care for the disabled, and honours older people.

We can now derive a list of progressive utopian features with which to frame the political imaginaries of street choir members. Some features remain distinctly problematic, however. Just one – highly pertinent – example is care. Recall that Held acknowledged: 'The social changes a focus on care would require would be as profound as can be imagined.'[43] Well, *Woman on the Edge of Time*'s imagining of such social changes was certainly profound. Martin Delveaux senses the dystopian in Piercy's future, stressing the perils of eugenics.[44] Confronting criticisms on reproductive rights, Piercy has said that, were she to re-write the novel, she would include the choice for women to give birth naturally.[45] Other prominent features from our utopias include:

equality, community, mutuality, common ownership, the rejection of money, anti-authoritarianism, environmental sustainability, creativity, beauty, diversity, and ambiguity/scepticism. We note, too, that utopias are most often driven by – even invigorated by – rival dystopias: they are not fantasies that evade entanglements of power, but rather thrive on resistance to domination, or the threat thereof.[46] Merlin Coverley notes that 'the sufferings and hardships encountered' by Le Guin's utopians, for instance, are 'not only necessary but desirable, acting as a cohesive in maintaining a spirit of mutual reliance.'[47]

WE'RE THE FUTURE[48]

So, finally, we can critically regard the futures that street choir members desire: the society that they are singing for, the ways they imagine their perfect world. Along the way we will also consider the possible futures and routes to them that are expressed in some street choirs' songs. In our analysis we are always aware of how street choirs might better contribute to bringing into being more caring and just futures. In particular, we are interested in how their public performances might stimulate audiences to imagine such futures – and how to get to them; i.e. how that might not only raise awareness of political issues but also stimulate thinking about alternatives, including alternative political processes. Let's begin with some future imaginaries that largely focus on street choirs and the songs they sing:

Nest Howells: 'It's very hard, isn't it, at the moment. Well, if we're still here in a few years, it would be good to see, there are so many groups trying to do good work, bring about peace and collaboration, cooperation, it would be nice to see those having a bit of prominence, instead of all the awful things, and all the groups who are destroying things, just building on that. I just feel a bit desperate about it at the moment... [Côr Gobaith] keeps us focused on more positive things, striving for something more positive, more hopeful.'

Chris Booth: 'The Holly Near song comes to mind again: "We are

a gentle angry people and we are singing for our lives." So, it's an issue of survival that we are actually organising and resisting some of the horrible things that are happening. The anger is important but it's coupled with gentleness. So, it's not about dominating, it's not about imposing something. It's about somehow moving towards a way of living where we're actually co-operating more. I suppose there's an element, at its best, when a group like Protest in Harmony or Raised Voices is actually being the seed of that. So, we're creating a microcosm in the present of the sort of society that we hope to be more generally present, just in the way that we relate to each other: the way that we work together, the way we sing together. And I think that it's important to remember that. It's not just about a dream of something in the future, it's about carving out little niches, carving out little areas where we're actually doing that now…If we're going to get this better society, it's not just about the practicalities, although that's of course crucial, it's actually about changing consciousness, changing how we think and how we relate, changing our assumptions about how things can be. Because I think that often one of the things that prevents that kind of political change happening is that we lack the imagination to think that things could be any different.'

Claire Baker Donnelly: 'Where people have equal opportunities and equal – um – sort of equal distribution of opportunities, if you like…I love the friendliness of the choir and the supportiveness, and I wish the whole world could be like that, you know.'

Morag Carmichael: 'The ideal future for the choir to sing in? It's everyone realizing, for one thing, that we need to pull together to save life on Earth…And, actually, that means we've got to cooperate and stop taking more than our share, you know. And through cooperating it actually should become fun, actually: much better relationships with everyone…If you are really cooperating, it is fun.'

Ruth Owen: 'We wouldn't have left the EU, because at least that was the link where there were no passports, and freedom of movement: it would be easier for good ideas to be disseminated. I want to see socialism in Britain. I want to see world disarmament. And I want to see "the sharing of life's glories", to quote "Bread and Roses." Cos at the moment…

It certainly ain't shared right at the moment!'

Elaine: 'I think in terms of locally, and by local I mean Britain, I would like to see a fairer society... There's more social justice at that local level and so people have enough to live on, and are treated fairly when times are hard...That for me, you know, I sing about that... that's really behind why I'm there, because I want people to have better lives. In terms of globally, in a way it's a similar thing about that, you know, social justice on a broader scale. A world where we have managed to – I mean this feels utopian for me – but where we manage to sort out our differences without resorting to bombing each other or nuking folk. Hopefully, we'll never come to nuking each other because that'll be it. But a world where we've actually found a better way to deal with conflict. And if that means unhooking ourselves from some of the current economies, oil for example, and finding a different way to be in the world that reduces the need for these conflicts. Yes, so, it's a bit utopian, but a world that's living in peace where social justice prevails...I think one thing that Protest in Harmony offers is a sense of community. And I personally think that it's almost alright to have that in an end itself.'

Along with fellow Raised Voice composers Morag Carmichael and Ros Brown, Cynthia Cockburn has written a song called 'The Road'. The song is based on the poem 'Traveller Your Footprints' by Antonio Machado.[49] The chorus expresses the foundational message:

Caminante, no hay camino, se hace camino al andar. Oh!
Walking we see no road ahead, we are making the road as we go.[50]

Cynthia Cockburn: 'We have a big problem about imagining the future at the moment, don't we? The whole country and indeed the whole world is in chaos... At this moment in time, we somehow have to pluck up the courage to think that as we do walk we do make it [the road ahead], that we're laying down the parameters for the world we want by the way we're doing it. Street music is good in that sense: it's convivial, it's taking communication and relationship with people out there in the world seriously enough to not just write an article in *The Guardian*

but to go out and sing to them. It can be part of searching for an active revolutionary movement.'

Karen Jonason: 'I'd like to see the choirs grow and every town having one... It's a great movement, used to be. I mean the Workers' Music Association, they used to have... choirs all over the UK and now they've only got about three left. And, then, all over the UK choirs were a big thing, but that could have been... Perhaps more people were involved in grassroots politics. And also, it was before the era of TV and the mass media and people stuck to their laptops and their iPhones etc. However, I think that modern technology can be used to our advantage as well.'

Jane Scott: 'I'd like to see a fair society and I would like to see us [Birmingham Clarion Singers/street choirs], kind of, gilding the lily rather than having to struggle for people to get basic rights, you know. "Bread and Roses", really: I'd like to be giving people the roses.'

Caring relations within street choirs was a through-going theme in people's stories. Such relations served to foster solidarity and a sense of hope that inspired street choir members to keep singing and so doing their politics. Street choir members echo a number of the virtues that we gleaned from our reading of literary utopias. In particular, we note a take on economy, specifically from the song 'Bread and Roses', that demands more from the perfect future than meeting basic material needs: 'Yes it is bread we fight for, but we fight for roses too' is surely an active wish for a world of more caring relations, a world of beauty and, indeed, love. Prefiguration emerged as a conscious feature of street choir life with people striving to be the change they want to see in the world via the way they relate to others. Raised Voices' song 'The Road' reproduces a compelling take on prefiguration, casting utopia not as a completed vision or final destination but as always a work in progress, a journey. We will return to this key theme of prefiguration. Meanwhile, justice as fairness, sharing and equality was clearly a key motivation for people's political engagement. For at least some street choir members, singing, their political activism, is an existential act: they truly fear for the survival of life on Earth, especially in the face of environmental crises and the terrible prospect of nuclear conflict. This apocalyptic

perception invests people's political singing with a zealous passion. In Morag's account, such passion went hand in hand with a prefiguration in which the fun of cooperating featured prominently. Also focussing on a possible apocalyptic future, Elaine's aspiration to non-violence was tempered by a realist awareness of the difficulty of achieving peace. Let's now turn our attention to peoples' imaginings for the perfect world beyond their street choirs.

Ian 'Onion' Bell: 'When I close my eyes and imagine, if we all just went out there and made the world how we want it to be, as individuals, we'd be doing it collectively. When the sea washes up on the prom in Aberystwyth, people go out there with brooms and sort it out themselves[51] – we don't need government to tell us what to do, we know what needs to be done.[52] So for me that would be where I'd be aiming for. Probably that's a very simplistic way of seeing things, but unless you have that kind of view you're never going to move towards it – to encourage people to stand up for what they believe in. Maybe, hopefully – Choir of Hope![53] It's more around things about Occupy and that kind of approach really – and the 99%, Noam Chomsky, I would say that kind of philosophy – more than any big utopia, kind of nirvana place. It's making things how we want them, and working together for the good of everybody.'

Eileen Karmy: 'I hope that we could have a future more, I don't know, democratic and horizontal...Different countries with not so much authorities or hierarchies. Especially for those countries that are, you know, in the worst positions because of other countries that dominate them or take their resources or establish wars over them and occupy them or... It's difficult to know what is going to happen but I'm not very optimistic in this way, but I hope...For example, in my own country [Chile] for the first time in, I don't know, thirty years, we have a coalition of really left people for the next presidential elections. They have not any chance to win but at least they are organising themselves...And for the future, maybe in several decades more, they can win the election. So, that's something that we didn't expect and now it's happening. Because they were struggling since, I don't know, the late [nineteen] nineties.'

Andy Dykes: 'Well it would be, certainly in a country, a community,

that did take the time and trouble to think about each other, that didn't walk by. I suppose I'm going back to my, my sort of Christian roots, Sally Army roots, analogy, you know the parable of the person who's on the side of the road in desperate need and the people that walk by on the other side and you just think: why, two thousand so many years later, are we still walking by on the other side? Why can't we think about each other in a caring, compassionate way? Why do we have to have this blinkered attitude of: I'm alright Jack, fuck you?...for some people, you know, it would be: "utopia, it's not possible." But it's only not possible because we're not...not working towards it: because we're so into dicking over each other.'

Lesley Larkum: 'I'd like to see a society where we together build the alternative...where you place the human being at the centre of all considerations. In today's society, capital is at the centre of all considerations...We talk about providing health that is affordable, or housing that is affordable, or not being able to afford to give rights to refugees because we can't afford it...We can afford to find billions to fund Trident and we can't afford to fund our national health: It doesn't make sense...So, the future is a very exciting one: where we all must play a part, where mechanisms must be found, where each individual has their place, nobody should feel on the margins...In the future, wouldn't it be wonderful if the cultural life would...all be part of life? And it should be! We are all working so damn hard just to survive and then you have no time left to be human.'

Prefiguration is once again a prominent theme in this set of stories. 'Onion' Bell and Eileen Karmy draw attention to the actions of wider social movements and the inspiration they provide. Both 'Onion' and Elaine ponder futures of more anarchist political relations. Andy Dykes is very clear on the work involved in making the road as we walk. He also pinpoints the compassion that such work must entail, specifically for strangers. With his referencing of the story of the Good Samaritan, Andy enhances the metaphor of the road: a journey invested with the practices of an ethics of care *is* a utopian destination. Like Andy, Eileen Karmy highlights work – organising – as a virtue of prefigurative politics. Evident

in many of the stories we heard, as well as in our own involvements with street choirs, perseverance is also a vital prefigurative virtue. For Lesley Larkum, care would be the guiding ethic of a future economy: an economy that made time for leisure and integral space for cultural expression. Lesley also viewed sociability as a virtue, while echoing *The Dispossessed's* concern with finding utopian space for individuality. Our next few stories extend prefiguration to another of the key themes to emerge from our interviewees' imaginings: perfectability, i.e. futures that can be (made) perfect.

Annie Banham: 'Oh, it [the perfect future] looks glorious! It looks like a society where people actually care about each other, and I think in the last few days with all the horrible stuff that's gone on in Manchester [Arena bombing, 22 May 2017] there's been elements of that, where people have, they've opened their hearts and they've opened their doors and, um, and they've used humour…And that's the kind of society, I'd love to see out there: that people don't rush to be angry, that people kind of think about each other, and think about nurturing each other…and life isn't about possessions and competition, to me it's about sharing and openness – and being happy…Oh, yeah! We'd [still] be singing for joy! Which to some degree we do now, because I think that we do sing for joy, that there is hope, you've got to have hope. Otherwise, what a terrible life it would be, no hope. You always have to have that future ahead, that's what we want!'

Pat Richards: 'My vision? Lots of wind turbines and solar energy and a government that actually listens to us, a government that represents more than the rich. Some future for our, whether we have children or not, some future for our young people…I'd like to see a massive sea change in politics. I again think that means us coming together: strength lies always in an alliance of progressive people, young, old, everybody. I can't see any other way forward. I don't think it's in the old parties, really. If all of us who felt green was best voted together. I'd like a different parliamentary system, and different parties and just some acknowledgement that we have this one planet, and we're wrecking it, we're ruining it.'

Steph Howlett: 'It would be multi-racial; it would accept diversity. It

would be a world where people looked out for each other – it's really decent human values – supported each other; where we cared for the planet; where it wasn't driven by consumerism and having to have an economy that's always growing so you're using up more and more resources. It would value people's work and provide education, healthcare, and hope for everyone. It's a utopia, isn't it, but that's what we need to aspire to!...It would be a different place for the choir, wouldn't it? Because in that kind of world it would be singing within the mainstream rather than campaigning.'

George Askwith: 'A future of equality. I have a friend in Italy who is becoming increasingly right-wing because of the situation there with migrants... And she is very much of the [view]: We have to look after our own. Whereas, I think: no, we're all on one planet and if my living standard has to drop so that someone isn't trying to make a living on a rubbish dump in a Third World country, then that's okay because that's how it should be. We have a planet that we could divide up the resources so much better than we do now, that's what I'd like to see. So, not just LGBT, but equality for everyone.'

Ilona McCulloch: 'A world where we don't have hate. Where people can all love one another, live together, you know. Basic human rights, I think. A world where we can support one another. Where we don't have these divisions, particularly between rich and poor. A fair society.'

Sean Maddison Brown: 'A gay choir might not exist in the future. The need for it would disappear...I'd still be singing because I like singing. And I suppose it would be a community choir because I couldn't cope with an audition [laughs]. The issue of gay should disappear, like the issue of women should disappear. The issue around women and women needing to come together, to be separate, to have support, to fight for their rights and so forth. In an ideal world we wouldn't have any of that because we would be [equal].'

Diane McKinlay: 'It would be a much fairer and more tolerant world where people actually genuinely respected one another and were a united community...So, yeah, in my world there would be no borders and people would treat each other properly, however you define properly – just,

you know – and see beyond the divisions…And I just wish more people would see through kind of capitalist, selfish: "I'm going to organise the world, because that's the way it suits me, so that I can make loads of money out of it, I actually don't care about the rest of you." That is just so despicable to me and I wish more people could see through that and see that it would be a better world if we were all looking after each other and doing things because it was right for everyone.'

Val Regan: 'I think there just has to be an end to this distancing of ourselves from other human beings who are just like us. That just seems to be underlying absolutely everything… Capitalism encourages us to brutalize ourselves, that's what it is, and then when we become brutalized then we start pushing other people away and when we start pushing other people away we start thinking they're not worth the same as us or they're different from us and then we stop caring and on and on it goes… That there's just an end to them and us in every way that can possible happen. That we're no longer institutionally and systematically set up to be divided from each other. I think that's the ultimate oppression that leads to all other oppressions.'

Diana Bianchi: 'It's a big dream, we're all brothers and sisters in one, one big global village, regardless of race, colour or religion. A family, a family of man, isn't it, or woman [laughs], tolerance…And obviously to get rid of capitalist greed…We are destroying everything…ourselves, destroying the values of people who are trying to show us a better way of life – and destroying the planet! And that's all to do with greed' [Interviewer: Would you still sing?] 'Yes, we'll be singing harmonies with everybody else…from the same hymn sheet of peace, justice, freedom and happiness.'

Ziba Nadimi: 'The world I'm singing for is a fairer world. The world with more togetherness. Less people being pushed into their boxes. A feeling of support that people potentially can give to each other. Because I just believe that it makes it a wonderful, fun, happier world – that we don't have at the moment. The fact that we are being pushed into our boxes frightens me. For future generations, for my kids and my grandchild, I find it very worrying.'

For Ziba, 'being pushed into our boxes' meant being pressed to think only about number-one and not seeing or caring about others. She told us: 'It doesn't matter who is fainting next to you; doesn't matter who is in crisis – your next-door neighbour: you don't know about your next-door neighbour although some of them are dying of loneliness, you don't know about that.'

One again, caring relations impelled and infused the future imaginings of our interviewees. Care and capitalism were repeatedly posited as antithetical. As in our literary utopias, the conception of value and thus the constitution of economy were vital aspects of people's stories. As the future loomed larger in people's stories, so concern for the environment came to the fore, and some of our stories clearly linked environmental sustainability with a more equitable human economy. Diversity emerged as a key value, with welcome and communality as associated virtues. Steph Howlett and Diana Bianchi brought integrated or multi-racial societies to the utopian fore. As with Sean Maddison Brown's speculation on 'gay' and 'women' disappearing as issues, there are echoes of *Woman on the Edge of Time*'s agglomerating take on gender and culture in the imaginings of some street choir members. Meanwhile, intersectional and international solidarities were prefigurative utopian political forces anticipated by, among others, Pat Richards and George Askwith. Joy, fun and happiness featured prominently in a number of people's visions of the future. Remembering the Turbulence Collective's inquiry into what it would mean to win, the stories of Steph Howlett and Sean Maddison Brown, especially, raise the question of what it might mean for all our activist identities to be singing as part of 'the mainstream'. While such a question might be utopian in the concept's most abstracted sense, imagining such a scenario may yet serve to illuminate alternative directions of travel on our shared road to the future. For us, a key statement in this set of story extracts came from Steph Howlett: '*It's a utopia, isn't it, but that's what we need to aspire to!*' In this, Steph echoes *Red Pepper*'s Ruth Potts. Let's turn our attention to a final set of stories wherein our respondents are (even) more sceptical or 'realistic' about utopia and utopian imagining.

Bernard Bourdillon: 'That's not the way I think. I think you are asking me to fantasise, to put to one side constraints... I'm a humanist, I believe in the importance of evidence, of, and in a certain way, I mean: things like women's rights follow from the fact that anything but gender equality is so absolutely stupid...evidence of absolutely fundamental underlying equal-ness in humanity. So, one talks about fairness and equality, about respect for the individual...about an understanding that the world is precious, that the earth is precious, about the future and humanity is precious and things can flow from that. I could go on and on.'

Rosemary Snelgar: 'No cars in central London! Why do we have cars in Central London? You know, we've got really good transport, why do we have cars? Renewable energy sources, solar panels on every roof... A joined up approach to housing and not saying, as people seem to be saying now, we should... give up the green belt because people need housing, but that protection of our green belt is why we've got the reasonable amount of environment that we have now...Wages and salaries, I can't bear the thought of these people on obscene amounts of money and there is a suggestion – I've forgotten where this comes from – that the lowest-paid person should get no less than one tenth of what the highest paid gets and that should include contract staff...Less commercial, throw-away society would be nice, as well, not having so much stuff. People want "stuff" [laughs]. I like scarves...I have a huge collection of scarves... [I'm] not immune.'

Rod London: 'I'd like to be in a world, which is less politically divided, where there's a stronger sense of social, political and economic inclusion of all the constituent parts of the country, um, in which we have a strong sense of looking outwards to the rest of the world, to Europe, to the rest of the world which is feeling, I think, increasingly closed off.'

Andrew Wilcox: 'A generally more accepting, more socially equal – economically equal – society, really, would be the ideal. Something that values, you know, the planet and respects that...Peace everywhere and harmony everywhere, I don't think that exists. As human beings we have to strive for things and there's an element to us where there'll always be conflict whether that be physical or ideological conflict. But a society

that kind of encompasses, is more enlightened and less competitive and less violent.'

Chris Norris: 'Well, it's got to be a realistic utopia, I think. It would be something like traditional socialist utopia, actually. Or even a communist utopia, which really is the socialist utopia minus all the compromises and fudge. So, it would be: from each according to their means, to each according to their need.[54] And it would involve a thoroughly socialist and democratically organised restructuring of the means and relations of production. And it would be an end to all the entrenched ways of perpetuating class prejudice and differential opportunities. All standard socialist things, really. And it would be a massive improvement in [the] education system. Because the education system exists at the moment largely to deepen and perpetuate differences of opportunity. It would certainly be an end to [student] fees… Above all, everyone should get the same income. That's the absolutely crucial reform; and the recognition that being good at anything is great, and if you're not particularly good at anything, still, you should still get exactly the same wage…. Oh [we'd] still be singing, yes: the same things! There'd still be private tragedies, wouldn't there: there'd still be malfunctions of the system, and there'd still be all kinds of injustices. I mean, that's why you can't really talk about utopia.'

Paradoxically, Bernard Bourdillon's humanist viewpoint with its faith in reason seems to resonate with the optimism that literary utopias typically have about the intelligence of our species. In her utopian imagining centred on environmental sustainability and reduced inequality, Rosemary Snelgar raises the critical question of our own implication in the perpetuation of capitalism. A number of theorists have also posed this question. Charles Lee, for instance, notes that it is impossible for academics and activists to maintain a 'purified' opposition to global capitalism: we are also producers and consumers and so simultaneously configure the political life that we critique and resist.[55] Rod London and Andrew Wilcox voice modest aspirations for the future that are distinctly non-perfectionist. Andrew then expresses the ambiguity that Le Guin wrote into her utopia: the perfect future will always be a contested work

in progress. Chris Norris also notes this ambiguity, taking a thoroughly grounded view of the future in explicating his 'realistic utopia'. Ambiguity, then, joins perfectability and perfection as a key theme of the future imaginaries of street choir members.

UTOPIA UNDONE?

In our utopian framing of interviewees' imaginings of the perfect future we have opened up something of a can of worms. Most of our interviewees, it seems, whether they embrace or reject utopian imagining, have quite a different notion of utopia to that which we derived from politically relevant literary utopias. With the notable exception of John Hamilton, most of the people we interviewed appear to equate utopia more with a fantasy take on the future than a political blueprint. Utopian thinking is often criticised for being nostalgic and, worse, unrealistically nostalgic: hankering after a time that never was, or at least for a romanticised version of a period in history; wholesale or piecemeal, that period is then transplanted into an imagined future. Under the banner of nostalgia, utopias are accused of harping back to the pastoral or Arcadian, pre-industrialisation days of self-sufficiency, supposedly simpler times. In such cases, in addition to imagining the future, authors are viewed as imagining the past. Critics of utopianism, particularly adherents of Karl Marx, have observed that all too often these time-travelling imaginations fail to ground themselves in 'real' history. David Pepper, as just one pertinent example from a plethora, concludes that the transgressive potential of environmental utopias is ambiguous and limited by idealism and unrealistic assessments of actually existing socio-economic dynamics.[56]

As Lyman Tower Sargent notes, utopianism starkly divides political theorists into pro- and anti- camps.[57] From our reading of politically relevant literary utopias, we derived a utopian analytical framework that is sceptical or ambiguous and grounded in the everyday world of material things. Philosophically diverse commentators have spoken of 'realistic',

'concrete', 'relative' or 'active' utopias to express this kind of take on the notion.[58] In a similar vein, Marge Piercy writes that:

'Utopia is born of the hunger for something better, but it relies on hope as the engine for imagining such a future. I wanted to take what I considered the most fruitful ideas of the various movements for social change and make them vivid and concrete – that was the real genesis of *Woman on the Edge of Time*.'[59]

In an attempt to counter a demotivating theoretical impasse in some Marxist analyses, Andy Merrifield has argued for 'de-materialised Realist Marxism.'[60] Merrifield's 'Magical Marxism' conjures imagination to focus on the future rather than history, emphasising passionate local action ahead of cold-blooded structural analysis.[61] In everyday, real-world practice, the social movement that has variously been labelled 'the global justice movement', 'the alter globalisation movement' or 'the movement of movements' fosters a utopia that is constituted through such countless and diverse local strivings.[62] The quote from Subcomandante Marcos with which we opened this chapter comes from one of the most influential of these localised struggles, the Zapatista movement in southern Mexico. Such attempts to reimagine and practice the future through prefigurative politics, often recognise the importance of democratic political processes as a utopian goal in itself.[63]

Another bank of criticism targeting utopia focuses on its alleged tendency to ideology and totalitarianism. Sargent writes that 'if a utopia is sufficiently attractive and powerful, it can transform hope and desire into belief and action to bring the utopia into being through a political or social movement.'[64] Acknowledging that in reality such a transformation is a rarity, Sargent nevertheless cautions that bringing utopia about will almost certainly transform it into ideology, whence it must be challenged by one or more new utopias. A utopia that denies change succumbs to ideology, understood here as any dogma that, while it is driven by utopian thinking, tends to entrench power relations and foreclose the possibility of social transformation. As we've seen, although some literary utopias do tend to be static, more insightful utopian authors realised the need for challenge and constant change in their imagined future worlds. As

such, utopia can be a vital tool for critiquing ideology (including by street choirs in the composition and performance of their songs).

We have no wish to take sides in any 'war of the utopias' that may smoulder on in political theory. The analytical framework that we derived came from a literature that might just as well be described as political visions rather than literary utopias. All the authors whom we drew upon constructed their visions from political theory and/or the ideas and practices of actual social movements. Like Laurence Davis, our understanding of utopia is as an empirically-grounded, dynamic, and open-ended feature of the real world. If our research can contribute anything to an intersecting theory of social movements and utopia, it is that we might embrace Thomas More's paradox and simultaneously imagine the good and the intangible. If we can do so without wholly succumbing to either escapist fantasy or hopeless inertia, we just may reveal a glimpse of another possible world, a better world that is achievable. Citing Le Guin's novel *The Farthest Shore*, Katherine Buse argues that seeking utopia in times of ecological crisis must transcend the boundaries of 'the possible' (N.B. this is in sharp contrast with the view of David Pepper, highlighting perhaps the crux of the theoretical division on utopia).[65] In a similar vein to Buse, in the context of mitigating climate change, Dale Jamieson stresses the inadequacy of our current conception of practical reason and (so) the paralysis of our (formal) politics.[66] In real-world efforts to bring about a liveable world, Buse contends, fiction has an indispensable function. And, *if* that is true for fiction, it must surely hold for 'art': for song lyrics and music. So, street choirs might write and sing songs of utopian promise and, in those creative processes, possibly identify desirable features of political futures beyond the confines of rationality. Such songs and the singing of them may also help bring about beneficial social transformations, though possibly not those that we imagined when we wrote and sang them.

PERFECTABILITY, AMBIGUITY AND PREFIGURATION

> We are the future knocking at your door.
> Change can't wait.
> We are the ones we were waiting for.
> Love trumps hate.[67]

We've posed an awful lot of questions in the course of this chapter. So, let's review our findings and try to answer at least some of them. With some reservations and some notable exceptions, street choir members generally thought that the world they were singing in had changed for the worse. Community and social cohesion seemed to be particular casualties of this change. Perceived improvements in LGBT rights was an oft-noted exception to the worsening rule, though we have already made cautionary remarks in this regard. Some political gains of Scottish devolution were also noted. There were contrasting stories about what overall social change meant for street choirs themselves. While some accounts were pessimistic, others felt that hard times were generating increased political activity, including recruits for their choirs. Street choirs emerged as stoic in 'dark times', responding by singing more. If hope was in short supply in theory, in practice street choirs continued to expound it. In this, people were impelled by their values, acknowledging, too, that it felt good to sing with others with whom they were in political harmony.

Turning to the utopian future imaginaries of our interviewees, despite some reservations about utopian thinking, overall our respondent views of the perfect future compared favourably with the framework we drew from literary utopias. Actually, both the future imaginings of street choir members and the utopia of the fiction we reviewed were profoundly sceptical. Prefiguration emerged as a key feature with a number of people actively fostering the kind of caring relations in their street choir that they wished for in a future world. Via Raised Voices' song 'The Road', prefiguration was specifically recognised and extolled in the street choirs' repertoire. Diversity in some social form or other was a key value of a number of people's future imaginaries, while intersectional solidarity

was an aspiration. We heard a number of stories of, if not perfect, much better, more caring and just futures. For instance, while people found it difficult to imagine a world at peace, they did feel able to talk about less violent futures. We mark here the street choirs' songs in which hope extends utility beyond material communal benefit, particularly 'Bread and Roses'.

Environmentally, although they were pessimistic about climate change, street choir members could evidently see enough material evidence of change in the present to facilitate quite concrete imaginings of, for instance, more renewable energy provision in future. Capitalism was judged antithetical to the achievement of street choir members' perfect worlds. That duly noted, we observed that street choir members, like most if not all people, were implicated in perpetuating the capitalism that we resist and judge irreconcilable with achieving a just and caring future. This implication contributes to the difficulty of imagining beyond the constraints of the present. As Jameson famously repeated: 'it has become easier to imagine the end of the world than the end of capitalism.'[68] A few respondents restricted themselves to what we might term 'rationally constrained' views of a better future, insisting on future imaginaries that were grounded, realistic and/or sceptical. As we've seen, ambiguity about the notion of utopia, the need to challenge its abstractions, can itself contribute to imagining a future that is not beyond reason but that may reveal something fresh, vibrant and liberating.

THE ONES WE WERE WAITING FOR

In conclusion, let's consider how the future imaginaries of our interviewees might contribute to the development of street choirs and the Campaign Choirs Network: *what else could be done?* We are going to make three proposals. First, we propose that imagining perfection and, indeed, developing our knowledges to be better able to imagine perfection, can play a transformative role in developing our movement. With particular reference to socialist and feminist utopias, Jameson

stresses how important it is to keep trying to imagine a perfect future even though we are bound by the culture and ideology of our presents to fail.[69] Only via repeated attempts and failures might we achieve some change for the better in society, a reduction in hierarchy or gender oppression, a change that, by Jameson's thinking, most likely wasn't that for which we were striving. In a parallel vein, gender and queer theorist Jack Halberstam argues for a conception of failure as a way of knowing the world differently and so, counter-intuitively, realising alternative – more creative, cooperative and surprising – forms of resistance to oppression.[70] We mark here how feminist, lesbian and gay utopias might have contributed to the legitimation of same sex marriage in the UK, which wasn't the perfection imagined by these utopias nor yet the goal of many LGBT activists.[71] Indeed, it could be said that same-sex marriage was the result of the defeat of utopian visions, not their success![72]

Let's now consider how street choirs might embrace and elaborate upon ambiguity, a key theme of their members' future imaginaries. Wonderfully, ambiguity is itself an ambiguous term, open to different definitions. For our purposes we understand ambiguity as signifying the need to constantly question interpretations of events. We've argued that ambiguity need not contradict perfectabilty but rather can be constitutive of it. As such, it is a concept that can help street choirs avoid the pitfalls of ideology. We need to keep questioning even those aspects of social transformation that we might tend to assume as wholly beneficial for the community. In this regard, we exemplified gay marriage. And, difficult as it may be, we can incorporate ambiguity into *some* of our songs: we can employ more question marks in our lyrics, literally as well as perhaps metaphorically. Ambiguity is a means of making songs more complex, introducing subtleties, and so expanding understanding, not least of ourselves. On the notion of ambiguity and 'relative utopia', Lyman Tower Sargent writes: 'One needs to be able to believe passionately and also be able to see the absurdity of one's own beliefs and laugh at them.'[73]

Reviewing *Woman on the Edge of Time* 40 years on, Marge Piercy wrote: 'The point of a novel about the future is not to predict…The point of creating futures is to get people to imagine what they want and

don't want to happen down the road – and maybe do something about it.'[74] Similarly, recall the motivation to change the present that William Morris' Guest derived from his dream of the future. Our third proposal for street choirs, then, is that we redouble our efforts to be the change we want to see in the world. More consciously organised around the values we hold dear, our choirs can increasingly prefigure caring utopian spaces. As Chris Booth put it, we can create microcosms in the present of the sort of society we'd like to see in the future. We can then extend these practices into our politics and our singing: take our utopias out into the world, extol them, embody them, defend them…And then, both inevitably and desirably, be prepared to challenge and change them.

ENDNOTES

1 Subcomandante Insurgente Marcos. *Our Word is Out Weapon.* Edited by Juana Ponce de León (London: Serpent's Tail, 2001), 18.

2 Turbulence Collective. *What Would It Mean To Win?* (Oakland: PM Press, 2011).

3 Almost as we wrote this sentence, on 27 December 2017 Barack Obama told an interviewer on Radio 4's *Today Programme*: "The world is healthier, wealthier, better educated, more tolerant, more sophisticated and less violent than just about any time in human history."

4 See for instance Yuval Noah, Harari, *Homo Deus* (London: Vintage, 2017), *esp.* Chapter 1. Also Steven Pinker, *Enlightenment Now: The Case for Reason, Science, Humanism, and Progress* (London: Allen Lane, 2018).

5 From a conversational exchange 29 December 2017.

6 See, for instance: Richard Wilkinson and Kate Pickett. *The Spirit Level: Why equality is better for everyone* (London: Penguin, 2010); Danny Dorling, *Injustice: Why social inequality persists* (Bristol: The Policy Press, 2011).

7 For Butler, "public assembly" signals mass expressions of dissent in urban streets and public squares, the moments when people make themselves politically visible and embody their "right to appear".

8 Judith Butler, *Towards a Performative Theory of Assembly* (Harvard: Harvard University Press, 2015),15.

9 "Mark My Words" is a song by Grace Petrie, arranged for street choirs by Sandra Kerr, with additional lyrics by Kelvin Mason.

10 Section 28 of the Local Government Act 1988 prohibited local authorities from "promoting" homosexuality or gay "pretended family relationships". It prohibited councils from spending money on educational materials and projects that depicted a gay lifestyle. Section 28 was repealed on 18 November 2003.

11 See for instance: Cesare Di Feliciantonio and Gavin Brown, "Introduction: The sexual politics of austerity". *ACME: An International Journal for Critical Geographies*, 14, 4 (2015): 965-974.

12 Gavin Brown, "Marriage and the spare bedroom: Exploring the sexual politics of austerity". *ACME: An International Journal for Critical Geographies*, 14, 4 (2015): 975-988.

13 Channelling Dylan Thomas, of course.

14 This is not quite correct. In Leicester, the White *British* population do not form the majority of the population, though White people overall marginally do.

15 Recall Brown and Pickerill's observations in this regard from Chapter 4.

16 As underlined by Danny Boy's homage to the NHS in the opening ceremony of the 2012 Olympics in London and, indeed the approbation the ceremony received.

17 "Imagine" written by John Lennon from the eponymous album (1971)

18 For instance: Krishnan Kumar, *Utopia and Anti Utopia in Modern Times* (Oxford: Blackwell, 1987); Frank E. Manuel and Fritzie P. Manuel, *Utopian Thought in the Western World* (Cambridge MA: Harvard University Press, 1979); Roland Schaer, Gregory Claeys and Lyman Tower Sargent (eds.) *Utopia: The search for the ideal society in the western world* (Oxford: Oxford University Press, 2001).

19 Malcolm Miles, *Urban Utopias: The built and social architecture of alternative settlements* (London: Routledge, 2008).

20 Chris Carlsson, *Nowtopia* (Oakland CA: AK Press, 2008). And Carlsson, Chris and Francesca Manning. "Nowtopia: Strategic

exodus". *Antipode*, 42, 4 (2010): 924-953.

21 Lyman Tower Sargent, *Utopianism* (Oxford: Oxford University Press, 2010).

22 Laurence Davis, "History, Politics, and Utopia: Towards a Synthesis of Social Theory and Practice." *Journal of Contemporary Thought*, 31, Summer, (2010), 79-94, 93.

23 Davis, "History, Politics, and Utopia", 79.

24 See José Esteban Muñoz, *Cruising utopia: The then and there of queer futurity* (New York: New York University Press, 2009).

25 Thomas More, "Utopia." In *Three Early Modern Utopias: Utopia, New Atlantis and The Isle of Pines*, edited by Susan Bruce, 1-129 (Oxford: Oxford University Press, 2008)

26 See for instance Peter Ackroyd, *The Life of Thomas More* (London: Vintage, 1999).

27 Ruth Potts, "Daring to dream." *Red Pepper*, 211 (Dec/Jan, 2017), 15-16.

28 William Morris, *News From Nowhere (or An Epoch of Rest)* (Oxford: Oxford University Press, 2009).

29 Karl Marx and Friedrich Engels. *The Communist Manifesto* (London: Penguin Classics, 2015).

30 Ernst Callenbach conception of an ecological utopia, which we discuss briefly in a subsequent passage.

31 Laurence Davis, "Morris, Wilde, and Le Guin on Art, Work, and Utopia. *Utopian Studies* 20, 2 (2009), 211.

32 Ursula K. Le Guin, *The Dispossessed* (London: Millennium, 1999).

33 Avery Plaws, "Empty Hands: Communication, Pluralism and Community in Ursula K. Le Guin's The Dispossessed." In *The New Utopian Politics of Ursula K. Le Guin's The Dispossessed*, edited by Laurence Davis and Peter Stillman, 283-305 (Oxford: Lexington Books, 2005), 299.

34 Dan Sabia, "Individual and Community in Le Guin's The Dispossessed." In *The New Utopian Politics of Ursula K. Le Guin's The Dispossessed*, edited by Laurence Davis and Peter Stillman, 111-128 (Oxford: Lexington Books, 2005).

35 Claire P. Curtis, "Ambiguous Choices: Skepticism as a Grounding for Utopia. In *The New Utopian Politics of Ursula K. Le Guin's The Dispossessed*, edited by Laurence Davis and Peter Stillman, 265-282 (Oxford: Lexington Books, 2005).

36 Marge Piercy, *Woman on the Edge of Time* (London: The Women's Press, 1979).

37 Billie Maciunas, "Feminist Epistemology in Piercy's Woman on the Edge of Time." Belo Horizonte 10, 1 (1989), 15-21, 17.

38 Maciunas, "Feminist Epistemology," 19. See Also D.M. O'Byrne, "Marge Piercy's Non-Utopia in Woman on the Edge of Time." In *Utopia* edited by R. Bradshaw, 75-84 (Nottingham: Five Leaves, 2012).

39 Marge Piercy, *Parti-Coloured Blocks for a Quilt* (Michigan. Ann Arbor: University of Michigan Press, 1982). *Our emphasis.*

40 Ernest Callenbach, *Ecotopia* (Berkeley: Banyan Tree Books, 1975).

41 Starhawk, *The Fifth Sacred Thing* (London: Bantam, 1993).

42 In *The Fifth Sacred Thing,* the desire to attain spirit may inspire disobedience and resistance. Elsewhere, Starhawk writes of spirit as center, conscience, character, intuition or the small voice inside.

43 Held, *The Ethics of Care,* 19.

44 Martin Delveaux, "The Biologisation of Ecofeminism? On Science and Power Marge Piercy's Woman on the Edge of Time." *Green Letters: Studies in Ecocriticism,* 5, 1 (2013): 23-29.

45 Marge Piercy, "Woman on the Edge of Time, 40 years on: 'Hope is the engine of imagining utopia." *The Guardian.* November 29 2016. Accessed November 22 2017.
https://www.theguardian.com/books/2016/nov/29/woman-on-the-edge-of-time-40-years-on-hope-imagining-utopia-marge-piercy

46 Douglas Spencer, "The Alien Comes Home: Getting Past the Twin Planets of Possession and Austerity in Le Guin's The Dispossessed." In *The New Utopian Politics of Ursula K. Le Guin's The Dispossessed,* edited by Laurence Davis and Peter Stillman, 95-109 (Oxford: Lexington Books, 2005).

47 Merlin Coverley, *Utopia* (Harpenden: Pocket Essentials, 2010), 146.

48 From the refrain "No Future" in the Sex Pistols' "God Save the Queen", in keeping with the ambivalence of literary utopias.

49 Antonio Machado, *There Is No Road: Proverbs by Antonio Machado*. Translated by Mary G. Berg and Dennis Maloney (Buffalo NY: White Pine Press, 2003).

50 A literal translation is: "Walker, there is no path, the path is made by walking."

51 In 2014 a BBC report quoted "community spirit" as some 200 volunteers helped to clear away tonnes of stones deposited on seafront streets by a huge storm http://www.bbc.co.uk/news/av/uk-wales-25696069/community-spirit-in-storm-clear-up-in-aberystwyth

52 See: Rebecca Solnit, *A Paradise Built in Hell: The extraordinary communities that arise in disaster* (London: Penguin, 2009).

53 "Choir of Hope" is a somewhat inelegant translation of Côr Gobaith into English.

54 The well-known slogan "from each according to his ability, to each according to his need (sometimes 'needs')" originates in the writing of Karl Marx.

55 Charles T. Lee, Charles "Decolonizing Global Citizenship." In *Routledge Handbook of Global Citizenship Studies*, edited by Engin F. Isin and Peter Nyers, 75-85 (London: Routledge, 2014).

56 David Pepper, "Utopianism and Environmentalism." *Environmental Politics*, 14, 1 (2005): 3-22.

57 Sargent, *Utopianism*.

58 See respectively John Rawls, *The Law of Peoples* (Cambridge: Harvard University Press, 1999); Ernst Bloch, *The Principle of Hope* (Massachusetts: MIT Press, 1995); Albert Camus, "Neither Victims Nor Executioners." In *Camus at 'Combat': Writing 1944-1947*, 274-276 (Princeton: Princeton University Press, 2007); Zygmunt Bauman, *Socialism the Active Utopia* (Abingdon: Routledge, 2009).

59 Piercy, *Parti-Coloured Blocks*, 4.

60 Andy Merrifield, *Magical Marxism: Subversive politics and the imagination* (London: Pluto Press, 2011).

61 Kelvin Mason, "Magical Marxism: Subversive Politics and the Imagination" (a review). *AREA*, 44 (2012): 129-130.

62 See for instance Paul Kingsnorth, *One No, Many Yeses* (London: The Free Press, 2003); Susan George, *Another World Is Possible If...* (London: Verso, 2004); Simon Tormey, *Anti-capitalism* (Oxford: One World Publications, 2004).

63 Donatella della Porta and Dieter Rucht, *Meeting Democracy: Power and Deliberation in Global Justice Movements* (Cambridge: Cambridge University Press, 2014).

64 Sargent, *Utopianism* 124.

65 Katherin Buse, "Genre, utopia, and ecological crisis: world multiplication in Le Guin's fantasy." *Green Letters: Studies in Ecocriticism*, 17, 3 (2013): 264-280.

66 Dale Jamieson, *Reason in a Dark Time* (Oxford: Oxford University Press, 2014).

67 "Song Made from Placard Slogans" is a round, written by Boff Whalley for Commoners Choir, an "explicitly political" member of the Campaign Choirs Network who sing about 'inequality and unfairness and about the things that need changing'. http://www.commonerschoir.com/

68 Frederic Jameson, "Future City." *New Left Review* 21, May/June (2003), 76.

69 See: Frederic Jameson, *Archaeologies of the Future: The Desire Called Utopia and Other Science Fictions* (London: Verso, 2007); Tom Moylan, (ed.) "Special Section on the Work of Fredric Jameson." *Utopian Studies* 9, 2 (1998): 1-7.

70 Jack Halberstam, *The Queer Art of Failure* (Durham: Duke University Press, 2011).

71 See: Mary Bernstein, "Same-Sex Marriage and the Future of the LGBT Movement." *Gender & Society*, 29, 3 (2015): 321-337; Owen Jones, "Gay people have come a long way – but hatred is still out there." *Independent* 27 January, 2012. Accessed 19 February 2018. http://www.independent.co.uk/voices/commentators/owen-jones-gay-people-have-come-a-long-way-but-hatred-is-

still-out-there-6295272.html

72 Again, see for instance Muñoz, *Cruising Utopia.*

73 Sargent, *Utopianism*, 127.

74 Piercy, "Woman on the Edge of Time, 40 years on."

CHAPTER 6

'STREET CHOIRS 2.0'

Time to address the question that has driven all of our work: how can the Campaign Choirs Network develop its radical potential in ways that take into account the everyday realities, competences, hopes and dreams of members of street choirs? Before addressing this question head-on, though, we assess that radical potential by asking our interviewees what difference they thought their street choir and campaigning choirs more generally made. We also asked how street choirs were currently attempting to boost and diversify their memberships, to attract and retain a new generation of political songsters. Having some idea of street choirs' radical potentials and how they are currently pursuing their development, we then review what we've learned about street choirs via our overall framing of some of their social movement features within an ethics of care. We consider what our interviewees revealed about their street choir's composition and identity, its politics and music, its social practices, solidarities and spatialities, the emotions at play in and around the choir, and members' visions of the future. We ponder any modest contribution our care-full analysis might make to theories of social movements, activism across the life course, social practices, solidarity, and utopianism.

As engaged activists from within the Campaign Choirs Network, our primary responsibility is to ask how our research can be useful to street choirs and, hopefully, social movements more widely. In this vein, we ask what is special about music and singing in the realm of cultural

activism: how can street choirs remain politically vibrant and increase their public engagement? We then ponder the potential benefits and drawbacks of further popularising street choirs. We wonder who future members could be, what they might be singing about, who they are likely to be singing to, and where. Drawing on our research with LGBT street choirs and LGBT street choir members, especially, we consider potential Campaign Choirs Network solidarities with, for instance, black, environmental and youth social movements. We are also interested in how cultural creativity might be increasingly mobilised in street choirs. Finally, we return to the ethics of care to evaluate the practices of street choirs and so propose 'better ones' for consideration.

'SMALL GREAT THINGS'

A number of our interviewees were of the opinion that whether or not their street choir made a difference was unquantifiable. Subjectively, though, there was a consensus, with members believing that singing with their street choirs did make a difference on a variety of levels: to themselves personally, to other members of their choir, to their audiences, and as part of wider movements for progressive social change. Let's begin with some stories that touch upon these levels:

Rosemary Snelgar: 'Well, in my most demoralised times I do wonder that...There's two different ways of thinking about it, one is for ourselves, because...for me, it just makes me feel that I'm doing something for these things that I believe strongly in, which, sometimes it seems that a lot of the population don't care about, I just feel I'm doing something. But, also, I do think some of the people who listen will be influenced by the songs, so might start to think a bit differently...Often when you haven't been exposed to anything...you don't see anything wrong with the status quo...Yeah, I think having a tune that they're familiar with helps a lot... So, there's a "Top Cat" one that tends to draw people's [attention].'[1]

Ian 'Onion' Bell: 'Well I don't know; it makes a difference to the people in it, because we've got each other, we've a community, people feel that

they've got the support there. It's also, you know, that solidarity with other groups as well: that we can take the choir and go and sing at other people's events and show solidarity elsewhere. And maybe now and again it gets through to people that there is another way of seeing the world. You never know – might do. But I don't know how you measure what difference it makes. You can't be certain, but doing nothing is not going to achieve anything!'

Karen Jonason: 'I think we're part of the political culture of Liverpool. Whether we make a difference, I don't know, but I know that when we have done, for example the NHS stuff, those people who're on strike there are very, very pleased to see us and really think it's great. When we've been singing outside things, we've seen drivers honk their horn and go like that [gives thumbs-up]. So, obviously, we make some impact. And being a small place, we're seen: people have heard of us. Personally, it's very important to me, because I love singing and also it's a good, it's a social thing for me as well – very important. I didn't really know anybody when I came up here.'

Bernard Bourdillon: 'Everything is a contribution to a big cause, but the big cause is the sum of those small contributions… In terms of the individuals involved, it keeps people's spirits up, it keeps people going… and as a group it brings together like-minded people in a positive way in which they can share their concerns.'

These excerpts underline that street choir members are conscious of the benefits their activism brings to themselves and their fellow singers. There is acknowledgement too that street singing is part of a larger movement for social change. Bernard Bourdillon smartly highlights that, in practice, there is no 'big cause' without local activism. Moreover, as we discussed with respect to the global justice movement, local activism works to reconfigure the big cause. 'Onion' Bell's seemingly self-evident observation about the alternative of doing nothing is actually loaded with the hope that it is possible for street choirs to achieve something in the arena of social change. Rosemary Snelgar's impression was that a lot of the population don't care about the injustices which galvanise her to action. In Chapter 5 we discussed the precarity that can render people

hopeless and so politically inert. Street choirs should, we suggest, trouble the assumption that the population – their audiences – are uncaring or apathetic. That said, many of our other interviewees did home in on the difference they thought street choirs made to others. In what follows, they highlight: support on demonstrations; raising awareness and making people think; making politics differently accessible; extending the invitation to sing; and presenting the opportunity to be part of a communal grouping.

Jane Scott: 'I just think if you go on a demonstration and you sing, you can see people being lifted, you can see that it makes a difference. Having the songs there makes a difference, definitely.'

Chris Booth: 'I think we've reached a stage where, if there's a demonstration going on, people will notice if Protest in Harmony aren't there. And I think that's quite an achievement because a lot of times when you're singing, you know, you can go completely unnoticed.'

Maxine Beahan: 'It [the choir singing on demos] does seem to add something, add interest: a lot of people film us now when they're going past. And they might not stop for very long but it's something different.'

Claire Baker Donnelly: 'We've never had a visible LGBT community compared to other cities of a comparable size. You know [Sheffield] we're the fourth biggest city in England...We've really raised visibility and really raised the stakes on that and made a difference in terms of people being able to see, you know, the community out and about... Making people think.'

Nest Howells: 'It's a difficult one, isn't it, who knows? I hope it raises awareness, even if it makes one person who passes us on a Saturday morning, even if it makes one person think, wonder what we are doing and why...You know, quite a few new members have joined us because they heard us singing somewhere...A lot of the time we're preaching to the converted...but, I mean, who knows?'

Sean Maddison Brown: 'I think the choir itself provides a positive image of gay people within the city [Sheffield] and outside the city. And also, hopefully, it can be an inspiration. And, for people who are not out, to something other than a commercial world: that there can be a more

social aspect to being gay than the gay scene.'

Cynthia Cockburn: '[Street choirs] add to the quality of political life in the sense that they bring politics out into the open onto the street, off the editorial pages of newspapers and, I suppose like Momentum, make you feel you can belong in some way, can contribute in some way.'[2]

Chris Norris: 'Well, I think, a lot of difference…It's impossible to quantify, but a surprising number of people stop and listen – and people very often who are visibly torn, if you like. You know, there's something that's sort of pulling them away – very often someone they're with, in fact! But they will stop, and they'll occasionally talk, and on very rare occasions they'll actually come along and join the choir. Several of our members have joined us through that happening…A lot of people take leaflets or whatever literature we're handing out or just read the posters. It'll make them go off and think.'

Ruth Owen: 'Well yes, I think we make a difference in that we're raising awareness with our street singing, and also the fact that people know we exist, because we're asked to sing in all sorts of places… When you see a body of people standing there singing enthusiastically, and the words have some meaning, I think it must have some influence: it just raises awareness that there are things going on, there are things to think about.'

Annie Banham: 'Twice a year we have a concert and people will come along and because we've got the time to put things into context, people do go away thinking: "Well, I didn't know that" or "Wow, that's interesting!" And it kind of joins the dots.'

Raising awareness and making people think are the strongest recurrent themes in these extracts. A couple of interviewees also noted that performance is one of street choirs' methods of recruitment. With respect to Annie Banham's comment, specifically, in Chapter 4 we recorded that performances where there isn't time to explain songs and put them into context can amount to a poor way of doing politics for street choirs. To continue with our stories, several respondents picked up on the part that street choirs play in wider social movements and solidarities, some highlighting the special contribution that singing can make.

Pat Richards: 'It's a difficult question, isn't it? I suppose you have to

think, was it Martin Luther King who said: "It's the small great things?"[3] We can't all do the huge things, so we do these little things, but we do them and we do them and we do them, so they, the accretion of all those little things, I think, makes a difference…standing up and bearing witness to what you believe in, and treating people with respect.'

Diana Bianchi: 'Every Saturday we sing here, and maybe people pass us and see all the posters we hold up… if for Palestine, or raising money for Syrian refugees, get the message through… I'm sure it does stick in their minds, you know. It must do, er, cos everybody seems to know about us now.'

Leni Solinger: 'I think music lifts the spirits, so yes – I mean we're not making a big difference in the world, that's a big ask, but I think that we have added to struggles by coming along, definitely.'

John Hamilton: 'Well, there are political gatherings which are enhanced by having a musical contribution: we're often asked to sing at them… big demonstrations…smaller things in our area…it brings our choir members together by hearing each other's views a bit and…I think it just generally enhances other political activity.'

Once again, our interviewees underscore the small contributions they believe street singing makes to larger struggles. Along with the observations here, a number of other interviewees recorded that their street choirs have become fixtures of the local political geography, recognised when present and noted when absent. We suggest that, to some extent, mass actions by the Campaign Choirs Network must also be establishing themselves as regular features of national demonstrations. All the street choir members we interviewed believed that choral singing added something (different) to political struggles. Talking of 'bearing witness', Pat Richards reminded us that members of different street choirs also participate in Women in Black actions. Opposite in one key aspect to street singing, we've seen that the *silent* vigils of Women in Black often attract a larger audience.[4] Silence on the street is, it seems, even more curious than singing. It may also be easier to actively engage with, i.e. for people to join in. Oddly enough in the wake of that observation, we turn now to a couple of quotes where our interviewees focus on the

power of music and lyrics:

Moira Harbord: 'It's a difficult question, really, because sometimes you feel you are singing to the converted…I've always felt that when you sing a song that people are marching about it reinforces [it] with them… There is something magical about music that if you hear the message that you are marching for, sung to you, it makes you feel good, but at the same time, you would like to be singing to people who need to learn the message. I think that is important, too, that you get out on a Saturday morning in the shopping centre where people wouldn't normally think about climate change or the teachers' strike or the NHS, necessarily, because they are too busy with their lives…I think it's got to be not only to the converted, but you've got to get out there!'

Steph Howlett: 'The choirs, in general, I think they do make a big difference. On a demonstration, if you've got that music…And some of the songs are so clever. And so you have a combination sometimes of really beautiful, poignant music that just sort of encapsulates how you feel, and then the funny ones like the fracking song and 'Fat Cat'… And we need humour, when times are dark, to feel that you're part of a community…Poking fun is a really important weapon, I think.'[5]

As mentioned in Chapter 4, humorous lyrics can be problematic and we note here that while 'Fat Cat' is intended as an anti-capitalist protest song, it may also reinforce common-sense attitudes about fat people as greedy and selfish, thus serving to alienate and stigmatise a marginalised group.[6] Poking fun, though, is only one of many emotionally engaging strategies open to street choirs. Apart from laughter, singing can move audiences to sympathetic tears, rapture, righteous anger, and all emotional stations between. What street choirs should surely aim never to do is *not* to move the audience at all. However, as some singers told us, this can indeed be their perception of the 'audience' passing by on the street. That said, Moira Harbord stresses how important it is for street choirs to continue trying to engage with audiences who are not in tune with the same politics. We would add that, as much as it's about getting a message across, street choirs should strive for space in which the audience can respond to that message: the singers should also 'listen'.

Lowenna Turner told us: 'I think it's important to reach out to people you wouldn't normally speak to.' As we heard from Chris Norris previously, Côr Cochion is one of the street choirs which are conscious of the need to engage with the views of their audience, even – or perhaps especially – when those views are hostile. Finally in this section, we include a few excerpts from people's stories that highlight the role of street choirs in the politics and care of their members:

Lowenna Turner: 'Some days I wonder, and some days I think we did very, very well... It's hard to say, who has gone past, who has stopped to listen. If nothing else, if everyone on the street ignored us, everything, if we just didn't have any effect on anyone, I would say that we at least gave hope to ourselves.'

Ilona McCulloch: 'It certainly makes a difference to the people in the choir because, you know, some people aren't as politically active as others or don't feel that they can become politically active. But this is a politically active thing to do.'

Wendy Lewis: 'I think it's [the choir] a lifeline, on the personal level, for a lot of people. And it is a social thing, and we're very, very supportive of each other. So, you know, some people have had difficulties over the past year and they know that the choir will be there for them, and I think that makes a big difference. And on a political level, just being there week after week, we've seen the difference in Cardiff...More and more understanding and less and less instinctive reaction against or assuming that our motives are bad.'

These passages pick up on how street choirs give hope to their members, provide them with a route into politics, and extend a traditional, macro-level conception of politics to the social and the mutual aid of caring. Wendy Lewis also restates a point we have made previously about the importance of the *persistence* of presence to grassroots politics.[7] Briefly, with respect to recruitment, apart from attracting new members via their performances, street choirs are variously: maintaining websites, though self-confessedly not always very well; using social media, predominantly Facebook but also Twitter; distributing posters and flyers locally; and using word of mouth to persuade people along to a choir

practice. Other recruitment methods have been tried. For instance, Côr Gobaith used to recruit at Aberystwyth University's Freshers' Fair. However, the choir recruited just one student member by these means over the course of several years, and the practice was abandoned.[8]

So how, given our street choir members' views on making a difference, would we assess the radical potential of street choirs? It seems key that street choirs offer people, both singers and audiences, a different way into politics: into considering and contesting injustices at the community level. At their best, street choirs have a pedagogic rather than propagandist ambition: to raise awareness and make people think. Street choirs also bring into play a prefigurative ethics of care within the group, with members taking responsibility for proximate others. In other words, as many interviewees told us initially, street choirs can be a political home for their members.

WHAT WE'VE LEARNED (AND HOW WE LEARNED IT)

LIFE COURSE ACTIVISM

One thing that interested us from the start of the research process was the age profile of the members of many of the street choirs in the Campaign Choirs Network. Although many choirs do have younger members, most are predominantly comprised of women aged between 50 and 70. As we've said already, the relatively few men singing with street choirs are actually over-represented in the 'sample' of people whom we interviewed. We wanted to know about the individual and collective histories of activism and campaigning that this group of middle-aged and senior citizen, mainly female, singers brought to their choirs. We wanted to think about how performing with a street choir enabled older activists to continue to participate in campaigns, protests, and direct actions in a way that fitted with their stage in the life course. In other words, what was it about choral singing that was attractive to campaigners as they entered middle age and beyond?

There are several answers (and even more questions) that follow from this. We wondered whether the gendered composition of choirs reflected a tendency for women to be more interested in – and maybe less embarrassed by – choral singing on the streets. This may be the case, but we also believe it is important to consider the political lives of this particular generation of women: to explore how their involvement in politics over the last four decades or more has encouraged and impelled them to continue to find opportunities for political involvement as they've aged. Amongst the older women we spoke to, several had been involved in the New Left and the feminist movements of the late 1960s and 1970s. Many more had first become politicised during the mass anti-nuclear movements of the early 1980s. In particular, some singers had spent time at the Greenham Common Women's Peace Camp, protesting against the plans to position cruise missiles there at a time when Cold War tensions between the USA and the Soviet Union were getting decidedly more heated. For other women, the Miners' Strike of 1984-85 had been a key moment of politicisation and intense campaigning: many worked closely with women from mining communities through the Women Against Pit Closures campaign. Building on the successes (and failures) of the 1970s feminist movement, both Greenham Common and Women Against Pit Closures challenged strongly-held assumptions about women's social roles and their capacity for political action. Sasha Roseneil famously argued that, even for heterosexual women, Greenham 'queered' many assumptions about women's place in society and taught them to question the authority of all social forces that encouraged them to forsake an active involvement in shaping the world for a life of domesticity.[9]

As our bodies age, our physical capacities change. We seldom have the energy or stamina that we might have had when we were younger. This inevitably impacts on our capacity to engage in certain forms and intensities of political activity. We suggest that joining a street choir is one response to reconciling a commitment to continuing political activity with the demands of an ageing body. Here we must interject to note that many current street choir members have been singing as cultural activism for many years: they did not join street choirs as 'older people'. That

said, ageing in street choirs, or indeed other social movement affinity groups, becomes an issue not only for the individual but also for the collective. As their members age and perhaps their health deteriorates, some choirs must surely consider how best to care for their members and to support their continuing participation. Although the feminist movement has repeatedly raised the provision of care (and other forms of social reproduction[10]) as a political issue, the question of care for the elderly is still seldom addressed as a priority issue by many sections of the Left.[11] Given how many of the singers we interviewed had long-term engagements in feminist activism, it is paradoxical – but not entirely surprising – that few of our interviewees viewed the care provided by their street choirs as 'political'. This seems to be a key issue for the Campaign Choirs Network to reflect upon. We certainly feel that an important aspect of many street choirs is that they provide a space where their members can continue to be politically active, with dignity, as they age. Acknowledging this as part of the political work of at least some street choirs could open up space for important discussions about the politics of social reproduction, care, and ageing.

An assumption at the start of our research was that street choirs needed to recruit more younger people, otherwise some might be in danger of, literally, dying out. Of course, led by the example of Birmingham Clarion Singers, many street choirs have survived for long periods and clearly have recruited new members, albeit seemingly not so many below the age of 50. So, while it may remain an aim of street choirs to recruit new members in their 20s, 30s, and 40s, we observe that this will have to be integrated with maintaining a caring space for older members. Red Leicester, we know, are one choir who have been proactive in this regard, seeking professional guidance. From our experience with our own street choirs, we know that making space for individuals with physical disabilities, as well as those with mental health issues, does change the dynamic of the choirs' collective activism. So, the many relational gains of fostering solidarities across age, physical and mental health 'divides' will have to be balanced with street choirs' more militant activist ambitions. We noted earlier that street choirs 'might consider

the meanings, competences and materials that could facilitate members' more equal participation. Here we'll add that such participation might be conceived and constructed as 'equal but different.'[12]

SOCIAL PRACTICES

A key contribution of this study has been to consider the practices of street choirs. In Chapter 3, building on the work of Elizabeth Shove and her colleagues, we argued that social practices emerge out of the dynamic interactions between the materials and competences required to carry out a practice and the meanings attached to that practice. Materials in this context are the actual things that we use when doing something. These could be small objects like song-sheets or costumes, technologies like the internet, or large-scale infrastructures like the transport system used to get to a demonstration. Competences are the skills and techniques that we know how to use in order to do something. Here we might think about how singers learn how to breathe whilst singing, or how people sing in tune. But, in the context of campaigning street choirs, competences could also be the ability to make a placard or design a flyer, or the embodied skill of knowing how to avoid being kettled by the police. In Table 1 we outlined in detail the range of materials, competences and meanings that might be used by the members of street choirs in doing what we do.

In thinking about the practices of campaigning street choirs, it quickly became apparent that they do many different things. We can think of this in terms of the life of a street choir comprising a bundle of related social practices: most obviously, there are a series of practices associated with singing as a choir and a series of practices related to protesting as a campaigning street choir. In the background there are also the administrative practices associated with keeping a choir running. But, as we have argued throughout this book, there are also practices of care within choirs. None of these practices are entirely discrete. They overlap and share components: material tools and technologies might be used to do more than one thing; some competences come in handy both for

singing and protesting. Certainly, over time, the meanings attached to individual practices and the bundle of things that a choir does will change. They will change as the members of the choir change, bring new skills, make fresh interpretations of – and so give new meanings to – what the choir does. Some skills and competences might fall away over time, either as members leave or because they are no longer quite as useful – particularly perhaps as technology changes – and so don't get practised enough. The longer a choir has existed and been singing together, the more likely the longevity of the choir itself will become part of the dynamic mix of meanings attached to their singing, campaigning and the relationships between members.

The time and space available to any street choir are key resources for them.[12] The constraints of both affect what they do and how they enact their practices. Street choirs come together in a particular time and place, and within their initial membership there must be the skills and competences to bring a campaigning choir into being and give its singing meaning. Our research suggests that most street choirs manage to sustain themselves over time. They might take on new members, but seemingly few choirs grow significantly[14] or even substantially diversify their practices over time.[15] They certainly tend to remain rooted in the location where they began. The practicalities of regular – typically weekly – rehearsals and performances mean that they usually only recruit members from a relatively constrained geographical area. Given that many choirs claim to be interested in recruiting new (and, often, younger) members, as well as more men, further thought may need to be given to the practices that enable – or inhibit – the choir to be welcoming to new members and to facilitate their inclusion. Evidence from Brown's research on anti-apartheid activism in the 1980s suggests that many new people joined the Non-Stop Picket of the South African Embassy precisely because someone was friendly, encouraged them to stay a while, introduced them to the others present, taught (and trusted) them to do a small task while they were there, and gave them a reason to come back in the near future.[16]

Similarly, our research identified welcome as a factor in retaining street

choir members. To this we would add that extending this welcome into nurturing over time is key: street choirs cannot extend a warm initial welcome to new members and thereafter leave them to sink or swim in our extensive and challenging musical repertoires, our idiosyncratic choir cultures, our unfamiliar technologies, and the assumption of our shared politics. A rider that we would add on welcome is how new technologies may facilitate a wider recruitment of sorts for street choirs. Already technologies such as Dropbox, Skype and podcasts could be used to sustain the participation of members unable to make every practice session. Conceivably, such technologies could also be used to support or complement sister choirs emerging in far-flung locales. Street choirs have already used the internet to develop international solidarities. As just one ready example, Côr Gobaith recorded and shared songs with children in the Palestinian village of Bil'in, including a Welsh lullaby, 'Cwsg Osian', dedicated to children everywhere for whom a safe night's sleep is denied by violence.[17] The choir's action followed a talk given in Aberystwyth by Iyad Burnat, a Palestinian non-violent campaigner for justice and against Israel's 'apartheid wall'. At the time of writing (mid-January 2018) Iyad's son Abdul-Khalik Burnat, 17, was detained by the Israel Defence Forces along with his friends Hamzah Al-Khatib and Malik Rahdi.[18]

Some singers told us that amongst the routine practices of their choir (and of the Campaign Choirs Network) they often felt there was not enough time to talk about the politics related to their song choices or to contextualise the relationships with people near and far that underpin some of the songs they sing. This was said despite the fact that many singers discussed how long their choirs could end up debating the politics and ethics of specific lyrics within songs! What this seems to reveal is that within choirs there is an understanding of the personal and political meanings associated with their repertoire, but there was also an awareness that this might not always be adequately conveyed to their audiences, especially when busking or at demonstrations. What we're trying to tease out here is the apparent contradiction that some interviewees recorded that their choirs debated the meanings of some songs almost endlessly,

while other people believed that there was not enough time in choir for discussion of politics in the practices of street choirs. From our own experience, we note the often only partially inclusive and unsatisfactory exchanges on issues that can take place on email lists, intended mainly for administrative choir matters, and on social media.

It is interesting to consider which of the practices of street choirs matter and why. When exploring this issue with choir members, there was a discrepancy between the practices that they felt should matter – which were often focused on the politics of their actions and how their songs impacted on the audiences in various contexts – and the practices that made a difference for them personally. Often, choir members prioritise the political solidarity they perform for others over the social solidarity enacted between members of the choir. We argue that choirs may want to reconsider this separation and to think politically about how some of the elements of their practices that enable them to act in solidarity with others might also serve to enact an ethics of care within the choir. We recognise that it can be difficult to extend care beyond the confines of the active membership of a street choir. However, by giving new meanings to certain materials and competences (as well as other meanings) within the practices of the choir, street choirs may be able to rethink their singing, solidarity and protests as part of a revitalised politics of care. Finally on this theme, we found the perspectives of an ethics of care and social practice theory to be distinctly complementary, with reflection on the one yielding insights into the other.

SOLIDARITIES

Many street choirs perform in solidarity with people experiencing injustice and oppression, both in their communities and around the world. The songs they sing are often chosen as a form of cultural activism that performs that solidarity and resistance. They sing songs about solidarity from past and present political struggles. Sometimes those songs are an expression of specific local or regional forms of 'militant

particularism' from the place where the choir is based: songs that express something of the political histories and priorities of that location and the ways they are embedded in local culture. At other times, choirs learn songs in languages other than English (or Welsh) from other places as an expression of international solidarity and a shared transnational culture of resistance.

We understand political solidarity as a practice that addresses oppression and injustice: it's not simply about offering charitable or humanitarian aid to others, but rather assisting them in confronting the root causes of that injustice in order to transform social (and ecological) relationships and construct a freer and more just society. Political solidarity addresses injustice in the present, but also has an orientation to the future. Given that many members of street choirs are in their 50s, 60s and 70s and bring with them a lifetime of political activity, we think that street choirs also engage in a form of solidarity with the past that is tempered by experience. Most often, this experience is shared with and absorbed by younger choir members. So, street choirs carry with them individual and collective radical histories, often expressed through their songs. This care for the heritage and lessons of past struggles forms part of the practices of many street choirs: those songs and memories get reused as materials and competences for their political solidarity in the present, as well as helping to give it meaning. In this way, the practices of street choirs reveal a relationship between care (for the past, for others, and for the future), solidarity, and justice.[19]

If the practice of solidarity seeks to open space for building ways of organising society in both the present and the future, then we suggest members of street choirs should pay attention to the interpersonal relationships that they foster through their solidarity activism. In this regard, choirs could be more conscious of the ways in which their practices of political solidarity with people outside the choir also enable (or constrain) the practices of social solidarity and care that glue their choirs together. As we have argued previously, we believe that, in the context of a campaigning street choir, this care should be understood politically. To consciously reflect on and share the lessons of building

politicised communities of care within choirs could be a powerful contribution that the Campaign Choirs Network could make to initiating a broader conversation about the politics of care and social reproduction.

EXTENDING SOLIDARITY LATERALLY

Dee Coombes: 'What I would really, really love to happen to the choir [Liverpool Socialist Singers] would be for some black people to join it. I would really, really like it if it was racially mixed…And also more gay people would be good…We do have some young people, but we certainly need more…That connection with the audience…It would be lovely to get more teenagers to come.'

In this book we have often discussed LGBT street choirs joining the Campaign Choirs Network as an example of, if not strictly intersectional solidarity, then extending solidarity laterally, as Brown and Yaffe described it.[20] In this discussion we have tended to over-exemplify Out Aloud, not least because they were the LGBT choir whom we interviewed. A fuller picture of extending Campaign Choirs Network notions of solidarity to LGBT politics would more explicitly include the many LGBT+ members of street choirs that do not identify as LGBT choirs. Unfortunately for any goal of 'quantification' that we might be foolish enough to cling to, we didn't ask people about their gender or sexual orientation. However, from our experience in our own street choirs and from exchanges with street choirs across the UK, we venture that the movement – and its politics – has a distinctive LGBT 'tonality': we know that many of our friends and comrades identify as LGBT and bring those political and cultural sensibilities to bear in their street choirs.

While acknowledging the differences between the 'communities', we could make similar observations with respect to environmentalists: though there are no explicitly 'green' choirs in the Campaign Choirs Network, environmentalist members of street choirs have evidently helped to bring that political sensibility to bear. We suggest that there are at least two factors in play in this 'greening' of street choirs. First,

there is an environmental crisis, especially with regard to climate change, that means many street choir members consider environment to be an urgent issue. In parallel, a number of street choir members revealed their disaffection with the Labour Party during the period where it had shifted to a Blairite or New Labour stance. Hence, some sought an alternative political home in the Green Party (in Scotland and Wales, other street choir members have migrated to the SNP or Plaid Cymru). If street choirs have adopted a green politics, they have not so successfully extended solidarity laterally to Black, Asian, and Minority Ethnic (BAME) communities and activists. In an email exchange on our titular song in the course of this research, Kelvin Mason commented: 'I find it very moving to actually *be* "LGBTQ and straight together" while, on the other hand, it can be excruciatingly embarrassing to sing "black and white together" because we're plainly not.' Which is not to disparage the ethnic diversity that does exist in street choirs, nor disregard the links formed by several choirs with refugee and asylum-seeker groups.

Beyond street choirs, though, we note that such lateral solidarities *are* being formed more proactively and radically. On 28 March 2017, for example, activists from End Deportations, Plane Stupid and Lesbians and Gays Support Migrants, together stopped a Home Office deportation flight to Nigeria and Ghana taking off from Stansted Airport.[21] Sharing songs may well have been welcomed as part of this action and, we suggest, the Campaign Choirs Network could engage in more of the emotional work needed to forge solidarities with such groups. Again beyond street choirs, we note that there are many Black/POC-led and majority choirs out there.[22] We suggest that street choirs might find it harder to recognise the political in such choirs as their politics may be Afrocentric, post-colonial or otherwise differently focussed. Some such choirs may well be political through church affiliations, an even more problematic politics for the largely secular street choirs movement to identify and engage with collectively perhaps? In the course of our research respondents told us stories of their street choirs declining to participate in community or charitable singing events that they identified as religious.

MUSICAL ACTIVISM

> On the streets, creativity is our greatest tactical advantage. This is
> why clowns and spiral dance rituals and women in tutus armed
> with feather dusters were so effective during the Global Justice
> Movement.[23]

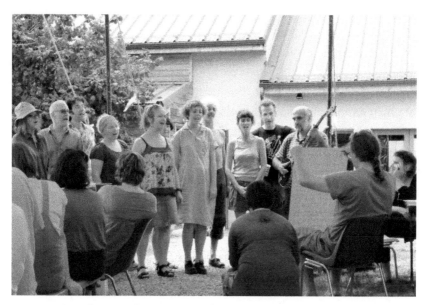

Figure 15: 'A song for every meal'. Strawberry Thieves and fellow chefs
present their kitchen song at *Rencontres de Chorales Révolutionnaires* at
Royère de Vassivière in July 2016. Credit: Martin Vickers

Throughout this book, although we've repeatedly referred to the active
role of songs in street choirs, and although we've reproduced some lyrics
that have proved insightful in our analysis, we still feel we have somewhat
underplayed music. So, in this section we give considerable attention
to street choir singing and music more generally, considering them in
terms of cultural activism. We've seen that some street choir singers have
come from singing to political activism, others from activism to singing.
For yet others, activism and singing have long been integrated parts of
their lives. Whether or not we realise it, music is part of our lives from

birth. Jeanette Bicknell notes that music forms an important part of social bonding and mentions three key categories: bonding between a caregiver and an infant, bonding between a pair of adults, and bonds linking social groups and communities.[24] Bicknell refers to research on how parents (and other adults) across the world talk to infants in a sing-song, rhythmic and repetitive way that is important for mutual bonding, care and, hence, infant survival. So, even where there is no actual singing, we hear 'musical' speech from birth: it forms part of caring and being cared for. Regarding relationships between adults (or near-adults), certain music often plays an important part of bonding (e.g. 'romantic' music, dance music, music related by memory to a significant event), and we retain an emotional response to that music.

Street choirs clearly fall in the category of bonding that links social groups and communities, and it was evident from all the interviews that there are strong bonds within choirs. We were told of differences in political opinions and differences in preferences of songs, often on political grounds, as we indicated earlier. Such differences were discussed at length, sometimes heatedly. However, choirs still manage to accommodate their differences and we speculate that, perhaps, the double bond of music and political values allows for greater understanding and a desire for 'the glue to hold' in the face of differences of opinion. In other words, if there is a lingering, potentially divisive, political tension, musical commitment will serve to maintain cohesion, and vice versa. That said, as noted by Wendy Lewis in Chapter 2, without a basic sharing of political values, 'lovely voices' will probably not stick around.

Jenny Patient: 'I would argue that street choirs offer a continuity of left identity – since SSC [Sheffield Socialist Choir] formed thirty years ago, for example, everything in politics has changed: many members left the Blairite Labour party, some re-joined under Corbyn, or moved to the Green Party, or have become staunchly non-party people, but we are still in the same choir. The biggest recent exodus from SSC was when several members left to join Out Aloud, considerably reducing the diversity of SSC, but they are still part of the wider 'family' of our choir. I think street choirs manage to offer this continuity by tolerating

a certain fuzziness of politics.'

Singers generally trusted and supported causes that fellow choir members felt strongly about. So, while not everybody was necessarily enthused about the same songs, we noted a genuine feeling of how choir members sing with passion for a range of causes and how they feel empowered by singing together. Some of the particularly memorable moments recalled were about standing together, facing up to adversarial groups, notably the EDL, as mentioned by Charlotte Knight, Julie Burnage and Lowenna Turner. Wendy Lewis talked about the power of singing: 'we started singing and they [the BNP] melted away, it was like magic.' Being part of big groups all singing together was another highlight mentioned by many singers. Rehearsals at Street Choirs Festivals can be powerful and moving occasions, especially when experienced for the very first time: people often 'have a moment' as Andy Dykes termed his own emotional response. Singers expressed feelings of elation and fulfilment through moments of audience engagement, too, as when Elaine connected with a Syrian woman and thought: 'Okay, it's right to be doing this'; and when Dee Coombes described the response to Liverpool Socialist Singers singing *Raise Your Banner* at a demonstration: 'this absolute sea of banners just shot into the air, and it was so moving.'

Drawing on our own experiences, Lotte Reimer recalls being moved to tears when singing 'E Malama' during her first mass sing rehearsal in Manchester in 2007: 'The harmonies were so beautiful and singing them with five-hundred other people totally overwhelmed me. I still love that song, and I still get a lump in my throat when I think of that moment.'[25] Maxine Beahan had her 'best day ever' singing with the Big Choir in London in 2012. (That same event seemingly touched others too, inspiring some street choir members to pursue the formation of the Campaign Choirs Network.) These are just a few examples of the emotional power of music. Street choir members talked about beautiful songs, songs with a message, songs of solidarity, joyful singing… But *why* are we moved by music? While not even learned music scholars are able to answer the question with any degree of certainty, we presume to suggest that for street choirs, perhaps more even than the tunes and

the lyrics, *it is the act of singing, singing together for a common cause, a common set of values, that moves and bonds singers together* – even beyond their own choirs. Some of the most joyful collective singing during Street Choirs Festivals happens spontaneously after the Saturday evening concert, when all the organised events have finished. Here, we note that many members of 'community choirs' join in with the songs of the 'street choirs'. A little late in the day, perhaps, we should stress that the divide between 'community' and 'street' choirs is more an abstraction, defined by particular views on what constitutes 'the political', than it is an actual separation of individuals or groups of people. Moreover, 21 individual members of choirs self-identifying as community choirs are signed up to the Campaign Choirs Network.[26]

Having already noted that even musicologists don't understand how music works, or at least don't all agree on their understandings, somewhat presumptuously again we turn our attention back to the part music plays in constructing the collective consciousness that mobilises political action. In other words, we would like to pursue – just a little – how it is that music can have (political) meaning. Nicholas Cook argues that music is a way of creating meaning that can provide insights into the geographical, historical and social 'other'. Music can, he maintains, communicate across barriers such as race, culture and class. Recall that in her story Annie Banham viewed music as 'a great leveller', an aspect of childhood that challenged barriers of class and poverty. However, Cook also maintains that *how* music works remains mysterious. So, as much as it *could* promote understanding across barriers, it could also create or foster misunderstanding.

From our experience with street choirs we are confident of the potential for an international political solidarity of music, while acknowledging – indeed, celebrating – that that relation will always be an agonistic work in progress.[27] The meaning of a song such as 'Nkosi Sikelel' iAfrica' is, we suggest, almost universally agreed: it is imbued with the struggle against apartheid and the hopes of, as Cook terms them, 'new South Africans *and their sympathisers across the world.*'[28] Moreover, the song has come to symbolise freedom for peoples globally. So, an all-white

British street choir singing 'Nkosi Sikelel' iAfrica' is unlikely to be accused of cultural appropriation. Rather, the act would be recognised as both commemoration, celebration and continuing aspiration, at least by 'right-minded people', i.e. those on the political left. Moreover, at least in Côr Gobaith's experience of singing the song on the street, South African and Southern African passers-by have been moved and delighted to hear it so far from home. Not all songs are so unproblematic, however, and street choirs should be attuned to the possibilities of appropriation and misrepresentation. Relational space and context are key here. Following the 2016 murder of 49 people and the wounding of 58 others in a gay night-club in Orlando, the cultural-political meaning of the song 'Over The Rainbow' was extended, and it was appropriate and profoundly moving for LGBT and straight people to sing it together at vigils around the world.[29] On the other hand, Milck's song 'Quiet', which became the anthem of the worldwide Women's March in 2017, especially in the US, may yet be a space of musical solidarity to be respectfully reserved for women and their rights claims. So, it's not always music *per se* that can be political, but rather who sings what, where, when, with and to whom.

Typically, street choirs sing not only for themselves: their main aim is to sing for others, to raise awareness, get a message across, entertain and move others to take action. We were told of regular street singing, special events and demonstrations, support for other social movements, blockades such as at Faslane, of special concerts, of visiting activist struggles in other countries...All part of cultural activism. Birmingham Clarion Singers brought 'good music performances' to the factories and streets in the 1940s for people who otherwise had no access to such entertainment. While not involving political music, the choir's action was certainly political. So, how can street choirs best 'get the message across' and reach others? What exactly are we trying to do, what are we about? Well, to answer these questions, we could do worse than heeding the words of Augusto Boal:

> Theatre should be happiness, it should help us learn about ourselves and our times. We should know the world we live in, the better to

change it. Theatre is a form of knowledge; it should and can also be a means of transforming society. Theatre can help us build our future, rather than just waiting for it.[30]

Substitute 'music' or 'singing' for 'theatre' and we believe we have a description of what street choirs are aiming to achieve. Street singing is a form of theatre and, like Boal's Forum theatre and other forms of participatory theatre, choirs aim to inform, entertain and 'give people something to go away and think about', as expressed by several interviewees in response to the question: 'What difference does the choir make?' Hence, being a street choir is not just a matter of singing, it's also about engaging with the public: communicating. Choirs do this to a greater and lesser degree and in different forms: displays or placards that show what they are singing for; flyers to hand out; members or supporters who actively engage in conversation while the choirs sing; song-sheets to hand out to the public, inviting them to sing along, and so on. And some street choirs already employ overtly theatrical forms as, for example, in the pantomime of Côr Cochion's 'nurses, doctors and patients' defending the NHS against 'Theresa May' (see Figure 2). We suggest that street choirs could be further inspired by and adapt the techniques of Augusto Boal's theatre of the oppressed and its games for actors and non-actors. Engaging with other forms of theatre might also be productive. For example, as part of its repertoire Playback Theatre already has forms where players sing the stories of audience members back to them.[31]

A great deal of history is handed down through songs, and several singers commented on how much they had learned about history and politics through joining their choir. Knowledge is shared and circulated through songs and, indeed, one of the key aims of the Campaign Choirs Network is song sharing.[32] Let's follow the story, or at least that part of the story we know, of one song by singer-songwriter Grace Petrie from Leicester: 'Mark My Words' was arranged for three voices (i.e. in three parts) by Natural Voice practitioner Sandra Kerr; the arrangement was circulated to the Campaign Choirs Network email list by Janet Russell,

Musical Director of East Lancs Clarion Choir; in Aberystwyth, Kelvin Mason added three verses, initially for Côr Gobaith to sing; Lotte Reimer taught the song in London at the Strawberry Thieves' event Chants for Socialists; from there it entered the repertoires of choirs in London, Liverpool and Sheffield; in Totnes, Lotte shared the song with the newly formed Voices for Peace (now Voices for Freedom) street choir; in July 2017 'Mark My Words' crossed the Channel and was one of the songs participating choirs chose to learn during the *Rencontres de Chorales Révolutionnaires*. Six months later, two members of Amiens choir ZAD Vengeurs reported: 'We were in Trieste on Monday [visiting Voci Arcutinate choir] and sang "Mark my words" at the end of the practice at dinner time. I thought you might be pleased to know it.'[33] Over several years, Strawberry Thieves and others have taken many songs to the *Rencontres de Chorales Révolutionnaires*. Some have become standards for choirs in France and Spain, including prominently Holly Near's anti-war song 'Watch Out'. In tandem, the Thieves have brought songs from French and Italian choirs back from the festival and shared them with other UK street choirs. So, songs become actors in constructing the stories and, thus, histories of street choirs.

Choirs sing in different spaces: the street, concert halls and community centres to name but a few. Some choirs also take direct action in the form of blockades and occupations of public spaces. An example that inspires us both politically and musically was the Shell Out Sounds choir staging a pirate performance of 'Oil in the Water' before a Shell-sponsored concert at the Royal Festival Hall.[34] The song is a re-write of the African American spiritual 'Wade in the Water'. Melodic and beautifully performed, the song both entertained and informed the audience, who applauded warmly. Other street choirs have conceived and performed similar actions in surprising – or surprised – spaces, including Rise Up Singing blockades at Faslane, flash-mob singing in Marks & Spencer to highlight the supermarket's sale of Israeli goods,[35] and singing against Trident replacement in the Houses of Commons.[36] Such actions clearly have different impacts on different audiences to, say, when street choirs come together to support a national demonstration with a Big Choir.

With the notable exception of Out Aloud, most choirs we interviewed were acutely aware of being predominantly white, female and 'not getting any younger'. So, they were looking to increase their numbers, specifically to recruit younger and more ethnically diverse members as well as more men, where men are viewed musically, i.e. more as bass voices than as a gender or a politics. So, if the aim of growing and diversifying is to be pursued, what songs do street choirs need to sing? And where do we need to sing them? It's something of a chicken and egg scenario: a more diverse membership, for example, will surely diversify street choirs' musical repertoires, and more diverse repertoires will likely attract a more diverse membership. But where do we start? Do we actually need to seek diversity within our choirs as an aim in and of itself?

We suggest that it's likely to be more productive to extend our networks on the activist front. Street choirs could explore the possibility of cultural song-exchange events with groups such as refugees and asylum seekers; we might offer song-writing or singing workshops to the likes of Reclaim the Power, Black Lives Matter, and People's Assembly groups. Campaign Choirs Network members have already supported anti-fracking movements, teaching songs in protest camps as well as singing at demos; Penny Stone of Protest in Harmony ran a singing workshop at Peace News Summer Camp in 2017. Increasingly, street choirs can meet prospective new members in those people's own spaces, whilst simultaneously doing the politics of justice, freedom, equality and sustainability that we believe in. Moreover, such actions may seed choirs in a new generation of social movements.

Picking up on songs again, some singers expressed the need for new songs to be written: songs of and for our time; new tunes and arrangements. For example:

Harriet Vickers: 'I think that there's a real big place for it [singing] within activism as a tactic, but that needs to be brought back. So, with a lot of the housing stuff that I'm doing, I want to bring a few songs into that because things like banner-making and placard-making and such like, that's just something you do for every demo, but you don't do a song – and you could! Like here [*Rencontres de Chorales Révolutionnaires*]

we write a song for every bloody meal! (See Figure 15). There needs to be more of that rather than just seeing it as a way of keeping songs alive. We need to be writing new stuff and adapting things and taking it out there and not being too precious about stuff.'

In Chapter 5 we proposed as challenges for street choirs: imagining perfection; embracing ambiguity, questioning our own ideological formations and being able to laugh at ourselves; and prefiguration, being the change we want to see in the world by enacting the same care for each other that we strive for across the world. When Lotte Reimer talked with Peggy Seeger following the latter's performance at Aberystwyth Arts Centre on 18 November 2017, with reference to street choirs Peggy said: 'I hope their songs are *for*!' What she meant was that our songs should be proposing alternatives, setting new directions, and so inspiring fresh hopes. Whilst we maintain that there will always be a place for protest songs *against* the horrors of war, the proliferation of nuclear weapons, environmental destruction and the awful like, we concur that it is also vital to compose and sing more utopian songs: perfect, ambiguous, and prefigurative; joyful songs, quizzical songs, caring songs. An example of a certain type of utopian song that springs to mind is 'Big Rock Candy Mountain' by Harry McClintock, a life-long Wobbly.[37]

BACK TO THE FUTURES

> Finally, I cannot avoid a critical attitude to what I consider to be the scourge of neoliberalism with its cynical fatalism and its inflexible negation of the right to dream differently, to dream of utopia.[38]

Recall that in Chapter 5 we considered the communal future that street choir members were singing to bring about. Our assumption was that there *had to be* such imaginings: street choirs could not just be singing against injustice and oppression, they must be *for* something different? We observed that the relationship between utopia and social

movements was underexplored, and that we were not alone among contemporary activists in looking to utopia for political inspiration. To frame our analysis of the stories that people told us we used literary utopias, specifically examples of the genre that were closely related to real world politics and social movements. Our 'findings' can be nicely summarised with reference to the Turbulence Collective's three questions: why we do what we do, why we keep doing it, and what else could be done? Our starting point was that our interviewees generally viewed the present as dystopian and worsening, though with some fragile and potentially divisive political gains. Although literary utopias are often written in optimistic times, a dystopian present and/or a dystopian or even apocalyptic view of the future could also spur utopian imaginings, whether in literature or otherwise.

Paramount among the many reasons why street choirs sing was that members judged it to be: a statement of their values; a politically worthwhile action; a way of countering fear and precarity, communal and social fragmentation; a means of disrupting apathy in some audiences; a way of fostering hope within as well as outwith the choir. Plus, singing is joyful, as emphasised by Julie Burnage: 'I love singing, it makes me feel fab!' Here we note that the individualising precarity that Butler raised is likely to be felt most intensely by people between 20 and 50, i.e. those that street choirs find it hardest to recruit. In addition to their reasons for doing what they do, street choirs *keep singing* because, where doubts set in, one of their key virtues is stoicism, embodying stubborn and defiant hope.

Turning now to the question of what else can be done, we looked to the future imaginaries of street choir members for direction. Attending to caring relations, and so generating solidarities and fostering hope, were central to people's imaginings. In this regard, prefiguration manifested as a utopian theme. Care and capitalism were judged to be antithetical, and street choir members had a more humane, emotionally cognisant and aesthetic view of economies. We proposed that street choirs' future imaginaries could be presented as an ethics of care with its key values being: compassion, justice (collective) responsibility, diversity, solidarity,

(joyful hard) work, and hope. Engaging with our imaginaries of the future could, we suggested, be one way of developing the radical potential of street choirs. In this regard, perfectability and ambiguity emerged alongside prefiguration as persistent themes that we drew from our utopian analysis. Moreover, we noted that song was a medium well-suited to recalling political histories, contextualising contemporary politics, *and* imagining better futures.

OUR RHYTHM METHOD?

Conducting research about an activist project that one is closely involved with presents particular problems. If the work is deemed 'too academic', then it often lacks credibility with activist comrades (even if they readily read academic work on other topics). Conversely, amongst academic audiences, there is often the suspicion that the research is too close to the activist 'mission' and so cannot be deemed 'critical' enough. The three of us who conducted the interviews for this project all sing with campaigning street choirs, but Gavin, who has acted as our 'academic advisor' throughout the process does not (although he has sung political songs on the street as part of a choir in the past). This combination of differing degrees of involvement with the Campaign Choirs Network helped us to challenge some of our own assumptions throughout the research and writing process. All knowledge comes from some perspective, and we believe it was highly beneficial to our research to have our personally engaged activist assumptions and interpretations of 'data' challenged academically from a step or two outside the Campaign Choirs Network. Similarly, we hope that our research from within, by and for street choirs, challenges and makes a singular contribution to academic understandings of activists and social movements. Not least, we think our challenge concerns *who* is empowered and legitimated to carry out and present research. In this we note the privileged access to academic journals and books: knowledge generated by our universities but made inaccessible to the public by publishing corporations' paywalls.

Once again, without our academic advisor and the direct provision of their work by some academic authors, whom we sincerely thank and commend, we would not have been able to carry out this project. Finally on this thread, everyone on the team was committed to the principle of generating knowledge *with* street choirs: being able to offer a different perspective is not the same as detachment.

Caitlin Cahill reminds us that, beyond any methodological consideration, Participatory Action Research (PAR) is defined by this 'commitment to working *with* communities.'[39] Cahill explores the ethics of PAR, proposing that its epistemological – knowledge-making – orientation is as a relational praxis, indeed an ethic of care. Such a construction meshes very nicely with our through-going research approach, of course. The knowledge that PAR seeks is primarily a contingent, local knowledge aimed at addressing the self-defined problem(s) of the community. Thereafter, PAR may have the potential to render such local knowledge useful to other struggles on other scales.[40] In our case, the community's problem was expressed as the imperative to develop the radical potential of street choirs. Researchers' ethical responsibilities are then, Cahill proposes, to address questions of representation, political strategy, and emotional engagement.

Even for PAR researchers such as ourselves, who are themselves *within* the field of study and who are committed long-term to the community that they research, representation can be problematic. To present and interpret a community's stories to the public, to academia and, most crucially, to the community itself can be daunting. Certainly, the experience of selecting, framing and analysing excerpts from people's stories has been at once extremely challenging, profoundly humbling and ultimately rewarding: a privilege, in fact. On a methodological note, at the outset we acknowledged the representational limitation of transcribing oral histories: so much of the meaning is inevitably lost to the reader.[41] However, we suggest that further encounters between oral history and PAR can be productive, especially in terms of developing an authentic and revealing intersubjectivity. It is PAR's ethical commitment to transparency and accountability that renders representation not only

doable but also productive as itself an element of research. In short, if street choir members do not contest and counter our interpretations of their stories, we will be surprised *and* disappointed: the purpose of our work is to promote the discussion of 'solutions', not to impose them.

By 'political strategy', Cahill is thinking of the researchers' responsibilities vis-à-vis telling the stories of the community: their commitment to assess the benefits and the risks involved. In our case, for example, we are conscious of the risk of increasing any tensions between street and community choirs. However, it is our assessment, as well as our fervent hope, that telling these stories of the street choirs will prompt reflection, discussion and thence action on this issue, from both 'sides'. In fact, this is our aspiration with respect to all the issues highlighted by the research. To conclude this discussion, transparency, acknowledging our ongoing emotional engagement with the street choirs' community, our inclusion, is our counter to the fallacy of objectivity in research.

CONCLUSION

In this book we have explored how street choirs might develop politically. That consideration has involved many if not all aspects of street choirs, with their songs featuring prominently as political practices of both composition and performance.[42] Our macro-analytical framework throughout has been the ethics of care, substantively as theorised by Held. We have brought that theory into 'conversation' with a number of other theories and concepts that can be applied to social movements: life course activism, social practice theory, solidarity, emotions, cultural activism, and literary utopias. Throughout, our analysis has been space-relational, i.e. we have considered space as at once material, the places of street choirs, and also as the social space constructed by the relations between people.[43] The difference is between an empty street corner in Sheffield and that same corner when one of the city's street choirs is singing there and engaging an audience; space-relationality is a function of both the material and the social, of their interaction, in fact. Obviously, our

principal source of data has been the 42 oral history interviews that we carried out between 2014 and 2017. To that we added the participant observations and sensibilities of our own long-term engagement with street choirs, drawing also on our wider experience in social movements, political but also musical.

To state the obvious, perhaps, for the Campaign Choirs Network to develop its radical potential, current street choirs need to sustain and prosper. We suggest, too, that developing the movement means that new street choirs must emerge. Although street choirs emerge in different ways, it's common for them to be born out of other groupings, including other social movements. Some of the street choirs whom we interviewed emerged from the Clarion movement, the Communist Party, the Workers' Educational Association and the social forum movement. In these cases, class was evidently a key vector. Then, the peace, anti-nuclear, and women's movements were also seedbeds for street choirs. Out Aloud, of course, emerged predominantly from the struggle for LGBT rights and community. We have expressed the hope that the future will see the emergence of, among others, green, black, refugee and youth movement choirs, as well as people from these groups joining existing street choirs. While we hope that many diverse people will come to street choirs, street choirs can also interact with other social movements and communities on their home ground and there engage with their values and practices.

Shared political values are vital to the emergence and then survival of a street choir. Shared musical or artistic values are also important. Some of the main ways that choirs sustain are through: practices of care that bond members to each other; paying attention to the welcome and nurturing of new members; retaining a certain critical mass that allows for some fluctuation in membership numbers over time (we hesitate to propose a number as this will depend on local circumstances); having sufficient material resources, critically a suitable space for rehearsals and meetings; and retaining or replacing key competences, not least a Musical Director/conductor/song-leader or finding a collective way of fulfilling that role; attracting, retaining and developing new audiences. Conversely, based mainly on the story of Velvet Fist, we suggest that

street choirs tend to disappear when they don't – or can't – sufficiently attend to such matters.

Our research findings indicate that, to develop in terms of their impact, street choirs could try to engage differently and more deeply with their audiences. They could also engage with different audiences and explore political song in different, surprising, places. We've also noted that street choirs need to evaluate and consider increasing our utilisation of new technology and social media. As with individual street choirs, we propose that sustaining and developing the Campaign Choirs Network also means attending to its values and practices. Areas we've identified that demand attention include:

- Building a politicised community of care
- The 'institutional' structure of the Network, especially developing roles and responsibilities, including those of Network representatives within street choirs
- The Network's relationship with money (from our stories, we suggest a strategy of minimising that relationship)
- Developing lateral solidarities beyond the local scale
- Exploring uncommon ground with community choirs[44]
- Providing support to emerging street and 'community' choirs
- Rethinking participation in the annual Street Choirs Festival, specifically how Campaign Choirs Network members interact with other choirs and their members (and how the festival format facilitates or impedes such interaction)[45]
- Additional times and spaces for face-to-face Network meetings, whether at musical events/gatherings or specific, 'administrative' meetings for street choir representatives, spokespersons or delegates (the practices of the Natural Voice Network may be relevant here)
- Alternative national, regional and thematic Network gatherings, building particularly on the format developed by Strawberry Thieves for 'Chants for Socialists'
- Encouraging movement visions, including composing and

singing more songs of prefiguration (practicing aspirations for better futures in the present), perfectability (depicting perfect futures, whether playful, hard-fought or ethereal) and ambiguity (portraying futures where contestation is constituent of perfection and so the antithesis of stasis and ideology).

We're aware that bringing our interest in care for the future to this research project, we have 'skewed' our findings towards care in proposing how the Campaign Choirs Network could develop its radical potential. That said, we *did* find care at the heart of the social practices, solidarities, imaginings and, to an extent, songs of the street choirs. This too, we understand, is not a startling finding, as care (or the lack of it) is at the heart of life itself, from conception through ageing till death us do part.[46] Viewing care as an ethical concept that defines a politics is (still) a departure in most people's thinking, however. If we have anything to offer beyond our attempt to address the local 'problem' of street choirs' development as a political network, it is perhaps that social movements more widely consider their politics as a more capacious and compassionate relational praxis. They could also sing more. We'll leave you with the words of a song well-known to many street choirs, 'Keep you in peace' by Sarah Morgan:

> May you not lack for good bread to feed you,
> May you not lack for good hope to speed you,
> And for your singing, a heart to heed you,
> Keep you in peace till we meet again.

ENDNOTES

1 We believe this is actually a reference to the song "Fat Cat", which is sung to the *Top Cat* theme tune (Hanna/Barbera/Timmins) with words by Liverpool Socialist Singers. Fat Cat includes the line "He's unfair, he don't care, he's a millionaire."

2 "Momentum is a grassroots campaigning network… mobilising the mass campaigning movement that we need to get Labour into government." http://www.peoplesmomentum.com/

3 "If I cannot do great things, I can do small things in a great way" is a quote attributed to Martin Luther King Jr.

4 Women in Black http://womeninblack.org/

5 "You won't be fracking long". Words by Côr Cochion's Marie Walsh, set to the tune of 'The Laughing Policeman' by Charles Penrose

6 Charlotte Cooper, *Fat Activism: A Radical Social Movement* (Bristol: HammerOn Press, 2016).

7 See too Brown and Yaffe, *Youth Activism and Solidarity.*

8 In 2018 Côr Gobiath decided to revive singing at Aberystwyth University Freshers Fayre as much as a welcome and move towards "town and gown" solidarity as awareness raising or a recruitment tactic.

9 Sasha Roseneil, *Common women, uncommon practices: the queer feminisms of Greenham* (London: Cassell, 2000).

10 We view social reproduction as the transmission of inequality from one generation to the next via the various structures that simultaneously reproduce capitalism. See for instance Tithi Bhattacharya (Ed.) *Social Reproduction Theory: Remapping Class,*

Recentering Oppression. London: Pluto Press, 2017.

11 Silivia Federici, "On elder care," *The Commoner*, 15 (2012): 235-261. Available online at: www.commoner.org.uk/wp-content/uploads/2012/02/10-federici.pdf.

12 To quote the Au Pairs song "It's Obvious" from the 1981 album *Playing with a Different Sex*.

13 Time and space can both be considered as, at least partly, constructions, materials, competences and meanings.

14 John Hamilton noted that Strawberry Thieves quickly got up to about 25 members when they formed in 1986, and "it has been the same ever since."

15 With the notable exception of Out Aloud, street choirs have not taken steps to limit how many people are in the choir.

16 Brown and Yaffe, *Youth Activism and Solidarity*.

17 "Cwsg Osian" was written by Heather Jones. The others songs shared were "Song for Gaza" by Michael Heart, "Vine and Fig Tree" by Mary Miche, and "Asikatale", a South African song sung by the anti-apartheid movement re-worded for the Palestinian struggle by, we believe, Leon Rosselson, Roy Bailey and Frankie Armstrong. The songs are available on Google Drive https://drive.google.com/drive/folders/0BxpZhU6ry7OHUkw3RUE2eUNtYlk

18 "Palestinian child prisoner Abdul-Khalik Burnat, 17, charged in occupation military court". Samidoun Palestinian Prisoner Solidarity Network. 3 January 2018. http://samidoun.net/2017/12/new-yorkers-protest-to-freeabdul-khalik-burnat-and-palestinian-child-prisoners. Accessed 14 January 2018.

19 Lowenna Turner, "young" member of Côr Cochion: "I'm sure I've heard these stories and seen astounding events, because someone needs to say: this is how it was, and that's how it was for people I knew. I can take Ray [Davies] and I can take Meic Peterson, like when people start talking about: oh, they should do national service, I can say: maybe you should go and talk to Meic and ask him about what it is actually like if you have to go, if you're sent somewhere by your country and told to kill people, maybe you

would feel differently, if you spoke to Meic. And it's very important to take that history that I have been able to experience second hand and tell it to people and keep hold of it and hopefully preserve it for future generations."

20 See the debates in F Tormos, "Intersectional Solidarity." *Politics, Groups, and Identities* 5, 4 (2017), 707-720.

21 Jo Ram, "Drawing a line." *Red Pepper* 214, June/July (2017): 30-31.

22 Person Of Colour.

23 David Graeber, *The Democracy Project* (London: Penguin, 2014), 255.

24 Jeanette Bicknell, *Why Music Moves Us* (Basingstoke: Palgrave Macmillan, 2009).

25 "E Malama", a Hawaiian Earth Blessing, has been arranged by Nickomo Clarke.

26 The Campaign Choirs Network has 126 individual members out of whom 95 are with affiliated choirs, 21 are with non-affiliated choirs and 8 do not belong to a specific choir. These members represent 60 choirs, of which 43 are also affiliated as choirs.

27 Where "agonistic" signals a politics of contestation that is positively channelled and appreciated by contestants: the primary aim is not to win an argument but to extract mutual learning from it and so make a better decision because of the (revealing) contest.

28 Cook, *Music*, 79, emphasis added.

29 With music by Harold Arlen and lyrics by Yip Harburg, "Over the Rainbow" was composed for the movie *The Wizard of Oz* in which, of course, it was sung by Judy Garland who played Dorothy Gale.

30 Boal, *Games for actors and non-actors*, xxxi.

31 Playback Theatre http://www.playbacktheatre.org/

32 In February 2018, for instance, Sea Green Singers emailed the network to ask for "songs about slavery particularly reflecting the English perspective" for an evening of protest songs: "Hear the People's Voices: Hidden History."

33 ZAD Vengeurs are named in support of the ZAD, an autonomous area of France resisting the development of an airport at

Notre-Dame-des-Landes https://zad.nadir.org/?lang=en.

34 "Oil in the water" by Shell Out Sounds https://www.youtube. com/watch?v=Oxh4sneLbgY. Shell has been condemned by the UN for decades of oil spills in Nigeria, and is pressing ahead with destructive projects in the Canadian tar-sands and the Artic.

35 Boycott, Divestment, Sanctions (BDS) is a Palestinian-led movement for freedom, justice and equality https://bdsmovement. net/

36 "Trident is a War Crime" oratorio, composed by Camilla Cantantata, performed in the lobby of the House of Commons https://www. youtube.com/watch?v=WVQcc7V4A5U

37 "Wobblies" is shorthand for members of the Industrial Workers of the World https://iww.org.uk/

38 Paulo Freire, *Pedagogy of Freedom: Ethics, Democracy, and Civic Courage* (Lanham: Rowman and Littlefield, 2000), 22.

39 Caitlin Cahill, "Repositioning Ethical Commitments: Participatory Action Research as a relational praxis of social change". *ACME* 3, 3 (2007): 360-373.

40 Kelvin Mason, "Participatory Action Research: coproduction, governance and care." *Geography Compass* 9, 9 (2015): 497-507.

41 We anticipate that our oral history interviews will be available via the East Midland Oral History Archive in the University of Leicester https://www.le.ac.uk/emoha/

42 Thanks to Cynthia Cockburn for alerting us to the importance of this aspect.

43 See, for instance, Doreen Massey, *For Space* (London: Sage, 2005).

44 Uncommon ground can be a difficult notion to grasp. It is a relational space where the defining politics of the parties present is not in play, and where the parties act together on something that is not the usual matter for any of them. For instance, street and community choir members might attend a football match together (although they would probably sing!) The essence of uncommon ground is to build caring human relations into which the later introduction of political discussion is less likely to be divisive.

45 We are aware of the 2018 Street Choirs Festival hosts, Brighton's Hullabaloo Community Choir, taking a different approach to the format, holding the choir concert over two evenings and interspersing choir singing with local entertainer acts, in order to shorten the, traditionally very long, Saturday choir concert. This may not, however, facilitate the space for politics, whether building solidarities in the Campaign Choirs Network, contesting values and practices, or exploring common ground with community choirs.

46 See, for instance, Atal Gawande, *Being Mortal. Illness, Medicine and What Matters in the End* (London: Profile Books, 2015).

BIBLIOGRAPHY

Abrams, Lynn. *Oral History Theory*. London: Routledge, 2010.

Ackroyd, Peter. *The Life of Thomas More*. London: Vintage, 1999.

Adler, William M. *The Man Who Never Died: The Life, Times, and Legacy of Joe Hill, American Labor Icon*. New York: Bloomsbury, 2012.

Adorno, Theodor. *Essays on Music*. Oakland: University of California Press, 2002.

Adorno, Theodor. *Philosophy of Modern Music*. London: Bloomsbury, 2016.

Alozie, Nicholas, James L. Simon and Bruce D. Merrill. "Gender and Political Orientation During Childhood". *The Social Science Journal*, 40, 1, (2003): 1-18.

Askins, Kye. "Activists." In *The Ashgate Research Companion to Critical Geopolitics*, edited by K. Dodds, M. Kuus and J. Sharp, 527-542. Farnham: Ashgate, 2013.

Ball, Philip. *The Music Instinct: how music works and why we can't do without it*. London: Vintage, 2011.

Bartos, Anne E. "Children Caring For Their Worlds: The politics of care and childhood." *Political Geography*, 31 (2102): 157-166.

Bauman, Zygmunt. *Socialism: The Active Utopia*. New York: Homes and Meier, 1976.

Bergamini, Matteo. "Compulsory political education is a must if we are to stem the flow of disengagement from politics." *Democratic Audit*. September 5, 2014. http://www.democraticaudit.com/2014/09/05/compulsory-political-education-is-a-must-if-we-are-to-stem-the-flow-of-disengagement-from-politics. Accessed September 11, 2017.

Bernstein, Mary. "Same-Sex Marriage and the Future of the LGBT Movement." *Gender & Society*, 29, 3 (2015): 321-337.

Bicknell, Jeanette. *Why Music Moves Us*. Basingstoke: Palgrave Macmillan, 2009.

Bithell, Caroline. *A Different Voice, A Different Song: Reclaiming Community Through The Natural Voice And World Song*. Oxford: Oxford University Press, 2104.

Bloch, Ernst. *The Principles of Hope*. Oxford: Blackwell, 1986.

Blunt, Alison and Robyn Dowling. *Home*. London: Routledge, 2007.

Blyth, Mark. *Austerity: The history of a dangerous idea*. Oxford: Oxford University Press, 2015.

Boal, Augusto. *Theatre of the oppressed*. London: Pluto, 1979.

Boal, Augusto. *Games for actors and non-actors*. London: Routledge, 1992.

Bogard, L.M. "Tactical Carnival: Social Movements, Public Space and

Dialogical Performance." In *A Boal Companion*, edited by Jan Cohen-Cruz and Mady Schutzman, 46-58. London: Routledge, 2006.

Bosco, F.J. "Emotions that build networks: Geographies of human rights movements in Argentina and beyond. *Tijdschrift voor economische en sociale geografie*, 98 (2007): 545–563.

Brown, G. "Mutinous Eruptions: Autonomous spaces of radical queer activism." *Environment and Planning A*, 39 (2007): 2685-2698.

Brown, Gavin and Jenny Pickerill. "Space for emotion in the spaces of activism." *Emotion, Space and Society*, 2, 1 (2009): 24-35.

Brown, Gavin. "Marriage and the spare bedroom: Exploring the sexual politics of austerity". ACME 14, 4 (2015): 975-988

Brown, G. and Yaffe, H. "Practices of solidarity: opposing apartheid in the centre of London." *Antipode*, 46, 1 (2014): 34-52.

Brown, Gavin and Helen Yaffe. *Youth Activism and Solidarity: The non-stop picket against Apartheid*. London: Routledge, 2017.

Brown, Gavin, Anna Feigenbaum, Fabian Frenzel and Patrick McCurdy (Eds.) *Protest Camps in international context*. Bristol: Policy Press, 2017.

Buse, Katherine. "Genre, utopia, and ecological crisis: world multiplication in Le Guin's fantasy." *Green Letters: Studies in Ecocriticism*, 17, 3 (2013): 264-280.

Buser, Michael and Jane Arthurs. *Cultural Activism in the Community*. UWE Bristol: Connected Communities, 2013.

Butler, Judith. *Towards a Performative Theory of Assembly*. Harvard: Harvard University Press, 2015.

Callenbach, Ernest. *Ecotopia.* Berkeley: Banyan Tree Books, 1975.

Cahill, Caitlin. "Repositioning Ethical Commitments: Participatory Action Research as a relational praxis of social change". *ACME* 3, 3 (2007): 360–373.

Camus, Albert. "Neither Victims Nor Executioners." In *Camus at 'Combat': Writing 1944-1947.* Princeton: Princeton University Press, 2007.

Carlsson, Chris. *Critical Mass: Bicycling's defiant celebration.* Oaklnad, AK Press, 2002.

Carlsson, Chris. *Nowtopia.* Oakland CA: AK Press, 2008.

Carlsson, Chris and Francesca Manning. "Nowtopia: Strategic exodus". *Antipode.* 42, 4 (2010): 924-953.

Carter, Will. "The strange neglect of political education - and how to revive it." *New Statesman,* 18 August 2016.

Castells, Manuel. *Networks of Outrage and Hope: Social Movements in the Internet Age.* Cambridge: Polity Press, 2015.

Chesters, Graeme and Ian Welsh. *Social Movements: The Key Concepts.* London: Routledge, 2010.

Clough, Nathan L. "Emotion at the Centre of Radical Politics: On the affective structures of rebellion and control." *Antipode,* 44, 5 (2012): 1667-1686.

Collins, Patricia Hill and Sirma Birge. *Intersectionality.* Cambridge: Polity Press, 2016.

Cook, Nicholas. *Music: A very short introduction*. Oxford: OUP, 1998.

Corning, Alexandra, F. and Daniel J Myers. "Individual Orientation Towards Engagement in Social Action". *Political Psychology*, 23, 4 (2002): 703-729.

Coverley, Merlin. *Utopia*. Harpenden: Pocket Essentials, 2010.

Crenshaw, K. *On Intersectionality: Essential writings*, New York: The New Press, 2017.

Cresswell, Tim. *Place: A Short Introduction*. Hoboken: Wiley-Blackwell, 2013.

Culshaw, Peter. "Mozart was a political revolutionary." *The Telegraph*, 03 Jul 2006.

Curran Giorel. *21st Century Dissent: Anarchism, Anti-Globalization and Environmentalism*. London: Palgrave Macmillan, 2007.

Curtis, Claire P. "Ambiguous Choices: Skepticism as a Grounding for Utopia. In The New Utopian Politics of Ursula K. Le Guin's The Dispossessed, edited by Laurence Davis and Peter Stillman, 265-282. Oxford: Lexington Books, 2005.

Dallas Street Choir, Vision. https://www.dallasstreetchoir.org/ about-2/. Accessed 2 October, 2017

Dave, Naisargi. *Queer Activism in India: A story in the anthropology of ethitcs*. Durham: Duke University Press, 2012.

Davies, A. D. "Assemblage and social movements: Tibet Support Groups and the spatialities of political organisation." *Transactions of the Institute of British Geographers*, 32, 2 (2012): 273-286.

Davis, Angela. *Freedom Is a Constant Struggle: Ferguson, Palestine, and the Foundations of a Movement*. Chicago: Haymarket Books, 2016.

Davis, Kathy, Monique Leijenaar and Jantine Oldersma (Eds.). *The Gender of Power*. London: Sage, 2009.

Davis, Laurence. "Morris, Wilde, and Le Guin on Art, Work, and Utopia. *Utopian Studies* 20, 2 (2009): 213-248.

Davis, Laurence. "History, Politics, and Utopia: Towards a Synthesis of Social Theory and Practice." *Journal of Contemporary Thought*, 31, Summer, (2010): 79-94.

Davis, Laurence and Peter Stillman (Eds). *The New Utopian Politics of Ursula K. Le Guin's The Dispossessed*. Oxford: Lexington Books, 2005.

Delanty, Gerard. *Community*. London: Routledge, 2003.

della Porta, Donatella and Mario Diani. *Social Movements: An Introduction*. Oxford: Wiley-Blackwell, 2010.

della Porta, Donatella and Dieter Rucht. *Meeting Democracy: Power and Deliberation in Global Justice Movements*. Cambridge: Cambridge University Press, 2014.

della Porta, Donatella. *Social Movements in Times of Austerity: Bringing Capitalism Back into Protest Analysis*. Cambridge: Polity Press, 2015.

Delveaux, Martin. "The Biologisation of Ecofeminism? On Science and Power Marge Piercy's Woman on the Edge of Time." *Green Letters: Studies in Ecocriticism* 5, 1 (2013): 23-29.

DeMartini, J. R. "Social Movement Participation: Political socialisation, generational consciousness and lasting effects." *Youth and Society*, 15

(1983): 195-233.

De Neve, J.-E. "Personality, Childhood Experience, and Political Ideology." *Political Psychology*, 36, 1 (2015): 55–73.

Denisoff, R. S. "Protest Movements: Class Consciousness and the Propaganda Song." *Sociological Quarterly*, 9, 2 (1968): 228–247.

DeNora, Tia. *After Adorno: Rethinking Music Sociology*. Cambridge: Cambridge University Press, 2010.

Di Feliciantonio, C., & Brown, Gavin. "Introduction: The sexual politics of austerity". *ACME* 14, 4 (2015): 965-974.

Dinas, Elias. "Why Does the Apple Fall Far from the Tree? How Early Political Socialization Prompts Parent-Child Dissimilarity." *British Journal of Political Science*, 44, 4, (2014): 827-852.

Dittmer, J. "Geopolitical assemblages and complexity". *Progress in Human Geography*, 38, 3 (2014): 385-401.

Dorling, Danny. *Injustice: Why social inequality persists*. Bristol: The Policy Press, 2011.

Epstein, R. (Director) *The Times of Harvey Milk*. New York: New Yorker Films, 1984

Eyerman, Ron and Andrew Jamison. *Music and Social Movements: Mobilising traditions in the twentieth century*. Cambridge: Cambridge University Press, 1988.

Eyerman, Ron. "Music in Movement: Cultural politics and old and new social movements." *Qualitative Sociology*, 25, 3 (2002): 443-458.

Fairley, J. "Annotated bibliography of Latin-American popular music with particular reference to Chile and to nueva canción." *Popular Music* (1985): 305-356.

Featherstone, D. "Some Versions of Militant Particularism: A Review Article of David Harvey's Justice, Nature and the Geography of Difference." *Antipode*, 30 (1998): 19–25.

Featherstone, David. "Towards the Relational Construction of Militant Particularisms: Or Why the Geographies of Past Struggles Matter for Resistance to Neoliberal Globalisation." *Antipode*, 37 (2005): 250–271.

Featherstone, David. *Solidarity: Hidden Histories and Geographies of Internationalism*. London: Zed, 2012.

Federici, Silvia. "On elder care", *The Commoner*, 15 (2012): 235-261. Available online at: www.commoner.org.uk/wp-content/uploads/2012/02/10-federici.pdf.

Fernández, Pablo D, Ignasi Martí, Tomás Farchi. "Mundane and Everyday Politics for and from the Neighborhood." *Organization Studies*, 38, 2 (November 03 2016): 201-223.

Flanagan C. A. and Tucker C. J. "Adolescents' explanations for political issues: concordance with their views of self and society." *Dev Psychol.*, 35, 5 (1999):1198-209.

Francis, Becky. "The role of The Boffin as abject Other in gendered performances of school achievement." *The Sociological Review*, 57 (2009): 645–669.

Francis, Becky. *Boys, Girls and Achievement: Addressing the Classroom Issues*. London: Routledge, 2000.

Francis, Becky. "Relativism, Realism, and Reader-Response Criticism: An analysis of some theoretical tensions in research on gender identity." *Journal of Gender Studies*, 11, 1 (2002): 39-54.

Francis, Becky. and Skelton, C. *Reassessing Gender and Achievement: Questioning Contemporary Key Debates*. London: Routledge, 2005.

Friedman, J. C. (Ed.) *The Routledge History of Social Protest in Popular Music*. Abingdon: Routledge, 2013.

Freire, Paulo. *Pedagogy of Freedom: Ethics, Democracy, and Civic Courage*. Lanham: Rowman and Littlefield, 2000.

Fyfe, Nicholas (Ed.) *Images of the Street: Planning, Identity and Control in Public Space: Representation, Experience and Control in Public Space*. London: Routledge, 1998.

Ganesh, Shiv. "The Orlando shootings as a mobilizing event: against reductionism in social movement studies." *Communication and Critical/ Cultural Studies*, 14, 2 (2017): 193-197.

George, Susan. *Another World Is Possible If...* London: Verso, 2004.

Gibson-Graham, J. K., Jenny Cameron and Stephen Healy. *Take Back the Economy: An ethical guide for transforming our economies*. Minneapolis: University of Minnesota Press, 2013.

Giuliano, G. and Susan Hanson (Eds.) *The Geography of Urban Transportation*. New York: The Guilford Press, 2017.

Gluck, S. B. and Patai, D. (Eds). *Women's Words: The feminist practice of oral history*. London: Routledge, 1991.

Goldstone, J., D. McAdam, E. Perry, W. Sewell, S. Tarrow, et al, 89-125.

Cambridge: Cambridge University Press, 2001.

Goodwin, Jeff, Hames M. Jasper and Francesca Polleta. *Passionate Politics: Emotions and social movements*. London: University of Chicago Press, 2001.

Goodwin, Jeff and James M. Jasper (Eds.) *The Social Movements Reader: cases and concepts*. Oxford: Blackwell, 2003.

Goodwin, J., Jasper, J. M. and Polletta, F. "Emotional Dimensions of Social Movements." In *The Blackwell Companion to Social Movements*, edited by D. A. Snow, S. A. Soule and H. Kriesi, Blackwell Publishing Ltd, 413-432. Oxford: Blackwell, 2004.

Gordon, Hava Rachel. "Gendered Paths to Teenage Political Participation: Parental Power, Civic Mobility, and Youth Activism." *Gender and Society*, 22, 1 (2008): 31-55.

Graeber, David. *The Democracy Project. A history; A Crisis; A movement*. London: Allen Lane, 2013.

Graeber, David. "Caring too much: That's the curse of the working classes." *The Guardian*, March 26, 2014.

Gupta, Rahila. "The journey of a feminist slogan." https://www.opendemocracy.net/5050/rahila-gupta/personal-ispolitical-journey-of-feminist-slogan. Accessed 8 October, 2017

Gutierrez, Ana. "Peace profile: Victor Jara." *Peace Review*, 10, 3 (1998): 485-491.

Halberstam, Jack. *The Queer Art of Failure*. Durham: Duke University Press, 2011.

Halvorsen, Sam. "Losing Space in Occupy London: Fetishising the protest camp." In *Protest Camps in International Context* edited by Gavin Brown, Anna Feigenbaum, Fabian Frenzel and Patrick McCurdy, 163-178. Bristol: Policy Press, 2107.

Harari, Yuval Noah. *Homo Deus*. London: Vintage, 2017.

Hargreaves, Tom. "Practice-ing behaviour change: Applying social practice theory to pro-environmental behaviour change." *Journal of Consumer Culture*, 11, 1 (October 26, 2011): 79 – 99.

Harvie, David, Kier Milburn, Ben Trott and David Watts (eds.) *Shut Them Down! The G8, Gleneagles 2005 and the movement of movements*. Leeds/Brooklyn: Dissent!/Autonomedia, 2005.

Harvey, David. *Spaces of Hope*. Edinburgh: Edinburgh University, 2000.

Held, Virginia. *The Ethics of Care: personal, political, and global*. Oxford: OUP, 2006.

Herman, Edward S. and Noam Chomsky. Manufacturing Consent. London: Vintage, 1994.

Hilliard, Russell E. "A Social and Historical Perspective of the San Francisco Gay Men's Chorus. *Journal of Homosexuality*, 54, 4 (2008): 345 -361.

Hillman, Nick and Nicholas Robinson. *Boys to Men: The underachievement of young men in higher education – and how to start tackling it* (Report 84, 12 May). Oxford: Higher Education Policy Unit, 2016.

Hunt-Hendrix, *Leah. The Ethics of Solidarity: Republican, Marxist and Anarchist interpretations* (PhD Dissertation, January). Princeton, NJ: Princeton University, 2014.

Ince, Anthony. "Anti-fascism: attack as defence / defence as attack." *ACME* 16, 4 (2017): 628-631.

Irwin, Colin. "Power to the People." *The Guardian,* August 10, 2008.

Isin, Engin. *Being Political: Genealogies of citizenship.* London: University of Minnesota Press, 2002.

Jameson, Frederic. "Future City." *New Left Review* 21, May/June (2003), 65-79.

Jameson, Frederic. *Archaeologies of the Future: The Desire Called Utopia and Other Science Fictions.* London: Verso, 2007.

Jamieson, Dale. *Reason in a Dark Time.* Oxford: Oxford University Press, 2014.

Jasper, James M. "The Emotions of Protest: Affective and Reactive Emotions in and around Social Movements." *Sociological Forum,* 13, no. 3 (1998): 397-424.

Jasper, James M. "Motivation and Emotion." In *The Oxford Handbook of Contextual Political Analysis,* Edited by Robert E. Goodin and Charles Tilly. Oxford: Oxford University Press, 2006.

Jasper, James M. "Emotions and Social Movements: Twenty Years of Theory and Research." *Annual Review of Sociology,* 37, 1 (2011): 285-303.

Jennings, M. Kent and Richard Niemi. *The Political Character of Adolescence: The Influence of Families and Schools.* Princeton, NJ: Princeton University Press, 1974.

Jennings, M. Kent, Gregory B. Markus, Richard G. Niemi, and Laura Stoker. Youth-Parent Socialization Panel Study, 1965-1997: Four Waves

Combined. Ann Arbor, MI: Inter-university Consortium for Political and Social Research [distributor], 2005-11-04. https://doi.org/10.3886/ICPSR04037.v1.

Jones, Owen. "Gay people have come a long way – but hatred is still out there." *Independent,* January 27, 2012.

Jones, Owen. *Chavs: The demonization of the working class.* London: Verso Books, 2012.

Jordan, John. "Clandestine Insurgent Rebel Clown Army." In Boyd, A. (Ed.) *Beautiful Trouble: A Toolbox for Revolution,* edited by Andrew Boyd and Dave Oswald Mitchell, 350 -353. Or Books, 2016.

Jordan, John. "Reclaim The Streets." In *Beautiful Trouble: A Toolbox for Revolution,* edited by Andrew Boyd and Dave Oswald Mitchell, 350 -353. Or Books, 2012.

Kallio, Kirsi Pauliina and Jouni Häkli. "Tracing Children's Politics." *Political Geography,* 30 (2011): 99-109.

Kelliher, D. "Solidarity and sexuality: Lesbians and gays support the miners 1984–50." *History Workshop Journal,* 77, 1 (2014): 240-262.

Kindon, Sara, Rachel Pain and Mike Kesby. *Participatory Action Research Approaches and Methods.* London: Routledge, 2007.

Kingsnorth, Paul. *One No, Many Yeses.* London: The Free Press, 2003.

Klocker N and Drozdzewski D. "Career progress relative to opportunity: How many papers is a baby 'worth'?" *Environment and Planning A,* 44 (2012): 1271-1277.

Koopman, Sara. "Imperialism Within: Can the Master's Tools Bring

Down Empire?" *ACME [S.l.]* 7, 2, (2008): 283-307.

Koopman, Sara. "Social Movements." In *The Wiley Blackwell Companion to Political Geography*, edited by J. Agnew, V. Mamadouh, A. J. Secor and J. Sharp, 339-351. Chichester, UK: John Wiley & Sons, 2015.

Kumar, Krishnan. *Utopia and Anti Utopia in Modern Times.* Oxford: Blackwell, 1987.

Lave, J. "Situating learning in communities of practice." *Perspectives on socially shared cognition*, 2 (1991): 63-82.

Lee, Charles T. "Decolonizing Global Citizenship." In *Routledge Handbook of Global Citizenship Studies*, edited by Engin F. Isin and Peter Nyers, 75-85. London: Routledge, 2014.

Leeworthy, D. "For our common cause: Sexuality and left politics in South Wales, 1967–1985." *Contemporary British History*, 30, 2 (2016): 260 – 280.

Le Guin, Ursula K. *The Dispossessed.* London: Millennium, 1999.

Le Guin, Ursula K. "A Response by Ansible from Tau Ceti." *In The New Utopian Politics of Ursula K. Le Guin's The Dispossessed*, edited by Laurence Davis and Peter Stillman, 305-308. Oxford: Lexington Books, 2005.

Leigh, Mike. "True Anarchists." *The Guardian.* November 4, 2006.

Leopold, David. "Socialism and (the rejection of) utopia." *Journal of Political Ideologies*, 12, 3 (2007): 219 -237.

Levine, Linda J. and David A. Pizarro. "Emotion and Memory Research: A Grumpy Overview." *Social Cognition*, 22 Autobiographical Memory:

Theoretical Applications (2004): 530-554.

Lovell, David. "Marx's Utopian legacy." *The European Legacy*, 9, 5: (2004).

Lowery, Wesley. *They Can't Kill Us All: The Story of Black Lives Matter*. London: Penguin, 2017.

Maciunas, Billie. "Feminist Epistemology in Piercy's Woman on the Edge of Time." *Belo Horizonte* 10, 1 (1989), 15-21.

Machado, Antonio. *There Is No Road: Proverbs by Antonio Machado*. Translated by Mary G. Berg and Dennis Maloney. Buffalo NY: White Pine Press, 2003.

Manchester Community Choir. https://manchestercommunitychoir. org.uk/about-us/. Accessed 10 October 2017.

Manuel, Frank E. and Fritzie P. Manuel. *Utopian Thought in the Western World*. Cambridge MA: Harvard University Press, 1979.

Marx, Karl and Friedrich Engels. *The Communist Manifesto*. London: Penguin Classics, 2015.

Mason, Kelvin. "No Names, No faces, No Leaders: The risible rise and rise of CIRCA, an obscene army of the deviant, dangerous and - er – deeply democratic!" In *Tackling Trident: Academics in Action through Academic Conference Blockades* edited by Vinthagen, S. J. Kenrick & K. Mason, 208 - 225. Irene Publishing. Sweden, 2012.

Mason, Kelvin. "Magical Marxism: Subversive Politics and the Imagination" (a review). *AREA*, 44 (2012): 129-130.

Mason Kelvin and Kye Askins. "COP15 and beyond: Politics, protest and climate justice." *ACME Special Issue: The Politics of Climate Change,*

12, 1 (2013): 9-22.

Mason, Kelvin. "A Dirty Black Hole: Open-cast coalmining." *Red Pepper*, August, 184 (2013): 16.

Mason, Kelvin. "Decades of Devastation ahead: Fracking and open-cast mining in Wales." *Planet: The Welsh Internationalist*, 212, Winter (2013): 57-65.

Mason, Kelvin. "A Dirty Black Hole: Open-cast coalmining." *Red Pepper*, August. 184 (2013): 16.

Mason, Kelvin. "Participatory Action Research: Coproduction, governance and care." *Geography Compass*, 9, 9 (2015): 497 – 507.

Mason, Kelvin and Lotte Reimer. "Raised Voices: The campaign Choirs movement". *Red Pepper*, 205, January (2016): 42-44.

Mason, Paul. *Why it's kicking off everywhere: The new global revolutions.* London, Verso, 2012.

Mason, Paul. "The leftwing case for Brexit (one day)". https://www.theguardian.com/commentisfree/2016/may/16/brexit-eureferendum-boris-johnson-greece-tory. Accessed 11 October 2017.

Massey, Doreen. *Space, Place and Gender.* Cambridge: Polity, 1994.

Massey, Doreen. "Geographies of Solidarities." In *Material Geographies* edited by N. Clark, D. Massey and P. Sarre, 311-362. London: Sage, 2008.

Marx, Karl and Friedrich Engels. *The Communist Manifesto.* London: Penguin Classics, 2015.

Mather, Mara and Matthew Sutherland. "The selective effects of

emotional arousal on memory. *Psychological Science Agenda*, Science Brief, February (2012).

Mattern, M. *Acting in Concert: Music, Community, and Political Action.* Rutgers University Press: New Brunswick, 1998.

Mayton, D. M. II and Furnham, A. "Value Underpinnings of antinuclear political activism: A cross-national study." *Journal of Social Issues*, 50 (1994): 117-128.

McAdam, Douglas and William H. Sewell, "It's about time: Temporality in the study of social movements and revolutions." In *Silence and voice in the study of contentious politics.* Aminzade, Ronald R. et al (Eds.) Cambridge: Cambridge University Press, 2001, 89-125.

McIntyre, Alice. *Participatory Action Research*, London: Sage, 2007.

McKay, George. "A soundtrack to the insurrection: street music, marching bands and popular protest." *Parallax*, 13 , 1 (2007): 20-31.

McSherry, J. P. "The Political Impact of Chilean New Song in Exile." *Latin American Perspectives*, 44, 5 (1 December 2016): 13 – 29.

Merrifield, Andy. *Magical Marxism: Subversive politics and the imagination.* London: Pluto Press, 2011.

Miles, Malcolm. *Urban Utopias: The built and social architecture of alternative settlements.* London: Routledge, 2008.

More, Thomas. "Utopia." In *Three Early Modern Utopias: Utopia, New Atlantis and The Isle of Pines,* edited by Susan Bruce, 1 – 129. Oxford: Oxford University Press, 2008

Morris, N. "Canto porque es necesario cantar: The New Song movement

in Chile, 1973-1983." *Latin American Research Review*, 21, 2 (1986): 117-136.

Morris, William. *News From Nowhere (or An Epoch of Rest)*. Oxford: Oxford University Press, 2009.

Moylan, Tom (ed.) "Special Section on the Work of Fredric Jameson." *Utopian Studies*, 9, 2 (1998): 1-7.

Mumford, Lewis. *The City in History*. London: Penguin, 1987. Oakland: AK Press, 2002.

Muñoz, José Esteban. *Cruising utopia: The then and there of queer futurity*. New York: New York University Press, 2009.

Nicolson, Paula. *Gender, Power and Organization*. London: Routledge, 2015.

Nolas, Sevasti-Melisssa, Christos Varvantakis and Vinnarasan Aruldoss. "Political activism across the life course." *Contemporary Social Science*, 12, 1-2 (2017): 1 -12.

North, Peter. *Local Money: How to Make it Happen in Your Community*. Cambridge: Green Books, 2010.

Notes from Nowhere (eds.) *We are everywhere: The irresistible rise of global anticapitalism*. London: Verso, 2003.

O'Byrne, D. M. "Marge Piercy's Non-Utopia in Woman on the Edge of Time." In *Utopia* edited by R. Bradshaw, 75-84. Nottingham: Five Leaves, 2012.

Ockelford, Adam. *Comparing Notes: How we make sense of music*. London: Profile Books, 2017.

Ogden, D. C. "The Welcome Theory: An Approach to Studying African American Youth Interest and Involvement in Baseball." *NINE: A Journal of Baseball History and Culture*, 12, 2 (2004): 114-122.

Okigbo, Austin C. and Bellarmine A Ezumah. "Media Health Images of Africa and the Politics of Representation: A South African AIDS Choir Counter Narrative." *Journal of Asian and African Studies* 52, 5 (2015): 705-721.

Park, B. "An Aspect of Political Socialisation of Student Movement Participants in Korea." *Youth and Society*, 25 (1993): 171-201.

Peddie, Ian. (Ed.) *The Resisting Muse: Popular Music and Social Protest.* Farnham: Ashgate, 2006.

Pepper, David. "Utopianism and Environmentalism." *Environmental Politics*, 14, 1 (2005): 3-22.

Perks, Rob & Thomson, Alistair. (Eds.) *The Oral History Reader*. London: Routledge, 1998.

Piercy, Marge. *Woman on the Edge of Time*. London: The Women's Press, 1979.

Piercy, Marge. *Parti-Coloured Blocks for a Quilt*. Michigan. Ann Arbor: University of Michigan Press, 1982.

Piercy, Marge. "Woman on the Edge of Time, 40 years on: Hope is the engine of imagining utopia." *The Guardian*, November 29, 2016.

Pilcher, Jane. "The Gender Significance of Women in Power: Women Talking About Margaret Thatcher." *European Journal of Women's Studies*, 2, 4 (1995): 493-508.

Pile, Steve. "Emotions and affect in recent human geography." *Transactions of the Institute of British Geographers* 35, 1 (2010): 5–20.

Pinker, Steven. *Enlightenment Now: The Case for Reason, Science, Humanism, and Progress.* London: Allen Lane, 2018.

Plaws, Avery. "Empty Hands: Communication, Pluralism,and Community in Ursula K. Le Guin's The Dispossessed." In *The New Utopian Politics of Ursula K. Le Guin's The Dispossessed*, edited by Laurence Davis and Peter Stillman, 283-305. Oxford: Lexington Books, 2005.

Polletta, Francesca. *Freedom is an endless meeting: Democracy in American social movements.* Chicago: University of Chicago Press, 2012.

Portelli, Allesandro. "What makes oral history different." In *The Oral History Reader* edited by Rob Perks and Alistair Thomson. London: Routledge, 1998.

Porter, Bob. "The British choral tradition: an introduction." https://bachtrack.com/british-tradition-choral-month-article. Accessed 29 September 2017.

Potts, Ruth. "Daring to dream." *Red Pepper,* 211 (Dec/Jan, 2017), 15-16.

Ram, Jo. "Drawing a line." *Red Pepper* 214, June/July (2017): 30-31.

Rawls John. *The Law of Peoples.* Cambridge: Harvard University Press, 1999.

Reckwitz, A. "Toward a Theory of Social Practices." *European Journal of Sociology*, 5, 2 (2002): 243–263.

Roelvink, Gerda, Kevin St. Martin and J. K. Gibson-Graham (Eds.). *Making Other Worlds Possible: Performing Diverse Economies.*

Minneapolis: University of Minnesota Press, 2015.

Roseneil, Sasha. *Common women, uncommon practices: the queer feminisms of Greenham*. London: Cassell, 2000.

Rosenthal, Rob & Flacks, Richard *Playing for Change: Music and Musicians in the Service of Social Movements*. Boulder CO: Paradigm, 2012.

Routledge, Paul. "Convergence space: process geographies of grassroots globalization networks." *Transactions of the Institute of British Geographers*, 28 (2003): 333-349.

Routledge, Paul. "Sensuous Solidarities: Emotion, Politics and Performance in the Clandestine Insurgent Rebel Clown Army." *Antipode*, 44 (2012): 428-452.

Routledge, Paul and Cumbers, A. *Global justice networks: Geographies of transnational solidarity*. Oxford: Oxford University Press, 2013.

Roy, W. G. *Reds, Whites and Blues: Social movements, folk music, and race in the United States*. Princeton: Princeton University Press, 2010.

Sabia, Dan. "Individual and Community in Le Guin's The Dispossessed." In: *The New Utopian Politics of Ursula K. Le Guin's The Dispossessed*, edited by Laurence Davis and Peter Stillman, 111-128. Oxford: Lexington Books, 2005.

Sacks, Oliver. *Musicophilia: Tales of music and the brain*. London: Picador, 2007.

Samuel, Chris. "Why don't men join choirs?" *The Guardian*, June 13 2013.

Samuel, Raphael. *The lost world of British communism*. London: Verso,

2006.

San Roman, Gabriel. *Venceremos: Victor Jara and the New Chilean Song Movement*. Oakland: PM Press Pamphlets, 2014.

Sargent, Lyman Tower. *Utopianism*. Oxford: Oxford University Press, 2010.

Sayer, Andrew *Why Things Matter to People: Social science, values and ethical life*. Cambridge: Cambridge University Press, 2011.

Schaer, Roland, Gregory Claeys and Lyman Tower Sargent (Eds). *Utopia: The search for the ideal society in the western world*. Oxford: Oxford University Press, 2001.

Sharpe, Joanne, Ronan Paddison, Chris Philo and Paul Routledge (Eds.). *Entanglements of Power: Geographies of Domination/Resistance*. London: Routledge, 2000.

Sherkat, D. E. and T. J. Blocker. "The Political Development of Sixties Activists: Identifying the influence of class, gender and socialisation on protest participation." *Social Forces*, 72 (1994): 821-842.

Shilts, R. *The Mayor of Castro Street: The Life and Times of Harvey Milk*, New York: Macmillan, 1982.

Shove, E., Pantzar, M. and Watson, M. *The Dynamics of Social Practice: everyday life and how it changes*. London: Sage, 2012.

Skelton, C. and Francis, B. "Successful Boys and Literacy: Are "Literate Boys" Challenging or Repackaging Hegemonic Masculinity?" *Curriculum Inquiry*, 41 (2011): 456–479.

Skelton, Tracey. "Children, young people and politics: Transformative

possibilities for a discipline?" *Geoforum*, 49 (2013), R4-R5.

Smith, Evan & Worley, Matthew (Eds.). *Against the Grain: The British Far Left from 1956*. Manchester: Manchester University Press, 2014.

Smith, Martin J. "From consensus to conflict: Thatcher and the transformation of politics." *British Politics*, 10, 1 (April 2015): 64-78.

Solnit, Rebecca. *Hope In The Dark: The Untold History of People Power*. Edinburgh: Canongate Books, 2005.

Spencer, Douglas. "The Alien Comes Home: Getting Past the Twin Planets of Possession and Austerity in Le Guin's The Dispossessed." In: *The New Utopian Politics of Ursula K. Le Guin's The Dispossessed*, edited by Laurence Davis and Peter Stillman,95-109. Oxford: Lexington Books, 2005.

Starhawk. *The Fifth Sacred Thing*. London: Bantam, 1993.

Staum, Myra J. "A Music/Nonmusic Intervention with Homeless Children." *Journal of Music Therapy*, 30, 4, December (1993): 236–262.

Stone, Penny. "Gentle Angry People". *Peace News,* August-September, Issue 2596-2597 (2016).

Street, John. "Fight the Power: The Politics of Music and the Music of Politics". *Government and Opposition*, 38 (2003): 113–130.

Stulberg, Lisa. *LGBTQ Social Movements*. Cambridge: Polity Press, 2017.

Subcommandante Insurgente Marcos. *Our Word is Out Weapon*. Edited by Juana Ponce de León. London: Serpent's Tail, 2001.

The Living Tradition. http://www.livingtradition.co.uk/node/781.

Accessed 10 October, 2017.

Thien, D. "After or beyond feeling? A consideration of affect and emotion in geography." *Area*, 37 (2005): 450-454.

Thrift, Nigel. "Intensities of feeling: towards a spatial politics of affect." *Geografiska Annaler,* Series B, 86 (2004): 57-78

Tolbert, P. S., M. E. Graham, & A. O. Andrews. "Group gender composition and work group relations: Theories, evidence, and issues." In *Handbook of gender and work* edited by G. Powell, 179-202. Thousand Oaks, CA: Sage, 1999.

Tormey, Simon. *Anti-capitalism*. Oxford: One World Publications, 2004.

Tormos, F. "Intersectional Solidarity." *Politics, Groups, and Identities.* 5, 4 (2017): 707-720.

Tuan, Yi-Fu. *Cosmos And Hearth: A Cosmopolite's Viewpoint*. Minneapolis: University Of Minnesota Press, 1999.

Turbulence Collective. *What Would It Mean To Win?* Oakland: PM Press, 2011.

Urry, John. *Mobilities.* Cambridge: Polity, 2007.

Verson, Jennifer. "Why we need cultural activism." In *Do It Yourself: A handbook for changing our world,* edited by Trapese Collective, 171-186. London: Pluto Press, 2007.

Verba S, Schlozman K, Burns N. "Unequal at the Starting Line: Creating Participatory Inequalities across Generations and Among Groups." *American Sociologist,* 34 (2003): 45-69.

Virdee, Satnam and Brian McGeever. "Brexit, Racism, Crisis." *Ethnic and Racial Studies* (2017): 1-18.

Voices Now Choral Survey. https://www.surveymonkey.co.uk/r/ VoicesNowSurvey, Accessed 2 October, 2017.

Wagg, S. and Pilcher, J. (Eds.). *Thatcher's Grandchildren? Politics and Childhood in the Twenty-First Century.* Basingstoke: Palgrave, 2014.

Walker, Gordon. *Environmental Justice: concepts, evidence and politics.* London: Routledge, 2011.

Weber, William. "The Myth of Mozart, the Revolutionary." *The Musical Quarterly*, 78, 1 (1994): 34-47.

Wenger, E. *Communities of practice: Learning, meaning, and identity.* Cambridge: Cambridge University Press, 2000.

Wetherell, Margaret. *Affect and Emotion.* London: Sage, 2012.

Whiteley, S., Bennett, A. & Hawkins, S. (Eds.) *Music, Space and Place: Popular Music and Cultural Identity.* Ashgate: Farnham, 2005

Wilce, Hilary. "Bullied boys: Why bright lads are being picked on." *Independent* (13 May 2009).

Wilkinson, Richard and Kate Pickett. *The Spirit Level: Why equality is better for everyone.* London: Penguin, 2010.

Williams, Raymond. *Resources of Hope: Culture, Democracy, Socialism.* Edited by Robin Gable. London: Verso, 1989.

Williams, Roderick. "Singing for solidarity." A choral history of Britain. BBC Radio 4. 20 September 2017. Accessed 29 September 2017. http://

www.bbc.co.uk/programmes/b0952str

Wood, J. L. and Wing-Cheung Ng. "Socialisation and Student Activism: Examination of a Relationship". In *Research in Social Movement, Conflict and Change*, edited by L. Kriesberg, 21-44. Greenwich, CT: JAI Press, 1980.

Wray-Lake, Laura and Amy K Syvertsen. "The Developmental Roots of Social Responsibility in Childhood and Adolescence." *New Directions for Child and Adolescent Development* (2011): 11-25.

Yang, G. "Activism." In *Digital Keywords: A vocabulary of information society and culture* edited by B. Peter, 1-17. Princeton, NJ: Princeton University Press, 2016.

APPENDIX 1

Street Choirs Festivals - Brief historic overview[1]

From 1984 to 1990 the Festival was organised by street bands and known as the National Street Band Festival, while being joined by emerging political street choirs

1984 Sheffield, National Street Bands Festival (NSBF)

1985 Newcastle (May) and Manchester (November)

1986 Bradford, NSBF

1987 Bristol, NSBF

1988 Liverpool, NSBF

1989 Leicester, NSBF

1990 Newcastle, NSBF

1991 Hackney, renamed National Street Music Festival (NSMF), jointly organised by Big Red Band and Raised Voices

1992 Sheffield, NSMF, co-organised by Sheffield Socialist Choir

1993 Cardiff, NSMF, co-organised by Côr Cochion

1994 Leeds, NSMF, organised by Leeds People's Choir

1995 Stroud, NSMF

1996 Nottingham, NSMF, organised by Nottingham Clarion Choir

1997 Morecambe, NSMF, organised by Pete Moser. Choirs only from now on, while bands had a separate festival.

1998 Leicester, NSMF, organised by Red Leicester

1999 Bradford, NSMF

2000 Manchester, NSMF

2001 Nottingham, NSMF, organised by Nottingham Clarion Choir

2002 Hebden Bridge, NSMF, organised by Calder Valley Voices

2003 Belper, NSMF

2004 Leeds, NSMF, organised by Leeds People's Choir

2005 Saltaire/Shipley, NSMF

2006 Gateshead, renamed National Street Choirs Festival (NSCF), jointly organised by Caedmon Choir and Heaton Voices

2007 Manchester, NSCF, organised by Manchester Community Choir

2008 Brighton, NSCF, organised by Hullabaloo

2009 Whitby, NSCF, organised by Whitby Community Choir

2010 Sheffield, NSCF, organised by Out Aloud. Festival charities: Amnesty International's LGBT Network and Sheffield Palestine Solidarity Campaign (SPSC).

2011 Whitby, NSCF, organised by Whitby. Festival Charity: Justice First

2012 Bury, NSCF, organised by Bury Acapeelers Community Choir. Festival charities: Musicians Without Borders, Alzheimers Society Bury, Eagles Wing Bury (asylum seeker support), Jigsaw Bury (support for young disabled people), Bury Cancer Support Group.

2013 Aberystwyth, renamed Street Choirs Festival (SCF, 'National' being dropped as the UK incorporates several nations), organised by Côr Gobaith. Festival charities: Radio Bronglais (local hospital radio station), Wales Women's Aid, Médecins Sans Frontières (MSF).

2014 Hebden Bridge, SCF, organised by Calder Valley Voices. Festival Charities: Gorilla Organisation, CROWS (Community Rights Of Way Services), Living Well cancer support, Todmorden Food Drop-in, NSPCC.

2015 Whitby, NSCF ('National' temporarily sneaked back in), organised by Whitby Community Choir. Festival charities: The Open Nest (adoptive families support), Cameroon Human Rights Group, James Cook University Hospital ICU, Musicport Education.

2016 Leicester, SCF, organised by Red Leicester. Festival charities: International Disaster Volunteers, Pride Without Borders, Leicestershire Autistic Society, Soundcafé Leicester.

2017 Kendal, SCF, organised by David Burbidge and Lakeland Voices

2018 Brighton, SCF, organised by Hullabaloo Quire. Still in the organising phase at the time of writing.

APPENDIX 2

Campaign Choirs

Birmingham Clarion Singers, birminghamclarionsingers.wordpress.com

Bolton Clarion Choir, boltonclarionchoir.com

Bradford Voices, bradfordvoices.org.uk

Bradford Women Singers, bradfordwomensingers.org.uk/

Caedmon Choir, Gateshead, caedmonchoir.org.uk

Calder Valley Voices, Hebden Bridge, caldervalleyvoices.org.uk

Canwyr Stryd Bangor Street Singers, Bangor, Facebook: www.facebook. com/groups/1660422787540766/

Change the World in Song, Belfast, naturalvoice.net/choir/ change-the-world-in-song

Commoners Choir, Leeds, www.commonerschoir.com

Côr Cochion, Cardiff, corcochion.wordpress.com

Côr Gobaith, Aberystwyth, corgobaith.wordpress.com

East Lancs Choir, Burnley, www.clarion-choir.co.uk

Holler4Activists, London, www.holler4.co.uk

Hullabaloo Quire, Brighton, www.hullabalooquire.org

Kadenza, Horwich and Bolton, www.kadenza.org.uk

Las Pasionarias, Hastings

Liverpool Socialist Singers, www.liverpoolsocialistsingers.net

Making Waves, Cullercoats

May Contain Notes, Bradford, www.voicemailharmony.co.uk

Nottingham Clarion Choir, www.nottinghamclarionchoir.net

Open Voice, Manchester, Facebook: Open Voice www.facebook.com/
groups/84413436020/

Pales Peace Choir, Llandegly, thepales.org.uk/peace-choir

Protest in Harmony, Edinburgh, www.protestinharmony.org.uk

Quarternotes, Manchester, quarternotes.uk

RabbleRousers, Lancaster, naturalvoice.net/choir/rabblerousers

Raised Voices, London, www.raised-voices.org.uk

Red and Green Choir, London, www.redandgreenchoir.org

Red Leicester, redleicesterchoir.com

Red Notes Socialist Choir, Bristol, rednoteschoir.org.uk

Rise Up Singing Group, London, singawaye17.weebly.com/rise-up-singing

Rough Truffles Community Choir, Belper, roughtruffles.webs.com

Sea Green Singers, Oxford, www.seagreensingers.com

Sheffield Socialist Choir, www.socialistchoir.org.uk

Sing for Health, Scarborough, naturalvoice.net/choir/sing-for-health

Sing with Pride, Norwich, singwithpride.shutterfly.com

Strawberry Thieves Socialist Choir, London, www.strawberrythieveschoir.org.uk

The Rabble Chorus, Suffolk, www.therabblechorus.co.uk

UpRoar People's Choir, Brighton, www.uproarpeopleschoir.co.uk

Vocaloca, Belfast, naturalvoice.net/choir/vocaloca

Voices of Freedom, Totnes, www.robcarneymusic.co.uk/voices-of-freedom

Walcot State Choir, Bath, walcotstatechoir.com

Whitby Community Choir, whitbycommunitychoir.wordpress.com

Wildfire Women's Choir, Leith Edinburgh, www.wildfirechoir.btck.co.uk

APPENDIX 3

Other useful links

Campaign Choirs network, campaignchoirs.org.uk

East Midlands Oral History Archive, Leicester University, www.le.ac.uk/emoha

Natural Voice Network, naturalvoice.net

Singing For Our Lives, www.singing4ourlives.net

Street Choirs Festival, streetchoirs.org

INDEX

Lightning Source UK Ltd.
Milton Keynes UK
UKHW01f0630230618
324673UK00003B/123/P